The Robert Lehman Collection

VI

The Robert Lehman Collection

VI

Italian Eighteenth-Century Drawings

James Byam Shaw

George Knox

The Metropolitan Museum of Art, New York
in association with
Princeton University Press, Princeton

Egbert Haverkamp-Begemann, Coordinator

Published by The Metropolitan Museum of Art, New York

John P. O'Neill, Editor in Chief
John Daley, Editor
Bruce Campbell, Designer
Jean Wagner, Bibliographer

Type set by Columbia Publishing Company, Inc., Baltimore, Maryland
Printed and bound in Italy by Amilcare Pizzi, S.p.a., Milan
Duotone negatives by Robert J. Hennessey, Middletown, Connecticut

LIBRARY OF CONGRESS CATALOGING-IN-PUBLICATION DATA
(Revised for vol. 6)
The Metropolitan Museum of Art (New York, N.Y.)
The Robert Lehman Collection.
Includes bibliographies and indexes.
Contents: v. 1. Italian paintings / John Pope-Hennessy—
v. 6. Italian eighteenth-century drawings /
James Byam Shaw, George Knox.
1. Lehman, Robert, 1892–1969—Art collections—
Catalogs. 2. Art—Private collections—
New York (N.Y.)—Catalogs. 3. Metropolitan Museum
of Art (New York, N.Y.)—Catalogs.
I. Byam Shaw, James, 1903– . II. Pope-Hennessy, John Wyndham, Sir,
1913– . III. Knox, George, 1922– . IV. Title.
N611.L43N48 1986 708.147'1 86-12519
ISBN 0-87099-479-4 (v. 1)
ISBN 0-691-04045-1 (Princeton: v. 1)
ISBN 0-87099-473-5 (v. 6)
ISBN 0-691-04046-X (Princeton: v. 6)

Contents

FOREWORD BY EGBERT HAVERKAMP-BEGEMANN / vii

NOTE TO THE READER / x

CATALOGUE / 1

COLORPLATES / 227

BIBLIOGRAPHY / 247

EXHIBITIONS / 254

INDEX OF ARTISTS / 259

INDEX OF PREVIOUS OWNERS / 260

PHOTOGRAPH CREDITS / 262

Foreword

New York may be considered the largest repository in the world of Venetian eighteenth-century drawings. It owes this distinction mainly to a small number of enlightened collectors and their purchases of both entire collections and individual pieces. Of two generations of collectors, Philip Lehman (1861–1947) and his son Robert Lehman (1892–1969) stand out for having brought together the excellent drawings by the Tiepolos, Francesco Guardi, Canaletto, and others catalogued in this volume.

Some of the purchases of the later Italian drawings that are catalogued here go back to the mid-1930s, for example Canaletto's great *Warwick Castle: The East Front* (No. 19), bought by Philip Lehman from the Fauchier-Magnan sale of 1935, and the celebrated *Bacchus and Ariadne* by Giambattista Tiepolo (No. 76), from the collections of William Bateson and Philip Hofer. In the years before World War II a number of studies by Tiepolo also were bought which are not listed here, for Robert Lehman presented them to the Yale University Art Gallery and to the Lyman Allyn Museum in 1941 (see No. 83). Robert Lehman continued to purchase individual drawings or small groups of them until the mid-1960s. Most significant among these were the two large panoramic views of Venice by Francesco Guardi (Nos. 29, 30) and the large number of drawings by Giandomenico Tiepolo. His great coup in this field, however, was the acquisition of the main part of the collection of Paul Wallraf in 1962. The majority of the drawings catalogued here (at least 117 out of 186), and many of the finest, came from that collection.

Paul Wallraf was a member of a banking family of Cologne, the same family to which belonged Ferdinand Franz Wallraf (d. 1824), canon of Cologne Cathedral, whose fine collection formed the nucleus of the Wallraf-Richartz-Museum. Paul Wallraf's distaste for the Hitler regime brought him to England before the war. He was an inveterate collector with a passion for Venetian art, which at times strained his means. He became a successful *marchand-amateur*, with close links to Messrs. Wildenstein. After his second marriage, to Muriel Ezra née Sassoon, who shared his tastes, he and his wife assembled a very large collection of paintings, drawings, bronzes, and innumerable objets d'art, all crowded together into two separate apartments, hers above, his below, at Grosvenor Place in London. They also had a beautiful apartment in Palazzo Malipiero in Piazza Santa Maria Formosa in Venice. The completion of their collection of Venetian eighteenth-century drawings was marked by an exhibition at the Fondazione Giorgio Cini in Venice, in 1959, which was shown later that same year in Cologne.

Robert Lehman's acquisition of this collection, the last of its type, recalls other fundamental purchases that made New York the center for study of Venetian eighteenth-century prints and drawings: the purchase by Eleanor and Sarah Hewitt of the album of Tiepolo etchings in Paris, in August 1905 (now in the Cooper-Hewitt Museum); the purchase by J. Pierpont Morgan of the Charles Fairfax Murray collection, in 1910; the purchase of the album of the duc de Biron by The Metropolitan Museum of Art, in 1937; the purchase by Rudolf Heinemann of the collection of Tomas Harris; and the purchase by Samuel Kress of the Albrizzi album of Piazzetta drawings, which passed to the Pierpont Morgan Library in 1961. One also must not forget Dan Fellows Platt and Janos Scholz, who brought so many drawings of this school and period to these shores (the former's now at

the Art Museum, Princeton University, the latter's largely at the Pierpont Morgan Library).

Three of the five drawings by Francesco Guardi and all of those by his son Giacomo in the Robert Lehman Collection came from Paul Wallraf, as did no less than 36 of the fine group of 41 by Giambattista Tiepolo. But Robert Lehman must have realized that the Wallraf collection was not equally strong in drawings by Giambattista's son Domenico. He bought a great number of drawings by Giandomenico between 1956 (No. 117) and 1966 (Nos. 171, 174), therefore both before and after the acquisition of the Wallraf collection. He brought the individual drawings together from many different sources: from London and New York dealers, and from London and Paris salerooms. By enlarging the Wallraf group of Giandomenicos substantially—only 22 of the present 64 in this catalogue belonged to Wallraf—Robert Lehman greatly raised the level of the collection as a whole. Wallraf did not own any drawing of the famous Punchinello series, which in recent years has become the most appreciated of all Domenico's productions. Robert Lehman acquired no less than nine of them, one or two at a time from five different sources.

It is most fortunate for scholarship, and especially for the study of Venetian drawings, that two of the foremost scholars in this field were willing to write this catalogue. James Byam Shaw, the dean of scholars and connoisseurs of Venetian drawing, whose first study in this field (on Bellini) was published in 1928 in *Old Master Drawings*, the periodical which he helped to found, has once more applied his erudite skill and subtle wit to artists he has admired and cherished for a great number of years, thereby putting generations of art historians in his debt. George Knox, whose studies of Giambattista Tiepolo have created a firm structure used gratefully by all students of the artist, has defined the place of the artist's drawings in his œuvre, and has analyzed a great number of drawings by others.

The assistance of individuals and institutions should here receive grateful acknowledgment. A catalogue such as this depends upon the cumulative studies of generations of collectors, scholars, and museum officials. But perhaps it is only proper in this instance to make a special mention of the debt that is owed to the library founded by Sir Robert Witt, which now belongs to the Courtauld Institute of Art in London. Students of Venetian art also remember fruitful hours spent among the books of Teodoro Correr and Pompeo Molmenti in the Biblioteca Correr in Venice and among the books, many of them assembled by Giuseppe Fiocco, in the magnificent seventeenth-century library that has passed from the Benedictines of San Giorgio Maggiore to the Fondazione Giorgio Cini. A special tribute must be paid to Antonio Morassi, who devoted himself to the study of the Tiepolos and the Guardis and who prepared the catalogue of the Wallraf drawings, published in conjunction with the exhibitions in Venice and Cologne in 1959, that is the starting point of many entries in the present publication. Finally, it may not be out of place to offer a note of thanks to dealers, who do much to stimulate the interest of collectors, who make available many things that might otherwise be inaccessible, and who are often the repositories of invaluable out-of-the-way information.

A special word of thanks should be expressed for the careful, patient, and expert editorial care that the late John Daley bestowed on this volume. Furthermore, I join the authors in acknowledging the assistance received from graduate students at the Institute of Fine Arts, New York University—Ethan M. Kavaler, Jennifer M. Kilian, and Wendy Persson Monk—and from the members of the staff of the Robert Lehman Collection.

This catalogue of all the Italian drawings of the eighteenth century in the Robert Lehman Collection is published as Volume VI of the joint project of the Robert Lehman Collection, The Metropolitan Museum of Art, and the Institute of Fine Arts. Its readers will agree with me that the three institutions are to be congratulated on this result of their endeavor.

Egbert Haverkamp-Begemann
The John Langeloth Loeb Professor of the History of Art, Institute of Fine Arts, New York University; Coordinator of the Robert Lehman Catalogue Project

NOTE TO THE READER

The drawings have been remeasured for this catalogue. Measurements have been taken through the center of the drawing. Height precedes width.

"Inscription" and "inscribed" refer to comments, notes, words, and numbers presumably written by the artist who made the drawing; "annotation" and "annotated" refer to the same when added by another hand.

"Lugt" and a number, in parentheses following the name of a collector, indicates that the collector's mark, identified in F. Lugt, *Les marques de collections de dessins & d'estampes* (Amsterdam, 1921) and *Supplément* (The Hague, 1956), is found on the drawing.

Bibliographical references have been abbreviated to the author's name and the date of publication, and references to exhibitions to place and year. A key to these references is found in the Bibliography and the List of Exhibitions on pp. 247 and 254. In the case of traveling exhibitions, only the first venue is given in the abbreviation.

CATALOGUE

Jacopo Amigoni

Venice 1675(?)–Madrid 1752

Horace Walpole tells us that Amigoni was born in Venice in 1675,[1] though the artist is said to have stated late in life that he was born in Naples in 1682. His name appears in the lists of the Fraglia dei Pittori in Venice in 1711. It seems not unlikely that he was a pupil of Antonio Bellucci's, as Walpole says he was. From 1717 until 1728 he was active in Bavaria, at Schleissheim, Nymphenburg, and Ottobeuren, mainly as a fresco painter specializing in ceilings. From 1729 until 1739 he was in England. There he became important as a portrait painter, obtaining many royal commissions, though he continued to work as a history painter at Moor Park and elsewhere. Between 1739 and 1747 he was back in Venice; the most notable recorded works of this time are altarpieces. His last five years were spent in Spain, where he continued to work as both a portraitist and a decorative painter for the Spanish court. No comprehensive study of Amigoni's career has yet appeared.[2]

G. K.

NOTES:
1. Walpole 1762–80, vol. 4, p. 59.
2. Two recent dissertations deal with aspects of his work: Holler 1984 with the German period, and Hennessey 1983 with the Venetian period.

LITERATURE: Garas 1978.

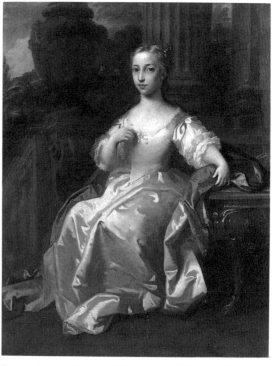

Fig. 1. Jacopo Amigoni. *Portrait of Princess Mary or Princess Louisa*. New York, Suida Manning collection

Attributed to Amigoni

1. Portrait of a Lady

1975.1.263

Black, white, and red chalk, with pastel (mainly flesh-colored and brown), on brownish paper. 290 × 245 mm. Water-stained near the bottom edge toward the right.

The literature records two pastels by Amigoni: a portrait of Queen Amalia of Spain in the Gatti-Casazza collection,[1] and a *Rebecca at the Well* in a private collection in London.[2] Gladys Wilson, who is working on Amigoni, suggests that the Lehman drawing may be a portrait of either Mary or Louisa, the two youngest daughters of King George II. Certainly it is not dissimilar to the portrait of one of these princesses in the Suida Manning collection (Fig. 1).[3] The pearls in the hair and the ermine cloak are also found in the portrait of Princess Caroline at Ickworth.[4] While the attribution of the drawing to Amigoni should be treated with caution, it should be allowed to stand until more conclusive evidence comes to light.

G. K.

NOTES:
1. Venice 1929, p. 115, no. 21; Fiocco 1929, pp. 531–32.
2. Noted by B. Suida Manning in Portland 1956, p. 35.
3. Claye 1974, p. 43.
4. Ibid., p. 45, fig. 3.

PROVENANCE: Mathias Komor, New York. Acquired by Robert Lehman in 1965.

EXHIBITED: New York 1981, no. 1.

LITERATURE: Szabo 1983, no. 59.

2

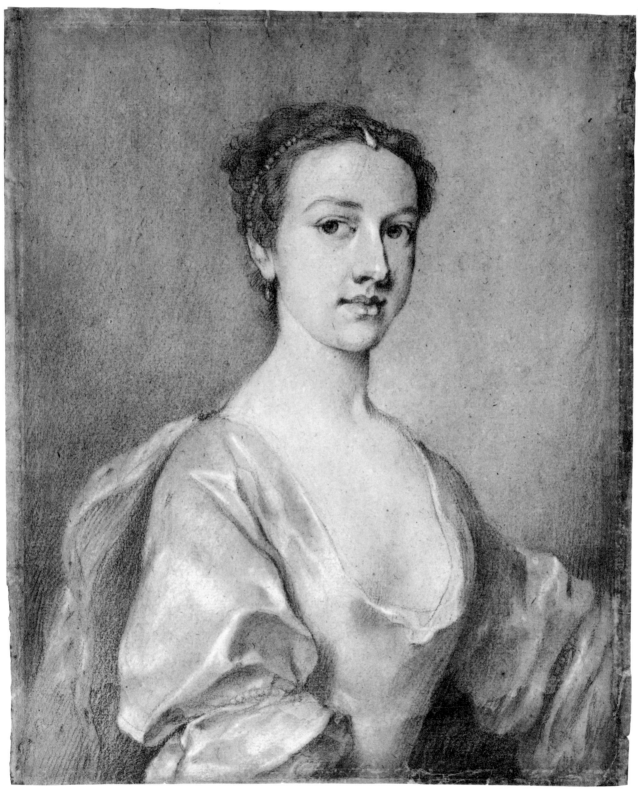

No. 1

Nicolò Bambini

Venice 1651–Venice 1736

Bambini was the oldest of the generation of history painters, born in the 1650s, that included Antonio Bellucci (b. 1654), Gregorio Lazzarini (b. 1655), Antonio Molinari (b. 1655), and Sebastiano Ricci (b. 1659). It is recorded that he was a pupil of Sebastiano Mazzoni's, and he also studied in Rome under Carlo Maratta. He established himself as a leading artist in Venice with his ceiling for Ca' Pesaro of 1682, but after that his career is difficult to trace. He painted fine altarpieces for Santo Stefano and San Pantalon, perhaps in the nineties, and a series of grisailles on the ground floor of the Scuola dei Carmini, which may be dated between 1697 and 1704. Three large canvases with the story of Scipio, now dismembered into seven pieces, decorate the great room of Ca' Vendramin-Calergi. His ceiling in the Palazzo Arcivescovile at Udine is dated 1708, and two great canvases depicting incidents in the life of Saint Teresa, in the church of the Scalzi, may be dated about 1700.

G. K.

Fig. 2. Nicolò Bambini. *Danaë*. New York, Janos Scholz collection

2. The Stoning of Saint Stephen

1975.1.266

Pen and brown ink, brown wash, over red and black chalk. 208 × 314 mm.

Verso: The Stoning of Saint Stephen. Pen and brown ink, over traces of red chalk.

Two other drawings by Bambini from the De Mestral collection are in the collection of Janos Scholz and are entirely consistent in style with this drawing. One of them was shown in the exhibition *La pittura del Seicento a Venezia;*[1] the other (Fig. 2) bears the annotation *del Kav. Bambini* on the verso. Another drawing, very close to these examples, a *Martyrdom of Saint Hippolytus,* is in Warsaw.[2] One of quite different character, a *Finding of Moses* in Udine, is annotated *K.ʳ Niccolò Bambini.*[3]

None of these drawings can be associated with any known painting by Bambini. However, in 1977 Andrée Czére published a drawing in the Szépművészeti Múzeum, Budapest, which appears to be a full and careful study for the *Miraculous Communion of Saint Teresa,* one of the two large paintings by Bambini in the chapel of Saint Teresa in the church of the Scalzi (Santa Maria di Nazareth) in Venice.[4] There are two difficulties about the Budapest drawing: first, it is strange that an experienced artist like Bambini should have prepared a drawing whose format comprises almost a square and a half for a canvas that is practically square; second, the architectural background is entirely in the manner of Antonio Bellucci as seen, for example, in the great canvas on the right of the choir in San Pietro di Castello.[5] Notwithstanding these reservations, however, and given the extreme rarity—for a painter whose active career extended over more than half a century—of Bambini drawings, the Budapest study may well be by Bambini, and its style is not inconsistent with that of No. 2 or of the two drawings in the Scholz collection.

G. K.

NOTES:
1. Venice 1959c, no. 90.
2. Warsaw, Muzeum Narodowe, no. 190778; pen and wash, 200 × 320 mm. Unpublished.
3. Udine, Musei Civici. Rizzi 1970, no. 2.
4. Czére 1977, passim, figs. 118, 119.
5. Pallucchini 1981, vol. 2, fig. 1193.

PROVENANCE: Armand-Louis de Mestral de Saint-Saphorin; J. L. Reichlen, Lausanne; Janos Scholz, New York; Helene C. Seiferheld, New York. Acquired by Robert Lehman in 1962.

EXHIBITED: New York 1981, nos. 2a (recto), 2b (verso); Rochester 1981, no. 1 (recto).

LITERATURE: Szabo 1983, no. 50

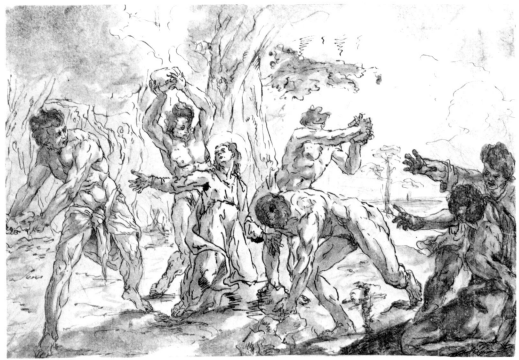

No. 2

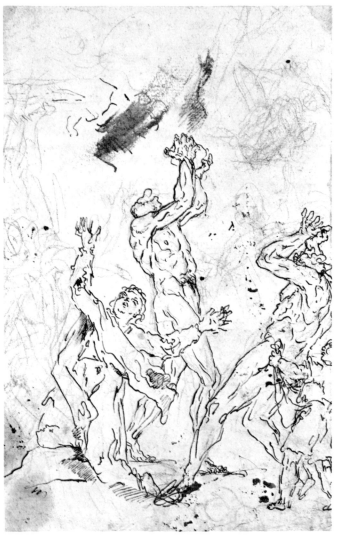

No. 2, Verso

5

Bernardo Bellotto,
sometimes called Canaletto

Venice 1721–Warsaw 1780

A view painter and etcher, Bellotto was the nephew and pupil of the more celebrated Antonio Canal, also called Canaletto. He appears in the lists of the Fraglia dei Pittori in 1738, and he is said to have visited Rome in about 1742. In 1744 he began to travel, and his now independent career took him to Florence, Turin, and Verona. In 1747 he moved to Dresden with his family, becoming court painter in 1748, and remained there until 1758. He then moved to Vienna, to Munich in 1761, and finally in 1763 to Warsaw. His large detailed views of all these cities constitute a superb record of their appearance at that time. In some cases he made large reproductive etchings as well.

It is here proposed that the thirteen drawings which follow are apprentice drawings and other early drawings by Bellotto.

<div align="right">G. K.</div>

LITERATURE: Kozakiewicz 1972.

3. The Grand Canal from Ca' Moro-Lin and Ca' Foscari to the Carità

1975.1.303

Pen and brown ink, gray wash. 253 × 431 mm. Vertical fold in center. Partly erased annotation in pencil on backing paper, bottom right: *Canal Grande*.

This is the first of a series of five drawings evidently based upon Antonio Visentini's engravings in his *Urbis Venetiarum Prospectus*, which was published in its complete form in Venice in 1742.[1] However, the first fourteen of Visentini's plates were issued in 1735 and our drawings relate to plates II, III, VI, VII, and VIII. It seems fairly certain that they are the exercises of an apprentice, concentrating on the buildings and excluding the boats entirely. These drawings are rather less accomplished than seven others in the Lehman Collection (Nos. 8–14) which are similarly related to etchings by Canaletto and which evidently represent a slightly later stage in the training of the same apprentice. No other drawings of this kind are recorded. As Antonio Morassi notes, the suggestion that the young apprentice should be identified as Bernardo Bellotto was first advanced, verbally, by James Byam Shaw.[2]

No. 3

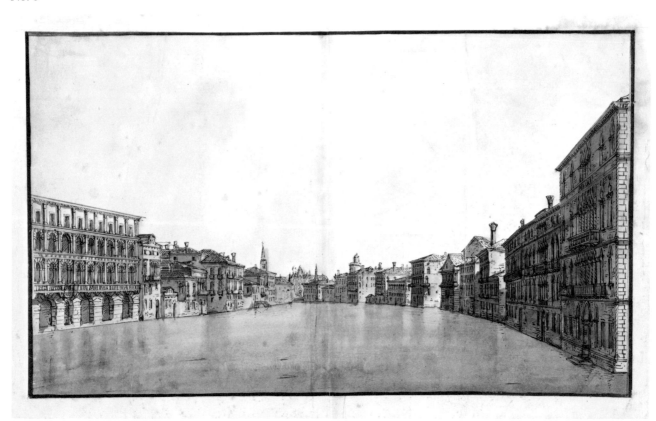

Bellotto's early drawings are discussed at length by Stefan Kozakiewicz;[3] nothing said by that author should rule out the notion that Nos. 3–7 are apprentice drawings made by Canaletto's nephew at the age of perhaps fifteen or sixteen years.

The present drawing, as Morassi points out, relates to plate II in Volume I of Visentini's *Prospectus*.[4] Its borders on either side correspond exactly to the borderline of the print.

<div align="right">G. K.</div>

NOTES:
1. The relation between the drawings and the engravings was noted by Antonio Morassi in Venice 1959a, pp. 15–16. For a recent account of Visentini (1688–1782) as an engraver, see Gorizia 1983, pp. 415–26.
2. Venice 1959a, pp. 16, 18.
3. Kozakiewicz 1972, vol. 1, pp. 18–19, vol. 2, pp. 7–38.
4. Venice 1959a, p. 18, no. 9.

PROVENANCE: Paul Wallraf, London. Acquired by Robert Lehman in 1962.

EXHIBITED: Venice 1959a, no. 9 (as School of Canaletto); Cologne 1959, no. 9 (as School of Canaletto); New York 1981, no. 16 (as Venetian Artist, School of Canaletto).

4. The Grand Canal from the Carità to the Dogana da Mar

1975.1.305
Pen and brown ink, gray wash. 253 × 433 mm. Vertical fold in center. Partly illegible annotation in pencil on backing paper, bottom right: *Venezia C. de Boni [ta?]*. Annotated in pencil on verso of backing paper: . . . *Palazzo Giustinian a S. Moise (104) rechts Academia*.

See No. 3. Morassi points out that this drawing relates to plate III in Volume I of Visentini's *Urbis Venetiarum Prospectus*.[1] The significance of the annotation on the recto is not clear.

<div align="right">G. K.</div>

NOTE:
1. Venice 1959a, p. 17, no. 7.

PROVENANCE: Paul Wallraf, London. Acquired by Robert Lehman in 1962.

EXHIBITED: Venice 1959a, no. 7 (as School of Canaletto); Cologne 1959, no. 7 (as School of Canaletto); New York 1981, no. 15 (as Venetian Artist, School of Canaletto).

No. 4

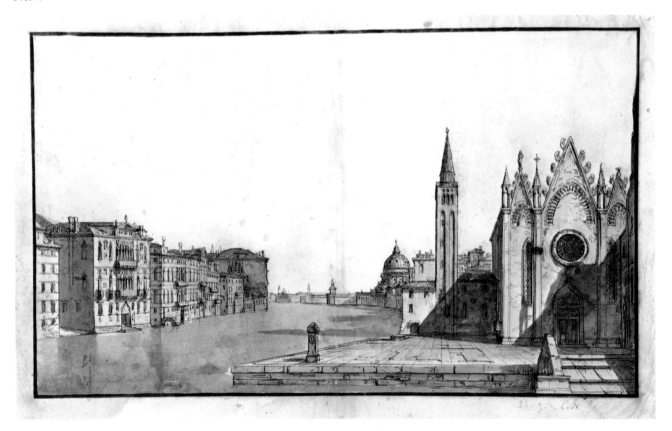

5. The Entrance to the Grand Canal, with the Dogana da Mar and Santa Maria della Salute on the Left

1975.1.304

Pen and brown ink, gray wash. 254 × 430 mm. Vertical fold in center; another to left of center. Drawing extended in pencil on backing paper at left and right. Annotated in pencil on backing paper, bottom right, partly erased: *Venezia Dogana*.

See No. 3. Morassi points out that this drawing relates to plate VI in Volume I of Visentini's *Urbis Venetiarum Prospectus*.[1]

G. K.

NOTE:
1. Venice 1959a, p. 17, no. 8.

PROVENANCE: Paul Wallraf, London. Acquired by Robert Lehman in 1962.

EXHIBITED: Venice 1959a, no. 8 (as School of Canaletto); Cologne 1959, no. 8 (as School of Canaletto); Huntington (N.Y.) 1980, no. 6 (as Venetian Artist from the School of Canaletto); New York 1981, no. 14 (as Venetian Artist, School of Canaletto); Rochester 1981, no. 8 (as Venetian Artist, School of Canaletto).

6. The Grand Canal with the Rialto Bridge, from the North

1975.1.306

Pen and brown ink, gray wash. 255 × 430 mm. Vertical fold in center. Annotated on verso of backing paper: *IL FONDACO DEI TEDESCHI / (heute Hauptpost / Telegraphenamt) / (141)*.

See No. 3. Morassi points out that this drawing relates to plate VII in Volume I of Visentini's *Urbis Venetiarum Prospectus*.[1] Its borders to either side correspond exactly to the borderline of the print, and the buildings in the print are closely copied, even to the awnings.

G. K.

NOTE:
1. Venice 1959a, p. 16, no. 6.

PROVENANCE: Paul Wallraf, London. Acquired by Robert Lehman in 1962.

EXHIBITED: Venice 1959a, no. 6 (as School of Canaletto); Cologne 1959, no. 6 (as School of Canaletto); Huntington (N.Y.) 1980, no. 7 (as Venetian Artist from the School of Canaletto); New York 1981, no. 13 (as Venetian Artist, School of Canaletto); Rochester 1981, no. 7 (as Venetian Artist, School of Canaletto).

7. The Grand Canal, with the Fabbriche Nuove on the Left and the Campanile of Santi Apostoli on the Right

1975.1.307

Pen and brown ink, gray wash. 255 × 430 mm. Vertical fold in center.

See No. 3. Morassi points out that this drawing relates to plate VIII in Volume I of Visentini's *Urbis Venetiarum Prospectus*.[1] Its borders to either side correspond exactly to the borderline of the print; the buildings in the print are closely copied, though there are no flags on the campanile of San Cassiano.

G. K.

NOTE:
1. Venice 1959a, pp. 15–16, no. 5.

PROVENANCE: Paul Wallraf, London. Acquired by Robert Lehman in 1962.

EXHIBITED: Venice 1959a, no. 5 (as School of Canaletto); Cologne 1959, no. 5 (as School of Canaletto); Huntington (N.Y.) 1980, no. 5 (as Venetian Artist from the School of Canaletto); New York 1981, no. 12 (as Venetian Artist, School of Canaletto).

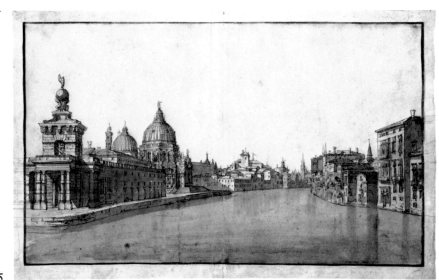

No. 5

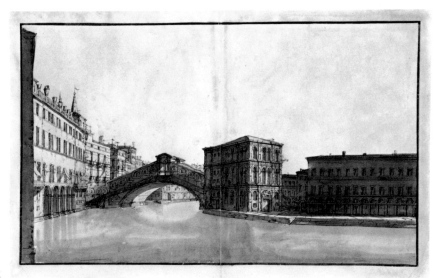

No. 6

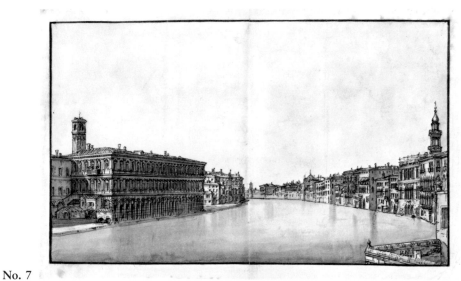

No. 7

8. View of Dolo

1975.1.301

Pen and brown ink, gray wash. 296 × 408 mm. Vertical fold in center.

This drawing is the first of a group of seven (Nos. 8–14) which, as Morassi points out, are related to the etchings of Canaletto.[1] The etchings were issued with a title plate that describes Joseph Smith as consul, an office to which he was appointed on June 6, 1744. It seems, however, that the etchings are earlier; they are possibly the product of an expedition along the Brenta made by Canaletto with the young Bernardo Bellotto in 1740 or 1741.

As we saw in the entry for No. 3, these drawings are evidently the work of an apprentice, who had earlier made copies after the Visentini plates (Nos. 3–7), and who has now attained a higher level of skill. In one case at least, No. 9, the manner comes very close to the known work of Bernardo Bellotto, and the entire group is here tentatively ascribed to him.

No. 8 is very closely related to no. 4 in the series of Canaletto etchings, entitled *Al Dolo*, which measures 298 × 427 mm.[2] The etching shows the whole of the villa on the left, and apart from boats and figures there are other minor variations—for example, in the etching the house to the left of the church has awnings and shutters. Thus the drawing can hardly be a copy after the etching.

There is a study for the etching by Canaletto, in the same sense and measuring 276 × 417 mm., in the Victoria and Albert Museum.[3] This shows only half of the villa on the left, but it also shows shutters and awnings on the house to the left of the church.

G. K.

NOTES:
1. Venice 1959a, p. 18. For recent accounts of Canaletto as an etcher, see Venice 1982, pp. 89–101, and Gorizia 1983, pp. 94–96, 97–110.
2. Bromberg 1974, pp. 54–59, no. 4; Venice 1982, p. 95, nos. 121–23.
3. Constable and Links 1976, vol. 1, pl. 123, no. 669, vol. 2, p. 544.

PROVENANCE: Paul Wallraf, London. Acquired by Robert Lehman in 1962.

EXHIBITED: Venice 1959a, no. 11 (as School of Canaletto); Cologne 1959, no. 11 (as School of Canaletto); New York 1981, no. 17 (as Venetian Artist, School of Canaletto); Rochester 1981, no. 9 (as Venetian Artist, School of Canaletto).

9. A Village on the Brenta

1975.1.302

Pen and brown ink, gray wash. 293 × 403 mm. Vertical fold in center.

See No. 8. As Morassi points out,[1] this drawing is very closely related to the Canaletto etching no. 9, *A Village on the Brenta* (Fig. 3), which measures 296 × 426 mm.[2] The etching shows a little more of the scene on each side, and apart from the addition of the figures there are many variations in details.

The etching can be shown to be based on two drawings, studies for houses along a river bank, in the Pierpont Morgan Library and the Fogg Art Museum,[3] which, however, show the scene in the reverse sense. This might be taken as demonstrating that No. 9 is a loose copy of the etching.

This drawing approaches the established manner of Bellotto more closely than any other specimen in our group. A comparable drawing is published by Kozakiewicz.[4]

G. K.

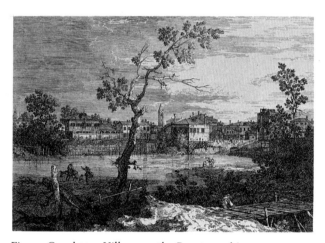

Fig. 3. Canaletto. *Village on the Brenta*, etching

NOTES:
1. Venice 1959a, p. 19, no. 12.
2. Bromberg 1974, pp. 78–81, no. 9; Venice 1982, p. 96, no. 130.
3. Constable and Links 1976, vol. 1, pl. 127, no. 695 a–b, vol. 2, pp. 553–54.
4. Kozakiewicz 1972, vol. 2, pp. 27, 29, no. 30.

PROVENANCE: Paul Wallraf, London. Acquired by Robert Lehman in 1962.

EXHIBITED: Venice 1959a, no. 12 (as School of Canaletto); Cologne 1959, no. 12 (as School of Canaletto); New York 1981, no. 18 (as Venetian Artist, School of Canaletto); Detroit 1983, no. 5 (as Venetian Artist, School of Canaletto).

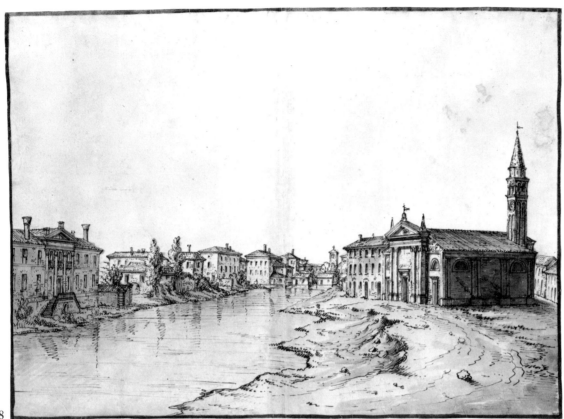

No. 8

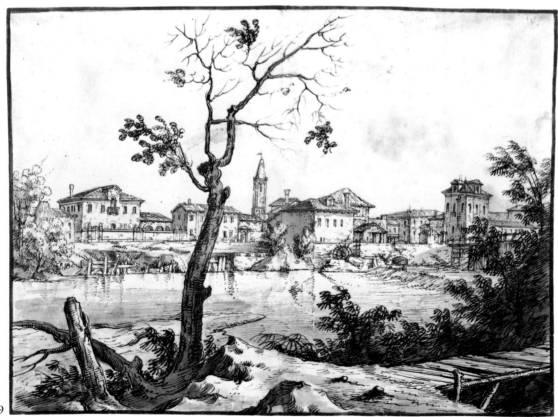

No. 9

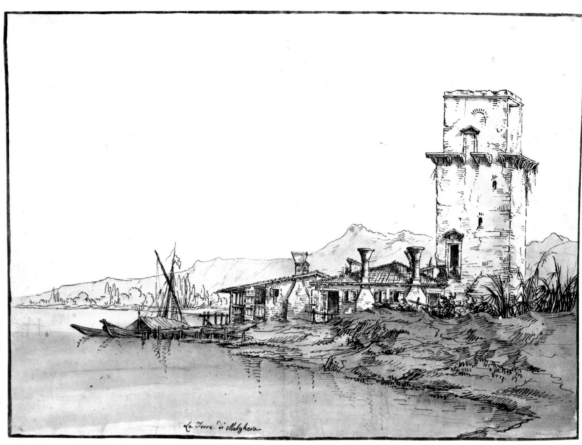

No. 10

10. The Tower of Marghera

1975.1.308
Pen and brownish black ink, gray wash, over graphite.
294 × 404 mm. Inscribed in brownish black at bottom center:
La Torre di Malghera.

See No. 8. As Morassi points out,[1] this drawing is related
to etching no. 2 by Canaletto (Fig. 4), which measures
297 × 427 mm. and is also inscribed *La Torre di
Malghera.*[2]

G. K.

NOTES:
1. Venice 1959a, p. 19, no. 131.
2. Bromberg 1974, pp. 42–47, no. 2; Venice 1982, pp. 94–95,
 nos. 118–19. "Malghera" is an old spelling for the present-
 day industrial center of Marghera.

PROVENANCE: Paul Wallraf, London. Acquired by Robert
Lehman in 1962.

EXHIBITED: Venice 1959a, no. 13 (as School of Canaletto);
Cologne 1959, no. 13 (as School of Canaletto); New York
1981, no. 23 (as Venetian Artist, School of Canaletto); Detroit
1983, no. 6 (as Venetian Artist, School of Canaletto); Pittsburgh
1985, no. 5 (as Venetian Artist, School of Canaletto).

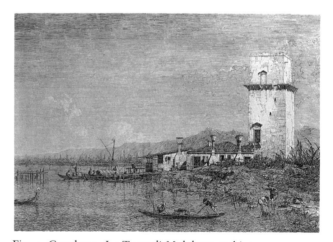

Fig. 4. Canaletto. *La Torre di Malghera*, etching

No. 11

11. View of Mestre

1975.1.309

Pen and brownish black ink, gray wash, over traces of graphite. 295 × 408 mm. Inscribed in brownish black ink at bottom center: *Mestre*. Vertical fold in center.

See No. 8. As Morassi points out,[1] this drawing is very closely related to the Canaletto etching no. 3, *Mestre* (Fig. 5), which measures 299 × 428 mm.[2] In this case, the drawing and the etching show exactly the same scene, including the same barrels and carts; only the boats and figures are lacking in the drawing.

A similar drawing by Canaletto at Windsor, measuring 251 × 405 mm., shows only half of the house on the left.[3]

G. K.

Fig. 5. Canaletto. *Mestre*, etching

NOTES:

1. Venice 1959a, p. 18, no. 10.
2. Bromberg 1974, pp. 48–52, no. 3; Venice 1982, p. 95, no. 120; Gorizia 1983, p. 98, no. 69.
3. Parker 1948, pp. 47–48, no. 89, pl. 61; Constable and Links 1976, vol. 1, pl. 123, no. 666, vol. 2, pp. 542–43; Venice 1982, pp. 39–40, no. 17.

PROVENANCE: Paul Wallraf, London. Acquired by Robert Lehman in 1962.

EXHIBITED: Venice 1959a, no. 10 (as School of Canaletto); Cologne 1959, no. 10 (as School of Canaletto); Huntington (N.Y.) 1980, no. 8 (as Venetian Artist from the School of Canaletto); New York 1981, no. 24 (as Venetian Artist, School of Canaletto).

No. 12

12. Santa Giustina and the Prato della Valle at Padua

1975.1.311

Pen and brown ink, gray wash. 320 × 426 mm. Vertical fold in center.

This and the following drawing together present a continuous panorama of the Prato della Valle at Padua, No. 12 depicting the left-hand portion and No. 13 the right-hand portion. There are two equivalent drawings by Canaletto at Windsor,[1] and these in turn are the models for his etchings nos. 7 and 8.[2]

G. K.

NOTES:
1. Parker 1948, pp. 44–45, nos. 72–73, pls. 53–54; Constable and Links 1976, vol. 1, pl. 126, nos. 689–90, vol. 2, pp. 551–52; Venice 1982, p. 44, nos. 35–36.
2. Bromberg 1974, pp. 72–77, nos. 7–8; Venice 1982, p. 96, nos. 128–29.

PROVENANCE: Paul Wallraf, London. Acquired by Robert Lehman in 1962.

EXHIBITED: Venice 1959a, no. 14 (as School of Canaletto); Cologne 1959, no. 14 (as School of Canaletto); New York 1981, no. 20 (as Venetian Artist, School of Canaletto).

No. 13

13. The Prato della Valle at Padua

1975.1.310
Pen and brown ink, gray wash. 320 × 424 mm. Vertical fold in center.

See No. 12.

G. K.

PROVENANCE: Paul Wallraf, London. Acquired by Robert Lehman in 1962.

EXHIBITED: Venice 1959a, no. 15 (as School of Canaletto); Cologne 1959, no. 15 (as School of Canaletto); New York 1981, no. 21 (as Venetian Artist, School of Canaletto).

14. Imaginary View of Padua

1975.1.299
Pen and black ink, gray wash. 319 × 426 mm.

No. 14 is related to Canaletto's etching no. 11 (Fig. 6).[1] However, it lacks the large tree on the left, which plays an important role in the design of the print, as well as the figures, vehicles, and boats.

The print is known in two states. In the first, a small tree stands to the right of the gateway, obscuring part of the domed church. In the second state (here illustrated) this is removed and a transept can be seen, as in the drawing.

<div align="right">G. K.</div>

NOTE:
1. Bromberg 1974, pp. 88–93, no. 11; Venice 1982, p. 97, nos. 134–35.

PROVENANCE: Paul Wallraf, London. Acquired by Robert Lehman in 1962.

EXHIBITED: Venice 1959a, no. 16 (as School of Canaletto); Cologne 1959, no. 16 (as School of Canaletto); New York 1981, no. 19 (as Venetian Artist, School of Canaletto).

Fig. 6. Canaletto. *An Imaginary View of Padua*, etching

15. A Venetian Villa

1975.1.300
Pen and brown ink, gray wash. 190 × 277 mm.

Morassi points out that this design was engraved by Fabio Berardi after Canaletto. The engraving (Fig. 7) measures 193 × 280 mm., and bears the inscription *L'età che non divora, Se strugge i sassi ancora.*[1]

There is also a painting of this subject, in the opposite sense, in the collection of Earl Cadogan.[2] There are many small differences, however, the most noticeable being the absence, in the drawing, of a statue over the entrance arch.

The arch (and indeed the whole building) seems to be associated with Ca' Papafava-Tasca at the Ponte della Guerra in Venice,[3] not very far from Canaletto's own house at San Lio. This gateway, a fine sixteenth-century structure, possibly by Guglielmo Grizi da Alzano, called Il Bergamasco, was brought here from the Palazzo Tasca at Portogruaro.

<div align="right">G. K.</div>

NOTES:
1. Venice 1959a, p. 21, no. 17. For Berardi see Gorizia 1983, pp. 75–80. I would like to thank Anna Forlani Tempesti and Sebastiano Timpanaro for this translation of the inscription: "What does not time devour, if it even consumes the stones!"
2. Constable and Links 1976, vol. 1, pl. 92, no. 502, vol. 2, pp. 462–63.
3. See Corboz 1985, vol. 1, pp. 119–20, fig. 127.

PROVENANCE: Paul Wallraf, London. Acquired by Robert Lehman in 1962.

EXHIBITED: Venice 1959a, no. 17 (as School of Canaletto); Cologne 1959, no. 17 (as School of Canaletto); New York 1981, no. 22 (as Venetian Artist, School of Canaletto).

Fig. 7. Fabio Berardi. *A Venetian Villa*, engraving

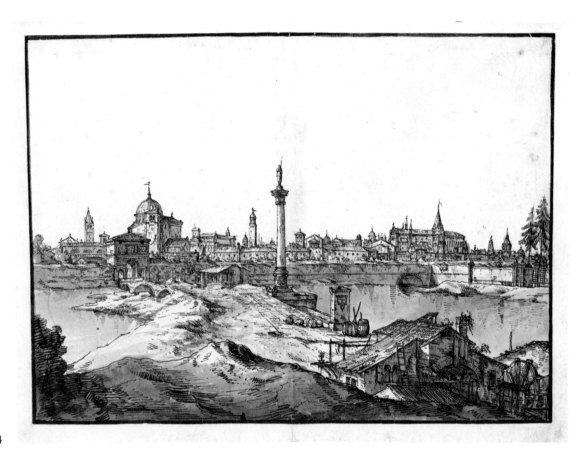

No. 14

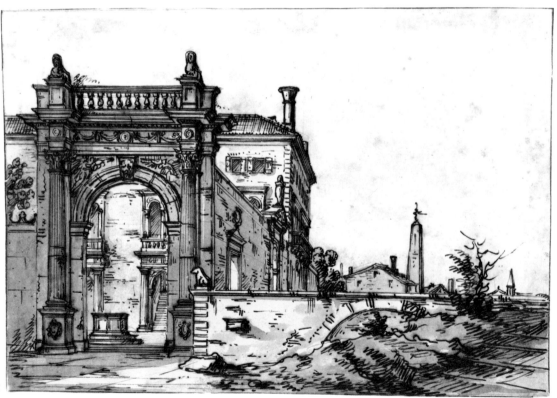

No. 15

Giuseppe Bernardino Bison

Palmanova 1762–Milan 1844

Bison, who was a painter, scenographer, and draftsman, was trained in Venice under Anton Maria Zanetti and Costantino Cedini (a follower of Tiepolo remembered for his ceiling in San Barnaba in Venice). Bison is recorded as working in two theaters in Ferrara in 1787, and in 1791 in the Villa Zannini at Lancenigo. In 1807 he is recorded in Zara and Trieste; he remained in the latter city until ca. 1831, when he moved to Milan. He is best known for his numerous and charming drawings, a last late flowering of the Venetian Settecento.

G. K.

LITERATURE: Udine 1962; Rizzi 1976.

16. The Nativity of Christ, with Shepherds and Kings in Adoration

1975.1.276
Pen and brown ink, brown wash, over red chalk. 178 × 241 mm. Signed in ink at bottom right: *Bison*.

This is an intriguing and unusual drawing by Bison, both by reason of its subject—religious subjects are rare in his oeuvre, and nothing comparable seems to be known—and of its style, which with its heavy juicy line and its dramatic luminosity seems to be an essay in the manner of the Dutch school.

G. K.

PROVENANCE: Paul Wallraf, London. Acquired by Robert Lehman in 1962.

EXHIBITED: Venice 1959a, no. 1; Cologne 1959, no. 1; New York 1981, no. 3; Rochester 1981, no. 2.

LITERATURE: Szabo 1983, no. 51.

No. 16

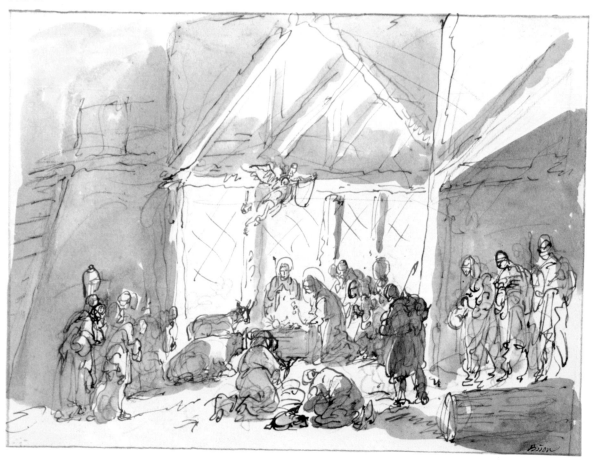

Carlo Antonio Buffagnotti

Bologna 1660–Ferrara 1715 (or later)

Buffagnotti was a prolific etcher, an engraver of decorative subjects, and a theater designer; he was active in Bologna, Genoa, Turin, and Ferrara. First known as a decorator of printed music, he worked in the theater from 1690 and was associated with the Bibiena family from 1703 onward. He is last recorded in Ferrara in 1715. The considerable collection of etchings by Buffagnotti in the print room at Bologna has been published by Giovanna Gaeta Bertelà and Stefano Ferrara.[1] Apart from No. 17, no drawings by him appear to be known.

<div style="text-align: right">G. K.</div>

NOTE:
1. Gaeta Bertelà and Ferrara 1974, nos. 118–216.

17. The Siege of a Fortress

1975.1.246

Pen and brown ink. 245 × 205 mm. Inscribed in brown ink at bottom: *veduta con rocca Assediata. Disegnata Carlo Buffagnotti.* Damaged and repaired along left edge.

The attribution to Buffagnotti is based entirely upon the inscription. The drawing is evidently by a hand skilled at engraving, though it is not related to any of the etchings by Buffagnotti in Bologna.

The two figures by the mortar in the middle ground to the left are strangely out of scale in relation to the figures in the foreground.

<div style="text-align: right">G. K.</div>

PROVENANCE: Not established.

EXHIBITED: New York 1979; New York 1981, no. 4.

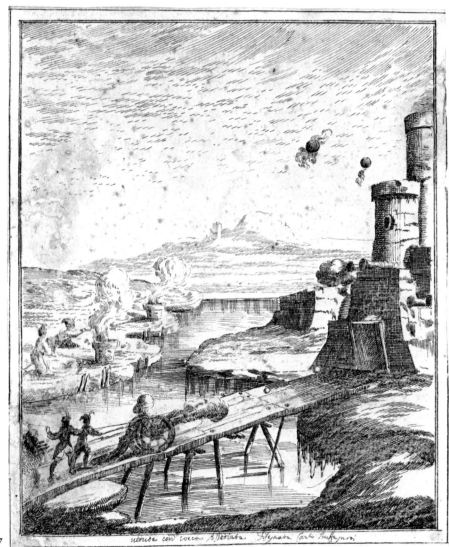

No. 17

Antonio Canal, called Canaletto

Venice 1697–Venice 1768

The most celebrated view painter of eighteenth-century Venice, Canaletto was the son of Bernardo Canal, a theatrical scene painter of some distinction, with whom he is recorded as working from 1716 onward. He is said to have been in Rome with his father in about 1719. In 1720 he appears in the lists of the Fraglia dei Pittori, and by 1723 he seems to have been established as a painter both of Venetian views and of architectural fantasies. The earliest documented works are those painted between August and November of 1725 for Stefano Conti of Lucca, and in 1726 the two McSwiny "tombs" for which he provided the "perspectives" are recorded as finished.[1] After this he was regularly at work for English patrons, chief among whom was Consul Smith. He also worked for Marshal von der Schulenburg and other European collectors. From 1746 to 1756 he lived and worked mainly in London, though his stay there was broken by two visits to Venice. He was elected to the Venetian Academy in 1763 and was prior of the Collegio dei Pittori in 1764. He was an active draftsman throughout his career, and he produced a number of fine etchings in a comparatively brief period in the early 1740s.

G. K.

NOTE:
1. See No. 18.

LITERATURE: Constable and Links 1976; Links 1977; Links 1982. For a recent account of Canaletto as draftsman, see Venice 1982, pp. 33–53.

18. A Magnificent Pavilion by the Lagoon

1975.1.292
Pen and brown ink. 203 × 142 mm.
Verso: The Grand Canal, with the Rialto Bridge from the South. Pen and brown ink, over traces of graphite. Annotated in brown ink at top right: *21.*

Regarding the drawing on the recto, Constable records a more elaborate version of the same subject, formerly in the collection of Mrs. Dudley Tooth, London, and now in that of Mr. and Mrs. Eugene V. Thaw.[1] The painting to which Morassi compares it in the Wallraf catalogue is not relevant.[2]

As for the verso, Constable suggests that it is "probably a sketch, made on the ground" for a more finished drawing at Windsor.[3] This may well be: though the balance of

the buildings is very different, there are also some important similarities, such as the hut in the right foreground. In my opinion, however, the present drawing also has a great deal in common with a small painting on copper in the collection of the Earls of Leicester at Holkham (Fig. 8).[4] Here the hut is not shown, and more of the Fondamenta del Vin is seen at the left, but the building at the right, the Fondaco dei Tedeschi, and the roof of the Palazzo dei Camerlenghi follow our drawing exactly. The Holkham picture may be dated 1727–29 by reason of its close connections with two pictures of the same size, also on copper, in the collection of the Duke of Richmond and Gordon at Goodwood, which were finished before November 18, 1727.[5]

This early dating is confirmed by the close stylistic similarity of our drawing to a sheet in the Ashmolean Museum,[6] which is beyond question a study for the *View of the Rialto from the North* which Canaletto painted between August and November of 1725 for Stefano Conti of Lucca.[7] It should be noted that the Ashmolean drawing is of exactly the same size as No. 18, 141 × 202 mm., but it differs in having a vertical fold in the center. It is also worthy of note that a view of the Rialto from the south was discussed with Stefano Conti, but not executed.[8] The paintings for Stefano Conti are the earliest documented works by Canaletto, since the letter of Owen McSwiny to the Duke of Richmond indicating that the *Monument to Lord Somers* by Canaletto, Cimaroli, and Piazzetta (now in the collection of the Earl of Plymouth at Ludlow) is "entirely Finished" is not dated March 8, 1722, as the

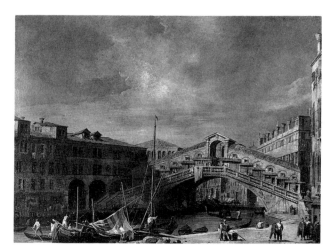

Fig. 8. Canaletto. *Grand Canal with the Rialto.* Holkham Hall, Norfolk

No. 18

No. 18, Verso

Canaletto literature endlessly insists it is, but March 8, 1726.[9] The drawing thus becomes an important document in any consideration of the early phases of Canaletto's career.

Another similar early view, a drawing in the Philadelphia Museum of Art,[10] is connected with another early painting on copper, at Chatsworth,[11] and to a lesser extent with a later painting, ordered by Samuel Hill in 1730, at Tatton Park.[12]

A drawing in the Albertina,[13] measuring 297 × 440 mm., also seems to be based upon this drawing; it shows the top of the campanile of Santi Apostoli in the correct position (though not too well understood), but not the hut. The Albertina drawing is attributed by Hermann Voss to Giovanni Battista Moretti.[14]

The building with the window from which this view was drawn is no longer extant; it must have been pulled down to make way for the Calle Larga Mazzini. It stood on the Grand Canal, next to the Ca' Dolfin; the porticoes of the two buildings communicated. It can be seen plainly in two paintings by Canaletto in the Galleria Nazionale d'Arte Antica (Palazzo Barberini) in Rome,[15] which also show the three wooden huts that overhung the Grand Canal on the Fondamenta del Ferro.

<div align="right">G. K.</div>

NOTES:

1. Constable and Links 1976, vol. 1, pl. 155, no. 825, vol. 2, pp. 608–9; New York 1975, p. 50, no. 39.
2. Venice 1959a, pp. 13–14, no. 2, referring to Constable and Links 1976, vol. 1, pl. 212, no. 511(a).
3. Constable and Links 1976, vol. 2, p. 510, no. 592; for the Windsor drawing, see vol. 1, pl. 108, no. 591, vol. 2, p. 509.
4. Ibid., vol. 1, pl. 47, no. 226, vol. 2, p. 294; Links 1982, p. 56, pl. 47 (in color).
5. Ibid., vol. 1, pls. 48, 49, nos. 232, 235, vol. 2, pp. 298–99, 301.
6. Ibid., vol. 1, pl. 108, no. 593, vol. 2, p. 510; Venice 1982, pp. 35–36, no. 3.
7. Constable and Links 1976, vol. 1, pl. 49, no. 234, vol. 2, p. 301.
8. Haskell 1956, pp. 298–99.
9. Knox 1983a, p. 229.
10. Formerly in the Pennsylvania Academy of the Fine Arts. Constable and Links 1976, vol. 1, pl. 103, no. 568, vol. 2, p. 499.
11. Ibid., vol. 1, pl. 35, no. 149, vol. 2, p. 258.
12. Ibid., vol. 1, pl. 27, no. 97, vol. 2, p. 233.
13. Stix and Fröhlich-Bum 1926, p. 163, no. 365.
14. Voss 1927–28, p. 266.
15. Constable and Links 1976, vol. 1, pls. 198, 199, nos. 223, 228(a)4, vol. 2, pp. 293, 295–96.

PROVENANCE: Sale, R. W. P. de Vries, Amsterdam, July 22, 1931, no. 297 (as Marco Ricci); H. J. Holgen, Amsterdam; Paul Wallraf, London. Acquired by Robert Lehman in 1962.

EXHIBITED: Venice 1959a, no. 2; Cologne 1959, no. 2; New York 1981, nos. 5a (recto), 5b (verso); Detroit 1983, no. 1; Pittsburgh 1985, no. 1 (verso).

LITERATURE: New York 1975, p. 50, under no. 39; Constable and Links 1976, vol. 1, pl. 108, no. 592, pl. 155, no. 824(I), vol. 2, pp. 509–10, 608; Corboz 1985, vol. 2, p. 769, no. D234.

19. Warwick Castle: The East Front

1975.1.297
Pen and brown ink, gray wash. 316 × 562 mm. Annotated in pencil on the verso, by a later hand: *Ingresso del Castello de Lord Brooke a Warwick.*
PLATE 1.

This fine drawing is one of a pair. The pendant, showing the east front of the castle from inside the courtyard, remained with No. 19 until the Fauchier-Magnan sale in

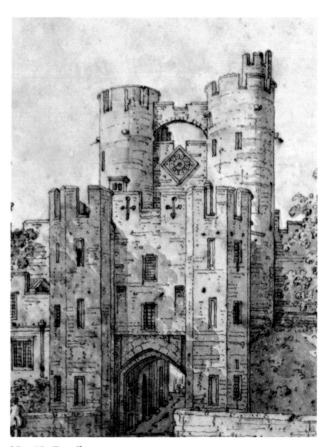

No. 19, Detail

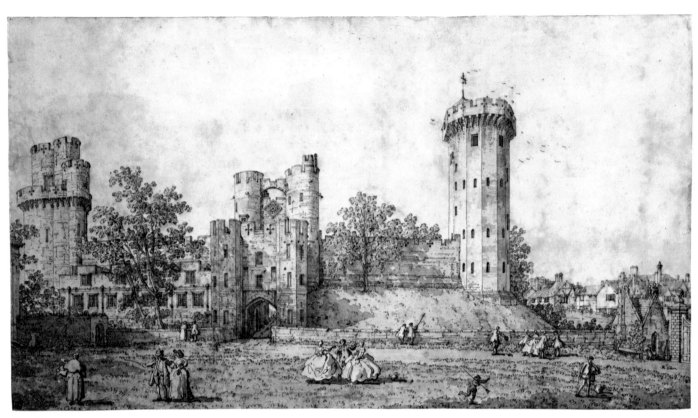

No. 19

1935, in which it was sold as lot 5. It is recorded by Constable as with the executors of Sir George Leon, Bart.[1] The paintings by Canaletto that are based on these drawings, until recently at Warwick Castle, are now in the City Museum and Art Gallery, Birmingham.[2]

Constable suggests a date of 1748 for Canaletto's work at Warwick.[3]

James Byam Shaw, in an unpublished essay, notes that the house from which the Lehman drawing was made has now been removed to Virginia.

G. K.

NOTES:
1. Constable and Links 1976, vol. 1, pl. 143, no. 760, vol. 2, p. 584.
2. Ibid., vol. 1, pl. 84, nos. 446, 447, vol. 2, p. 430; Links 1982, pp. 157–58, pls. 145, 146.
3. Constable and Links 1976, vol. 1, p. 142.

PROVENANCE: The Hon. Charles Greville (possibly); Paul Sandby (Lugt 2112); Lady Eva Dugdale, London; Dugdale sale, Sotheby's, London, November 18, 1920, lot 42; Adrien Fauchier-Magnan, Paris and Cannes-La Bocca; Fauchier-Magnan sale, Sotheby's, London, December 4, 1935, lot 4; P. & D. Colnaghi & Co., London; Philip Hofer, Cambridge (Mass.).

EXHIBITED: Cambridge (Mass.) 1940, no. 38; Northampton (Mass.) 1950; New York 1953, no. 18; Paris 1957, no. 89; Cincinnati 1959, no. 228; New York 1971, no. 157; Washington 1974, no. 103; New York 1981, no. 6; Rochester 1981, no. 3; Detroit 1983, no. 2; Pittsburgh 1985, no. 2.

LITERATURE: Finberg 1920–21, p. 68, pl. 27a; Benesch 1947, p. 37, no. 53; Matteucci 1957, p. 254; Bean 1971, p. 81; Szabo 1975, fig. 177; Constable and Links 1976, vol. 1, pl. 143, no. 759, vol. 2, p. 584; Szabo 1983, no. 54; Corboz 1985, vol. 2, pp. 734–35, no. D120.

20. Padua: The River Bacchiglione and the Porta Portello

1975.1.293
Pen and brown ink, gray wash. 185 × 265 mm.

The Porta Portello, the old gate of Padua on the road to Venice, was designed by Guglielmo Grizi da Alzano, known as Il Bergamasco, in 1518. A work of great distinction in its overall conception and in its details, it still survives much as Canaletto shows it, though the cannon balls are arranged on top of the attic (not, as in the drawing, on the entablature supported by the columns) and the tower has lost its cupola. The bridge still stands on its original piers, but it has been raised on arches so that it no longer articulates properly with the gate.

The design of No. 20 is very close to that of a drawing at Windsor,[1] but there are certain differences: the Porta Portello is here shown with freestanding columns facing the canal; the left section of the bridge is not a drawbridge; and the right section is covered with a wooden structure.

Hadeln refers to a similar drawing with Agnew in London,[2] and Parker mentions "a washed drawing, recently in the trade" that is "manifestly a copy, perhaps English" of the Windsor version.[3] Constable states that these two are the same drawing.[4] Whether No. 20 is the drawing in question is not clear, but it can hardly be dismissed as a copy of the Windsor sheet.

There is also a related drawing by Bernardo Bellotto at Darmstadt.[5]

G. K.

NOTES:
1. Hadeln 1929, p. 25, pl. 21; Parker 1948, p. 46, no. 82, pl. 56; Constable and Links 1976, vol. 1, pl. 124, no. 675, vol. 2, p. 546.
2. Hadeln 1929, loc. cit.
3. Parker 1948, loc. cit.
4. Constable and Links 1976, vol. 2, p. 546.
5. Kozakiewicz 1972, vol. 2, p. 30, no. 34.

PROVENANCE: Not established.

EXHIBITED: Cincinnati 1959, no. 227; New Haven 1960, no. 162; New York 1981, no. 7; Rochester 1981, no. 4.

LITERATURE: Chaet 1970, pp. 66–67, fig. 61.

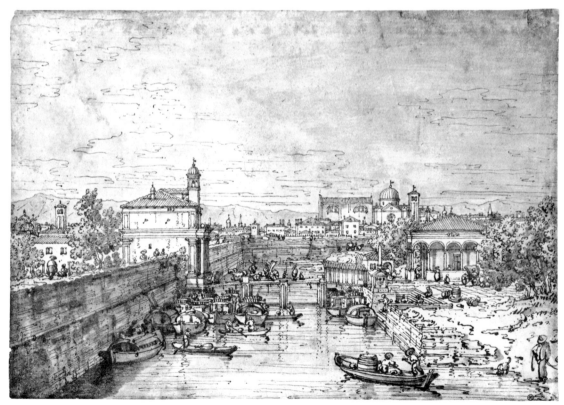

No. 20

21. Piazza San Marco from the Southwest Corner, with the Procuratie Nuove on the Right

1975.1.296
Pen and brown ink, brown and gray wash. 228 × 333 mm.
PLATE 2.

Constable's note on this drawing is brief.[1] He places it between a drawing at Windsor[2] and a painting in the National Gallery, London.[3] The latter is a vertical composition, derived from the right half of this design. Links adds a long note introducing the possibility that No. 21 may be a copy by William Henry Hunt (1790–1864), to whom a number of drawings after Canaletto in the British Museum Print Room are also attributed.[4] James Byam Shaw, however, considers both No. 21 and a version in the Heinemann collection, New York, to be autograph.[5]

Parker points out that No. 21 is far from being an exact copy of the Windsor drawing.[6] Apart from a number of changes in the staffage, it shows substantially more of the Procuratie Vecchie on the left, one of the domes of San Marco, and more of the Campanile, so that the top of the main shaft is shown level with the springing of the arch of the Procuratie Nuove rather than with the capital of the engaged half-column. The painting in the National Gallery offers a compromise in this respect, but it comes far

closer to the Lehman than to the Windsor drawing. Morassi, in the Cologne catalogue, refers to the Windsor drawing as a workshop version.[7]

Constable and Links publish two related figure drawings.[8] The first, in the National Gallery, London, is a study of two seated men and a standing man to their right; it is closer to No. 21 than to the Windsor drawing. The second is a study for the pair at the far left and the three men in the center, in the Boymans-van Beuningen Museum, Rotterdam; it is annotated *Sir John Stoddarts collection. Belotto Canaletto. 1724–1780.* Constable favors the traditional attribution to Bellotto, but Links does not rule out Canaletto's authorship.

G. K.

NOTES:
1. Constable and Links 1976, vol. 2, pp. 480–81, no. 526.
2. Parker 1948, p. 40, no. 57, pl. 37; Constable and Links 1976, vol. 1, pl. 95, no. 525, vol. 2, p. 480.

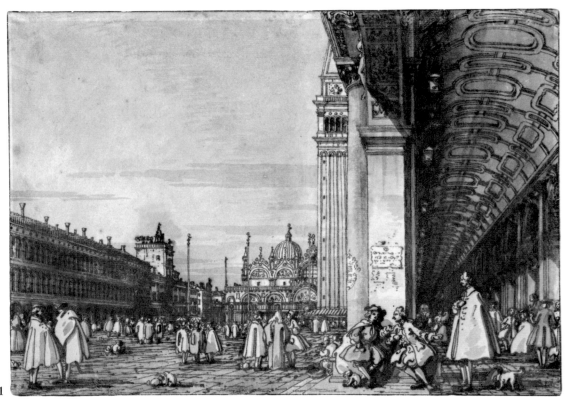

No. 21

3. Constable and Links 1976, vol. 1, pl. 15, no. 20, vol. 2, pp. 194–95.
4. Ibid., p. 481.
5. Byam Shaw 1981, p. 181, n. 2. For the Heinemann version (which was formerly in the Reveley collection), see New York 1973, p. 32, no. 29.
6. Parker 1948, p. 48.
7. Cologne 1959, p. 81.
8. Constable and Links 1976, vol. 1, pl. 159, nos. 841 and 842, vol. 2, p. 617.

PROVENANCE: Otto Gutekunst, London; Mrs. Otto Gutekunst, London; Villiers David, London; Paul Wallraf, London. Acquired by Robert Lehman in 1962.

EXHIBITED: London 1936, no. 70; London 1953a, no. 184; Cologne 1959, no. 120; Huntington (N.Y.) 1980, no. 3; New York 1981, no 9; Rochester 1981, no. 5; Detroit 1983, no. 3; New York 1985; Pittsburgh 1985, no. 3.

LITERATURE: Hadeln 1929, p. 18; Parker 1948, p. 40 (under no. 57); New York 1973, p. 32 (under no. 29); Constable and Links 1976, vol. 1, pl. 95, no. 526, vol. 2, pp. 480–81; Byam Shaw 1981, p. 181, n. 2; Szabo 1983, no. 56; Corboz 1985, vol. 2, p. 770, no. D241.

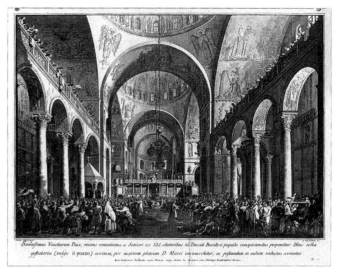

Fig. 9. Giambattista Brustolon. *The Doge Leaving San Marco*, engraving

22. Interior of the Basilica of San Marco, Showing the Crossing and the Choir

1975.1.295
Pen and brown ink over black chalk. 280 × 190 mm. Annotated in brown ink, bottom right: *Cannalletto*.

Constable suggests that this is a sheet from a sketchbook, and he points out a possible connection with paintings at Windsor and Montreal.[1] These, however, are general views of the interior of the church, whereas No. 22 shows only a comparatively small portion of it; Canaletto made the drawing while seated on a bench against the west wall of the nave, immediately to the north of the central door.

No. 22 is evidently contemporary with a very similar sheet in the collection of Janos Scholz,[2] which appears to come from the same sketchbook. Both probably belong to the last phase of Canaletto's career.

Alice Binion draws attention to a drawing with a similar view at Leipzig,[3] which is somewhat larger than both the Lehman and the Scholz drawings; she suggests that the Lehman drawing has been cut down. The Leipzig version is a slightly more detailed and careful performance, drawn from a point to the south of the main axis of the church. Binion makes the interesting suggestion that these sheets are preparatory to the drawing[4] for the first

engraving in Giambattista Brustolon's *Feste Dogali* series (Fig. 9).[5] That engraving does indeed show the interior of San Marco from a point next to the central door on the north side. The connection with the engraving implies that No. 22 may be no earlier than 1763.

G. K.

NOTES:
1. Constable and Links 1976, vol. 2, p. 497, no. 561; for the Windsor and Montreal paintings, see vol. 1, pl. 25, nos. 78 and 79, vol. 2, pp. 222–23; for the sketchbook, see vol. 2, pp. 642–46.
2. Ibid., vol. 1, pl. 102, no. 560, vol. 2, pp. 496–97.
3. Binion 1980, p. 375, pl. 47b.
4. Constable and Links 1976, vol. 1, pl. 115, no. 630, vol. 2, p. 528.
5. For the engravings see Gorizia 1983, pp. 87–93, nos. 59–66. The first ten of the series are clearly based upon the celebrated drawings by Canaletto from Stourhead, and two are equally clearly after designs by Francesco Guardi (see Knox 1980c, p. 204).

PROVENANCE: Italico Brass, Venice; Janos Scholz, New York; Paul Wallraf, London. Acquired by Robert Lehman in 1962.

EXHIBITED: Venice 1959a, no. 3; Cologne 1959, no. 3; Huntington (N.Y.) 1980, no. 2; New York 1981, no. 8; Rochester 1981, no. 6; Detroit 1983, no. 4; New York 1985.

LITERATURE: Constable and Links 1976, vol. 1, pl. 102, no. 561, vol. 2, p. 497; Binion 1980, p. 375; Szabo 1983, no. 55; Corboz 1985, vol. 2, p. 776, no. D218.

No. 22

23. A Venetian Interior, with a Young Man Seated by the Fire

1975.1.298
Pen and black ink, gray wash. 210 × 170 mm.

No other drawing of this kind by Canaletto has come to light. Morassi, in the Wallraf catalogue, states that "un disegno analogo, raffigurante lo stesso gentiluomo seduto sopra un divano davanti ad un tavolino e con una fantesca alla porta, trovasi nelle raccolte dei disegni del Courtauld Institute di Londra."[1] No drawing answering this description is in the Courtauld collection, however, nor can one be found in the files of the Witt Library.

G. K.

NOTE:
1. Venice 1959a, p. 15, no. 4.

PROVENANCE: Paul Wallraf, London. Acquired by Robert Lehman in 1962.

EXHIBITED: Venice 1959a, no. 4; Cologne 1959, no. 4; Huntington (N. Y.) 1980, no. 4; New York 1981, no. 10; Pittsburgh 1985, no. 4.

LITERATURE: Constable and Links 1976, vol. 1, pl. 220, no. 842**, vol. 2, pp. 617–18.

No. 23

Giuseppe Maria Crespi

Bologna 1665–Bologna 1747

A history painter and an etcher, Crespi was called Lo Spagnuolo by reason of his *tenebroso* style, reminiscent of Ribera's. He came to prominence with his frescoes in the Bolognese churches of San Michele in Bosco and the Spirito Santo in 1684, and embarked upon a very prosperous career. He enjoyed the patronage of Prince Eugene of Savoy, Prince Ferdinand de' Medici, and Cardinal Ottoboni. For the latter, in 1712, he painted the superb *Seven Sacraments* series, which passed to Dresden in the mid-eighteenth century. His son Luigi has left a full account of his life.

<div align="right">G. K.</div>

LITERATURE: Crespi 1769; Merriman 1980.

24. A Monk Preaching

1975.1.437
Pen and brown ink, wash. 268 × 195 mm.

This drawing, an early acquisition of Robert Lehman's, formerly carried an attribution to Giovanni Battista Tiepolo.

Two drawings in the Detroit Institute of Arts[1] bear code numbers that identify them as having belonged to the Bossi-Beyerlen collection, which originated in Domenico Tiepolo's studio and which was auctioned at Stuttgart in 1882.[2] On one of these, it appears that Domenico has written the name *Spagnoletto*, thus identifying the drawings as the work of Giuseppe Maria Crespi. They are very similar in style to the present drawing—one (Fig. 10) exhibits the same "carroty" fingers—and I think that the *Monk Preaching* clearly belongs to the Bolognese tradition of caricature as practiced by Guercino and others.

Apart from the two drawings in Detroit pen and wash drawings by Crespi are virtually unknown, and No. 24 is an important addition to his oeuvre. The earlier attribution may indicate that this, like the others, came from a source close to the Tiepolo studio.

<div align="right">G. K.</div>

Fig. 10. Giuseppe Maria Crespi. *Old Man Pointing, and Other Figures.* Detroit, Detroit Institute of Arts

NOTES:
1. Detroit Institute of Arts, nos. 1909.1SDR211 (pen and wash, 244 × 194 mm.), 1909.1SDR213 (pen and wash, 241 × 191 mm.; Fig. 10).
2. For the Bossi-Beyerlen collection see Stuttgart 1970, pp. 7–8, and Knox 1980b, pp. 200–207.

PROVENANCE: Not established.

EXHIBITED: Poughkeepsie 1943 (as Giovanni Battista Tiepolo); New York 1981, no. 89 (as Giovanni Battista Tiepolo); Rochester 1981, no. 33 (as Giovanni Battista Tiepolo).

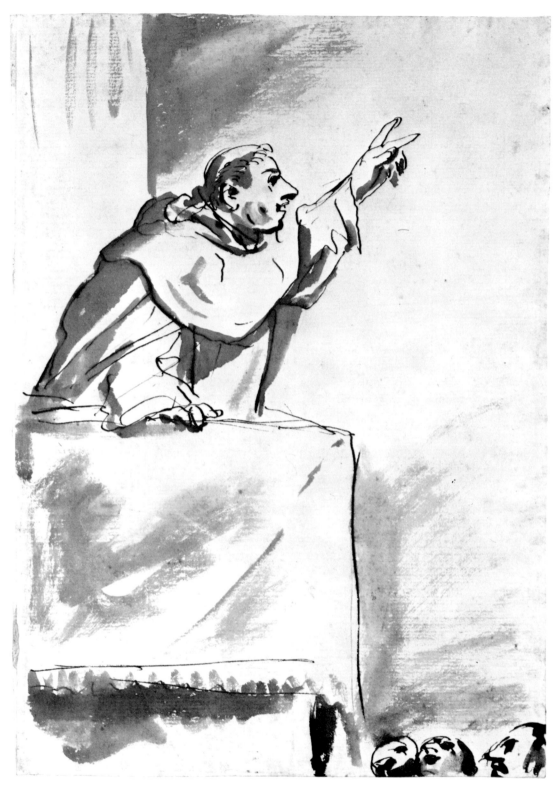

No. 24

Giuseppe Diziani

Venice 1732–Venice 1803

The history painter Giuseppe Diziani was a follower of his more celebrated father, the prolific Gaspare Diziani.

<div align="right">G. K.</div>

LITERATURE: Zugni-Tauro 1971.

25. The Virgin and Child Enthroned on a Cloud, with Saints Dominic, John Nepomuk, Sebastian, Mark, and Anthony Abbot

1975.1.322
Pen and brown ink over black chalk. 240 × 150 mm.

Antonio Morassi's attribution of this drawing to Giuseppe, son of the better-known Gaspare Diziani, is based on an annotation in "the reliable Venetian hand" giving a drawing in the Scholz collection to Giuseppe.[1] The attribution is confirmed by Anna Paola Zugni-Tauro, who points out that the Scholz drawing is a study by Giuseppe for the ceiling of San Giovanni in Valle at Cividale, datable about 1771, while another drawing, in the Miotti collection, is linked with Giuseppe's *Assunta* in the cupola of the cathedral at Cividale.[2]

I am grateful to Dulcia Meijers for drawing my attention to a sheet among the Diziani drawings in the Museo Correr in Venice (Fig. 11), which shows the present design worked up into a presentation drawing with only a few very minor alterations. This drawing has since been published in the second volume of the catalogue of Correr drawings, where Attilia Dorigato attributes it to Gaspare Diziani, describing the Lehman version as "una copia puntuale" by Giuseppe.[3] (An attribution of the Correr drawing to Pietro Antonio Novelli has also been considered possible.) There is also a closely related drawing from the collection of Frits Lugt in the Fondation Custodia, which Byam Shaw considers "a typical, fairly late work of Gaspare Diziani."[4] This is very close to the Correr drawing in style, though it is perhaps a little drier, and it shows the same group of saints in the same arrangement, but each one more or less varied in pose. The situation is further complicated by the fact that exactly the same group of saints, again shown in exactly the same arrangement but in poses that are quite unrelated, is the subject of Giovanni Antonio Guardi's magnificent altarpiece at Belvedere di Aquileia.[5] Notwithstanding Guardi's tendency to borrow figures and groups of figures from other works, it seems unlikely that he knew the Diziani compositions. But it is hard to avoid the conclusion that the Diziani

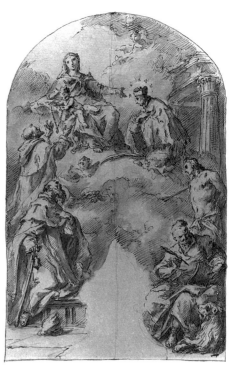

Fig. 11. Giuseppe Diziani (or Pietro Antonio Novelli). *Virgin and Child with Saints*. Venice, Museo Correr

drawings were made with the Belvedere commission in mind and with the same set of instructions in hand. The difficulty which then follows is that the dating of the Belvedere altarpiece varies between 1746, when the church, dedicated to Saint Anthony Abbot, was built, and 1750, indicated by an inscription in the church. In those years Giuseppe Diziani was fourteen to eighteen years old. It is somewhat difficult to interpret this brilliant drawing as the work of a precocious teenager improving on that of his father, though there is little question but that this is a better design than the drawing in the Lugt collection. It would be a bold move to suggest that the date of the Guardi painting should be advanced into the sixth decade of the century. There does not at present appear to be a happy solution to this problem.

<div align="right">G. K.</div>

NOTES:
1. Venice 1959a, p. 22, no. 19; for the Scholz drawing, see Venice 1957, no. 66, and Venice 1966, no. 92; for the anonymous eighteenth-century collector whose annotation appears on the Scholz drawing, see Venice 1966, pp. 13–24.
2. Zugni-Tauro 1971, p. 114; for the Miotti drawing, see Venice 1963, pp. 26–27, no. 23.
3. A. Dorigato in Pignatti 1981, pp. 75–76, no. 305.
4. Venice 1981, p. 65, no. 74; Byam Shaw 1983, vol. 1, pp. 280–82, no. 271, vol. 3, pl. 318.

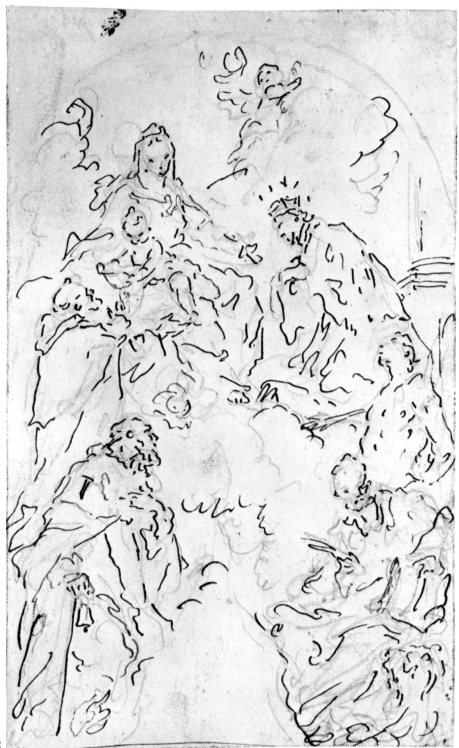

No. 25

5. Morassi suggests in Venice 1959a, loc. cit., that No. 25 "si riferisce ad una pala d'altare in tutto simile a quella dipinta da Antonio Guardi per la chiesa di Belvedere presso Aquileja circa il 1750"; for the altarpiece, see Morassi 1973, vol. 1, pp. 69–71 and 319, no. 63, vol. 2, pl. 70.

PROVENANCE: Paul Wallraf, London. Acquired by Robert Lehman in 1962.

EXHIBITED: Venice 1959a, no. 19; Cologne 1959, no. 19; New York 1981, no. 26; Rochester 1981, no. 11; Pittsburgh 1985, no. 7.

LITERATURE: Zugni-Tauro 1971, p. 114; Pignatti 1981, p. 75, under no. 305; Venice 1981, p. 65, under no. 74; Byam Shaw 1983, vol. 1, p. 281, under no. 271.

Mauro Gandolfi

Bologna 1764–Bologna 1834

Mauro was the son and pupil of Gaetano Gandolfi. Though he was also a painter, his fame as an engraver was such that in 1817 he was brought from Bologna to Washington to engrave John Trumbull's painting *The Declaration of Independence* in the Capitol. His autobiography was published by Vallardi in Milan in 1841.

G. K.

26. A Sheet of Heads

1975.1.325
Pen and brown ink. 290 × 205 mm. Folded three times horizontally and once vertically at left; minor damages along folds.

This is one of a clearly defined group of drawings that carried a traditional attribution to Gaetano Gandolfi.[1] In 1973, Catherine Johnston published two similar studies in the Uffizi,[2] the first of which (Fig. 12) is signed by Mauro Gandolfi. The attribution of the Uffizi drawings to Mauro was confirmed by Mary Cazort in the catalogue of the 1979 exhibition *L'arte del Settecento emiliano* in Bologna.[3]

The problem of these drawings is also discussed by Byam Shaw, who mentions the present example and prefers the attribution to Gaetano.[4]

G. K.

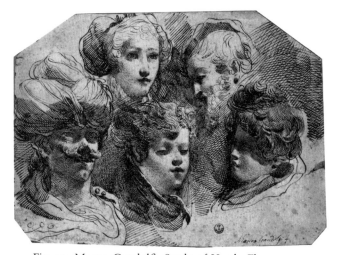

Fig. 12. Mauro Gandolfi. *Study of Heads*. Florence, Gabinetto Disegni e Stampe degli Uffizi

NOTES:
1. See, for example, London 1967, nos. 74, 75. For Gaetano Gandolfi's draftsmanship see Taylor 1976, pp. 159–60, and Bologna 1979, pp. 113–37, pls. 281–301.
2. Florence 1973, p. 107, nos. 130, 131, figs. 92, 93.
3. Bologna 1979, nos. 303, 304, pls. 302, 304.
4. Byam Shaw 1983, vol. 1, pp. 373–74, no. 379, vol. 3, pl. 434.

PROVENANCE: Helene C. Seiferheld, New York.

EXHIBITED: Huntington (N.Y.) 1980, no. 10 (as Gaetano Gandolfi); New York 1981, no. 28 (as Gaetano Gandolfi).

LITERATURE: Byam Shaw 1983, vol. 1, p. 374, under no. 379.

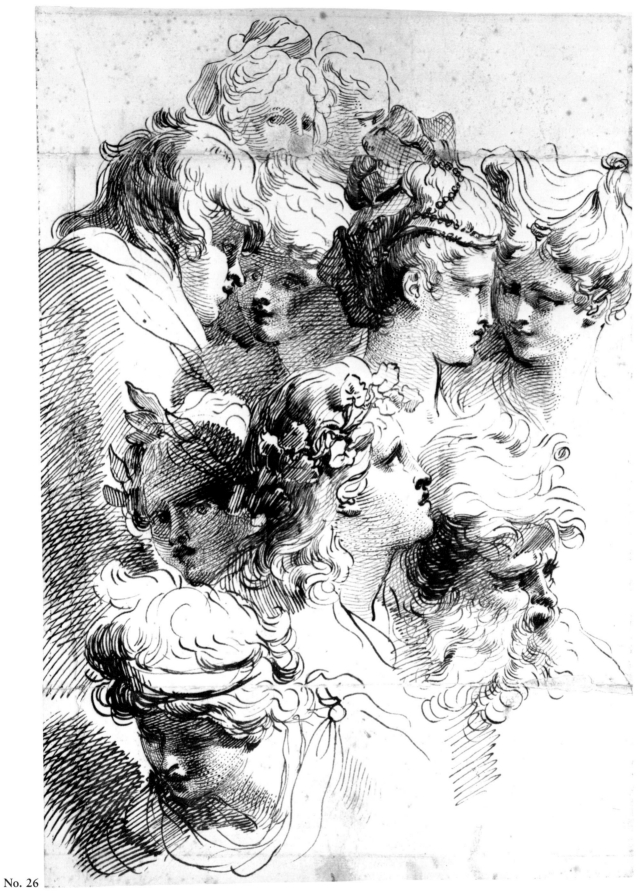

No. 26

Pier Leone Ghezzi

Rome 1674–Rome 1775

Son of the painter Giuseppe Ghezzi, who was secretary of the Accademia di San Luca from 1678 until 1719, Pier Leone was born into the leading artistic circles of Rome. He was painter to the pope from 1708 until 1747 and also served as secretary of the Accademia di San Luca. He was an engraver as well as a painter of histories and portraits, but he is best known today for his enormous output of caricatures. The most important groups of his drawings are in the Ottoboni collection in the Vatican Library, the Gabinetto Nazionale delle Stampe in Rome, the Uffizi, the Louvre, the British Museum, and the Hermitage. Of the 535 sheets by Ghezzi in the Hermitage, 419 are apparently in a single album; an album of 152 caricatures, belonging to Lord Braybrooke, was sold at Sotheby's on December 10, 1979 (the catalogue of this sale, by Antonella Pampalone, is an excellent introduction to Ghezzi's art). G. K.

LITERATURE: Loret 1935; Dobroklonsky 1961, pp. 61–76, nos. 240–775, pls. 34–35; London 1979.

27. Caricature of a Polish Count

1975.1.327

Pen and brown ink. 315 × 211 mm. Sheet folded three times horizontally and once vertically; top right corner and bottom right corner cut. Annotated on the verso in ink: *C.e Onajchi Polacco*.

No. 27

We have at present no indication of the identity of this Polish gentleman,[1] who was evidently a member of the foreign community in Rome. Neither do we have any information about the provenance of the drawing.

G. K.

NOTES:

1. I would like to thank Jan Białostocki of the Muzeum Narodowe, Warsaw, for kindly attempting to identify the subject of the caricature. He informs me that the name in the annotation on the verso is an unrecognizable distortion of a Polish name.

PROVENANCE: Not established.

EXHIBITED: New York 1981, no. 29; Detroit 1983, no. 9.

28. A Monk with a Carrot and a Woman with a Chamber Pot

1975.1.328
Pen and brown ink. 280 × 200 mm.

It has so far not been possible to elucidate the subject of this drawing. The monk would seem to be a herbalist, shown pointing out the peculiar properties of a carrot, with a number of learned tomes on the table behind him. The woman expresses astonishment and delight at the exposition, which we may hope is not excessively obscene.

G. K.

PROVENANCE: Mrs. R. Cavendish-Bentinck; P. & D. Colnaghi & Co., London. Acquired by Robert Lehman in 1960.

EXHIBITED: New York 1981, no. 30.

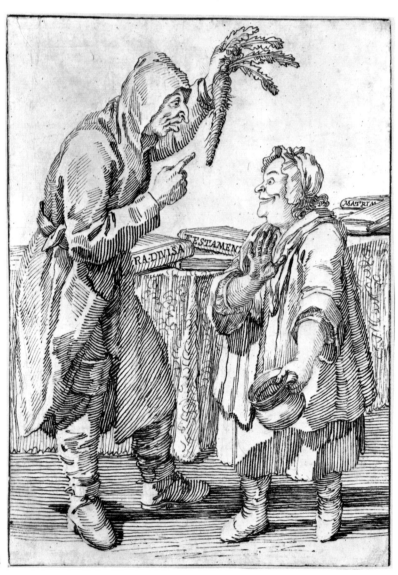

No. 28

Francesco Guardi

Venice 1712–Venice 1793

Since Giuseppe Fiocco published his researches on Francesco Guardi (chiefly in his monograph of 1923), it has been generally accepted that the artist began his career in the studio of his brother, Giovanni Antonio Guardi, who was fourteen years his senior and the head of the family—for their father Domenico, a painter of no great consequence, had died when Francesco was only four years old. The productions of the Guardi studio were "histories" —paintings of religious, historical, and mythological subjects—and Francesco continued to some extent to occupy himself with such subjects even after his brother's death in 1760; a few datable paintings and drawings attest the fact. But it is certain that by that time, and perhaps for half a decade before that, Francesco, attracted by Canaletto's success in painting views of Venice and selling them in large numbers to foreign visitors, had been turning his own hand to the same themes; and it is of course for his Venetian views that Francesco Guardi is chiefly famous today.

Whether or not he ever worked in Canaletto's studio, as certain early writers suggest (and as I myself am inclined to believe), it cannot be disputed that his earliest drawings of Venice, some of which are directly connected with paintings that can be dated (on firm topographical grounds) between 1755 and 1760, imitate Canaletto much more closely, both in the style of the figures and in the accuracy of their topography, than do Guardi's more familiar later works.[1] From about the middle sixties onward, Canaletto's influence gradually disappears; Guardi now takes liberties with the Venetian topography and everything seems to be concentrated on the "magia d'effetto," the suggestion of light and air and of instability, so characteristic of that beautiful city to this day.

No. 29, the *Panoramic View of the Bacino di San Marco*, is a perfect example of Guardi's ability to convey such effects, not only in a painting but also with his pen and a little transparent wash, in the latter part of his career. This must be a drawing of the 1780s. The figures in No. 31, on the other hand, still show Canaletto's influence, and this might be twenty years earlier. Late again, though drawn with a much broader (reed?) pen than the *Panorama*, are the two excellent *Capricci* (Nos. 32 and 33); they are examples of a mode which Guardi, with more imagination than Canaletto, exploited very successfully in later life—no doubt to suit the taste of his Venetian clients, to whom a literal view of Venice was something of a superfluity and hardly a work of art.

There are difficult problems in the study of Guardi drawings, and I do not think that they have all been completely resolved, though the late Antonio Morassi's great corpus (*Guardi: Tutti i disegni*, 1975), taken in conjunction with his catalogue of the paintings (1973), has done much to clarify the distinction between the "history" subjects of Giovanni Antonio Guardi and those of Francesco. That problem need not concern us here, as there are no drawings in the Lehman Collection that can be attributed to the elder brother and no drawings by Francesco that can be classified as "histories." We still know virtually nothing of the activities of the third brother, Nicolò, who seems to have been a painter and who presumably assisted in the studio until his death in 1786.[2] But there is one drawing in the Lehman Collection, No. 34, which illustrates the difficulty of determining the borderline between the less successful work of Francesco at the end of his life and the best efforts of his son Giacomo when he was young, working under his father's eye, and no doubt collaborating with him, perhaps extensively.[3] Some critics may have pronounced too hastily on the subject. For my part, in some cases—among the paintings especially—I am still not clear exactly where the dividing line should be drawn. In the meantime I refer the reader to my entry for No. 34.

J. B. S.

NOTES:
1. See Byam Shaw 1951, pp. 16–22.
2. Ibid., pp. 47–49.
3. See the biography of Giacomo Guardi preceding Nos. 34–56.

LITERATURE: Pallucchini 1943; Byam Shaw 1951; Pignatti 1967; Morassi 1973; Morassi 1975.

29. Panoramic View of the Bacino di San Marco, Looking up the Giudecca Canal

1975.1.342
Pen and brown ink, light brown wash, on two sheets of paper, joined. 349 × 676 mm. Watermark: see New York 1971, watermark no. 44. Tear near lower right corner.
PLATE 3.

The Giudecca is shown on the left, the Salute and the entrance to the Grand Canal on the right; a regatta is in progress.

At the far left are the convent and church of the Zitelle, with the Redentore to their right and the campanile of San

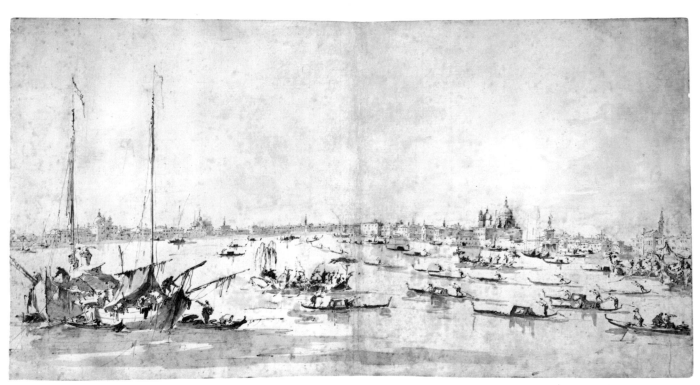

No. 29

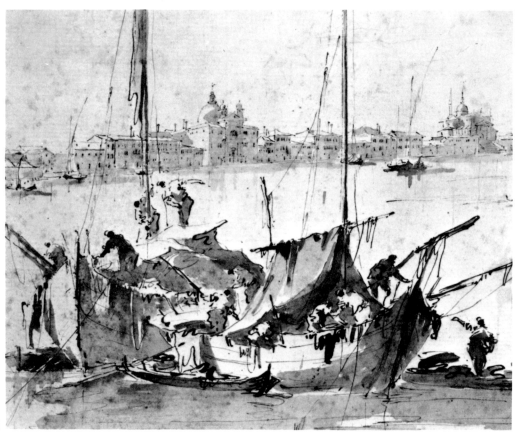

No. 29, Detail

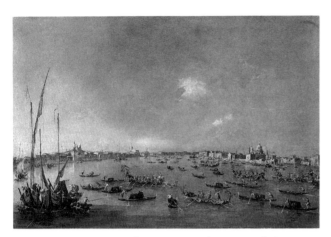

Fig. 13. Francesco Guardi. *Regatta in the Bacino di San Marco*. Munich, Sammlung der Bayerischen Hypotheken- und Wechsel-Bank in der Alten Pinakothek

Giacomo (destroyed in the early nineteenth century) just to the right of the Redentore. Further right, still on the Giudecca, is the church of Santa Eufemia. Next, from about the center of the drawing, we see the Fondamenta delle Zattere on the opposite side of the Giudecca Canal, with the Salute and the Dogana Point on the right. At the extreme right, on the north side of the Grand Canal, the campanile is probably that of Santa Maria Zobenigo (now no more than a stump).

It will be obvious from all this that this very important drawing is a panorama taken from at least two different points of view: the left half from the Molo near the site of the present Hotel Jolanda, just excluding the island of San Giorgio Maggiore on the extreme left; and the right half from a point much further eastward toward the present Via Garibaldi, perhaps near the (now disused) church of San Biagio, looking straight up the entrance to the Grand Canal. The different viewpoints and the panoramic effect are further emphasized by the fact that the horizon line slopes down from the center, slightly to the left and much more obviously to the right.

With this idiosyncrasy, which is characteristic of the draftsman, this is one of the most brilliant of Guardi's larger views of Venice. It seems to have been used for the beautiful painting (Fig. 13) now deposited in the Alte Pinakothek, Munich, by the Bayerische Hypotheken- und Wechsel-Bank.[1] There the view ends on the right just beyond the Dogana Point; and though the barges in the left foreground and the gay ceremonial gondolas (*bissone* or *peotte*) and other craft in the Bacino are much the same, the close correspondence is limited to the distant profiles of the Giudecca and the Zattere. The Lehman drawing may itself have been composed with the help of at least

two, if not three, other drawings in which Guardi has concentrated on the topography: one in the National Gallery of Canada, Ottawa, which corresponds to the right-hand part of ours;[2] one in the Fogg Art Museum, which corresponds to the center part;[3] and perhaps a third, untraced, corresponding to the section on the left, including the Zitelle. The Ottawa and Fogg drawings are surely earlier than the more pictorial Lehman view, or the Munich painting; these last can hardly be earlier than 1780–85.

Another very large, pictorial drawing of the same scene, corresponding in many respects both to the Lehman drawing and to the Munich painting, is one of a fine pair in the collection of M. de Rothschild, Geneva;[4] and a very rough sketch of the same again, in Guardi's most impressionistic style, is on the back of a drawing of a villa garden in the Victoria and Albert Museum.[5]

J. B. S.

NOTES:
1. Kultzen 1976, p. 219.
2. Byam Shaw 1951, p. 63, pl. 24; Morassi 1975, p. 141, no. 355, fig. 353.
3. Morassi 1975, p. 149, no. 401, fig. 402.
4. Ibid., p. 129, no. 295, fig. 301.
5. Ibid., p. 130, no. 296, fig. 303.

PROVENANCE: Lady Catherine Ashburnham, Battle Abbey, Sussex; Ashburnham sale, Sotheby's, London, June 24, 1953, lot 54.

EXHIBITED: Paris 1957, no. 104; Cincinnati 1959, no. 230; New Haven 1960, no. 163; New York 1971, no. 193; New York 1981, no. 34; Detroit 1983, no. 12; Pittsburgh 1985, no. 11.

LITERATURE: Byam Shaw 1951, p. 64, no. 27; Matteucci 1957, p. 254; Pignatti 1967, no. 62; Morassi 1975, p. 129, no. 294, fig. 302; Kultzen 1976, p. 219; Szabo 1983, no. 62.

30. Panorama of Venice from the Bacino di San Marco, Including the Project for the Proposed Teatro Manin

1975.1.341

Pen and brown ink, gray wash, and a little body color. Two sheets, joined at the center: 475 × 885 mm. Inscribed: *F. G. Pinxit* (lower right) and *P.B.A.A.C. Inv. Teat.* (lower left).

The arms of Lodovico Manin, who in 1789 became the last Doge of Venice, are in the center of a tablet with a dedicatory inscription, below; on both sides of the tablet is a key to the buildings depicted with numbers corre-

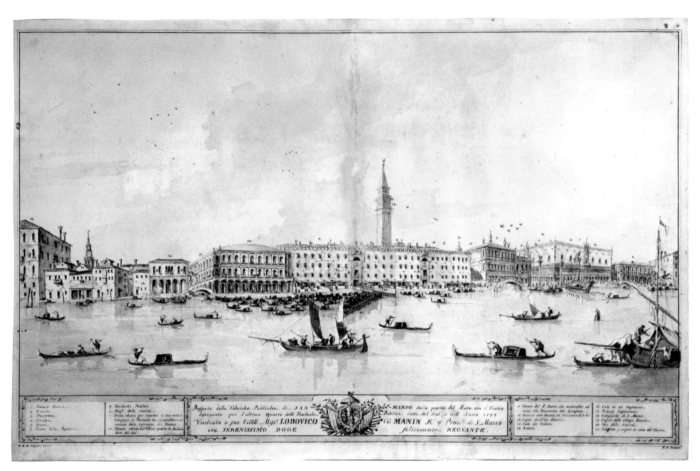

No. 30

No. 30, Detail

sponding to those on the drawing itself. The dedicatory inscription, on either side of the Doge's arms, reads: *Prospeto delle Fabriche Publiche di SAN MARCO dalla parte del Mare con il Teatro / dissegnato per l'ultimo Quarto delli Fondachi Publici detti del Sal, e nell'Anno 1787 / Umiliato a sua Eccell: Miss^r: LODOVICO Co^e: MANIN K^r: e Procc^r: di S. Marco / ora SERENISSIMO DOGE felicemente REGNANTE.* The key reads:

1. *Palazzo Ducale.*
2. *Carceri.*
3. *Piazzetta.*
4. *Libraria.*
5. *Zecca.*
6. *Ponte della Pescaria.*
7. *Fondachi Publici.*
8. *Mag^to: della Sanità.*
9. *Porta ideata per rimetter in Simetría il / Complesso de Fondachi che restarebbero ac- / corciati dalla Costruzion del Teatro.*
10. *Teatro ideato dal S^r: P.B. nel quarto de Fondachi / detti del Sal.*
11. *Fianco del d^o Teatro, che anderebbe ad / unirsi alle Proccuratie dell'Ascenssion.*
12. *Fondaco della Farina, ed'Accademia delle Arti.*
13. *Casino del S^r: Co: Alcaini.*
14. *Cale del Ridotto.*
15. *Ridotto.*
16. *Cale di Cà Giustinian.*
17. *Palazzo Giustinian.*
18. *Campanile di S. Marco.*
19. *Cupola della Chiesa Ducale.*
20. *Palo della Sanità.*
21. *Palaffitta p. coprir la riva del Teatro.*

The panorama extends from the mouth of the Grand Canal on the left to the Doge's Palace and the Prisons on the right. The vast building inserted in the left center of the view is the projected new theater, dedicated to Lodovico Manin, to which the inscription refers. It was to occupy, as the inscription says and the drawing shows, the westernmost quarter of that section of the waterfront which extends between two bridges across the center of our drawing (with the Campanile of San Marco showing behind). The bridge to the left (the Ponte della Luna) leads on the other side to the elegant little building that was then the Accademia dei Pittori and is now the Capitaneria del Porto; the bridge to the right (the Ponte della Cecca or Zecca, with the Mint and the Library of San Marco showing above it in the drawing) is no longer in public use,

being bypassed by the present waterfront parade. All this section (in Guardi's time the Granai, or granaries) is now occupied by the public garden (the former Giardino Reale), which lies between the back of the Procuratie Nuove and the waterfront.[1]

The theater was never built. But in 1933 Giuseppe Fiocco published a folio volume in the Correr Library containing the plans for it, dated 1788.[2] These plans were by the architect Pietro Bianchi, whose initials are inscribed opposite Francesco Guardi's on our drawing. The portfolio also contained three drawings for the decoration of the theater: one a large design for the proscenium, to which Francesco has contributed an allegorical sketch for the curtain, and the other two on one sheet, used as the frontispiece to the volume, clearly by Francesco's son Giacomo.[3] One of these last has the same view of Venice, showing the new theater imposed upon it, as in the Lehman drawing.[4] The Lehman drawing, then still in a private collection in Berlin, was also included in Fiocco's important publication of 1933.

A much smaller sketch for the proposed theater is in the collection of Miss Armide Oppé, Dorset, England.[5] It is evidently preliminary to the Lehman drawing, and bears what may be, in my opinion, a formal signature of Francesco's.

The date 1787 in the inscription on the tablet below the present drawing is probably the date of the initiation of the theater project.[6] The last line of the inscription must have been added after May 9, 1789, when Lodovico Manin became doge. A doge's cap has also been added above his coat of arms, and he is now described as "ora felicemente regnante." In fact it was he who, on May 12, 1797, surrendered the government of the Republic, which had lasted a thousand years, to the forces of Napoleon Bonaparte.

The drawing therefore belongs to the last years of Francesco's life, when he drew generally in his roughest *staccato*, not to say shaky, style—a style that we know from datable drawings such as *The Ascent of a Balloon in Venice in 1784* or the three sketches of the Fenice Theater, which was opened only in 1792.[7] The careful precision of No. 30 could not be more different, and it is not surprising that good authority (including that of Morassi himself, and also of Pallucchini) has been unwilling to assign this drawing to Francesco's hand and prefers an attribution to Giacomo.[8] But it is surely obvious that our drawing was intended for engraving (perhaps by Dionigi Valesi, who engraved at least three of Guardi's drawings[9]), and for that purpose it was necessary to adopt a much more finished style. Furthermore, though it is cer-

tain that Giacomo Guardi sometimes wrote his father's name on drawings by himself, to suggest that he was using a composition of his father's (see No. 35, below), the *F. G. Pinxit* at the lower right, balancing the initials of the architect Bianchi in the other corner, was surely not written by Giacomo; and *pinxit* is an expression often applied to a drawing finished, like this one, with wash and body color. I will not say that this drawing is as good as the fine *View of San Giorgio Maggiore* presented by Paul Wallraf to the Fondazione Giorgio Cini, which also bears a careful inscription below, as though for engraving; but it is so much better in every respect than the roundel by Giacomo in the portfolio in the Correr Library, which is of the same subject, that I find it impossible to believe that both are by the same draftsman. Nor can I believe that Giacomo, even working under his father's eye, ever drew as well as this.[10]

J. B. S.

NOTES:

1. I am indebted to J. G. Links for information and correction on certain points of topographical history in this paragraph.
2. Fiocco 1933, pp. 366–67.
3. Morassi 1975, p. 151, no. 408, fig. 410 (drawing for the proscenium), and fig. 634 (frontispiece by Giacomo).
4. The best reproductions are in Pallucchini 1943, nos. 62–64.
5. Byam Shaw 1950, pp. 154–55; Venice 1962, no. 98.
6. I had read the first word of the third line of the inscription as "Initiato" until John Daley drew my attention to the true reading, which is unquestionably "Umiliato"; he pointed out that this unusual word, which must mean "humbly offered," is also quoted by Fiocco in his publication of the Correr album (Fiocco 1933, p. 366).
7. Morassi 1975, pp. 132–33, no. 312, fig. 312, p. 150, nos. 404–6, figs. 406, 407, 409.
8. See Morassi 1975, p. 151, under no. 408.
9. Venice 1941, pp. 59–60.
10. The ex-Wallraf drawing is very well reproduced, in color, in Morassi 1975, pl. 11, and the engraving of the same view by Valesi is reproduced as fig. 350 in that publication. The immediate model for the print, however, was another version of this drawing. For the roundel by Giacomo in the Correr Library, see the large reproduction in Pallucchini 1943, p. 139, no. 63.

PROVENANCE: Private collection, Berlin; Paul Chevalier, Paris; Chevalier sale, Galerie Jean Charpentier, Paris, March 20, 1956, no. 16.

EXHIBITED: Cincinnati 1959, no. 231; Huntington (N.Y.) 1980, no. 13; New York 1981, no. 32; Rochester 1981, no. 13; Detroit 1983, no. 11; Pittsburgh 1985, no. 10.

LITERATURE: Fiocco 1933; Pallucchini 1943, p. 45, under no. 63; Byam Shaw 1950, pp. 154–55; Venice 1962, p. 71, under no. 98; Morassi 1975, p. 151, under no. 408, fig. 633; Szabo 1983, no. 61.

31. Figure Studies

1975.1.340

Pen and brown ink, light and dark brown and grayish brown wash. 167 × 260 mm. Traces of vertical fold at center.

Recto: Fifteen (or sixteen?) figures, including some children, mostly seen from behind, standing in front of a colonnade (the Ridotto at San Moisè?).

Verso: Five figure studies: left, two peasant women, with a pole or rod; center, a lady with a fan and a child; right, a man pointing.

A very similar drawing, with sixteen figures standing before the same sort of architecture, is in the Museo Correr in Venice.[1] It is annotated, in the hand of Conte Nicolò Barozzi (the director of that museum from 1864): *Corte del Ridotto a San Moisè*. The architecture is evidently intended to represent the same courtyard as in the Lehman drawing; and if Barozzi's identification is to be trusted, it must be that of the Ridotto as it was before it was redesigned by Macaruzzi in 1768.[2] Morassi seems to me to date the Correr drawing too late, and he is surely wrong in separating it from the Lehman drawing both in date and in the classification system of his catalogue (he places it in Section VI, called *Interni*, whereas the Lehman drawing is in Section XXII, called *Capricci Architettonici*). The style, especially in the use of the wash, is in fact exactly that of the *Seven Sacraments* in the Museo Correr, a series of drawings freely copied by Francesco from Pitteri's engravings after Pietro Longhi, which I published for the first time in 1933.[3] The date of these must be after 1755 (the date of Pitteri's prints); and Morassi's dating of the Lehman drawing, 1765–70,[4] is probably about right. As he says, very similar figures appear in the earliest of Guardi's series of paintings of ceremonies on the election of a Doge,[5] which are adapted, as is generally recognized, from Brustolon's prints after Canaletto. These prints were published in 1766; and though it seems certain (from style and costume) that Guardi's paintings are not all of the same date, the earliest of them, with figures very much like those in the Lehman drawing, must have been made soon after the publication.

Whereas the figures on the recto suggest a continuous composition, those on the verso seem to be three independent sketches. The two women on the left are like those that appear in other such figure sketches, called sketches for *macchiette*.[6]

J. B. S.

NOTES:
1. Pallucchini 1943, p. 43, no. 48; Morassi 1975, p. 113, no. 198, fig. 198.
2. Pignatti 1967, no. 30. To me the architecture suggests not a real view but rather a jumble of motives from the courtyard of the Doges' Palace.
3. Byam Shaw 1933, p. 50; Pallucchini 1943, p. 62, nos. 173–78; Morassi 1975, pp. 110–11, nos. 176–82, figs. 179–85.
4. Morassi 1975, p. 176, no. 564.
5. Morassi 1973, pp. 354–57, nos. 243–54, figs. 268–84.
6. See, for example, Morassi 1975, p. 120, no. 236, fig. 241.

PROVENANCE: Christopher Norris, London; Mrs. Clive Pascall; sale, Sotheby's, London, May 12, 1954, lot 108; Paul Wallraf, London. Acquired by Robert Lehman in 1962.

EXHIBITED: Venice 1959a, no. 21; Cologne 1959, no. 21; Huntington (N.Y.) 1980, no. 12; New York 1981, nos. 31, 31a; Rochester 1981, no. 12; Detroit 1983, no. 10; Pittsburgh 1985, no. 9.

LITERATURE: Morassi 1975, p. 176, no. 564, fig. 446 (recto); Szabo 1983, no. 60.

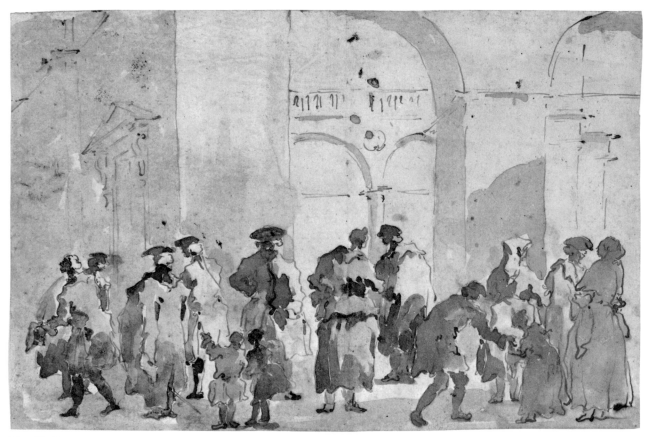

No. 31, Recto

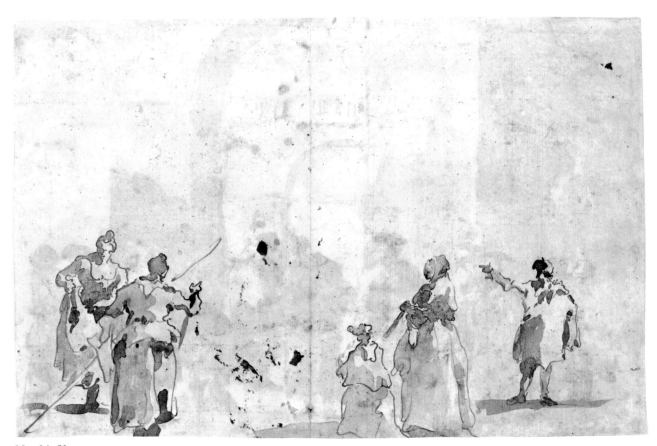

No. 31, Verso

32. A Venetian Capriccio: A Rio Leading to a Bridge

1975.1.338
Pen and brown ink, brown wash. 127 × 180 mm.

The view is probably fanciful, but might be a vague reminiscence of the Rio dei Mendicanti, leading to the Fondamenta Nuove in Venice (cf. the drawing by Giacomo Guardi, No. 39 below). A painting of the same composition, in which, however, a red flag is flying from the church tower, belonged, like the drawing, to Adrien Fauchier-Magnan and is now in an English private collection.[1]

The style of No. 32 is exactly that of another Lehman drawing, No. 33, and the date must be the same, ca. 1780–85. J. B. S.

NOTE:
1. Morassi 1973, p. 469, no. 856, fig. 776.

PROVENANCE: Adrien Fauchier-Magnan, Paris and Cannes-La Bocca; Fauchier-Magnan sale, Sotheby's, London, December 4, 1935, lot 26; Paul Wallraf, London. Acquired by Robert Lehman in 1962.

EXHIBITED: Amsterdam 1936, no. 185; Venice 1959a, no. 22; Cologne 1959, no. 22; New York 1981, no. 36.

LITERATURE: Morassi 1975, p. 182, no. 602, fig. 592.

33. An Architectural Capriccio, with Classical Ruins

1975.1.339
Pen and brown ink, brown wash. 253 × 195 mm. Numbered in pen and brown ink on verso: *14*.
PLATE 4.

No. 33 is identical in style, and in the most prominent part of its architectural composition, with a drawing formerly in the collection of Baron Paul Hatvany and now in that of R. Graham, London.[1] A more elaborate version, heightened with white body color, but closely corresponding in composition, is in the Boymans-van Beuningen Museum, Rotterdam,[2] and a very small painting with a modified

No. 32

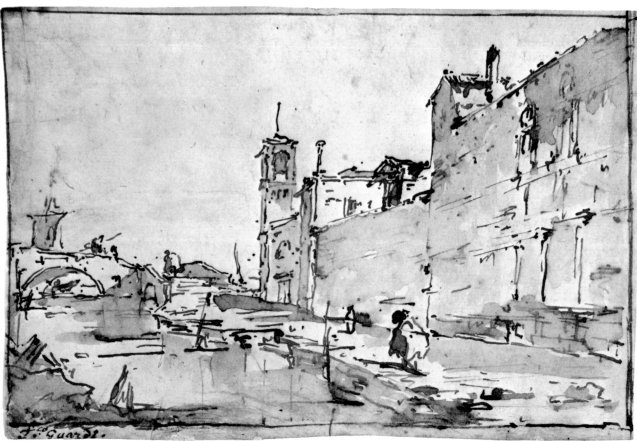

version of the same architecture is one of three framed as a triptych in the National Gallery, London.[3]

The date may be ca. 1780.

J. B. S.

NOTES:
1. Byam Shaw 1951, p. 75, pl. 62 (where I have drawn attention to various other connections); Morassi 1975, p. 169, no. 515, fig. 505.
2. Morassi 1975, p. 168, no. 513, fig. 504.
3. Morassi 1973, p. 496, no. 1009, fig. 891; see also Levey 1971, pp. 127–29.

PROVENANCE: Herbert P. Horne; F. Cooke, London; F. A. Drey, London; Paul Wallraf, London. Acquired by Robert Lehman in 1962.

EXHIBITED: New York 1949, no. 39; Venice 1959a, no. 23; Cologne 1959, no. 23; New York 1981, no. 35; Rochester 1981, no. 14; Pittsburgh 1985, no. 12.

LITERATURE: Byam Shaw 1951, p. 75, under pl. 62 (as belonging to F. Drey); Morassi 1975, p. 168, no. 512, fig. 503.

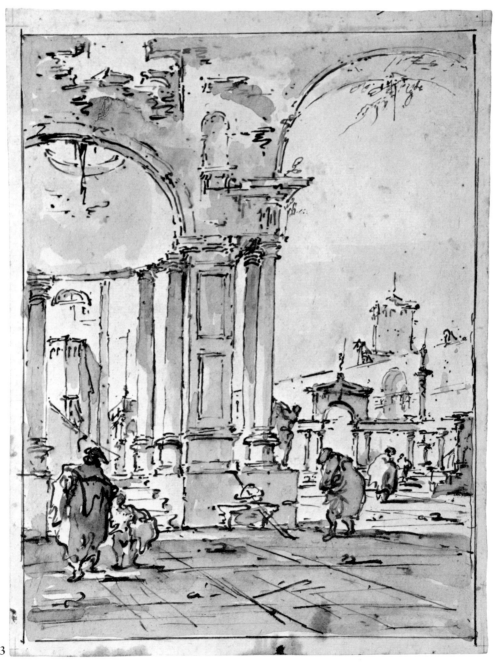

No. 33

Giacomo Guardi

Venice 1764–Venice 1835

Giacomo was the youngest son of Francesco Guardi and Maria Pagani. Through his father's elder sister Cecilia, the wife of Giovanni Battista Tiepolo, he was first cousin to Domenico Tiepolo, though thirty-seven years his junior, and like Domenico he was a devoted assistant to his father so long as Francesco lived. But whereas Domenico was a gifted artist in his own right, who, after Giovanni Battista's death in 1770, produced work that entitles him to very high rank among Venetian painters and draftsmen of the later Settecento (as the Lehman drawings suffice to show), Giacomo Guardi seems to have spent the forty-two years that remained to him after his father's death in 1793 painting indifferent imitations of Francesco's work, finishing, inscribing, and selling the contents of Francesco's studio, and producing on his own account a vast quantity of small views of Venice, either in pen and gray wash or brightly colored in gouache, to supply the demand for souvenirs of Venice among the less affluent foreign visitors. "Gardi [*sic*]," wrote the Hon. Lady Murray in 1816, "the son of the painter of that name, does views in distemper in the same style."[1] These are almost always inscribed on the back with Giacomo's name and address.[2]

A small pen-and-ink drawing of a lagoon scene in the Louvre, dated 1782 (when Giacomo was eighteen years old), though signed and inscribed as his own invention, is in fact copied from an engraving after Canaletto.[3] It shows how he began; and he seems also to have copied at this time parts of Francesco's drawings and paintings, sometimes using the backs of his father's drawings for the purpose.[4] A clear case of such copying is described in the entry for No. 35.

It is no doubt true that during the last few years of Francesco's life Giacomo, as his constant and perhaps his only assistant (Francesco's younger brother Nicolò had died in 1786), imitated his father's style in drawing more successfully than he did in later years; and some authorities (Arslan, Muraro, Pignatti) have wished to attribute to Giacomo many slight or less important drawings that are attributed by others to his father's old age. The fact is, however, that there is no definite evidence to justify our eliminating, simply on grounds of quality, the least good of the drawings considered to be Francesco's—for instance, among the large collection in the Museo Correr—and giving them instead to Giacomo; and such elimination is a dangerous procedure on which to embark, for the borderline is very difficult to define.[5]

Giacomo's developed style, on the other hand, is easy to recognize in the little Venetian views, which are repeated again and again, "plain or colored"; no one would mistake these for Francesco's work. But they vary in quality according to the amount of trouble that Giacomo gave himself, and they are not easy to date exactly. Nor is it easy to determine, except on occasional topographical grounds, how far they were done on the spot and how far in the studio, borrowed from other sources—drawings or paintings by his father, or engravings such as those in Visentini's *Isolario veneto*. The numbered series of views in the Robert Lehman Collection provides good examples. There are, however, in the Museo Correr, a number of small, very slight sketches in black chalk, and a few pen sketches as well, which bear notes suggesting that these at least were drawn on the spot—notes indicating the color of the buildings or the place from which the sketch was made.[6] These no doubt represent Giacomo's own slender resources, which provided at least some of the material for the familiar views.

Eighteen of the drawings by Giacomo Guardi in the Lehman Collection were exhibited in 1959, while still in the Wallraf collection, at the Fondazione Giorgio Cini in Venice, and twenty-two of them later that year at the Wallraf-Richartz-Museum in Cologne.

J. B. S.

NOTES:

1. *Journal of a Tour in Italy*, published anonymously and without date, but identified by Sir Francis Watson as by Lady Murray, who traveled in Italy in 1816 and 1835.
2. Generally "all'Ospedaletto in calle del Perruchier al N° 5245." But at least one other address is also given (see Nos. 39, 53).
3. Byam Shaw 1951, p. 79, pl. 76.
4. See Byam Shaw 1951, pp. 50, 79, pl. 77. Examples are in the Metropolitan Museum; the Ashmolean Museum, Oxford; the Graphische Sammlung Albertina, Vienna; and the Boymans-van Beuningen Museum, Rotterdam.
5. I refer to such scribbles as Pallucchini 1943, pp. 55–56, nos. 128, 131, 132. And are we to suppose that the sheet of figure studies in Berlin (Morassi 1975, p. 115, no. 209, fig. 211), which is precisely dated February 2, 1781 (*more veneto*, i.e. 1782), was produced by Giacomo, born April 13, 1764, because the figures are rather feebly drawn? Such an assumption would draw suspicion on much else besides.
6. See, for instance, Venice 1977, pp. 41, 44, 49, 58, nos. 22, 28, 38, 54.

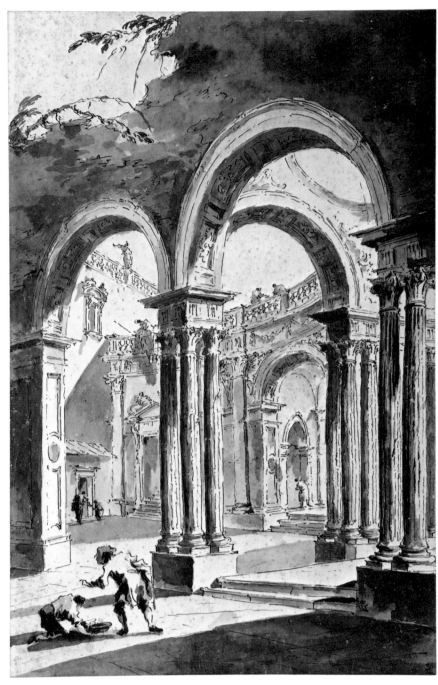

No. 34

Francesco (?) and Giacomo Guardi

34. A Colonnade, Partly Ruined, with Figures

1975.1.337
Pen and brown ink, brown and gray wash. 454 × 301 mm.

The drawing is a rather close replica, spoilt by the heavy-handed wash, of a smaller one, catalogued and warmly praised by Morassi, in a private collection in Paris.[1]

Morassi refers to the Lehman drawing as "probably by Giacomo."[2] The same scene, with variations, appears in a drawing in the Boymans-van Beuningen Museum, Rotterdam;[3] but in that there are no figures, and the whole composition is framed by an arch in the foreground. The figures of the man and the boy with a basket, in the left

49

foreground, are repeated from (or in) a drawing in the Museo Correr[4] and another in the Metropolitan Museum.[5] The style is the same, and the date is certainly late, ca. 1780–90. This is a *capriccio* in the manner of the theatrical designers, recalling Antonio Ioli's diploma picture in the Accademia, Venice, which was engraved for Joseph Wagner in 1779.[6]

The unpleasant blackish wash in the present drawing is surely by Giacomo, but the rest, drawn with a much finer pen than that used for Nos. 32 and 33, is delicate enough and, I believe, by Francesco. This would then be a case of the collaboration between father and son which I have suggested as probable at the end of Francesco's career.[7]

Similar very large drawings were in an album bought in Venice by the English admiral Lord Mark Kerr (1776–1840), of which six were in the Oppenheimer sale at Christie's in 1936.[8] In some of these the penwork as well as the wash was more characteristic of Giacomo. Many of them, like No. 34, were enlarged replicas of known drawings by Francesco. I have been unable to discover when the Kerr album was broken up or whether the present drawing could have belonged to it.

J. B. S.

NOTES:
1. Morassi 1975, p. 173, no. 542, fig. 534.
2. Ibid.
3. Byam Shaw 1951, p. 75, pl. 63; Morassi 1975, p. 173, no. 544, fig. 535.
4. Pallucchini 1943, p. 44, no. 53.
5. Morassi 1975, pp. 170–71, no. 527, fig. 524.
6. Marconi 1970, p. 36, no. 74, fig. 73.
7. See Byam Shaw 1951, pp. 50–51.
8. Sale, Christie's, London, July 10, 1936, lots 95–100.

PROVENANCE: William Mayor, London (Lugt 2799, stamped twice).

EXHIBITED: Springfield (Mass.) 1937, no. 46; Huntington (N.Y.) 1980, no. 46; New York 1981, no. 33; Rochester 1981, no. 15.

LITERATURE: Byam Shaw 1951, p. 75, under pl. 63; Morassi 1975, p. 173, under no. 542.

35. The Courtyard of the Doges' Palace

1975.1.343
Pen and brown ink, brown wash. 140 × 102 mm. Inscribed in ink, in the margin, bottom right, in Giacomo Guardi's hand: *Francesco Guardi.*

The inscription in Giacomo's hand is one of several examples of his attributing his own drawings to his father.[1] The justification for this apparently shady practice, which was no doubt aimed at the tourist market, might have been that the drawings were reproductions of the father's work. In fact, two paintings of this composition by Francesco Guardi are known, both in London: a small one in the Wallace Collection[2] and another, even smaller, in the National Gallery.[3]

This is a rather inaccurate view of the cortile of the palace, from the colonnade, looking toward the side of the Scala dei Giganti. The sculptured figure introduced by Giacomo at the top of the staircase on the right bears no resemblance to the giant *Neptune*, by Sansovino, which occupies that position. The statue is left out in Francesco's painted version in the National Gallery. The architecture of the basilica of San Marco, which should in fact be visible, in this view, in the upper background, is also left out in Giacomo's drawing as it is in both paintings by Francesco. Certain motives, both figures and architecture, were copied by Giacomo from one or the other of his father's paintings of this subject in pen sketches on the verso of Francesco's fine large drawing in the Pierpont Morgan Library, *The Bucintoro Leaving the Lido on the Feast of the Ascension;*[4] these were no doubt used in composing the present drawing. Other drawings by Francesco, to some extent relevant, are mentioned by Michael Levey in the National Gallery catalogue.[5]

J. B. S.

NOTES:
1. See Byam Shaw 1951, pp. 50–51, 79–80, pl. 78.
2. Morassi 1973, pp. 456–57, no. 789, fig. 718.
3. Ibid., p. 457, no. 790, fig. 719.
4. See Denison and Mules 1981, p. 111, no. 94, pl. 94 verso.
5. Levey 1971, pp. 125–26, under no. 2519.

PROVENANCE: Paul Wallraf, London. Acquired by Robert Lehman in 1962.

EXHIBITED: Venice 1959a, no. 42; Cologne 1959, no. 42; New York 1981, no. 58; Rochester 1981, no. 17; Detroit 1983, no. 15.

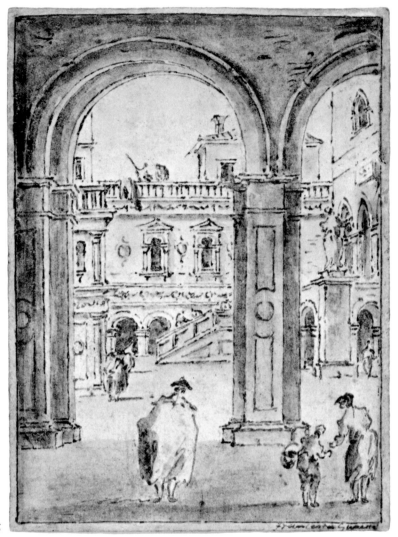

No. 35

36. Capriccio with a Statue of a Warrior and a Ruined Castle on the Shore of the Lagoon

1975.1.344
Pen and brown ink, gray wash. 471 × 347 mm.

The drawing corresponds exactly in style, and nearly in dimensions, with six drawings from the Henry Oppenheimer collection sold at Christie's in 1936.[1] According to the sale catalogue (by Sir Karl Parker) those drawings came from an album, the title page of which was inscribed with a note that it was bought in Venice by Admiral Lord Mark Kerr (1776–1840), a son of the Marquess of Lothian.

There is no record of the date at which this album was broken up, but Parker indicates that in 1936 drawings from it were already scattered in various collections. Two *capricci* in the same style, only slightly larger, are in the National Gallery, Washington.[2] All these drawings have been attributed in the past to Francesco Guardi; but in all of them known to me the coarse blackish wash is typical

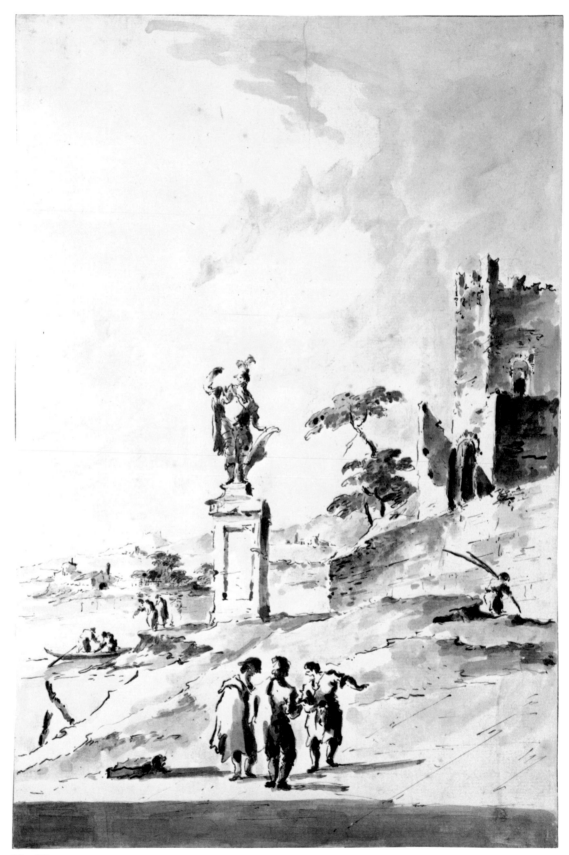

No. 36

of Giacomo. Occasionally, however, as in No. 34, which perhaps came from the same source, the penwork is of better quality than Giacomo's and may be due to Francesco, in his old age, collaborating with his son.[3] Smaller drawings by Francesco of several of the compositions are known.

The statue resembles that placed by Francesco at the top of the Scala dei Giganti, instead of Sansovino's giant *Neptune*, in his small painting in the Wallace Collection, London, referred to in the entry for No. 35.[4]

J. B. S.

NOTES:
1. Sale, Christie's, London, July 10, 1936, lots 95–100.
2. Washington, National Gallery of Art, inv. nos. B–21, 675–76.
3. Byam Shaw 1951, p. 51.
4. Morassi 1973, pp. 456–57, no. 789, fig. 718.

PROVENANCE: Admiral Lord Mark Kerr (probably); Paul Wallraf, London. Acquired by Robert Lehman in 1962.

EXHIBITED: Venice 1959a, no. 41; Cologne 1959, no. 41; New York 1981, no. 57; Pittsburgh 1985, no. 14.

37. Piazza San Marco, Looking toward the Basilica

1975.1.345

Pen and brown ink, gray wash. 125 × 212 mm. Annotated in brown ink (perhaps by Colonel Edward Roche: see below) on the old backing paper, below the double margin: *Piazza di S: Marco*. Numbered in brown ink, further to the right: *nº 1*. Inscribed in brown ink on the verso, in Giacomo's hand: *Veduta della Piazza di S. Marco*. Signed in brown ink on the verso: *Giacomo de Guardi*.

This is the first of a series of forty-eight views of Venice and the surrounding islands. They were once mounted in a small album which was identified by an inscription on the cover as the property of Colonel Edward Roche, who died in 1828. The views are identified on the verso by titles inscribed in Giacomo Guardi's hand and are, in most cases, signed by him (see No. 53 below, Fig. 15). The same titles appear (sometimes with variations) below each drawing on the recto of the old backing paper, in what is probably Colonel Roche's hand; here they are accompanied by numbers, at bottom right (see No. 53 below, Fig. 14).

Colonel Roche was an Irish gentleman of the family of the present Lord Fermoy, and Mrs. Amy Clarke, from whom

Colnaghi bought the album in 1956, was related to the same family. More than twenty years earlier, in 1934, Colnaghi had bought at Sotheby's two similar albums of Venetian views by Giacomo—one set colored in tempera, the other in pen and Indian ink only, but all inscribed and signed on the back in the same way as the present set. These too had belonged to Colonel Roche. Two of the colored set were annotated by him: *Riva de Schiavone* [sic], *my house on it in 1804*, and *Regatta for the Archduke John in 1804 near the Rialto*. Of the two sets sold at Sotheby's in 1934, the colored set passed into the collection of the late Sir Bruce Ingram; the black-and-white set was broken up by Colnaghi and the drawings dispersed to various buyers.[1]

Of the forty-eight drawings in the set that appeared in 1956, thirty-six were acquired by Paul Wallraf; twenty of these have passed into the Lehman Collection, and are catalogued here; all these were exhibited, either in Venice or in Cologne, or both, in 1959, when they were still in Mr. Wallraf's possession.

The late Antonio Morassi, in the 1959 Venice and Cologne catalogues, supposed that the date 1804, twice mentioned in Colonel Roche's annotations in one of the albums sold at Sotheby's in 1934, must apply to the present drawings as well.[2] This is not necessarily the case, since it is obvious that Giacomo must have repeated himself many times at various dates in making up these albums for sale to foreign tourists.[3] Nor is it necessary to suppose, as Morassi did, that the drawings so annotated must have been done before 1804. Colonel Roche may have bought the album on a subsequent visit to Venice; his note may simply record the fact that he had had a house on the Riva degli Schiavoni in that year; and as for the regatta scene, he may have identified it wrongly with one for the "Archduke John" that he had watched—many such regattas in honor of distinguished visitors took place, after all, both before and after the fall of the Republic. Judging by the few firmly dated drawings by Giacomo that are known to me,[4] I should date the Roche-Wallraf-Lehman series considerably later than 1804. The only valid *terminus ante quem* is 1828, the date of Colonel Roche's death.

The famous view of Piazza San Marco, which appropriately begins the numbered series, is probably derived from some earlier drawing or painting or print. Another drawing of the same view by Giacomo is in the National Gallery of Victoria, Melbourne, and two others, much larger, were once in the collections of C. R. Rudolf in London and Carlo Broglio in Paris.[5] There is no sign in any of these drawings of the top stories added to both wings of the Clock Tower, which were under construction in March

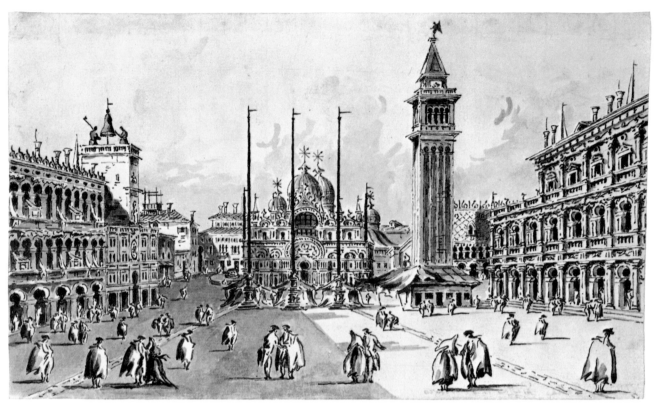

No. 37

1755, before Giacomo was born.[6] In all of them, the lighting is arbitrary: the shadows of the figures, falling both to right and left, are incompatible with the lighting of the scene as a whole, in which the left side of the piazza is in shadow from the afternoon sun.

J. B. S.

NOTES:

1. See Byam Shaw 1951, p. 41.
2. Venice 1959a, p. 27, under no. 25; Cologne 1959, p. 26, under no. 25.
3. See Byam Shaw 1951, p. 42, where I refer to yet another set of these Venetian views by Giacomo, which then belonged to H. L. Bradfer-Lawrence in Yorkshire.
4. Two, in the Museo Correr (Pallucchini 1943, nos. 171, 172), date from 1790 and 1800 respectively, and there is a large drawing of 1828 in the Royal Museum, Canterbury (Byam Shaw 1977, pp. 12–13, pl. 14). See also the entry for No. 41 in the present catalogue.
5. The Broglio drawing is illustrated in Morassi 1975, fig. 630.
6. See the diary of the Procurator Pietro Gradenigo for March 2, 1775 (Gradenigo 1942, p. 15).

PROVENANCE: Colonel Edward Roche, Co. Cork, Ireland; Mrs. Amy Clarke, Farran House, Farran, Co. Cork, Ireland; P. & D. Colnaghi & Co., London; Paul Wallraf, London. Acquired by Robert Lehman in 1962.

EXHIBITED: London 1956, no. 90; Cologne 1959, no. 121; New York 1981, no. 53; Pittsburgh 1985, no. 13.

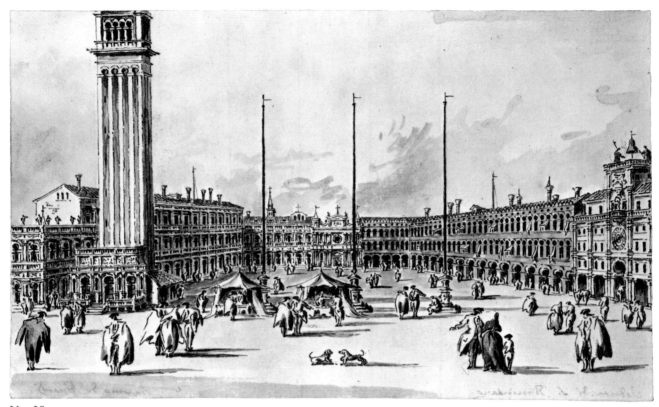

No. 38

38. Piazza San Marco, Looking toward the Church of San Gemignano

1975.1.346

Pen and brown ink, gray wash. 126 × 212 mm. Annotated in brown ink (perhaps by Colonel Edward Roche: see No. 37) on the old backing paper, below the double margin: *Veduta di S: Giminiano.* Numbered in brown ink, further to the right: *n° 2.* Inscribed in brown ink on the verso, in Giacomo's hand: *Veduta di S. Giminiano.* Signed in brown ink on the verso: *Giacomo de Guardi.*

This drawing was the second of the series that began with No. 37.

In 1804, which Morassi supposed to be the *terminus ante quem* for dating the series,[1] the church of San Gemignano would still have appeared as it is shown here, in the center of the buildings facing the basilica of San Marco; it was demolished, by command of the Emperor Napoleon, only between 1807 and 1810. It is, however, certain that Giacomo's drawing derives from some earlier painting, drawing, or print, since the top stories of the wings of the Clock Tower, which is shown at the extreme right, are imaginary and quite unlike the new top stories

as they were completed by Giorgio Massari in August 1755[2] and as they appear in all the other paintings and drawings of the piazza by Francesco or Giacomo Guardi that are known to me. Compare, for example, the large and brilliant rendering of the same view by Francesco in the Musée du Petit Palais, Paris,[3] and the drawing by Giacomo, No. 39 in the present catalogue.

J. B. S.

NOTES:
1. Venice 1959a, p. 27, under no. 25.
2. See the diary of the Procurator Pietro Gradenigo for August 14 of that year (Gradenigo 1942, pp. 17–18).
3. Morassi 1975, p. 136, no. 328, fig. 331.

PROVENANCE: Colonel Edward Roche, Co. Cork, Ireland; Mrs. Amy Clarke, Farran House, Farran, Co. Cork, Ireland; P. & D. Colnaghi & Co., London; Paul Wallraf, London. Acquired by Robert Lehman in 1962.

EXHIBITED: London 1956, no. 87; Cologne 1959, no. 122; New York 1981, no. 54; Rochester 1981, no. 16.

39. The Clock Tower of San Marco, from in Front of the Basilica

1975.1.347

Pen and brown ink, brown-gray wash. 125 × 212 mm. Annotated in brown ink (perhaps by Colonel Edward Roche: see No. 37) on the old backing paper, below the double margin: *Veduta dell' Orologio*. Numbered in brown ink, further to the right: *3*. Inscribed in brown ink on the verso, in Giacomo's hand: *Veduta dell' Orologio . . . [?] della chiesa di S. Marco a Venezia* and *a S. Canciano in Campiello della Madonna*. Signed in brown ink on the verso: *Giacomo de Guardi*.

The third in the series that began with No. 37, this is a fairly accurate view of the Torre dell'Orologio as it was from 1755 onward (compare the representation of the tower in Nos. 37 and 38, and see the entries for those drawings). It is interesting to compare Francesco's fine large drawing of the same view in the Musée du Petit Palais, Paris,[1] a very late work, of the time when Giacomo was working closely with his father and presumably imitating him more skillfully than in the present drawing, which may date from some years after Francesco's death in January 1793—though Giacomo's address is still given on the verso as "a San Canciano in Campiello della Madonna." This was the address of the house where Francesco Guardi lived with his elder son Vincenzo, who was a priest at San Canciano, and where he died; Giacomo, the younger son, no doubt lived there too and probably stayed on with his brother for some time after their father's death before moving to the address near the Ospedaletto (see also No. 53).

J. B. S.

NOTE:
1. For Francesco's drawing, which is a companion piece to the one referred to in the entry for No. 38, see Morassi 1975, p. 137, no. 333, fig. 330.

PROVENANCE: Colonel Edward Roche, Co. Cork, Ireland; Mrs. Amy Clarke, Farran House, Farran, Co. Cork, Ireland; P. & D. Colnaghi & Co., London; Paul Wallraf, London. Acquired by Robert Lehman in 1962.

EXHIBITED: London 1956, no. 77; Cologne 1959, no. 123; New York 1981, no. 55.

40. Campo Santi Giovanni e Paolo, Looking Toward the Scuola di San Marco

1975.1.348

Pen and brown ink, brown-gray wash. 125 × 212 mm. Annotated in brown ink (perhaps by Colonel Edward Roche: see No. 37) on the old backing paper, below: *Veduta di S: Giovanni e Paolo, detto S: Zanipolo*. Numbered in brown ink, further to the right: *13*. Inscribed in brown ink on the verso, in Giacomo's hand: *Veduta di S. Giov' e Paolo*.

This drawing was the thirteenth of the series that began with No. 37. The details of the architecture, especially in the windows of the church of Santi Giovanni e Paolo and in the beautiful façade of the adjoining Scuola di San Marco (now the Ospedale Civile), are extremely inaccurate. Giacomo has divided the *piano nobile* of the Scuola in two, and his rendering of the famous Colleoni monument on the right is a grotesque travesty. Contrast the very large and fine view of the same scene, drawn by Francesco from a slightly different angle, in the Szépművészeti Múzeum, Budapest.[1]

J. B. S.

NOTE:
1. Byam Shaw 1951, p. 60, pl. 14; Morassi 1975, pp. 147–48, no. 390, fig. 391.

PROVENANCE: Colonel Edward Roche, Co. Cork, Ireland; Mrs. Amy Clarke, Farran House, Farran, Co. Cork, Ireland; P. & D. Colnaghi & Co., London; Paul Wallraf, London. Acquired by Robert Lehman in 1962.

EXHIBITED: Cologne 1959, no. 124; Huntington (N.Y.) 1980, no. 14; New York 1981, no. 56; Rochester 1981, no. 18.

41. The Island of Poveglia, with British Naval Officers Embarking

1975.1.350

Pen and brown ink, gray wash. 125 × 211 mm. Annotated in brown ink (perhaps by Colonel Edward Roche: see No. 37) on the old backing paper, below: *Veduta di Poveglia inbarcandosi nella Nave Inglese*. Numbered in brown ink, further to the right: *15*. Inscribed in brown ink on the verso, in Giacomo's hand: *Veduta di Poveglia quando suaf.^{ti} [?] s'imbarca nella nave Inglese*.

This drawing was the fifteenth in the series that began with No. 37.

Poveglia, the most southerly of the small Venetian islands, became in Giacomo Guardi's time (in 1814, to be precise) an isolation hospital. The view corresponds fairly closely to that in Visentini's engraving, no. XVI of the *Isolario veneto* of 1777, and in a small painting in the Szépművészeti Múzeum, Budapest,[1] except that Giacomo's drawing shows no campanile—presumably it had fallen, for the present campanile has a different form. This, together with the introduction of the embarcation scene, suggests that the drawing was made on the spot, and that has some relevance to the dating of the series. The date of this drawing, which shows Giacomo's most characteristic mannerisms, must either be earlier than the fall of the Republic in 1797 (which may seem unlikely) or

No. 39

No. 40

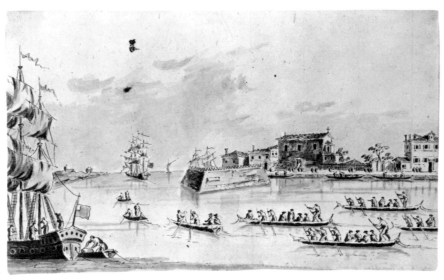

No. 41

No. 42

No. 43

No. 44

later than 1814–15, since the British navy would certainly not have paid a courtesy visit to Venice (as seems to be the occasion here) before the end of the Napoleonic wars.

To judge from their dress, the British sailors embarking (in at least three ships) must all be officers. They are accompanied, apparently, by two of their wives, in a separate boat in the center of the composition.

<div align="right">J. B. S.</div>

NOTE:

1. For the Budapest painting, see Térey 1916, pp. 280, 283, no. 237. It is one of a set of twelve island views, attributed by Morassi (Venice 1959a, under nos. 33, 34) to Giacomo; see also Morassi 1973, p. 436, under no. 679.

PROVENANCE: Colonel Edward Roche, Co. Cork, Ireland; Mrs. Amy Clarke, Farran House, Farran, Co. Cork, Ireland; P. & D. Colnaghi & Co., London; Paul Wallraf, London. Acquired by Robert Lehman in 1962.

EXHIBITED: Venice 1959a, no. 34; Cologne 1959, no. 34; New York 1981, no. 47.

42. The Rio dei Greci, with the Ponte della Pietà in the Distance

1975.1.349

Pen and brown ink, gray wash. 121 × 211 mm. Annotated in brown ink (perhaps by Colonel Edward Roche: see No. 37) on the old backing paper, below: *Veduta del Canal de Greci presso il Ponte.* Numbered in brown ink, further to the right: *19.* Inscribed in ink on the verso, in Giacomo's hand: *Veduta del Canal de Greci presso il Ponte.* Signed in brown ink on the verso: *Giacomo de Guardi.*

The nineteenth in the series that began with No. 37, this is a "wide-angle" view, looking south from different points on the Ponte dei Greci, which connects the Salizzada dei Greci with the present-day Fondamenta dell'Osmarin. The entrances to the church of San Giorgio dei Greci and its *scuola* are on the left. The wall on the right is now built higher and encloses police barracks. Giacomo should have shown the campanile, from this point of view, leaning noticeably to the right.

I know of no earlier or contemporary painting of the same scene.

<div align="right">J. B. S.</div>

PROVENANCE: Colonel Edward Roche, Co. Cork, Ireland; Mrs. Amy Clarke, Farran House, Farran, Co. Cork, Ireland; P. & D. Colnaghi & Co., London; Paul Wallraf, London. Acquired by Robert Lehman in 1962.

EXHIBITED: Venice 1959a, no. 30; Cologne 1959, no. 30; New York 1981, no. 44.

43. The Porto di Lido, with the Fortezza Sant'Andrea on the Left

1975.1.351

Pen and brown ink, gray wash. 123 × 212 mm. Annotated in brown ink (perhaps by Colonel Edward Roche: see No. 37) on the old backing paper, below: *Veduta del Porto di Lido.* Numbered in brown ink, further to the right: *22.* Inscribed in brown ink on the verso, in Giacomo's hand: *Veduta del Porto di Lido.* Signed in brown ink on the verso: *Giacomo de Guardi.*

This drawing was the twenty-second in the series that began with No. 37.

The fort on the left was constructed by Sanmicheli in the sixteenth century to guard the narrow entrance from the sea to the Venetian lagoon. It was from here that the Venetian commander Domenico Pizzamano fired the last defiant shots in an attempt to prevent the French advance guard from entering the channel on August 20, 1797.

On the right is the church of San Nicolò. This was the scene of the most famous of all Venetian festivals, held at the feast of the Ascension every year: the *Sposalizio del Mare,* in which the Doge, proceeding to the Lido in the Bucintoro, his state barge, accompanied by a whole fleet of state galleys, festival barges, and gondolas, performed the symbolic ceremony of wedding the Adriatic with a ring.

<div align="right">J. B. S.</div>

PROVENANCE: Colonel Edward Roche, Co. Cork, Ireland; Mrs. Amy Clarke, Farran House, Farran, Co. Cork, Ireland; P. & D. Colnaghi & Co., London; Paul Wallraf, London. Acquired by Robert Lehman in 1962.

EXHIBITED: Venice 1959a, no. 33; Cologne 1959, no. 33; New York 1981, no. 43.

44. The Church and Convent of San Mattia di Murano

1975.1.352

Pen and brown ink, gray wash. 125 × 211 mm. Annotated in brown ink (perhaps by Colonel Edward Roche: see No. 37) on the old backing paper, below: *Veduta di S: Mattia di Murano.* Numbered in brown ink, further to the right: *23.* Inscribed in brown ink on the verso, in Giacomo's hand: *Veduta di S. Mattia di Murano.* Signed in brown ink on the verso: *Giacomo de Guardi.*

This drawing was the twenty-third in the series that began with No. 37.

The church and convent are now only a ruin, and the deserted island is joined to the main island of Murano. It is shown here exactly as in Visentini's engraving, no. XV in the *Isolario veneto* of 1777, except that in Giacomo's

drawing there are two large external chimney-flues added at both ends of the convent façade.

Morassi refers to a painting of the same subject by Giacomo, in a private collection in Crema.[1]

J. B. S.

NOTE:
1. Venice 1959a, p. 33, no. 35.

PROVENANCE: Colonel Edward Roche, Co. Cork, Ireland; Mrs. Amy Clarke, Farran House, Farran, Co. Cork, Ireland; P. & D. Colnaghi & Co., London; Paul Wallraf, London. Acquired by Robert Lehman in 1962.

EXHIBITED: Venice 1959a, no. 35; Cologne 1959, no. 35; New York 1981, no. 48.

45. The Punta di San Giobbe, with the Island of San Secondo in the Distance

1975.1.353

Pen and brown ink, gray wash. 125 × 211 mm. Annotated in brown ink (perhaps by Colonel Edward Roche: see No. 37) on the old backing paper, below: *Veduta della Punta di S: Giobbe*. Numbered in brown ink, further to the right: *24*. Inscribed in brown ink on the verso, in Giacomo's hand: *Veduta della Punta di S. Giobbe*. Signed in brown ink on the verso: *Giacomo de Guardi*.

This drawing was the twenty-fourth in the series that began with No. 37.

The Punta di San Giobbe is at the northwest end of the Cannaregio canal. In Guardi's time the island of San Secondo was the site of a convent of Benedictine nuns, but it was converted into a fort for the defense of the city during the revolution of 1849, and is now deserted.

The same view was drawn by Giacomo, according to his inscription, on January 3, 1790 (*more veneto*, i.e. 1791 by our reckoning) in a very large sheet in the Museo Correr, Venice.[1] That version shows the canal and lagoon frozen over, with numerous figures walking on the ice. Presumably it was drawn on the spot; but it is noticeable that in it the campanile of San Secondo has a pointed spire, unlike the Baroque cupola in the Lehman drawing.[2] The Baroque cupola, however, resembles that shown in Visentini's engraving of 1777, no. XVIII of the *Isolario veneto*, and in a small painting in Budapest.[3] Both the engraving and the Budapest painting (which corresponds closely with it) show the other side of the island.

J. B. S.

NOTES:
1. Pallucchini 1943, p. 61, no. 171.
2. See the detail reproduced in Pallucchini 1943, p. 250.
3. Térey 1916, pp. 280, 283, no. 236. The painting belongs to the series of twelve island views attributed by Morassi to Giacomo: see No. 41, n. 1.

PROVENANCE: Colonel Edward Roche, Co. Cork, Ireland; Mrs. Amy Clarke, Farran House, Farran, Co. Cork, Ireland; P. & D. Colnaghi & Co., London; Paul Wallraf, London. Acquired by Robert Lehman in 1962.

EXHIBITED: Venice 1959a, no. 32; Cologne 1959, no. 32; New York 1981, no. 46.

46. San Pietro di Castello

1975.1.354

Pen and brown ink, gray wash. 124 × 211 mm. Annotated in brown ink (perhaps by Colonel Edward Roche: see No. 37) on the old backing paper, below: *Veduta di S: Pietro di Castello*. Numbered in brown ink, further to the right: *28*. Inscribed in brown ink on the verso, in Giacomo's hand: *Veduta di S. Pietro di Castello*. Signed in brown ink on the verso: *Giacomo de Guardi*.

There is a fine drawing of this view by Francesco Guardi in the Musée des Vosges at Épinal;[1] it was used by him for the beautiful painting in the Gulbenkian Foundation, Lisbon.[2] Other versions of the painting are in the Boymans-van Beuningen Museum, Rotterdam,[3] and (formerly) in the collection of the Duc de Talleyrand.[4]

Giacomo's drawing, the twenty-eighth in the series that began with No. 37, corresponds rather closely with the Gulbenkian and Talleyrand versions, even in the placing of some of the boats and the sailing-barge in the left foreground, but it shows a doorway, which is not in the paintings, in the façade of the low building immediately to the right of the church.

J. B. S.

NOTES:
1. Morassi 1975, p. 148, no. 391, fig. 393.
2. Morassi 1973, p. 422, no. 600, figs. 570, 573.
3. Ibid., pp. 422–23, no. 602, fig. 572.
4. Ibid., p. 422, no. 601, fig. 571.

PROVENANCE: Colonel Edward Roche, Co. Cork, Ireland; Mrs. Amy Clarke, Farran House, Farran, Co. Cork, Ireland; P. & D. Colnaghi & Co., London; Paul Wallraf, London. Acquired by Robert Lehman in 1962.

EXHIBITED: Venice 1959a, no. 25; Cologne 1959, no. 25; New York 1981, no. 37.

47. The Punta di Santa Marta, Opposite the Giudecca

1975.1.355

Pen and brown ink, gray wash. 125 × 212 mm. Annotated in brown ink (perhaps by Colonel Edward Roche: see No. 37) on the old backing paper, below: *Veduta di S: Marta di faccia S: Biaggio della Giudeca*. Numbered in brown ink, further to the right: *31*. Inscribed in brown ink on the verso, in Giacomo's hand: *Veduta di S. Marta di faccia S. Biaggio della Giudeca*. Signed in brown ink on the verso: *Giacomo de Guardi*.

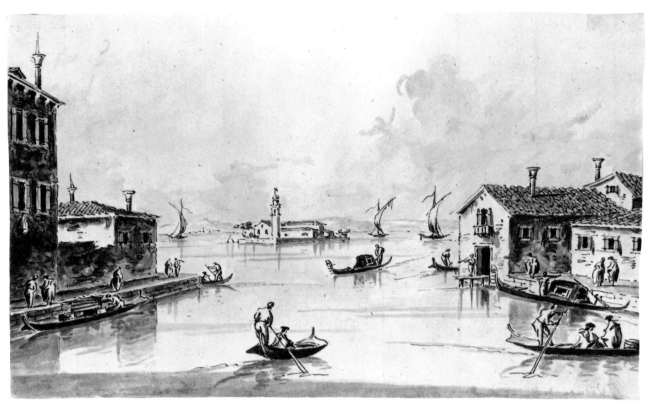

No. 45

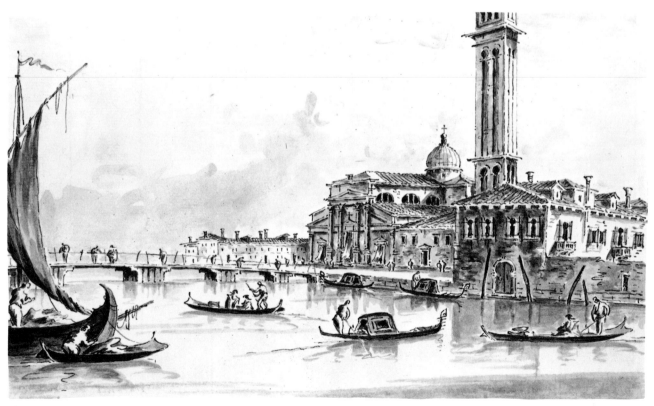

No. 46

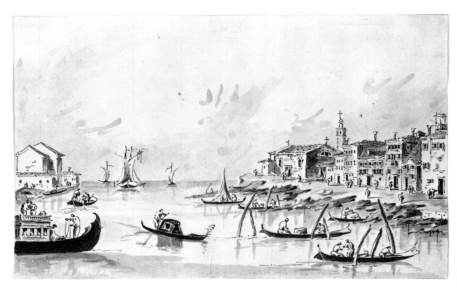

No. 47

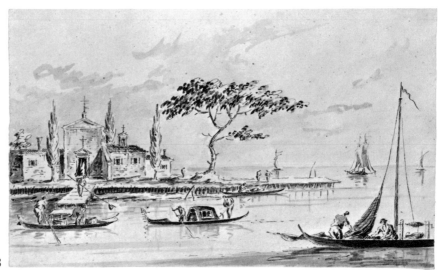

No. 48

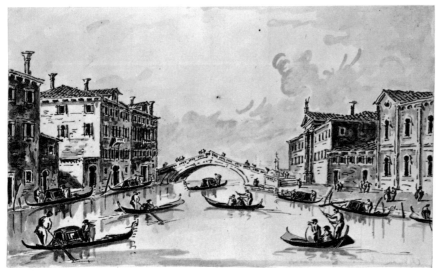

No. 49

This drawing was the thirty-first in the series that began with No. 37.

The church of Santa Marta, at the west end of the Zattere, is now a warehouse, and warehouses and factories occupy the site of San Biagio on the Giudecca opposite.

There is a rather similar view by Francesco Guardi in a painting in the Gulbenkian Foundation, Lisbon,[1] and a small and careful gouache by Giacomo was one of a set of eight sold by the Hon. William Buchan at Sotheby's in 1974.[2] The latter version is nearer in composition to Francesco's painting, excluding San Biagio on the left and showing the island of San Giorgio in Alga in the distance. In the left foreground of the Lehman drawing is the *burchiello*, the omnibus boat that plied between Venice and Fusina on the mainland, then along the Brenta Canal to Padua. This boat appears in the same place in the gouache drawing sold in 1974. J. B. S.

NOTES:
1. Morassi 1973, p. 427, no. 627, fig. 595.
2. Sale, Sotheby's, London, December 11, 1974, lot 30A (illustrated in the catalogue, p. 71).

PROVENANCE: Colonel Edward Roche, Co. Cork, Ireland; Mrs. Amy Clarke, Farran House, Farran, Co. Cork, Ireland; P. & D. Colnaghi & Co., London; Paul Wallraf, London. Acquired by Robert Lehman in 1962.

EXHIBITED: Venice 1959a, no. 29; Cologne 1959, no. 29; New York 1981, no. 41.

48. The Island of L'Anconetta, on the Way to Mestre, with the Church of La Madonnetta

1975.1.359

Pen and brown ink, gray wash. 124 × 211 mm. Annotated in brown ink (perhaps by Colonel Edward Roche: see No. 37) on the old backing paper, below: *Veduta dell'Anconetta per andar a Mestre*. Numbered in brown ink, further to the right: *33*. Inscribed in brown ink on the verso, in Giacomo's hand: *Veduta dell'Anconetta p. andar a Mestre*. Signed in brown ink on the verso: *Giacomo de Guardi*.

This drawing was the thirty-third in the series that began with No. 37.

Morassi reproduces, as by Francesco, two small paintings of the same scene, one in the Fogg Art Museum, Cambridge (Mass.), and the other in the Accademia, Venice.[1] The latter has figures of washerwomen and a two-oared gondola which are clearly by Francesco, but the rest is of poor quality. In discussing the Accademia version Morassi also mentions a drawing by Francesco in the Metropolitan Museum,[2] though this is omitted (prob-

ably by oversight) in his 1975 catalogue of Guardi drawings. Francesco's drawing is much rougher and more spirited than Giacomo's, but the view is identical—except that the former shows one more tall cypress tree to the right of the little church. Another drawing of L'Anconetta by Francesco was acquired for the Rijksmuseum, Amsterdam, in 1963 (this too is omitted by Morassi in his 1975 catalogue).[3] A very poor version of the same composition, by Giacomo, was sold at Sotheby's in 1974,[4] and another (inscribed on the verso as on the Lehman drawing) in 1978.[5]
 J. B. S.

NOTES:
1. Morassi 1973, p. 433, nos. 659, 660, figs. 618, 619.
2. New York, Metropolitan Museum of Art, acc. no. 37.165.84. The drawing was first published by H. W. Williams (Williams 1939, p. 272, fig. 4), and is reproduced in Byam Shaw 1970, p. 251, fig. 15.
3. See Byam Shaw 1976b, p. 859.
4. Sale, Sotheby's, London, June 27, 1974, lot 71.
5. Sale, Sotheby's, London, July 6, 1978, lot 122 (illustrated in the catalogue, p. 2).

PROVENANCE: Colonel Edward Roche, Co. Cork, Ireland; Mrs. Amy Clarke, Farran House, Farran, Co. Cork, Ireland; P. & D. Colnaghi & Co., London; Paul Wallraf, London. Acquired by Robert Lehman in 1962.

EXHIBITED: Venice 1959a, no. 38; Cologne 1959, no. 38; New York 1981, no. 50.

49. The Rio dei Mendicanti

1975.1.356

Pen and brown ink, gray wash. 123 × 209 mm. Annotated in brown ink (perhaps by Colonel Edward Roche: see No. 37) on the old backing paper, below: *Veduta delli Mendicanti*. Numbered in brown ink, further to the right: *35*. Inscribed in brown ink on the verso, in Giacomo's hand: *Veduta delli Mendicanti*. Signed in brown ink on the verso: *Giacomo de Guardi*.

Like No. 42, this drawing—the thirty-fifth in the series that began with No. 37—is a "wide-angle" view taken from different points on a bridge, in this case the Ponte Cavallo leading to Campo Santi Giovanni e Paolo. It shows part of the side of the Scuola di San Marco on the right; the bridge in the background leads (in both directions) to the Fondamenta Nuove, the northern edge of the main Venetian island. Morassi reproduces five paintings of this view by Francesco Guardi and refers to others less certainly by him;[1] in all of these the Dominican convent on the right (now partly incorporated into the Ospedale Civile: see No. 40 above) presents a much more extensive façade than in Giacomo's drawing, unbroken except for

the church of San Lazzaro; Giacomo seems as usual to have taken considerable liberties with the architecture.

Francesco's drawing, No. 32 above, is a *capriccio* that may echo remotely the right-hand side of the same view.

J. B. S.

NOTE:
1. Morassi 1973, pp. 424–25, nos. 609–613, figs. 579–583.

PROVENANCE: Colonel Edward Roche, Co. Cork, Ireland; Mrs. Amy Clarke, Farran House, Farran, Co. Cork, Ireland; P. & D. Colnaghi & Co., London; Paul Wallraf, London. Acquired by Robert Lehman in 1962.

EXHIBITED: Venice 1959a, no. 31; Cologne 1959, no. 31; New York 1981, no. 45.

50. The Island of the Beata Vergine del Rosario

1975.1.357

Pen and brown ink, gray wash. 126 × 212 mm. Annotated in brown ink (perhaps by Colonel Edward Roche: see No. 37) on the old backing paper, below: *Isola della Beata Vergine del Rosario*. Numbered in brown ink, further to the right: *36*. Inscribed in brown ink on the verso, in Giacomo's hand: *Isola della B. V. del Rosario*. Signed in brown ink on the verso: *Giacomo de Guardi*.

This drawing, the thirty-sixth in the series that began with No. 37, corresponds rather closely, though not quite exactly, to Visentini's engraving no. XVII in the *Isolario veneto* of 1777.

J. B. S.

PROVENANCE: Colonel Edward Roche, Co. Cork, Ireland; Mrs. Amy Clarke, Farran House, Farran, Co. Cork, Ireland; P. & D. Colnaghi & Co., London; Paul Wallraf, London. Acquired by Robert Lehman in 1962.

EXHIBITED: Venice 1959a, no. 39; Cologne 1959, no. 39; New York 1981, no. 51.

51. The Island of San Francesco del Deserto

1975.1.358

Pen and brown ink, gray wash. 126 × 211 mm. Annotated in brown ink (perhaps by Colonel Edward Roche: see No. 37) on the old backing paper, below: *Isola di San Francesco del Deserto*. Numbered in brown ink, further to the right: *38*. Inscribed in brown ink on the verso, in Giacomo's hand: *Isola di S. Francesco del Deserto*. Signed in brown ink on the verso: *Giacomo de Guardi*.

This drawing is the thirty-eighth in the series that began with No. 37.

A small painting in the Szépművészeti Múzeum, Budapest,[1] one of a series of twelve island views which Morassi attributes to Giacomo[2] but which I believe may be at least

partly by Francesco, corresponds closely, except for the boats and some of the trees, with this drawing, which may be based upon it. Visentini's engraving no. VI of the *Isolario veneto* also corresponds, but less closely.

According to the legend, Saint Francis of Assisi disembarked on this island from a Venetian ship on his return from Syria in the year 1220. It is still inhabited by Franciscan monks.

J. B. S.

NOTES:
1. Térey 1916, p. 284, no. 238.
2. Venice 1959a, p. 32, under no. 33.

PROVENANCE: Colonel Edward Roche, Co. Cork, Ireland; Mrs. Amy Clarke, Farran House, Farran, Co. Cork, Ireland; P. & D. Colnaghi & Co., London; Paul Wallraf, London. Acquired by Robert Lehman in 1962.

EXHIBITED: Venice 1959a, no. 37; Cologne 1959, no. 37; New York 1981, no. 42.

52. The Church of the Redentore from the Giudecca Canal

1975.1.360

Pen and brown ink, gray wash. 116 × 188 mm. Annotated in brown ink (perhaps by Colonel Edward Roche: see No. 37) on the old backing paper, below: *Veduta del Redentor alla Giudecca*. Numbered in brown ink, further to the right: *40*. Inscribed in brown ink on the verso, in Giacomo's hand: *Veduta del Redentor alla Giudeca*. Signed in brown ink on the verso: *Giacomo de Guardi*.

This drawing is the fortieth in the series that began with No. 37.

There are two paintings by Francesco Guardi of this view: one, in a private collection in London,[1] corresponds rather closely with Giacomo's drawing except in the lighting; the other, much smaller and much less accurate, is in a private collection in Milan.[2] There is also a drawing, formerly in the collection of Sir Bruce Ingram,[3] which both Pignatti and Morassi[4] have attributed to Giacomo (although it bears what I believe to be Francesco's signature) because the church and campanile of San Giacomo, which appear on the right of the present drawing, and which were destroyed between 1821 and 1835, are not represented. In reviewing Morassi's 1975 catalogue,[5] I pointed out that the modification or omission of an architectural feature is very unreliable evidence for determining the *terminus post quem* of a work by Guardi. In the small painting in Milan, referred to above, Francesco has displaced the east transept of the Redentore, whereas the London version and the Ingram drawing correspond closely with the actual view in this respect. It seems to me

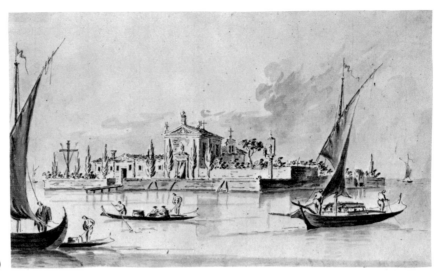

No. 50

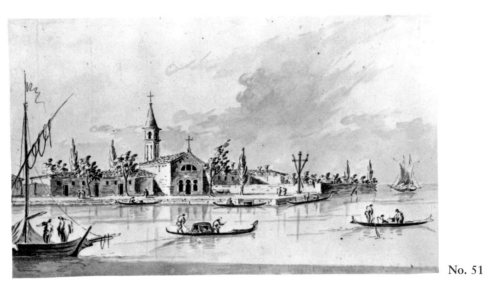

No. 51

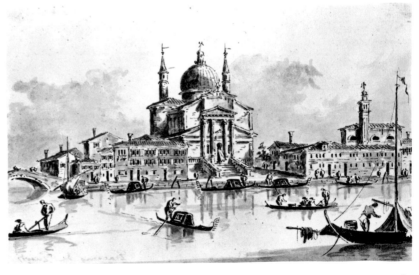

No. 52

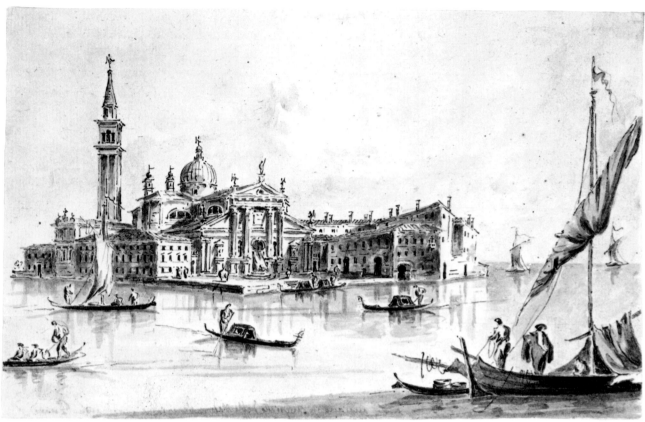

No. 53

that the contrast in style between the Ingram and Lehman drawings makes it certain that the Ingram drawing is by Francesco; Pignatti subsequently agreed with this view. I would concede that Giacomo may have drawn better, in a style more like his father's, while Francesco was still alive and they were working together; but if the Ingram drawing (whose present whereabouts I do not know) is to be attributed to Giacomo on topographical grounds, then it must be later than 1821, and later than the entirely characteristic Lehman drawing, in which the church and campanile of San Giacomo still appear—which seems to me inconceivable.

J. B. S.

NOTES:
1. Morassi 1973, p. 428, no. 631, fig. 600.
2. Ibid., p. 428, no. 635, fig. 601.
3. Venice 1962, p. 56, no. 67.
4. Pignatti 1963, pp. 49–53; Morassi 1973, p. 428, under no. 631; Morassi 1975, pp. 149–50, no. 402, fig. 403.
5. Byam Shaw 1976b, pp. 856–59.

PROVENANCE: Colonel Edward Roche, Co. Cork, Ireland; Mrs. Amy Clarke, Farran House, Farran, Co. Cork, Ireland; P. & D. Colnaghi & Co., London; Paul Wallraf, London. Acquired by Robert Lehman in 1962.

EXHIBITED: Venice 1959a, no. 28; Cologne 1959, no. 28; New York 1981, no. 40; Detroit 1983, no. 13.

53. The Island of San Giorgio Maggiore

1975.1.362

Pen and brown ink, gray wash. 111 × 177 mm. Annotated in brown ink (perhaps by Colonel Edward Roche: see No. 37) on the old backing paper, below: *Veduta di S: Giorgio Maggiore a S: Canciano, in Campiello della Madona.* Numbered in brown ink, at lower right corner of the backing paper: *41.* Inscribed in brown ink on the verso, in Giacomo's hand: *Veduta di S. Giorgio Maggiore* and *a S. Canciano in Campiello della Madonna Venezia.* Signed in brown ink on the verso: *Giacomo de Guardi.*

This drawing is the forty-first in the series that began with No. 37.

The annotation on the recto of the old backing paper (Fig. 14), with the subject and the address run together without a break, seems nonsensical: the church of San Canciano, not far from Santa Maria dei Miracoli and the Teatro Malibran, has no connection with San Giorgio Maggiore. *A San Canciano, in Campo della Madonna* was the address of the house where Francesco Guardi had

Fig. 14. Giacomo Guardi. *The Island of San Giorgio* (No. 53), with backing paper and annotation

lived with his elder son Vincenzo and where Giacomo probably continued to live with his brother after their father's death on January 1, 1793 (see No. 39). The autograph inscription on the verso (Fig. 15), so Professor Haverkamp-Begemann informs me, is in two different inks, which suggests that the address may have been added later by Giacomo. It may be noted that the address given on the verso of those numerous small views of Venice, now in various collections all over the world, that were painted by Giacomo in gouache or tempera colors, certainly later than the present drawing, is a different one: *all'Ospedaletto in calle del Perruchier al N° 5245.*[1] The way in which the earlier address is confused with the subject in the title under the present drawing suggests that none of the titles that appear on the rectos of the backing paper in the whole Lehman series are in Giacomo's hand, though they have been supposed to be so and are indeed nearly contemporary with the drawings. Colonel Roche, the first owner of the series, may have written them, copying Giacomo's own inscriptions from the versos.

No. 53 is one of the best drawn of the series. The view corresponds rather closely to engraving no. VII in Visentini's *Isolario veneto* of 1777. There are several versions of it by Giacomo. Another good one, inscribed and signed on the recto, is in the Ashmolean Museum, Oxford;[2] a good colored one, with different boats and figures, was one of four gouaches, the property of Eva, countess of Rosebery, sold at Sotheby's in 1974.[3] In a very large sheet, again with the same view, in the Museo Correr, Venice,[4]

Giacomo records the solemn occasion in 1800 when Pope Pius VII, newly elected by a special conclave in San Giorgio after the French invasion, entered the church with a vast train of cardinals and spectators.

J. B. S.

NOTES:
1. Byam Shaw 1951, pp. 41–42.
2. Ibid., p. 80, pl. 79; formerly in the Gutekunst collection.
3. Sale, Sotheby's, London, December 11, 1974, lot 7 (illustrated in the catalogue, p. 56).
4. Pallucchini 1943, p. 61, no. 172.

PROVENANCE: Colonel Edward Roche, Co. Cork, Ireland; Mrs. Amy Clarke, Farran House, Farran, Co. Cork, Ireland; P. & D. Colnaghi & Co., London; Paul Wallraf, London. Acquired by Robert Lehman in 1962.

EXHIBITED: London 1956, no. 86 (the dimensions recorded in the catalogue, 125 × 212 mm., are incorrect); Venice 1959a, no. 26; Cologne 1959, no. 26; Huntington (N.Y.) 1980, no. 15; New York 1981, no. 38; Rochester 1981, no. 19.

54. The Church of the Zitelle on the Giudecca

1975.1.363

Pen and brown ink, gray wash. 115 × 185 mm. Annotated in brown ink (perhaps by Colonel Edward Roche: see No. 37) on the old backing paper, below: *Veduta delle Zittelle alla Giudecca.* Numbered in brown ink, further to the right: *42.* Inscribed in brown ink on the verso, in Giacomo's hand: *Veduta delle Cittelle alla Zueca.* Signed in brown ink on the verso: *Giacomo de Guardi.*

This view, which was the forty-second in the series that began with No. 37, corresponds for the most part with a fine painting by Francesco Guardi that was formerly with M. Knoedler & Co., New York,[1] and also with a much smaller one in the National Gallery, London.[2] In neither painting, however, does the view extend as far as the walled garden at the extremity of the island (on the left in Giacomo's drawing). A good version by Giacomo, colored in gouache, was one of a pair sold at Sotheby's in 1976.[3]

J. B. S.

NOTES:
1. Morassi 1973, p. 428, no. 632, fig. 597.
2. Ibid., p. 428, no. 634, fig. 599.
3. Sale, Sotheby's, London, December 7, 1976, lot 51.

Fig. 15. Giacomo Guardi. *The Island of San Giorgio* (No. 53): autograph inscription on the verso

PROVENANCE: Colonel Edward Roche, Co. Cork, Ireland; Mrs. Amy Clarke, Farran House, Farran, Co. Cork, Ireland; P. & D. Colnaghi & Co., London; Paul Wallraf, London. Acquired by Robert Lehman in 1962.

EXHIBITED: Venice 1959a, no. 27; Cologne 1959, no. 27; Huntington (N.Y.) 1980, no. 16; New York 1981, no. 39.

55. The Island of the Beata Vergine delle Grazie

1975.1.361

Pen and brown ink, gray wash. 115 × 183 mm. Annotated in brown ink (perhaps by Colonel Edward Roche: see No. 37) on the old backing paper, below: *Veduta dell'Isola della Beata Vergine delle Grazie*. Numbered in brown ink, further to the right: *45*. Inscribed in brown ink on the verso, in Giacomo's hand: *Veduta dell'Isola della B. V. delle Grazie*. Signed in brown ink on the verso: *Giacomo de Guardi*.

This drawing was the forty-fifth in the series that began with No. 37.

Another drawing by Giacomo of the same island church, rather inferior in quality, is in the Muzeum Narodowe, Warsaw.[1] It is signed and inscribed on the back in the usual way, and perhaps once belonged to another set of views of the Venetian islands, sold to some foreign tourist in the early nineteenth century. Visentini's engraving, no. IX of the *Isolario veneto* of 1777, may have provided the model for both these drawings. In some respects, however, a small painting in Budapest,[2] belonging to the series of island views attributed by Morassi to Giacomo[3] (but which I believe to be at least partly by Francesco), resembles the Lehman version even more closely. A similar small painting, not as good as the one in Budapest and probably rightly attributed to Giacomo Guardi, was one of a set of six sold at Christie's in 1954,[4] and a small, carefully colored gouache by Giacomo was one of a set of eight sold at Sotheby's by the Hon. William Buchan in 1974.[5]

One more drawing of the same view—earlier, larger, and more careful than the Lehman drawing—is in the National Gallery, Washington.[6] It was attributed to Francesco Guardi, and in my opinion the three boats in the immediate foreground, which are much better drawn than the rest and washed in a lighter color, are indeed by the father, who must have left the rest of the paper blank; it was then filled in by Giacomo (with or without Francesco's consent) with the view of the Madonna delle Grazie. Two drawings in the Museo Correr are examples of the same procedure: one,[7] attributed by Pallucchini to the obscure Nicolò Guardi, but surely entirely by Francesco, is unfinished, whereas the other[8] has foreground boats and fig-

ures by Francesco, and buildings, distant ships, and some figures on the right added in a different ink by Giacomo.

The Gothic church, which once contained a miraculous image of the Virgin, was destroyed with all the other ancient buildings on the island during the revolution of 1849.

J. B. S.

NOTES:
1. Venice 1958b, pp. 67–68, no. 79.
2. Térey 1916, p. 285, no. 240.
3. See No. 41, n. 1.
4. Sale, Christie's, London, July 23, 1954, lots 40–42; afterwards with M. Bernard, London.
5. Sale, Sotheby's, London, December 11, 1974, lot 32B (illustrated in the catalogue, p. 70).
6. Washington, National Gallery of Art, acc. no. 1956.9.21.
7. Pallucchini 1943, p. 59, no. 158; Venice 1977, p. 73, no. 86.
8. Pallucchini 1943, p. 59, no. 161 (plate wrongly numbered 159); Venice 1977, p. 74, no. 87.

PROVENANCE: Colonel Edward Roche, Co. Cork, Ireland; Mrs. Amy Clarke, Farran House, Farran, Co. Cork, Ireland; P. & D. Colnaghi & Co., London; Paul Wallraf, London. Acquired by Robert Lehman in 1962.

EXHIBITED: Venice 1959a, no. 40; Cologne 1959, no. 40; New York 1981, no. 52.

56. View of Murano

1975.1.364

Pen and brown ink, gray wash. 139 × 213 mm. Annotated in brown ink (perhaps by Colonel Edward Roche: see No. 37) on the old backing paper, below: *Veduta di Murano*. Numbered in brown ink, further to the right: *48*. Inscribed in brown ink on the verso, in Giacomo's hand: *Veduta di Murano*. Signed in brown ink on the verso: *Giacomo de Guardi*.

This drawing was the forty-eighth and last in the series that began with No. 37.

Palazzo Contarini is on the left, and on the Fondamenta is the column with the statue of Domenico Contarini (Doge 1659–1675). On the other side of the bridge are the church and convent of Santa Chiara, suppressed at the beginning of the nineteenth century.

I know of no paintings or other drawings of this view either by Giacomo or by his father.

J. B. S.

PROVENANCE: Colonel Edward Roche, Co. Cork, Ireland; Mrs. Amy Clarke, Farran House, Farran, Co. Cork, Ireland; P. & D. Colnaghi & Co., London; Paul Wallraf, London. Acquired by Robert Lehman in 1962.

EXHIBITED: Venice 1959a, no. 36; Cologne 1959, no. 36; Huntington (N.Y.) 1980, no. 17; New York 1981, no. 49; Rochester 1981, no. 20; Detroit 1983, no. 14.

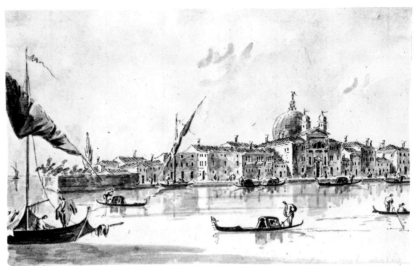

No. 54

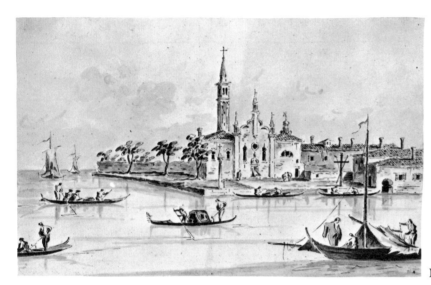

No. 55

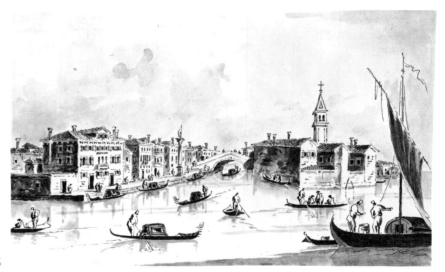

No. 56

Pietro Longhi

Venice 1702–Venice 1785

Longhi first worked as a history painter, completing his major work in that capacity, the *Fall of the Giants* on the staircase of Ca' Sagredo, in 1734. About 1740 he seems essentially to have given up history painting for genre, which occupied him for the rest of his life, though his frescoes in San Pantalon are datable to 1745. The diarist Pietro Gradenigo speaks of him in 1760 as "the painter for natural situations and speaking caricatures." The main body of his drawings is preserved in the Museo Correr, Venice.

G. K.

LITERATURE: Pignatti 1969.

57. A Dignitary Holding a Document

1975.1.312
Red chalk. 250 × 170 mm.

Antonio Morassi gave this drawing to Luca Carlevaris, suggesting an analogy in a painting by Carlevaris in Bergamo.[1] The attribution is not supported, however, by the drawing itself, nor has it been confirmed by subsequent work on Carlevaris.[2] Both Morassi and Pignatti[3] mention drawings attributed to Carlevaris, formerly in the Dubini collection in Milan.

Fig. 16. Attributed to Pietro Longhi. *Study of a Violinist.* New York, Pierpont Morgan Library

A possibility that deserves consideration is an attribution to Sebastiano Bombelli, though Bombelli drawings are virtually unknown. Those formerly ascribed to him in the Albertina[4] are now assigned to Ottavio Leoni. However, no. 22 in the catalogue of the exhibition devoted to Bombelli and to Antonio Carneo at Udine in 1964[5] is not unlike No. 57. Certainly the present drawing is of very high quality. The unusual costume, and the peculiar collar in particular, may ultimately assist a more exact identification.

A further possibility is an attribution to Pietro Longhi, whose name has been proposed for a quite similar drawing, a *Study of a Violinist* (Fig. 16), also in red chalk, until recently in the collection of Janos Scholz and now in the Pierpont Morgan Library.[6] One of the difficulties about Pietro Longhi is that nothing is known of his draftsmanship from the years before ca. 1742, when he attained the age of forty. I feel that the present drawing may well represent an early phase in his development. Longhi later went on to produce a very fine study for a standing portrait of a Venetian senator, now in the Pierpont Morgan Library,[7] which, though in black chalk on brown paper, seems in no way alien to our drawing.

G. K.

NOTES:
1. Venice 1959a, pp. 21–22, no. 18; for the Bergamo painting see Rizzi 1967, p. 87, figs. 45–46.
2. See, for example, Udine 1963 and Rizzi 1967.
3. In Washington 1974, p. 48.
4. Stix and Fröhlich-Bum 1926, pp. 113–14, nos. 231–234.
5. Udine 1964, no. 22.
6. New York, Pierpont Morgan Library, no. 1984.58; unpublished.
7. New York 1971, no. 174.

PROVENANCE: Paul Wallraf, London. Acquired by Robert Lehman in 1962.

EXHIBITED: Venice 1959a, no. 18 (as Carlevaris); Cologne 1959, no. 18 (as Carlevaris); Washington 1974, no. 98 (as Carlevaris); Huntington (N.Y.) 1980, no. 9 (as Carlevaris); New York 1981, no. 25 (as Carlevaris); Rochester 1981, no. 10 (as Carlevaris); Detroit 1983, no. 7 (as Carlevaris); Pittsburgh 1985, no. 6 (as Carlevaris).

LITERATURE: Szabo 1983, no. 57.

No. 57

Jacopo Marieschi

Venice 1711–Venice 1794

A pupil of Gaspare Diziani's, the history painter Jacopo Marieschi seems to have left only a few recorded works, the earliest being the lunette of 1743 in San Giovanni in Bragora, which is discussed below. In 1755 he contributed two *Stations of the Cross* to the series in Santa Maria del Giglio. His most considerable work consists of two canvases on the ceiling and four on the walls of the Scuola di San Giovanni Evangelista, painted about 1760.

G. K.

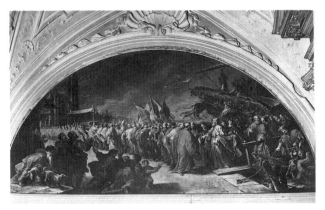

Fig. 17. Jacopo Marieschi. *The Arrival in Venice of the Relics of Saint John the Almsgiver.* Venice, San Giovanni in Bragora

58. The Arrival in Venice, from Alexandria, of the Relics of Saint John the Almsgiver in 1247

1975.1.375
Pen and brown ink, gray wash, with pencil underdrawing.
233 × 424 mm.

Morassi identifies this drawing as a study for the lunette (Fig. 17) in the second chapel on the right in the church of San Giovanni in Bragora in Venice, which was painted by Marieschi in 1743.[1] The composition shows the relics (which are still preserved in the chapel) being carried in procession under a canopy, with the doge Giacomo Tiepolo disembarking from the ship.

There is another study of the same subject, with slight variations and colored with touches of gouache, measuring 155 × 308 mm., in the Museo Correr, Venice. Pignatti, in 1964, noted that these two were the only established drawings by Marieschi;[2] a third, in a private collection in Prato, has since been identified by Alessandro Bettagno.[3]

G. K.

NOTES:
1. Venice 1959a, p. 37, no. 43.
2. Venice 1964, p. 35, no. 31.
3. Paris 1971, pp. 78–79, no. 163; London 1972, pp. 68–69, no. 130.

PROVENANCE: Paul Wallraf, London. Acquired by Robert Lehman in 1962.

EXHIBITED: Venice 1959a, no. 43; Cologne 1959, no. 43; New York 1981, no. 59; Rochester 1981, no. 21; Detroit 1983, no. 16; Pittsburgh 1985, no. 15.

LITERATURE: Szabo 1983, no. 63.

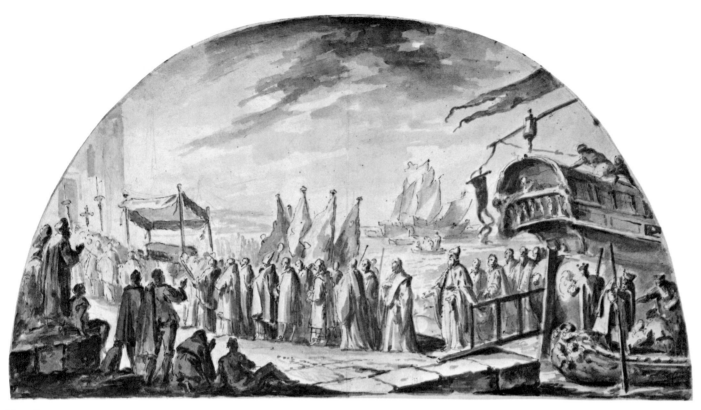

No. 58

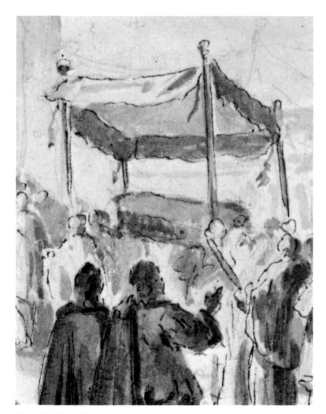

No. 58, Detail

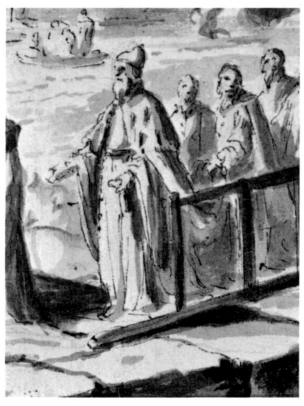

No. 58, Detail

Pietro Antonio Novelli

Venice 1729–Venice 1804

Novelli, an almost exact contemporary of Domenico Tiepolo's and a pupil of Jacopo Amigoni's, enjoyed a long and successful career as a decorative painter. Though he himself left behind him a fairly detailed account of his activities, no comprehensive study of his work has yet appeared, and there is at present little basis for ordering and dating his numerous drawings. His first recorded works are two paintings of 1759 and 1760 in Santa Fosca and a hundred designs for illustrations in the edition of Tasso's *Gerusalemme liberata* published by A. Groppo in Venice in 1760. The *Allegory of the Arts* in the Accademia was painted in 1766, and in 1768 Novelli became a member of the Venetian Academy. In his autobiography he mentions work done between 1767 and 1772, in collaboration with the *ornatista* Pietro Visconti, in the Venetian palace of the Procurator Francesco Pisani at Santo Stefano; a fine allegorical ceiling, in the room overlooking the campo on the right of the *portego*, and the frescoed decorations of the chapel survive. He records with pride a commission of 1772 from Catherine the Great, for which he chose the theme of Creusa and Aeneas, as a pendant to a painting by Pompeo Batoni. Novelli was one of the most active participants in the great wave of decorative painting that swept Venice and the Veneto in the last thirty years of the Venetian republic: he worked in Bologna for Fabrizio and Prospero Fontana in 1773–74; in Udine for Daniele Florio and in Venice for Marino Corniani in 1778; in Rome in 1779; in Padua for Pietro Vettor Pisani in 1782 and for a Signor Zigno in 1786. In 1797 he painted two ceilings, which survive, in the Palazzo Sangiantoffetti a San Trovaso.

G. K.

LITERATURE: Novelli 1834.

59. Half-Length Study for a Portrait of a Young Man

1975.1.385
Pen and brown ink, gray wash, with touches of pink and blue in the face. 167 × 117 mm.

The attribution of this drawing to Novelli is due to Morassi.[1] The portrait may well have been intended to be engraved for a book.

G. K.

NOTE:
1. Venice 1959a, p. 40, no. 49.

PROVENANCE: Paul Wallraf, London. Acquired by Robert Lehman in 1962.

EXHIBITED: Venice 1959a, no. 49; Cologne 1959, no. 49; Huntington (N.Y.) 1980, no. 19; New York 1981, no. 60; Rochester 1981, no. 23; Detroit 1983, no. 17; Pittsburgh 1985, no. 16.

No. 59

60. Saint John the Evangelist (?)

1975.1.324

Pen and dark brown ink. 380 × 270 mm. Paper ruled with horizontal and vertical lines. Annotated in ink, top right: 23.

This is a sheet from a much-discussed sketchbook distinguished by the ruled lines on its pages, suggesting an account book. It appears that the album, which contained at least fifty-five drawings,[1] was broken up in about the year 1920; sheets from it are found in the British Museum, the Metropolitan Museum of Art, the Art Museum of Princeton University, and elsewhere. The four drawings at Princeton were purchased from the London dealer Meatyard, who perhaps broke up the album, with an attribution to Sebastiano Ricci.[2] Two other specimens are recorded in the catalogue of an exhibition held at the Heim Gallery in London in 1967.[3]

The attribution of these drawings to Francesco Fontebasso, at one time generally accepted,[4] was first questioned by Janos Scholz.[5]

Terisio Pignatti, in a discussion of one of the series,[6] notes that a drawing from the same group in the Art Institute of Chicago is associated with the name of the Bolognese artist Ercole Graziani (1688–1765). A drawing by Graziani is recorded in the National Gallery of Scotland;[7] two others in the Uffizi are attributed to him by Catherine Johnston.[8]

Pignatti's suggestion that the present drawing and its companions should be given to Ercole Graziani appears to have no firmer foundation than the earlier attribution to Fontebasso. I consider it far more satisfactory to assign the entire group to the young Pietro Antonio Novelli.

G. K.

NOTES:

1. Princeton 1966, p. 57.
2. Gibbons 1977, vol. 1, p. 80.
3. London 1967, p. 15, nos. 67–68.
4. Gibbons 1977, p. 81.
5. Scholz 1967, p. 296.
6. Washington 1974, p. 43.
7. Andrews 1968, vol. 1, p. 59, no. D 1790, vol. 2, fig. 416.
8. Florence 1973, pp. 100–101, nos. 118–119, figs. 85, 88.

PROVENANCE: Charles E. Slatkin Galleries, New York. Acquired by Robert Lehman in 1960.

EXHIBITED: New York 1981, no. 27 (as Fontebasso); Detroit 1983, no. 8 (as Fontebasso); Pittsburgh 1985, no. 8 (as Fontebasso).

LITERATURE: Princeton 1966, p. 57; London 1967, p. 15; Washington 1974, p. 43; Gibbons 1977, vol. 1, p. 80; Szabo 1983, no. 58.

No. 60

61. A Venetian Family Portrait Group

1975.1.386

Pen and brown ink, wash, heightened with white, on paper covered with brown wash. 297 × 375 mm.

The attribution to Novelli is due to Morassi,[1] who points out a connection with the draftsmanship of Jacopo Amigoni, to whom Novelli had been apprenticed.

Elaborate portrait groups were fashionable in Venice after about 1750. There are at least three similar drawings by Giovanni Battista Tiepolo,[2] and there is a similarly conceived painting by Alessandro Longhi in the Accademia.[3]

G. K.

NOTES:
1. Venice 1959a, p. 38, no. 46.
2. See G. Knox in Cambridge (Mass.) 1970, no. 95.
3. Pallucchini 1960, p. 214, fig. 556 (then in the Bentivoglio d'Aragona collection, Venice).

PROVENANCE: Giuseppe Vallardi, Milan (Lugt 1223); P. & D. Colnaghi & Co., London; Paul Wallraf, London. Acquired by Robert Lehman in 1962.

EXHIBITED: London 1953b, no. 31; Venice 1959a, no. 46; Cologne 1959, no. 46; Huntington (N.Y.) 1980, no. 18; New York 1981, no. 61; Rochester 1981, no. 24; Detroit 1983, no. 18.

LITERATURE: Szabo 1983, no. 64.

No. 61

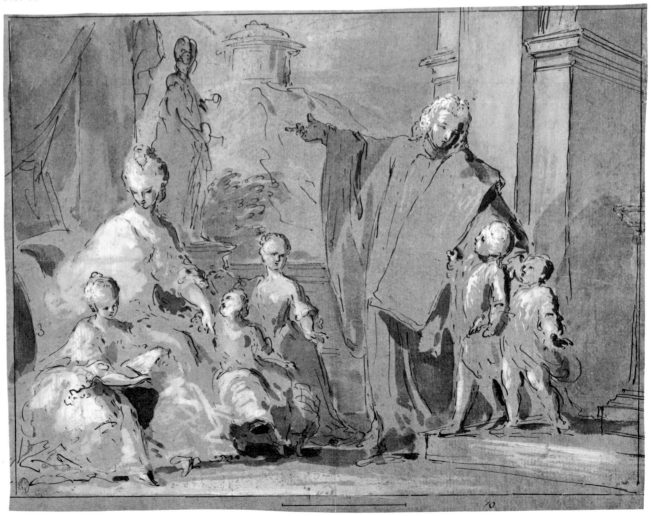

No. 62

62. Design for a Trade Card

1975.1.387

Pen and brown ink, gray wash. 225 × 155 mm. Inscribed: *AL DOGE VENETO / A. C. F. / Fabrica di Specchi, e d'ogni sorte / di lavori di Cristalli, e Perterri / Di Antonio Codognato, e Figlio / In Venezia.*

Such designs for trade cards, made for the engraver, are not rare in mid-eighteenth-century Venice. Several were engraved after designs by Piazzetta. It is not known whether the present example was engraved, but the idea of basing the design on a framed mirror or picture, with a vessel in the background with its great glazed lantern, is an elegant one. A further design for a trade card by Novelli is in the Lugt collection in the Fondation Custodia, Paris.[1]

G. K.

NOTE:

1. Venice 1981, no. 105.

PROVENANCE: Paul Wallraf, London. Acquired by Robert Lehman in 1962.

EXHIBITED: Venice 1959a, no. 48; Cologne 1959, no. 48; Huntington (N.Y.) 1980, no. 20; New York 1981, no. 65; Rochester 1981, no. 25; Detroit 1983, no. 19; Pittsburgh 1985, no. 18.

No. 63

chitettura were shown by Pietro Scarpa.[3] This group probably corresponds to a fairly early phase in Novelli's career. Two signed drawings of somewhat similar character, in pen on white paper, were in the collection of Tito Miotti.[4]

G. K.

NOTES:
1. Venice 1959a, p. 38, no. 45.
2. Paris, Ecole Nationale Supérieure des Beaux-Arts, Collection Masson, nos. 2412–16.
3. Paris 1978, no. 72.
4. Venice 1963, nos. 48, 49.

PROVENANCE: Paul Wallraf, London. Acquired by Robert Lehman in 1962.

EXHIBITED: Venice 1959a, no. 45; Cologne 1959, no. 45; New York 1981, no. 63; Detroit 1983, no. 20; Pittsburgh 1985, no. 17.

Fig. 18. Pietro Antonio Novelli. *Hope.* Paris, Ecole des Beaux-Arts, Collection Masson

63. Allegorical Figure of a Woman

1975.1.388

Pen and brown wash, heightened with white, on paper covered with light brown wash. 330 × 180 mm.

Morassi points out a connection between this drawing and the work of Parmigianino,[1] and in fact the similarity to the chiaroscuro woodcuts after Parmigianino by Anton Maria Zanetti is very striking. There are five similar drawings, this time on mustard yellow tinted paper, representing Abundance, Constancy, Liberality, Faith, and Hope (Fig. 18), in the Ecole des Beaux-Arts, Paris.[2] Four similar sheets inscribed *Musica, Pittura, Scultura,* and *Ar-*

78

64. A Seated Slave

1975.1.389

Pen and black ink, gray wash, over black chalk. 460 × 310 mm.

Verso: Four Figures (summary sketch for an *Adoration*?). Black chalk. Inscribed in black ink: *Ornati Prospettive Otiche Pratiche / d'Architetture.*

Morassi rightly associates the drawing with one of the four slaves (Fig. 19) designed by Pietro Tacca for the monument to Grand Duke Ferdinand 1 of Tuscany at Leghorn.[1]

Another drawing of similar character passed through the Hendecourt sale in 1929[2] and was exhibited in the following year at the Savile Gallery in London.[3] In pen and wash heightened with white, on paper covered with

mauve wash, and measuring 264 × 150 mm., it was identified by Tancred Borenius as a study for "one of the figures on the fountain in Leghorn" and ascribed to Tacca himself. It is evidently by Novelli, but the figure is not close to any of the four "Moors" on the monument to Ferdinand 1. Another similar drawing, also on mauve or violet tinted paper, was with Colnaghi in 1960 and is now in the Ashmolean Museum.[4] Hugh Macandrew, in his note on the Ashmolean drawing,[5] calls attention to a number of comparable drawings in American collections, where they have been variously attributed.[6] Two further drawings by Novelli, of quite similar character, are in the

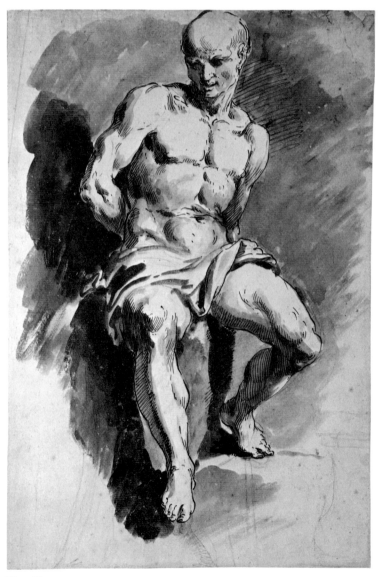

Fig. 19. Pietro Tacca. *A Slave*. Monument to Ferdinand 1, detail. Leghorn, Piazza Giuseppe Micheli

No. 64

Seilern collection, London, where they are attributed to Francesco Guardi.[7] They represent a pair of lions, and are apparently studies after sculpture.

<div style="text-align: right">G. K.</div>

NOTES:

1. Venice 1959a, p. 37, no. 44. For the monument see Venturi 1901–40, vol. 10, pt. 3, pp. 852–54, figs. 737, 738.
2. Sale, Sotheby's, London, May 8–10, 1929, lot 267.
3. London 1930, no. 25.
4. London 1960, no. 63; Macandrew 1980, pp. 179–80, no. 1029A.
5. Macandrew 1980, loc. cit.

6. See, for example, Wunder 1962, no. 28 (with an attribution to Filippo Parodi), and Washington 1974, no. 88 (with an attribution to Jacopo Guarana).
7. Seilern 1959, p. 95, nos. 133, 133 bis, pls. 93, 93 bis; Morassi 1975, p. 158, nos. 445, 446, figs. 447, 448.

PROVENANCE: Paul Wallraf, London. Acquired by Robert Lehman in 1962.

EXHIBITED: Venice 1959a, no. 44; Cologne 1959, no. 44; New York 1981, no. 64.

LITERATURE: London 1960, under no. 63; Parker 1960, pp. 58–59; Macandrew 1980, p. 179, under no. 1029A.

No. 64, Verso

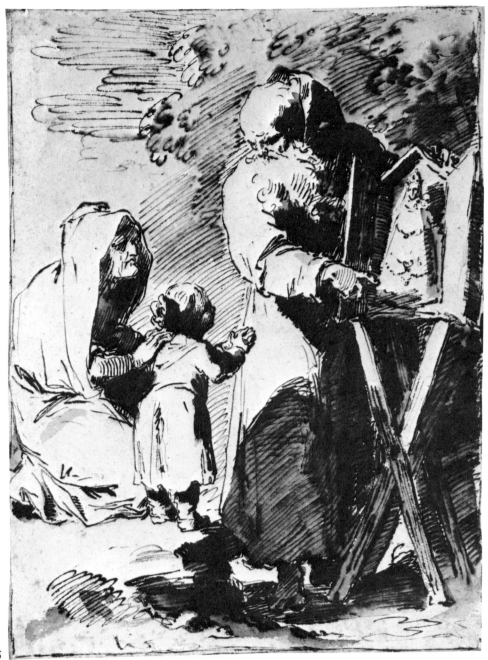

No. 65

65. A Bearded Monk Showing a Portable Altar to a Praying Child, with an Old Woman Kneeling

1975.1.390
Pen and brown ink, wash. 260 × 195 mm.

Antonio Morassi finds a suggestion of Magnasco in the subject of this drawing.[1]

G. K.

NOTE:
1. Venice 1959a, p. 39, no. 47.

PROVENANCE: Savoia-Aosta collection; Janos Scholz, New York; Paul Wallraf, London. Acquired by Robert Lehman in 1962.

EXHIBITED: Venice 1959a, no. 47; Cologne 1959, no. 47; Huntington (N.Y.) 1980, no. 21; New York 1981, no. 62; Rochester 1981, no. 22; Detroit 1983, no. 20.

LITERATURE: Andrews 1968, vol. 1, p. 80, under no. D 827; Szabo 1983, no. 65.

Giovanni Paolo Panini

Piacenza 1691 or 1692–Rome 1765

Panini was the leading painter of *vedute* and *vedute ideate* in eighteenth-century Rome, where he arrived in 1711 and remained for the rest of his life. He became a member of the Accademia di San Luca in 1719 and its president in 1754–55. In the early part of his career he worked on the decoration of Roman villas and palaces, including the Villa Patrizi (from 1718) and the Quirinale (in 1721–22 and again in 1743). Among his most famous works is a series of paintings commissioned by the Cardinal de Polignac in 1729 to record the celebrations in Rome on the occasion of the birth of the French dauphin.

G. K.

LITERATURE: Arisi 1961.

66. Ruins, with a Statue on the Left

1975.1.391

Pen and brown ink, gray, brown, blue, green, and yellow washes. 190 × 265 mm.

Verso: Tondo with Ruins. Pen and brown ink, gray wash. Annotated in black chalk, bottom right: [?] *ultimum*

Unfortunately, the most considerable body of drawings by Panini, a sketchbook in the British Museum, consists of work of a very different kind.[1] The present drawing, however, is very close to a group in the Uffizi[2] and there is a quite similar drawing, rather more meticulously drawn, signed and dated 1728, in the Art Gallery of Ontario, Toronto.[3] Other comparable drawings by Panini are in the Ashmolean Museum[4] and the Rhode Island School of Design.[5]

Though the Roman Doric order is something of a rarity in Panini's paintings,[6] it appears on both the recto and the verso of this drawing.

G. K.

No. 66

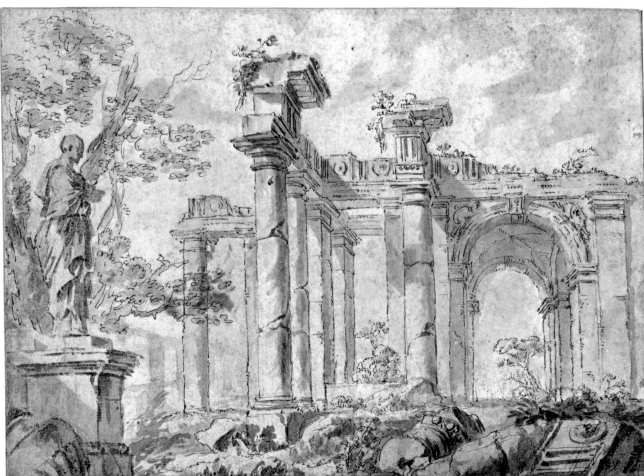

NOTES:

1. See Croft-Murray 1937.
2. Florence, Gabinetto Disegni e Stampe degli Uffizi, nos. 6404s, 6416s, 6426s. See, however, Arisi 1961, who lists 369 drawings by Panini, including 16 in the Uffizi: no. 6416s is his no. 45, but nos. 6404s and 6426s are not listed, which may imply rejection.
3. Ottawa 1976, no. 22.
4. Parker 1956, p. 518, no. 1031, pl. 223.
5. Wellesley 1960, no. 41, pl. 18; see also nos. 42, 43.

6. See, however, Arisi 1961, p. 132, no. 63, fig. 110, and p. 185, no. 190, fig. 240, for very comparable examples.

PROVENANCE: Edmond Fatio, Geneva; Lock Galleries, New York.

EXHIBITED: New York 1981, nos. 66a, 66b.

LITERATURE: Szabo 1983, no. 66.

No. 66, Verso

Giovanni Antonio Pellegrini

Venice 1675–Venice 1741

Pellegrini, the brother-in-law of Rosalba Carriera, was a prolific history painter. As a youth he accompanied Paolo Pagani to Austria, where he remained for some six years. Back in Venice by 1701 he worked on canvases for the Scuola del Cristo at San Marcuola, for Ca' Albizzi and Ca' Corner, and for San Moisè. In 1708 he went to England with Marco Ricci, at the behest of the Duke of Manchester, and worked at Kimbolton (1709), Castle Howard (1710), Narford, Hampton Court, and the London houses of the Duke of Manchester and the Duke of Portland. In 1713 he traveled to Düsseldorf, and in 1713–14 he painted fourteen large canvases for the Neue Schloss at Bensberg. In 1716 he went to Antwerp and in 1718 to The Hague. There the British ambassador, Lord Cadogan, invited him to England to decorate his country house (1719). In the following year he traveled to Paris to paint the ceiling (now lost) of the Banque Royale and decorations for the Château de la Muette. In 1721–22 Pellegrini was back in Venice, painting two ceilings for Ca' Pisani at Santo Stefano (now at Biltmore and the Marble House at Newport), and the *Martyrdom of Saint Andrew* for San Stae (1722). Further journeys followed, to Munich, Paris, Würzburg, Dresden, and Vienna. Pellegrini returned to Venice in 1730, and in 1736–37 made a final journey to Mannheim and Würzburg.

In spite of his extraordinary talent and his importance in the development of the Rococo style in painting, no monograph on Pellegrini has yet appeared. An album of drawings at Düsseldorf, which were ascribed to him at one time, are now given to Antonio Molinari, and the pattern of Pellegrini's development as a draftsman remains far from clear.

G. K.

LITERATURE: Venice 1959b; Venice 1969a.

67. The Last Supper

1975.1.392
Pen and brown ink, wash. 271 × 168 mm.

I regard Morassi's attribution of this drawing to Pellegrini[1] as very acceptable, notwithstanding the unusual subject (for Pellegrini) and the consciously classical setting of the scene. It may be worth noting that the Venetian guide of 1740, the *Forestiere illuminato*, mentions a painting by Pellegrini in the refectory of the convent of San Giorgio in Alga: though its subject is not recorded, the Last Supper would have been a highly appropriate one.[2]

A somewhat similar, though less elaborate, interior setting by Pellegrini is found in a sketch in a private collection in Udine, a *Banquet of Dido and Aeneas*.[3] This is rightly considered an early work, made prior to Pellegrini's departure for London. A similar date, ca. 1705, may be proposed for the present drawing.

G. K.

NOTES:
1. Venice 1959a, p. 40, no. 50.
2. For further details see Zorzi 1977, pp. 405–6, and Venice 1978b, pp. 59–79.
3. Gorizia 1973, no. 44.

PROVENANCE: Paul Wallraf, London. Acquired by Robert Lehman in 1962.

EXHIBITED: Venice 1959a, no. 50; Cologne 1959, no. 50; Venice 1959b, no. 70; New York 1981, no. 67; Pittsburgh 1985, no. 19.

No. 67

Giovanni Battista Piranesi

Mogliano Veneto 1720–Rome 1778

Although Piranesi worked principally in Rome from 1740 on, he seems to have been inspired by the enthusiasm for etching that sprang up in Venice between 1740 and 1743. His brilliant early style was fully formed by 1743–45, by which time he had settled in Rome permanently. By 1750 he had published his most celebrated inventions, the *Carceri* and the *Opere varie di architettura* (including the *Grotteschi*). The rest of his life was dedicated to a vast and magnificent output of archaeological and topographical etchings of Rome and southern Italy. Between 1764 and 1769, through the patronage of the Rezzonico pope, Clement XIII, he became active as an architect in Rome, restoring the church of Santa Maria del Priorato and making plans for the rebuilding of the west end of the Lateran Basilica. In his last years he became devoted to recording the antiquities of Pompeii and Herculaneum, evolving for this purpose a new and very austere method of drawing.

G. K.

LITERATURE: Thomas 1954; Venice 1978a.

Fig. 20. Francesco Piranesi, after Giambattista Piranesi. *View Through the Herculaneum Gate, Pompeii*, etching

68. View through the Herculaneum Gate, Pompeii

1975.1.400

Pen and brown ink over black chalk. 280 × 425 mm. Inscribed with numerals in brown ink. Squared for transfer. Inscribed or annotated in brown ink on the verso: *Tav. 8* (upper center); *Tav 9—* (center right); *6. dopio disonzione* [?] (bottom left); *veduta di prizione della Strada / [] de Portici* (bottom center).

PLATE 5.

This is one of a series of studies of Pompeii which, as Hylton Thomas has noted,[1] were made by Piranesi in the last months of his life. Several were etched at a later date by his son Francesco Piranesi and published in the magnificent *Antiquités de la Grande Grèce* (Paris, 1804). The present drawing is the study for Plate VI in Volume 1 of that work (Fig. 20), which is inscribed *Vue de l'intérieur de la Ville de Pompeïa, / avec les Portiques latéraux, et les fabriques extérieures. . . . Dessiné par J. B. Piranesi. / Gravé par F. Piranesi, l'an 12 (1804)*. The etching measures 365 × 543 mm., and is thus substantially larger than the drawing; this may explain the fact that the latter is squared for transfer. The etching contrives to eliminate the passage seen through the arch on the left, and it substitutes for the modern figures a smaller number of figures in antique costume.

A drawing in the British Museum is a study for Plate XXIV in Volume 1 of the *Antiquités*. It is entirely similar to our drawing, has similar numerals, and also comes from the collection of L. H. Philippi. A. M. Hind, in publishing the British Museum drawing,[2] suggested that it might be attributed to Francesco Piranesi, but this has not been accepted by subsequent writers.

Jacob Rosenberg published two further specimens, one in Berlin and one in the Cassirer collection (the second is now in the Rhode Island School of Design, Providence).[3] Both of these have inscriptions on the verso, and both had formerly been in the Philippi collection.

Hylton Thomas states that eleven Pompeiian scenes survive;[4] of these, nearly all appear to have come from the Philippi collection. Thomas points out that Sir John Soane and Philippi, who was also an architect, are the sole recorded nineteenth-century collectors of Piranesi drawings.[5] Felice Stampfle and Cara D. Denison indicate that certain others may be added to the list, bringing the total to sixteen.[6] Among these, however, they include the present sheet, which was in fact one of Thomas's original eleven.

G. K.

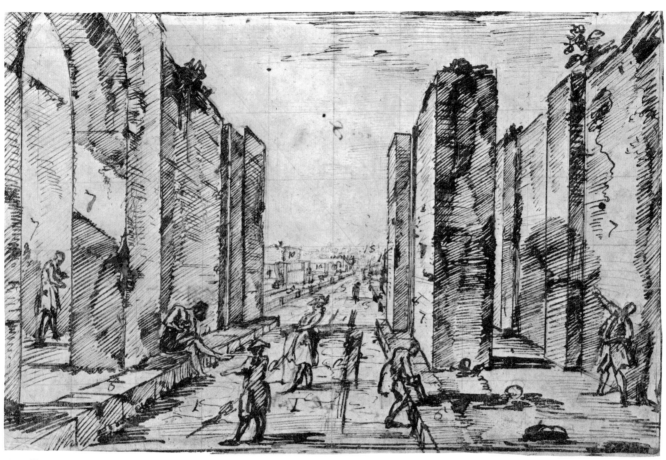

No. 68

No. 68, Detail

NOTES:
1. Thomas 1952–55, pp. 14–15.
2. Hind 1914, p. 188, pl. 3.
3. Rosenberg 1935, pp. 9–10, pls. 11, 12.
4. Thomas 1952–55, p. 15.
5. Thomas 1954, p. 30.
6. New York 1975, p. 61, under no. 50.

PROVENANCE: L. H. Philippi, Hamburg (Lugt 1335); Philippi sale, Lepke, Berlin, May 13, 1884, no. 450; Col. N. Colville, Penheale Manor, Launceston, Cornwall; Stephen Spector, New York. Acquired by Robert Lehman in 1961.

EXHIBITED: New York 1981, no. 68.

LITERATURE: Thomas 1952–55, pp. 20, 27 n. 10, fig. 7; New York 1975, p. 61, under no. 56; Szabo 1983, no. 67.

Marco Ricci

Belluno 1676–Venice 1730

Marco, the nephew of Sebastiano Ricci, seems to have been well established as a painter by 1706–7, when Lord Irwin purchased twenty of his seascapes, landscapes, and battle pieces, of which eighteen are still at Temple Newsam. In 1708 he traveled to London with Giovanni Antonio Pellegrini, at the behest of the Duke of Manchester, and worked as a theatrical designer at the Haymarket Theatre. In 1710 he was paid for four canvases for Castle Howard, after which he returned to Venice. He journeyed to London again, probably with Sebastiano, in 1712 and remained there until 1716, when he again returned to Venice; he is recorded as working in the Teatro Sant'Angelo in 1718 and 1719. His first known etchings are from 1723, and in that year he and Sebastiano became involved in the McSwiny project for Goodwood.[1] Their two pictures, the *Monument to the Duke of Devonshire* (signed and dated 1725) and the *Monument to Sir Cloudesley Shovell* were sent to England by October 1725. In 1728 Marco is recorded as being very actively involved with etching, and his collected oeuvre in that medium was published in 1730.

<div align="right">G. K.</div>

NOTE:

1. For the project, see Knox 1983a.

LITERATURE: Bassano 1964.

69. The House of Marco Ricci in the Bellunese

1975.1.415

Pen and brown ink, brown wash. 370 × 496 mm. Traces of vertical folding at the center. Worn and faded; damaged along the fold and at the sides; torn at left and right sides. Annotated in brown ink on the verso: *The House of Sig.ʳ Marco Ricci / in the Bellunese, among the Mountains; / with a View of an Adjacent Monastery.— / Taken by Sig.ʳ Marco Ricci & given on the Spot to Humphrey Mildmay, Esq.ʳᵉ An.º 1726.*

This characteristic drawing by Marco Ricci is of special interest on account of the annotation and date on the verso.

Morassi notes a drawing at Windsor, a *View of Belluno*, of similar character and on much the same scale (it measures 365 × 536 mm.).[1] There are also four similar large drawings in the Pierpont Morgan Library: a *Landscape with Cattle Crossing a Stream* (370 × 529 mm.), a *Landscape with a Castle and a River* (352 × 444 mm.), a *Mountain Landscape* (333 × 458 mm.), and a *Fantastic Landscape* (390 × 533 mm.).[2] Also now in the Morgan Library, from the collection of Janos Scholz, is the equally large *Brigands Attacking Travelers* (372 × 538 mm.).[3] There is another version of this last drawing at Rugby School, from the collections of William Young Ottley and Sir Thomas Lawrence.

<div align="right">G. K.</div>

NOTES:

1. Venice 1959a, p. 41, no. 51; see Blunt and Croft-Murray 1957, p. 33, no. 69, fig. 3.
2. New York, Pierpont Morgan Library, nos. I, 77 (reproduced in Fairfax Murray 1905–12, vol. I, pl. 77); I, 77a; I, 77b; 1961.35 (New York 1971, no. 26).
3. Scholz 1976, p. xxii, no. 131.

PROVENANCE: Humphrey Mildmay; Paul Wallraf, London. Acquired by Robert Lehman in 1962.

EXHIBITED: Venice 1959a, no. 51; Cologne 1959, no. 51; Huntington (N.Y.) 1980, no. 22; New York 1981, no. 69; Rochester 1981, no. 26; Detroit 1983, no. 22.

LITERATURE: Bassano 1964, p. xxiii, fig. 6.

No. 69

No. 69, Detail

Sebastiano Ricci

Belluno 1659–Venice 1734

After an early training in Venice with Federico Cervelli and possibly Sebastiano Mazzoni, Ricci left the city in 1678 or 1680 to set out on a career that would keep him constantly on the move for nearly forty years. He worked in Bologna, Parma, Rome, and Milan, where he decorated the cupola of San Bernardino dei Morti (1694). By 1700 he was back in the Veneto, and over the next decade he was active in Padua, Belluno, Vienna, Florence, and Venice. His most conspicuous work in Venice is his great altarpiece of 1708, the *Madonna and Saints* in San Giorgio Maggiore. By 1712 he was in London, painting Lord Burlington's staircase at Burlington House and the apse of the chapel at Chelsea Hospital; in 1716 he was in Paris; in 1717 or 1718 he settled once again in Venice. His last years were very active: he worked in close association with Consul Smith, who purchased many paintings, including the large religious canvases at Hampton Court. The great *Assumption of the Virgin*, commissioned for the new Karlskirche in Vienna, was completed shortly before his death. In his earlier decades, Sebastiano's style is inspired by Correggio and Pietro da Cortona. He is credited with an important role in the creation of the Rococo, though this distinction perhaps belongs more appropriately to Pellegrini and Rosalba Carriera. From the San Giorgio Maggiore altarpiece onward, however, Ricci revived the manner of Veronese and adapted it to the needs of his time, providing an example which was followed, after his death, by Giovanni Battista Tiepolo.

G. K.

LITERATURE: Daniels 1976a; Daniels 1976b.

70. Seven Male Heads

1975.1.416
Pen and brown ink, wash. 240 × 185 mm.

The attribution to Sebastiano Ricci is acceptable, though there is nothing strictly comparable among the known Ricci drawings. Two other sheets with groups of heads, at Windsor[1] and at Princeton,[2] are rather different, being executed in pen only.

G. K.

NOTES:
1. Blunt and Croft-Murray 1957, p. 67, no. 420, fig. 43.
2. Gibbons 1977, pp. 170–71, no. 516.

PROVENANCE: Agnes Mongan, Cambridge (Mass.).

EXHIBITED: New York 1981, no. 70.

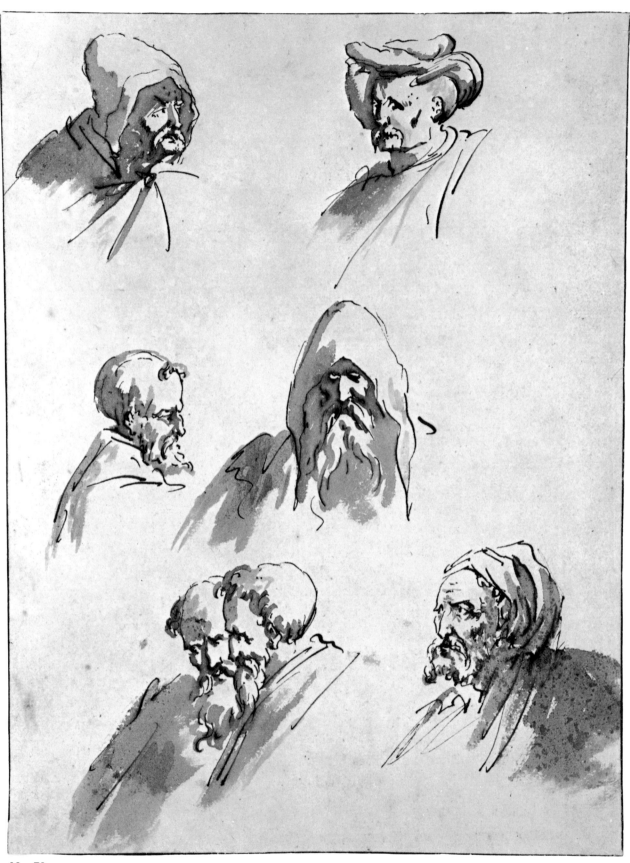

No. 70

Giovanni Battista Tiepolo

Venice 1696–Madrid 1770

Giambattista Tiepolo was a painter, an etcher, and a prolific draftsman. After an early training under Gregorio Lazzarini he began his career brilliantly in ca. 1715, soon becoming painter to the Doge Giovanni Corner, who died in 1722. During the 1720s he was sustained by the patronage of the Dolfin family in Udine and in Venice. In the 1730s he continued to work extensively for the Corner; he made three important visits to Milan, and his reputation became Europe-wide. In the 1740s he received commissions from St. Petersburg and painted his major works in Venice: the frescoes in Ca' Labia (1740) and the ceiling of the Scalzi church (1745, destroyed). In December 1750 he traveled to Würzburg and remained there three years, painting the ceilings of the Kaisersaal and the staircase in the Residenz. The most important works undertaken by him after his return to Venice were villa decorations in the Veneto: those of Villa Valmarana, Vicenza (1757), and Villa Pisani, Strà (1761). In 1762 Tiepolo was called to Madrid to paint the ceiling of the throne room of the Palacio de Oriente. Other ceilings followed; his last commission was a series of altarpieces for the church of San Pascual at Aranjuez.

G. K.

LITERATURE: Morassi 1955; Morassi 1962; Pallucchini 1968.

71. Soldiers Trying to Prevent Two Men from Fighting

1975.1.447

Pen and brown ink, wash, over black chalk. 361 × 530 mm. Annotated in black chalk, lower right: *Tiepolo f.*

Morassi suggests a date of 1728–30,[1] and Bean and Stampfle propose a link with the canvases of Ca' Dolfin,[2] one of which, the *Triumph of Marius* in the Metropolitan Museum of Art, is dated 1729.

Though Morassi states that the drawing was formerly owned by Giuseppe Vallardi, it does not bear that collector's mark.

There is nothing strictly comparable to this design among the Tiepolo drawings. The sheet has something of the quality of an academic exercise: the figures are firmly confined within a triangular boundary, while the lower edge is given a deliberately free-floating character by the way in which the leg of the seated soldier is left uncompleted.

G. K.

NOTES:
1. Venice 1959a, p. 43, no. 53.
2. New York 1971, p. 41, no. 60.

PROVENANCE: Giuseppe Vallardi, Milan (?); Paul Wallraf, London. Acquired by Robert Lehman in 1962.

EXHIBITED: Venice 1959a, no. 53; Cologne 1959, no. 53; New York 1971, no. 60; Birmingham (Ala.) 1978, no. 37; New York 1981, no. 72; Pittsburgh 1985, no. 21.

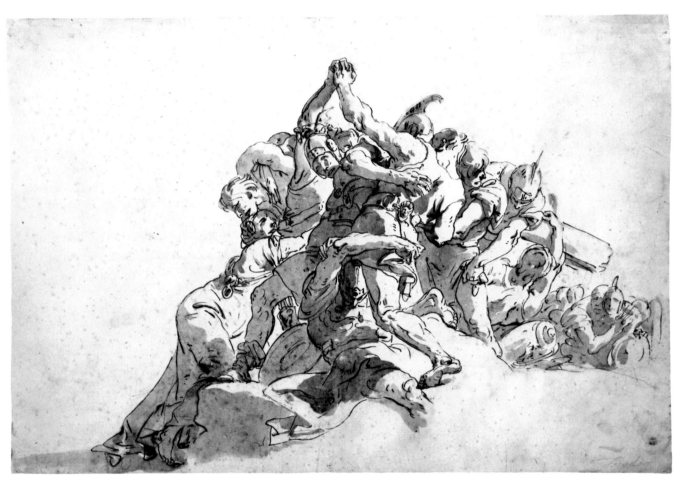

No. 71

72. Soldiers Around a Monument

1975.1.448

Pen and brown ink, brown wash, with white heightening, over black chalk. 423 × 280 mm.

Verso: Slight Study for a Figure (?). Black chalk.

Morassi relates No. 72 very convincingly to two drawings, an *Adoration of the Shepherds* and a *Saint Jerome in the Desert*, in the Museo Civico, Bassano, and this leads him to propose a date of ca. 1725.[1] He also notes that it has many links with the *Scherzi di Fantasia*, though he suggests that it must be much earlier than those etchings, and he draws attention to a drawing in the Victoria and Albert Museum.[2] He also notes a drawing in Trieste, which Vigni ascribes, evidently quite correctly, to the young Domenico Tiepolo,[3] and a drawing from the Duff-Gordon album,[4] which presents a considerable problem of attribution.

The links with the *Scherzi di Fantasia* are undeniable. The Victoria and Albert drawing (which is not used directly for any of the etchings), shows the monument with the medallion, the seated soldier, the horse's skull, and even the boy and his companion; the latter, however, are reversed and hence form part of a concentrated design, unlike their counterparts in the Lehman drawing. Another drawing in the Victoria and Albert Museum,[5] showing the pyramidal monument with the medallion, the boy and his companion, and the skull, is even closer to No. 72 in some respects. Several of the elements in these drawings find their way into the *Scherzi*: the standing boy and the skull appear in no. 5[6] and the monument and the soldier in no. 7.[7] There are also links with the *Capricci*, especially with no. 4.[8] All this material must be dated ca. 1743.

The notion that these elements in the etchings should have been adumbrated in an isolated drawing of nearly two decades earlier is really beyond belief. One may also note certain infelicities in No. 72, notably the way in which the boy and the man holding the vase almost completely block the soldier with the raised arm, and the addition of a somewhat inconsequential figure in the upper part of the drawing.

The finish of No. 72 suggests that it may have been made for a specific purpose, perhaps as a design for the frontispiece of a book, but a comparison with established ornamental works of this nature by Giambattista do little to support the attribution of this drawing to him. One may cite a comparable example of about 1725–28 in the Seilern collection, also from the Duff-Gordon album;[9] a carefully prepared drawing of 1746, the study for a mace, in the Heinemann collection;[10] a study for an inkstand,

No. 81 in the present catalogue; and, as an example of a frontispiece design, a late drawing in the Cooper-Hewitt Museum, New York.[11]

There is certainly a general connection between No. 72 and the series of Tiepolo drawings engraved and published by Pietro Monaco in 1739.[12] Such a connection also characterizes the two above-mentioned drawings in Bassano,[13] which I now consider to be pastiches of about 1740. I similarly consider No. 72 to be a pastiche after the *Scherzi*, dating from about 1743–45.

If this is so, one must address the question of the possible identity of the draftsman. Something of a clue is offered by the two halberds leaning against the pyramid. A similar detail is found in a drawing on the verso of a sheet in the Scholz collection, possibly representing the assassination of Julius Caesar (the drawing on the recto is somewhat loosely related to Tiepolo's altarpiece in Santa Maria della Fava);[14] though the sheets are rather different in other respects, both are characterized by an extremely fine pen line.

Certain other drawings exhibit rather similar characteristics. On the occasion of the Tiepolo exhibition held in 1970 at the Fogg Art Museum, some attempt was made to identify the stylistic personalities of Giovanni Raggi of Bergamo and Francesco Lorenzi of Verona. An important drawing in the Norfolk (Virginia) Museum of Arts and Sciences was given to Raggi,[15] and it was associated with the two above-mentioned drawings from the Duff-Gordon album and with another exhibited at the Galerie Cailleux, Paris, in 1952.[16] Further reflections on the general problem of the apprentices in the Tiepolo studio have since been published.[17]

The present drawing and the two in Bassano appear to exhibit a hand rather different from Raggi's. I feel that they approximate more closely to the manner of Francesco Lorenzi. Out of deference to other learned opinion, however, No. 72 is here left among the drawings attributed to Giambattista Tiepolo.

G. K.

NOTES:

1. Venice 1959a, pp. 41–42, no. 52. In some notes on the drawings in the Tiepolo exhibition held in Venice in 1951, Carlo Ragghianti (Florence 1953, pp. 24–25, nos. 2, 5) expressed considerable reservations about the Bassano drawings; his opinion is cited by Licisco Magagnato in Venice 1956, pp. 58–59, nos. 58, 59, and by Bruno Passamani in Bassano 1970, pp. 62–63, nos. 5, 6.
2. Venice 1959a, loc. cit.; for the drawing see Knox 1960, p. 64, no. 125.
3. Vigni 1942, p. 76, no. 253.

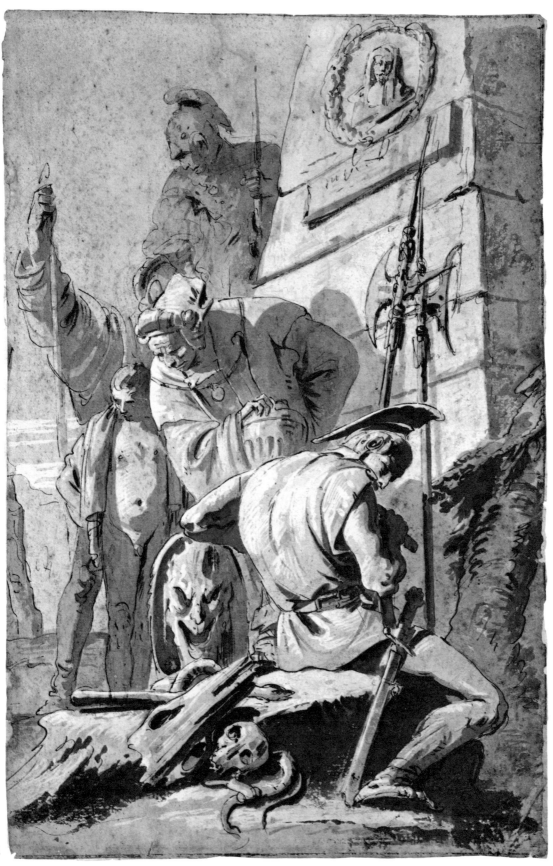

No. 72

4. Sale, Sotheby's, London, February 19, 1936, lot 66; Oppé 1930, pl. 10.

5. Knox 1960, p. 64, no. 124.

6. De Vesme 1906, no. 17.

7. Ibid., no. 19.

8. Ibid., no. 6.

9. Sale, Sotheby's, London, February 19, 1936, lot 67; Oppé 1930, pl. 9; Seilern 1959, p. 123, no. 149, pl. 119.

10. Knox 1978a, pl. 37.

11. Cambridge (Mass.) 1970, no. 96.

12. For this series see Knox 1965.

13. Knox 1965, pp. 395–96, A and B, figs. 10 and 11.

14. Venice 1957, p. 42, no. 67.

15. Cambridge (Mass.) 1970, no. 25.

16. Paris 1952, p. 42, no. 14, pl. 10.

17. See Knox 1976; Knox 1980a, passim.

PROVENANCE: Paul Wallraf, London. Acquired by Robert Lehman in 1962.

EXHIBITED: Venice 1959a, no. 52; Cologne 1959, no. 52; New York 1971, no. 59; Birmingham (Ala.) 1978, no. 30; New York 1981, no. 71; Rochester 1981, no. 27; Detroit 1983, no. 30; Pittsburgh 1985, no. 20.

LITERATURE: Rizzi 1971, p. 54, fig. xv; Szabo 1983, no. 68.

73. Two Allegorical Female Figures for a Ceiling

1975.1.446

Pen and brown ink, brown wash, over black chalk. 302 × 255 mm. Annotated in pencil on the verso. *G. B. Tiepolo* (right, below center); *Disegno originale di G. B. Tiepolo / circa 1730–35 / cm. 30·5 × 25·5 —— Antonio Morassi / penna e seppia* (bottom left); *? Studio per Pal. Archinto 1731* (bottom right).

Morassi suggests a date of ca. 1731 for this drawing, which he connects with the decorations of that year in the Palazzo Archinto in Milan.[1] However, no drawings can be linked unequivocally with the Palazzo Archinto, and I hold the present example to be an unused study for the frescoes in the Villa Loschi at Biron, which are dated 1734 and for which there are many drawings.[2]

On the ceiling of the Villa Loschi[3] there are two somewhat similar figures in the lower left section. There the woman wearing a helmet may be identified with some confidence as Strength, since she appears next to a column and is not encumbered with *putti* like her counterpart in the Lehman drawing. On the ceiling the second woman holds a vase and a pair of compasses; in the drawing, she at first held a spear in her right hand (as well as the wreath in her left, which suggests Virtue), but the right arm was then altered and the spear replaced by a vase. The other figures on the ceiling are more easily identified as Justice, Glory, "Fama Buona," and Prudence (the figures that decorate the Villa Loschi are in almost every case drawn quite directly from the pages of the *Iconologia* of Cesare Ripa).

G. K.

NOTES:

1. Venice 1959a, p. 43, no. 54.

2. For a recent discussion see Knox in Cambridge (Mass.) 1970, no. 13, and Vigni 1972, pp. 57–60, nos. 27–42.

3. Morassi 1962, p. 65, fig. 365.

PROVENANCE: Paul Wallraf, London. Acquired by Robert Lehman in 1962.

EXHIBITED: Venice 1959a, no. 54; Cologne 1959, no. 54; New York 1981, no. 73.

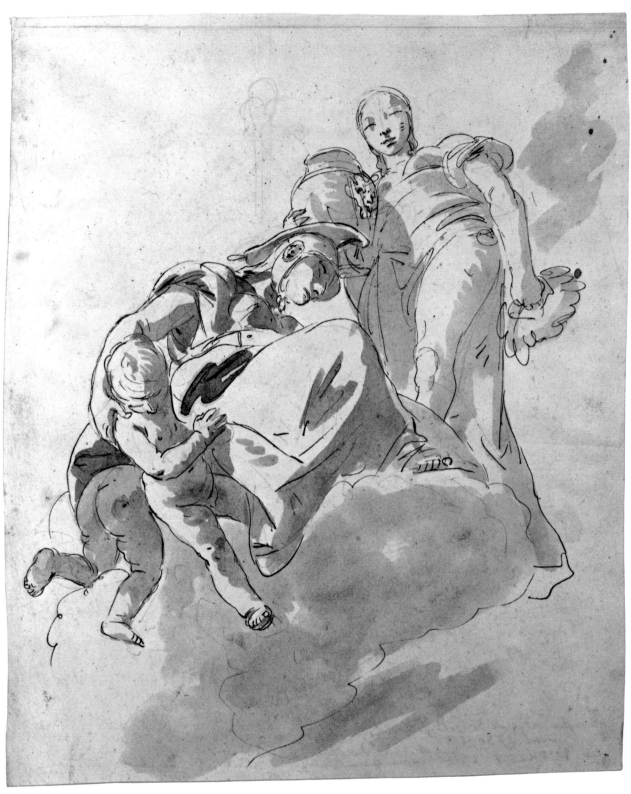

No. 73

74. Virgin and Child with Saint John of the Cross (?), Saint Sebastian, and Saint Peter of Alcantara

1975.1.440
Pen and brown ink, brown wash, over traces of black chalk.
456 × 300 mm.

Nos. 74 and 75 are two of a series of loosely related drawings from the Orloff album.[1] Five of these show a saint holding a large wooden cross, whom I identify as Saint Peter of Alcantara, canonized in 1669, the founder of the Discalced Franciscans and the close associate of Saint Teresa of Avila. The only painted representation of this saint by Tiepolo is the oval canvas of about 1769 from the church of the Discalced Franciscans at Aranjuez, now in the Prado.[2] At least three of the Orloff drawings seem also to depict Saint John of the Cross, the founder of the male order of Discalced Carmelites, who was canonized by Benedict XIII in December 1726. In an engraving by Marco Pitteri after Giambattista Piazzetta this saint is shown with a skull, a small cross, and a book. Here (as also in No. 75) his only attributes are a skull and a small cross. In Orloff 137 Saint John of the Cross appears in the foreground with a skull and a book, together with Saint Catherine of Alexandria and Saint Peter of Alcantara. In Orloff 135,[4] a design that has much in common with the present drawing, he may be the barefoot saint to the right, shown in company with Saint Catherine of Alexandria and Saint Sebastian. Other related drawings include one recorded in a 1918 sale,[5] with Saint Sebastian and Saint John of the Cross kneeling, of which a copy by Francesco Guardi appeared in the Pobé sale in 1979;[6] one in Berlin;[7] and one sold at Sotheby's in 1965,[8] showing the Holy Family with Saint Peter of Alcantara and Saint John of the Cross (?).

The composition is related to that of an altarpiece by Giambattista in the Pushkin Museum, Moscow (Fig. 21), where the saint on the left may again be identified as Saint John of the Cross; there he is shown holding a book, with his other attributes on the step before him, together with Saint Anthony of Padua and Saint Dominic.[9] A striking feature of the design of the painting is the group of angel heads in the center foreground; this is also found in the Fava altarpiece, which can be no later than 1732. Morassi's suggestion[10] that the Moscow painting may be identical with a *Madonna with Saint John Nepomuk, Saint Francesco di Paola, and Saint Anthony of Padua* recorded by F. M. Tassis in San Provolo, Venice, does not seem possible, unless Tassis was very unclear about the identity of the saints.

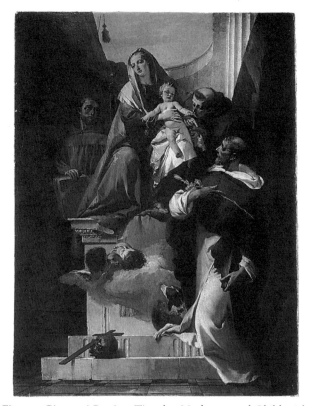

Fig. 21. Giovanni Battista Tiepolo. *Madonna and Child with Saints*. Moscow, Pushkin Museum

Saint Sebastian appears in Tiepolo's altarpieces for Diessen (1739) and Noventa Vicentina (ca. 1750),[11] but the present drawing and its companions seem to be earlier; a dating of about 1731–35 may be appropriate. Gino Fogolari noted that in 1732 the Discalced Carmelites in Venice undertook to decorate the first chapel on the left of the church of the Scalzi and that Tiepolo painted for it a ceiling fresco, *Christ on the Mount of Olives*;[12] the fresco was mentioned by Zanetti in 1733. It is possible that this project may have stimulated Tiepolo to produce a series of designs featuring Saint Peter of Alcantara and Saint John of the Cross, the latter the recently canonized founder of the order responsible for the commission.

G. K.

No. 74

NOTES:

1. For the provenance and character of the album, see Knox 1961. Nos. 74 and 75 are nos. 130 and 133 in the Orloff sale catalogue (Galerie Georges Petit, Paris, April 29–30, 1920); the other drawings in the series under consideration are nos. 131, 132, 134, 135, 137.
2. Morassi 1962, p. 21, fig. 187.
3. Hadeln 1928, p. 26, pl. 91.
4. Cambridge (Mass.) 1970, no. 15.
5. Sale, F. A. C. Prestel, Frankfurt am Main, November 12, 1918, no. 226 (illustrated in the catalogue, pl. 23).
6. Sale, Auctiones S. A., Basel, February 23, 1979, no. 96.
7. Hadeln 1928, p. 15, pl. 42.
8. Sale, Sotheby's, London, November 11, 1965, lot 30.
9. Morassi 1962, p. 30; Pallucchini 1968, p. 99, no. 94; Lavrova 1970, pp. 124–26. Morassi and Pallucchini misidentify Saint Dominic as Saint Louis of Toulouse and Saint John of the Cross as Saint Francis of Assisi; Lavrova (p. 130, n. 4) notes Morassi's error with regard to Saint Dominic, but also misidentifies the figure on the left as Saint Francis.
10. Morassi 1962, pp. 30, 57.
11. Ibid., pp. 11, 37, figs. 119, 145.
12. Fogolari 1931, p. 23; Morassi 1962, p. 57, fig. 50.

PROVENANCE: Prince Alexis Orloff, Paris; Orloff sale, Galerie Georges Petit, Paris, April 29–30, 1920, no. 130; Federico Gentili di Giuseppe, Paris; Mrs. Salem, Château du Haut Buc, Seine-et-Oise; Paul Wallraf, London. Acquired by Robert Lehman in 1962.

EXHIBITED: Venice 1959a, no. 56; Cologne 1959, no. 56; New York 1971, no. 70; Birmingham (Ala.) 1978, no. 44; New York 1981, no. 76; Pittsburgh 1985, no. 24.

LITERATURE: Hadeln 1928, p. 26, pl. 43; Knox 1961, p. 274, no. 10; Szabo 1983, no. 71.

75. The Virgin and Child Adored by Monks and Others

1975.1.439
Pen and brown ink, brown wash, over black chalk on white paper. 416 × 286 mm. Numbered, in black chalk or graphite, top right: 98.

This drawing, like No. 74, is from the Orloff album. The composition has something in common with an oil sketch in the National Gallery, London.[1] I consider Morassi's suggested date of ca. 1730–35 to be very acceptable.[2]

The Franciscan with the life-sized cross may be identified as Saint Peter of Alcantara.

G. K.

NOTES:

1. Morassi 1962, p. 16, fig. 86; Pallucchini 1968, p. 100, no. 100.
2. Venice 1959a, p. 44, no. 55.

PROVENANCE: Prince Alexis Orloff; Orloff sale, Galerie Georges Petit, Paris, April 29–30, 1920, no. 133; Paul Wallraf, London. Acquired by Robert Lehman in 1962.

EXHIBITED: Venice 1959a, no. 55; Cologne 1959, no. 55; New York 1971, no. 72; New York 1981, no. 77; Rochester 1981, no. 37.

LITERATURE: Knox 1961, p. 274, no. 14.

No. 75

No. 76

76. Bacchus and Ariadne

1975.1.443
Pen and brown ink, brown wash, over black chalk. 312 × 243 mm.
PLATE 6.

The Chicago catalogue of 1938 suggests a connection with the painting of the same subject in the Timken collection in New York.[1] This is one of a set of paintings which present some difficulty as to date but which are probably to be assigned to ca. 1740. The catalogue also refers to another Bateson drawing, *Zephyrus and Flora*,

now in the Barber Institute of Fine Arts in Birmingham, which is a study for one of the ceilings of the Ca' Labia, painted in about 1744, and it is not out of the question that No. 76 may be connected with the *Bacchus and Ariadne* ceiling in the same palace.[2] However, these figures also appear in the ceiling of 1740 in the Palazzo Clerici in Milan, and in the *Olympus* sketch in the Kimbell Art Museum, Fort Worth,[3] which may be a sketch of ca. 1742 for the Summer Palace at St. Petersburg.[4]

G. K.

NOTES:
1. Chicago 1938, p. 39, no. 71. For the Timken painting, see Morassi 1962, p. 36, pl. 260.
2. Morassi 1962, p. 59, pl. 265.
3. Formerly in the Hausammann collection, Zürich. Ibid., p. 69, pl. 319.
4. Knox 1980a, pp. 49–50.

PROVENANCE: William Bateson, London (Lugt 2604a); Bateson sale, Sotheby's, London, April 29, 1929, lot 99; Savile Gallery, London; Philip Hofer, Cambridge (Mass.).

EXHIBITED: London 1911, no. 71; London 1917, no. 71; London 1927, no. 35; Buffalo 1935, no. 64; New London 1936, no. 106; Chicago 1938, no. 71; Cambridge (Mass.) 1944, no. 51; Philadelphia 1950, no. 70; Waterville (Me.) 1956, no. 9; Paris 1957, no. 128; Cincinnati 1959, no. 226; New York 1971, no. 112; New York 1981, no. 74; Detroit 1983, no. 32; Pittsburgh 1985, no. 23.

LITERATURE: Sack 1910, p. 251, no. 100, fig. 230; Gaunt 1927, p. 64; Hadeln 1928, p. 21, pl. 73; Matteucci 1957, p. 254; Moskowitz 1962, vol. 1, no. 291; Ames 1963, pl. 91; Szabo 1983, no. 69.

77. A River God and Other Figures on a Parapet

1975.1.444
Pen and brown ink, brown wash, over black chalk. 170 × 269 mm.

Morassi suggests a date of ca. 1740 for this drawing; he associates it convincingly with the ceiling of the Palazzo Clerici in Milan, painted in that year.[1]

G. K.

NOTE:
1. Venice 1959a, p. 45, no. 57. For further discussion of the drawings associated with the Palazzo Clerici, see Cambridge (Mass.) 1970, nos. 18–20, and New York 1971, pp. 45–50, nos. 74–95.

PROVENANCE: William Bateson, London (Lugt 2604a); Bateson sale, Sotheby's, London, April 29, 1929, lot 97; Paul Wallraf, London. Acquired by Robert Lehman in 1962.

EXHIBITED: London 1917, no. 84; Venice 1959a, no. 57; Cologne 1959, no. 57; New York 1971, no. 122; New York 1981, no. 94; Rochester 1981, no. 39.

LITERATURE: Sack 1910, p. 252, no. 104; Byam Shaw 1928.

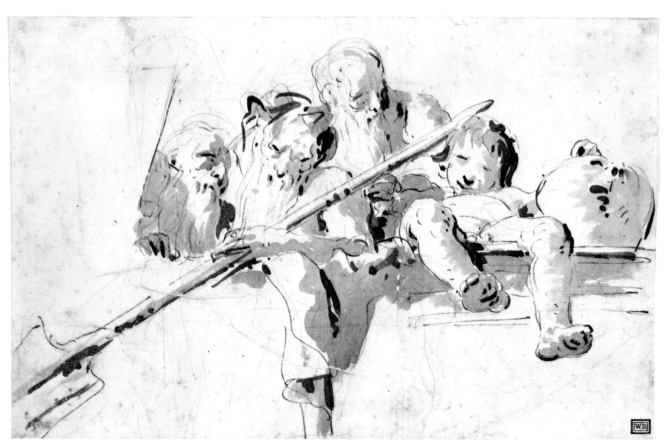

No. 77

78. Head of a Bishop

1975.1.423
Pen and light brown ink, wash, over black chalk. 211 × 145 mm. (the four corners cut).

This drawing is one of a series of fantastic heads, of which the earliest record is the catalogue of an exhibition at the Savile Gallery in 1928.[1] There about ten were shown, in association with thirty drawings on the theme of the Holy Family. This catalogue also includes a photograph of the bookplate of Edward Cheney, who purchased the album that contained the drawings in 1842, recording its provenance from Tiepolo himself through Leopoldo Cicognara, Antonio Canova, and Francesco Pesaro.[2]

Mark Oliver, a co-founder of the Savile Gallery, informed me that the album appeared in a sale of Ranfurly property in Dublin, and was bought for a small sum by a young woman. It was sold to Colnaghi for £800, and thence passed to Richard Owen, a *marchand-amateur* who lived on the Quai Voltaire in Paris. The Savile Gallery bought forty drawings from Owen, and about fifteen of these went to Alessandro Contini-Bonacossi; it does not appear that the present drawing was among them.

In the photographic archives of the Fogg Art Museum is a set of photographs, originating with Richard Owen, which records the appearance of ninety-three drawings in the series of fantastic heads. The present drawing is included among them.[3]

As for the date of these drawings, one rather atypical specimen in the collection of Antoine Seilern[4] is datable to ca. 1742, and two were used by Domenico Tiepolo as models for etchings bitten in 1757.[5] The series as a whole probably falls between these dates.

The drawings appear to have been made for their own sake, and cannot be associated directly with paintings.

G. K.

NOTES:
1. London 1928.
2. The photograph is reproduced and discussed in Knox 1960, p. 6.
3. Fogg Photographic Collection, no. 372d/T442/50(x).
4. Seilern 1959, pp. 154–55, no. 169, pls. 130, 131.
5. Knox 1970a, *Teste* I, 10 and I, 30.

PROVENANCE: Library of the Somasco convent at Santa Maria della Salute, Venice; Leopoldo Cicognara; Antonio Canova; Monsignor Canova; Francesco Pesaro; Edward Cheney, Badger Hall, Shropshire; Cheney sale, Sotheby's, London, April 29, 1885, lot 1024; E. Parsons & Sons, London; Earl of Ranfurly; P. & D. Colnaghi & Co., London; Richard Owen, Paris; Paul Wallraf, London. Acquired by Robert Lehman in 1962.

EXHIBITED: Venice 1959a, no. 59; Cologne 1959, no. 59; New York 1981, no. 79; Pittsburgh 1985, no. 25.

No. 78

No. 79

79. Bearded Man Wearing a Cap

1975.1.424

Pen and brown ink, brown wash. 292 × 205 mm. Numbered in ink, lower left: *67*.

No. 79 belongs to the same series of fantastic heads as No. 78.[1] Only a few of these drawings are numbered in the same way as the present example.

Morassi suggests a date of ca. 1740–45.[2]

G. K.

NOTES:
1. There is a photograph of it in the Fogg Photographic Collection, no. 372d/T442/50(kk).
2. Venice 1959a, p. 46, no. 58.

PROVENANCE: Library of the Somasco convent at Santa Maria della Salute, Venice; Leopoldo Cicognara; Antonio Canova; Monsignor Canova; Francesco Pesaro; Edward Cheney, Badger Hall, Shropshire; Cheney sale, Sotheby's, London, April 29, 1885, lot 1024; E. Parsons & Sons, London; Earl of Ranfurly; P. & D. Colnaghi & Co., London; Richard Owen, Paris; Paul Wallraf, London. Acquired by Robert Lehman in 1962.

EXHIBITED: Venice 1959a, no. 58; Cologne 1959, no. 58; Huntington (N.Y.) 1980, no. 23; New York 1981, no. 78; Rochester 1981, no. 28; Detroit 1983, no. 28.

No. 80

80. Head of a Man in Profile to the Left

1975.1.435
Pen and brown ink, brown wash, over graphite. 250 × 200 mm.

This drawing belongs to the same series of fantastic heads as No. 78.[1]

G. K.

NOTE:
1. There is a photograph of it in the Fogg Photographic Collection, no. 372d/T442/50(z).

PROVENANCE: Library of the Somasco convent at Santa Maria della Salute, Venice; Leopoldo Cicognara; Antonio Canova; Monsignor Canova; Francesco Pesaro; Edward Cheney, Badger Hall, Shropshire; Cheney sale, Sotheby's, London, April 29, 1885, lot 1024; E. Parsons & Sons, London; Earl of Ranfurly; P. & D. Colnaghi & Co., London; Richard Owen, Paris; Paul Wallraf, London. Acquired by Robert Lehman in 1962.

EXHIBITED: Venice 1959a, no. 60; Cologne 1959, no. 60; New York 1981, no. 96.

81. Study for an Inkstand

1975.1.425
Pen and brown ink, gray wash, with splashes of brown wash on
the left, over black chalk. 450 × 310 mm.

The important role of Armand-Louis de Mestral de Saint-
Saphorin (1738–1806), to whom this sheet belonged, as a
collector of Tiepolo drawings has been discussed else-
where by me.[1]

The drawing is described by Morassi in the Wallraf cat-
alogue as a study for a fountain,[2] but I have suggested
that it is a most interesting study for a magnificent ink-
stand, evidently to be executed in silver.[3] The design is of
considerable ingenuity, for the object is not seen straight
on but from a point to the left of its central axis. Two
female figures with long, twisting lower extremities each
use one "tail" to grasp the large scallop shell below and
thus to form a support for the whole structure, while the
other tail winds inward to support the central vase. On
either side there is a small conical shell to hold goose-
quills (which are indicated in pencil with sufficient clari-
ty), and the central vase is surmounted by the figure of
Sapienza, holding a torch and a book as she does in Ripa's
Iconologia.[4] It is a little difficult to arrive at a firm date for
this drawing: Morassi suggests ca. 1725–30,[5] but I prefer
a date in the early forties. The style is not unlike that of
certain drawings of this period in the Victoria and Albert
Museum.[6] One may note furthermore, that the three de-
signs for silver *fruttiere* in Trieste, associated with the
Banquet of Anthony and Cleopatra at Melbourne,[7] are
composed of somewhat similar elements; these must be
dated 1743. Similar mermaids with twisting tails appear
in another drawing of this time,[8] but this is a motif of
great antiquity which is often used for caryatid figures in
the Roman edition of Ripa. Another example of a design
for silver by Giambattista is the study for a processional
mace in the Heinemann collection, which can be dated
between August and December 1746.[9]

It may be worth recalling that Francesco Algarotti, on
September 4, 1743, records that he has made Tiepolo a
present of silverware and chocolate to the value of 1,148
lire (about 26 guineas in the English currency of the day)
for handling the sale of the Dolfin family's "Holbein" to
Dresden at a price of 1,000 sequins (500 guineas).[10] It is
thus not entirely out of the question that the present de-
sign may have been for a piece of silver for Giambattista's
own use.

G. K.

NOTES:
1. Knox 1970b, pp. 58–63; Knox 1980b, pp. 191–95.
2. Venice 1959a, pp. 60–61, no. 89.
3. Knox 1978a, pp. 61–62.
4. Ripa 1603, p. 441.
5. Venice 1959a, loc. cit.
6. Knox 1960, p. 57 no. 85, p. 63 no. 119, p. 64 no. 120.
7. Vigni 1972, p. 73, nos. 114, 115, 116.
8. New York 1971, p. 60, no. 131.
9. Knox 1978b, pp. 48–50, pl. 37.
10. Posse 1931, p. 54.

PROVENANCE: Armand-Louis de Mestral de Saint-Saphorin;
Paul Wallraf, London. Acquired by Robert Lehman in 1962.

EXHIBITED: Venice 1959a, no. 89; Cologne 1959, no. 89;
Birmingham (Ala.) 1978, no. 31; New York 1981, no. 81;
Rochester 1981, no. 31; Detroit 1983, no. 27; Pittsburgh 1985,
no. 26.

LITERATURE: Knox 1978a, pp. 61–62.

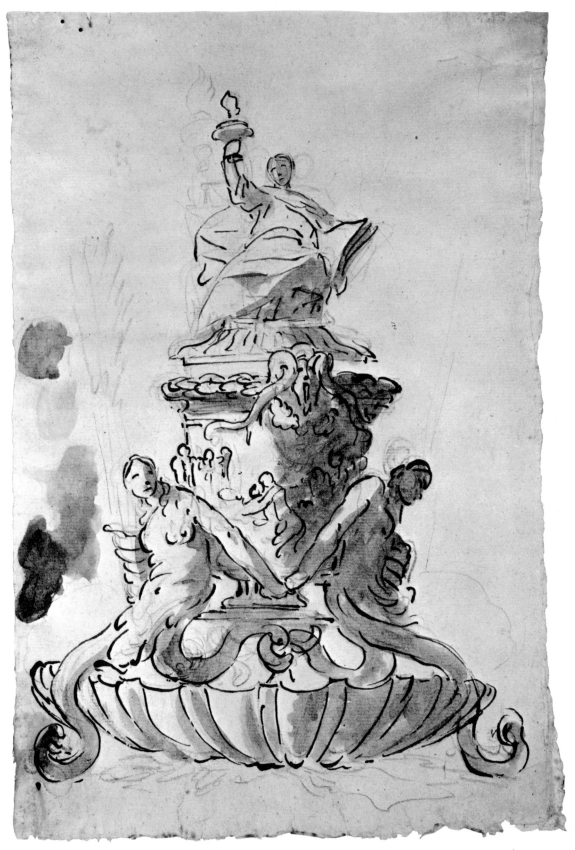

No. 81

No. 82

82. One of the Hours Holding the Bridle of a Horse of the Sun, and Other Figures

1975.1.445
Pen and brown ink, brown wash. 320 × 203 mm.
PLATE 7.

Morassi suggests a date ca. 1740–45,[1] but I feel that the style suggests a later dating and that the drawing may be very properly associated with the Würzburg years—indeed, with the ceiling of the staircase of the Residenz.[2] If this position can be sustained, No. 82 becomes the first sheet of pen studies to be linked with the staircase ceiling at Würzburg.[3]

G. K.

NOTES:
1. Venice 1959a, p. 60, no. 88.
2. See Freeden and Lamb 1956, pl. 83.
3. For a discussion of Giambattista's pen drawings of the Würzburg period, see Knox 1960, pp. 27–29.

PROVENANCE: Paul Wallraf, London. Acquired by Robert Lehman in 1962.

EXHIBITED: Venice 1959a, no. 88; Cologne 1959, no. 88; Washington 1974, no. 77; New York 1981, no. 95; Rochester 1981, no. 29; Detroit 1983, no. 31; Pittsburgh 1985, no. 28.

LITERATURE: Szabo 1983, no. 73.

83. An Old Man Holding a Sword, His Left Arm Outstretched

1975.1.426

Pen and brown ink, brown wash. 179 × 161 mm. (top left corner torn). Mounted on a page from an album measuring 280 × 248 mm. with the number *115* in brown ink, top right.

It now seems probable that among the volumes of Tiepolo drawings in the collection of Edward Cheney (see No. 78) there were four containing studies of single figures: two of standing figures and two of figures for ceilings. One of these, entitled "Sole Figure Vestite" and containing eighty-six single standing draped figures and three other drawings, is one of two volumes from the Cheney collection in the Victoria and Albert Museum.[1] The other three volumes with single figures, containing three hundred draw-

ings, were sold at Christie's in 1914;[2] they were bought by the firm of E. Parsons & Sons. Paul Oppé recalled that the three Parsons volumes were uniform with the two in the Victoria and Albert Museum and that one was lettered "Sole Figure per Soffitti."[3] These drawings were dispersed after the First World War; today some ninety-four can be counted that fall into the category of *sole figure vestite*, while some one hundred seventy-seven can be classified as *sole figure per soffitti*. Thus it seems likely that one of the three volumes contained standing figures and that two contained ceiling studies.

Robert Lehman appears to have purchased a substantial group of these drawings from a source that cannot be established. In 1941 he presented a group of twelve *sole figure per soffitti* to the Yale University Art Gallery.[4] In the same year he gave four others to the Lyman Allyn Mu-

No. 83

No. 84

seum in New London, Connecticut; two of them remain with that museum. [5] The present drawing belongs to this group of early acquisitions. With the purchase of the Wallraf collection in 1962, Mr. Lehman acquired three more *sole figure per soffitti* (Nos. 84, 85, 86). He also had two specimens of *sole figure vestite* (Nos. 89, 90) in his earlier collection, and acquired three more (Nos. 87, 88, 91) with the Wallraf drawings.

G. K.

NOTES:
1. See Knox 1960, pp. 3–4, and Knox 1975, p. 9.
2. Sale, Christie's, London, July 14, 1914, lot 49.
3. Oppé 1930, p. 29, n. 1.
4. Haverkamp-Begemann and Logan 1970, pp. 169–72, nos. 309–19.
5. Acc. nos. 1941.81, 1941.83.

PROVENANCE: Conte Algarotti-Corniani, Venice; Edward Cheney, Badger Hall, Shropshire; E. Parsons & Sons, London.

EXHIBITED: New York 1981, no. 90.

112

84. Standing Woman, Turned to the Left

1975.1.427
Pen and brown ink, brown wash. 196 × 141 mm.
Verso: Slight sketch of the upper body of a seated figure. Black chalk.

One of the series "Sole Figure per Soffitti": see No. 83.

G. K.

PROVENANCE: Conte Algarotti-Corniani, Venice; Edward Cheney, Badger Hall, Shropshire; E. Parsons & Sons, London; Paul Wallraf, London. Acquired by Robert Lehman in 1962.

EXHIBITED: Venice 1959a, no. 64; Cologne 1959, no. 64; New York 1981, no. 85.

85. Standing Woman Holding a Hoop

1975.1.428
Pen and brown ink, brown wash. 210 × 156 mm.

One of the series "Sole Figure per Soffitti": see No. 83.

G. K.

PROVENANCE: Conte Algarotti-Corniani, Venice; Edward Cheney, Badger Hall, Shropshire; E. Parsons & Sons, London; Paul Wallraf, London. Acquired by Robert Lehman in 1962.

EXHIBITED: Venice 1959a, no. 65; Cologne 1959, no. 65; New York 1981, no. 84.

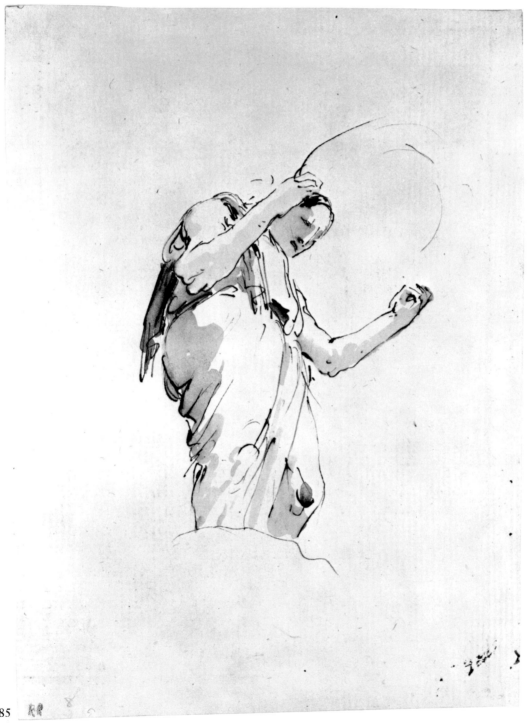

No. 85

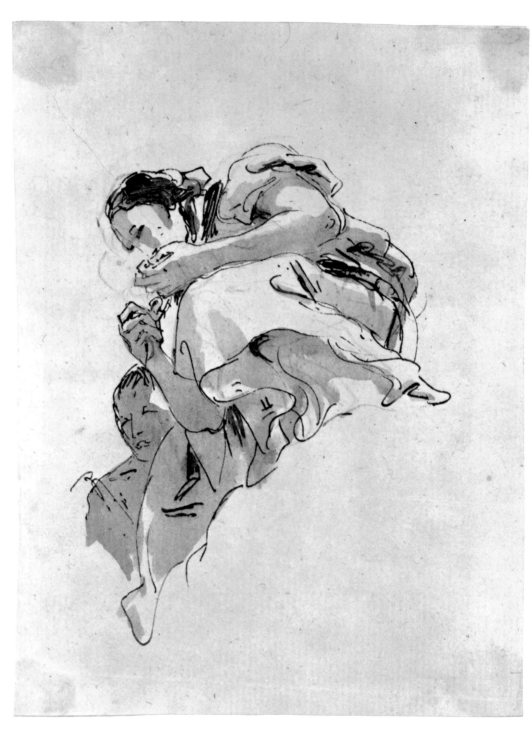

No. 86

86. Crouching Woman with a Boy Behind Her

1975.1.429
Pen and brown ink, brown wash, over black chalk. 195 × 148
mm. Mounted on a fragment of the page of an album.

One of the series "Sole Figure per Soffitti": see No. 83.

G. K.

PROVENANCE: Conte Algarotti-Corniani, Venice; Edward Cheney, Badger Hall, Shropshire; E. Parsons & Sons, London; Paul Wallraf, London. Acquired by Robert Lehman in 1962.

EXHIBITED: Venice 1959a, no. 63; Cologne 1959, no. 63; New York 1981, no. 83.

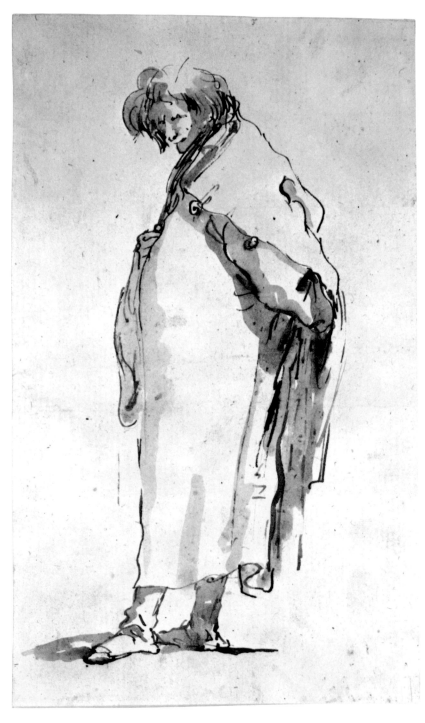

No. 87

87. Standing Man, Turned to the Left

1975.1.431
Pen and brown ink, brown wash. 193 × 116 mm.

One of the series "Sole Figure Vestite": see No. 83.

G. K.

PROVENANCE: Conte Algarotti-Corniani, Venice; Edward Cheney, Badger Hall, Shropshire; E. Parsons & Sons, London; Paul Wallraf, London. Acquired by Robert Lehman in 1962.

EXHIBITED: Venice 1959a, no. 67; Cologne 1959, no. 67; New York 1981, no. 86.

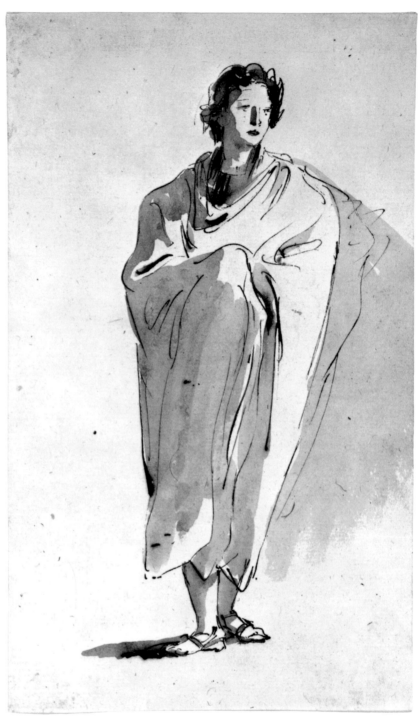

No. 88

88. Standing Figure of a Youth

1975.1.432
Pen and brown ink, brown wash. 200 × 120 mm.
PLATE 8.

One of the series "Sole Figure Vestite": see No. 83. Morassi suggests a date ca. 1755–60.[1]

G. K.

NOTE:
1. Venice 1959a, p. 51, no. 66.

PROVENANCE: Conte Algarotti-Corniani, Venice; Edward Cheney, Badger Hall, Shropshire; E. Parsons & Sons, London; Countess Wachtmeister; sale, Sotheby's, London, December 15, 1954, lot 115; Martin Asscher, London; Paul Wallraf, London. Acquired by Robert Lehman in 1962.

EXHIBITED: Venice 1959a, no. 66; Cologne 1959, no. 66; New York 1981, no. 87.

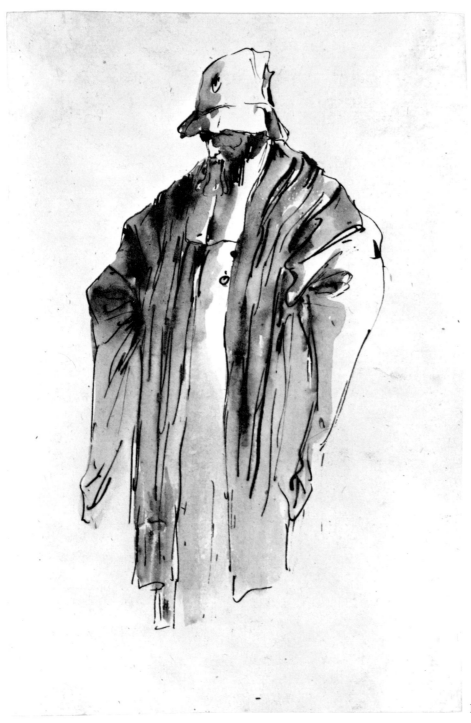

89. Bearded Man Looking Down to the Left

1975.1.433
Pen and brown ink, gray wash. 210 × 140 mm.
PLATE 9.

One of the series "Sole Figure Vestite": see No. 83. The
drawing is datable ca. 1760.

G. K.

PROVENANCE: Conte Algarotti-Corniani, Venice; Edward Cheney, Badger Hall, Shropshire; E. Parsons & Sons, London.

EXHIBITED: Huntington (N.Y.) 1980, no. 25; New York 1981, no. 80; Detroit 1983, no. 29.

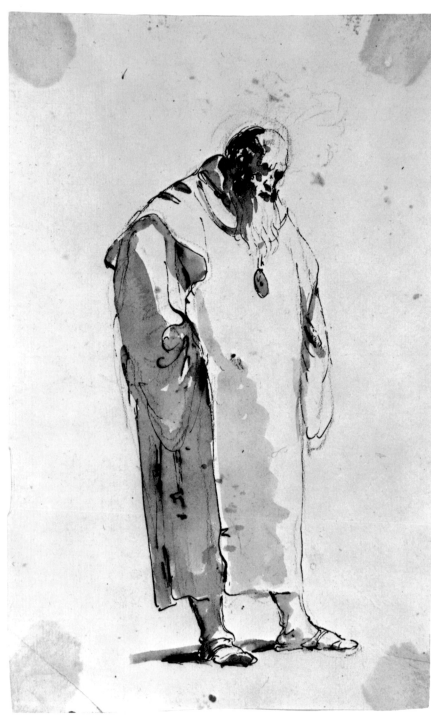

No. 90

90. Standing Man, Facing Half Right

1975.1.434
Pen and brown ink, brown wash. 224 × 140 mm. Mounted on a page from an album measuring 370 × 240 mm.

One of the series "Sole Figure Vestite": see No. 83. The drawing is datable ca. 1760.

G. K.

PROVENANCE: Conte Algarotti-Corniani, Venice; Edward Cheney, Badger Hall, Shropshire; E. Parsons & Sons, London.

EXHIBITED: New York 1981, no. 91; Rochester 1981, no. 32.

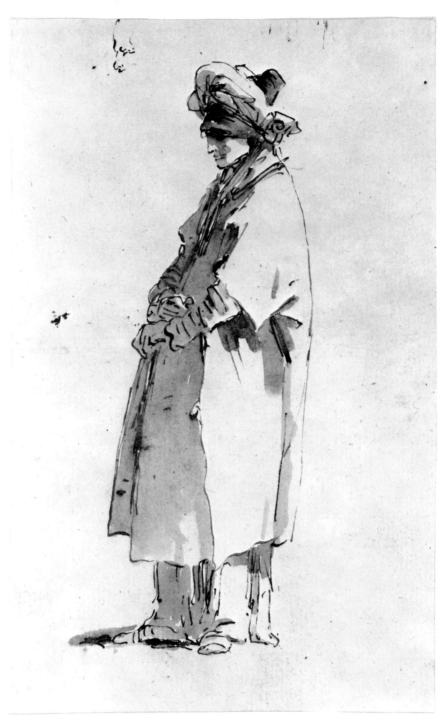

91. Man with an Elaborate Headdress, Facing Left

1975.1.436
Pen and brown ink, brown wash. 228 × 144 mm.

One of the series "Sole Figure Vestite": see No. 83. The
drawing is datable ca. 1755–60.

G. K.

PROVENANCE: Conte Algarotti-Corniani, Venice; Edward Che-
ney, Badger Hall, Shropshire; E. Parsons & Sons, London; Paul
Wallraf, London. Acquired by Robert Lehman in 1962.

EXHIBITED: Venice 1959a, no. 68; Cologne 1959, no. 68; New
York 1981, no. 88; Detroit 1983, no. 25.

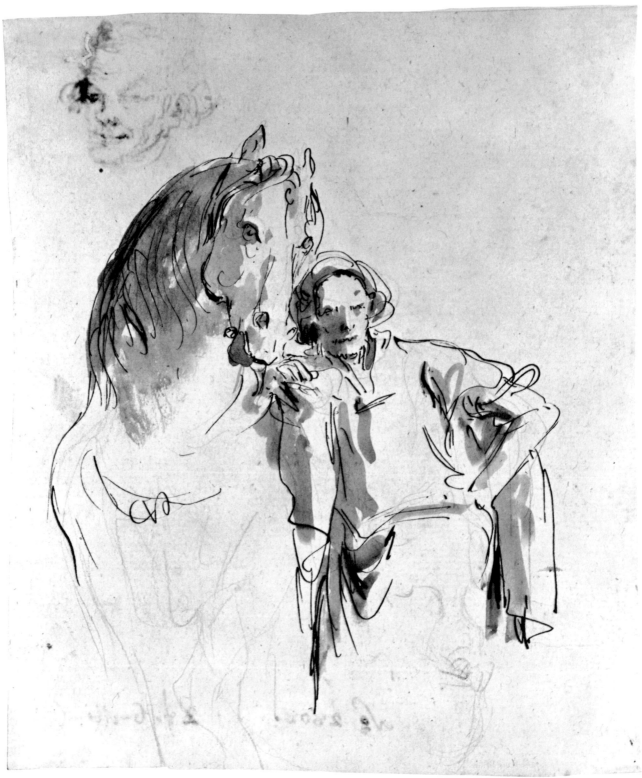

No. 92

92. Man Leaning against a Horse

1975.1.430

Pen and brown ink, brown wash, over black chalk. 195 × 165 mm.

Verso: Small study of a man's head, by a different hand. Annotated: *No 2808.2f. C.M.* (in ink); *601* (in pencil).

Morassi identified this drawing as a study for the fresco *Angelica Staunching the Wounds of Medoro* (Fig. 22) in the Sala dell'Orlando Furioso of the Villa Valmarana, painted in 1757.[1] An earlier study for this fresco, showing a parrot perched on a parapet instead of the present group, is in the Victoria and Albert Museum.[2]

The code on the verso identifies the drawing as having belonged to the Bossi-Beyerlen collection.[3]

G. K.

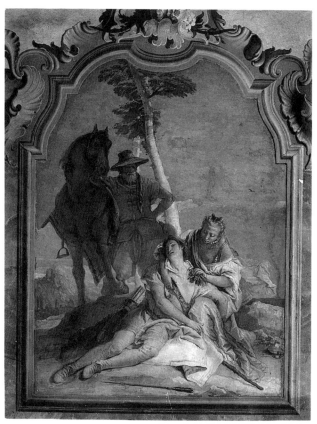

Fig. 22. Giovanni Battista Tiepolo. *Angelica Staunching the Wounds of Medoro.* Vicenza, Villa Valmarana

No. 92, Verso

NOTES:
1. Venice 1959a, pp. 48–49, no. 62.
2. Knox 1960, p. 83, no. 249; Knox 1975, pp. 85–86, no. 249.
3. See Stuttgart 1970, pp. 7–8, and Knox 1980b, pp. 200–207.

PROVENANCE: Giovanni Domenico Bossi, Munich; Karl Christian Friedrich Beyerlen, Stuttgart; Beyerlen sale, H. G. Gutekunst, Stuttgart, March 27, 1882; Sir Robert Abdy, London; Paul Wallraf, London. Acquired by Robert Lehman in 1962.

EXHIBITED: Venice 1959a, no. 62; Cologne 1959, no. 62; Washington 1974, no. 76; Huntington (N.Y.) 1980, no. 24; New York 1981, nos. 82a (recto), 82b (verso); Rochester 1981, no. 40; Detroit 1983, no. 26.

LITERATURE: Fröhlich-Bum 1957, p. 56, fig. 1; Szabo 1983, no. 72.

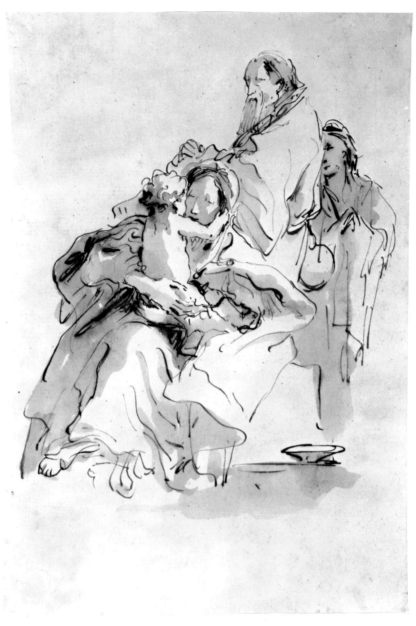

No. 93

93. The Holy Family with Saint John

1975.1.441
Pen and brown ink, brown wash. 291 × 202 mm.
PLATE 10.

At present some seventy-five variations on the theme of the Holy Family can be counted which come from the Owen-Savile Album, formerly the property of Edward Cheney.[1] A further sixteen specimens appear to come from other sources.

There is at present no evidence that offers a precise date for these drawings, but the period 1754–62 may be proposed on general stylistic grounds. Everything suggests that they were made entirely for their own sake, without reference to any projected painting. They float on the

page like exquisite arabesques, and together they represent the most magnificently sustained testimony to Giambattista's graphic inventiveness.

G. K.

NOTE:
1. For the history of the album see No. 78.

PROVENANCE: Library of the Somasco convent at Santa Maria della Salute, Venice; Leopoldo Cicognara; Antonio Canova; Monsignor Canova; Francesco Pesaro; Edward Cheney, Badger Hall, Shropshire; Cheney sale, Sotheby's, London, April 29, 1885, lot 1024; E. Parsons & Sons, London; Earl of Ranfurly; P. & D. Colnaghi & Co., London; Richard Owen, Paris; (possibly) sale, Sotheby's, London, May 31, 1932, lot 15; Henry S. Reitlinger, London; Reitlinger sale, Sotheby's, December 9,

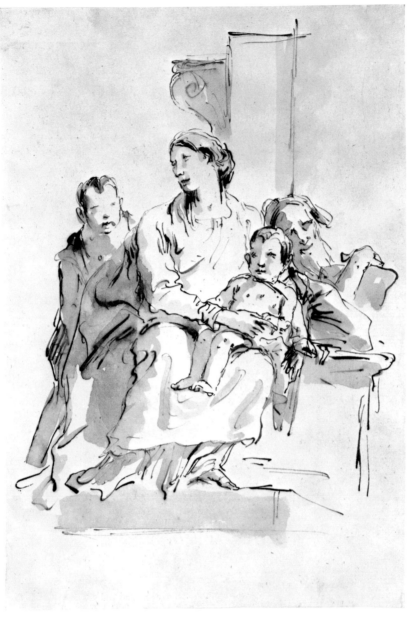

No. 94

1953, lot 109; Wildenstein & Co., London; Paul Wallraf, London. Acquired by Robert Lehman in 1962.

EXHIBITED: London 1954, no. 563; Venice 1959a, no. 69; Cologne 1959, no. 69; New York 1971, no. 133; Birmingham (Ala.) 1978, no. 79; New York 1981, no. 93; Pittsburgh 1985, no. 27.

LITERATURE: *Connoisseur* 1954, p. 265, fig. 10.

94. The Holy Family with Saint John

1975.1.442
Pen and brown ink, brown wash. 290 × 200 mm.

See No. 93. The drawing is datable to ca. 1754–62.

G. K.

PROVENANCE: Library of the Somasco convent at Santa Maria della Salute, Venice; Leopoldo Cicognara; Antonio Canova; Monsignor Canova; Francesco Pesaro; Edward Cheney, Badger Hall, Shropshire; Cheney sale, Sotheby's, London, April 29, 1885, lot 1024; E. Parsons & Sons, London; Earl of Ranfurly; P. & D. Colnaghi & Co., London; Richard Owen, Paris; Paul Wallraf, London. Acquired by Robert Lehman in 1962.

EXHIBITED: London 1954, no. 559; Venice 1959a, no. 70; Cologne 1959, no. 70; New York 1971, no. 132; New York 1981, no. 92; Rochester 1981, no. 38; Detroit 1983, no. 23.

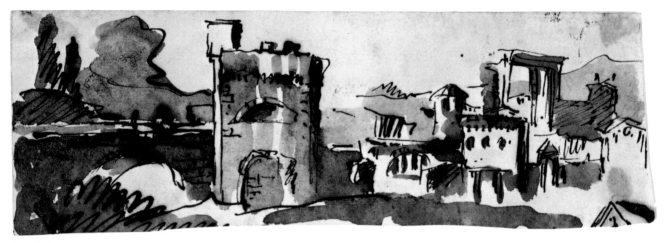

No. 95

95. View of a Town with a Fortified Bridge

1975.1.464
Pen and brown ink, brown wash. 60 × 175 mm.

I have suggested elsewhere that all the Tiepolo landscapes in pen and wash may have come from a single album, one of those bought by E. Parsons & Sons at the Cheney sale in 1885.[1] Two of the drawings are associated with the Villa Valmarana, and at least two are views of Udine: thus it seems that as a group they belong to the period ca. 1757–59.

No. 95 is a small but very beautiful example of a Tiepolo landscape drawing. It was an early acquisition of Robert Lehman's, and it may well have been bought from Parsons.

<div align="right">G. K.</div>

NOTE:

1. Knox 1973, p. 71, no. 55.

PROVENANCE: Not established.

EXHIBITED: Huntington (N.Y.) 1980, no. 31; New York 1981, no. 112; Pittsburgh 1985, no. 33.

LITERATURE: Knox 1973, p. 71, no. 55.

96. A Group of Punchinelli Seated

1975.1.438
Pen and brown ink, brown wash, over black chalk. 195 × 285 mm. Unidentified collector's mark in red.

Verso: Summary sketch of three figures for a ceiling. Black chalk.

The Punchinello drawings of Giambattista Tiepolo have been studied collectively by me elsewhere.[1] They appear to fall into three major groups. The earliest of these is a series of drawings which may be dated 1730–34; all of them show Punchinelli cooking and eating *gnocchi* and suffering the effects of *gnoccolonità*. The best examples of this group are those in the Art Institute of Chicago,[2] the Miotti collection in Udine,[3] the Museo Civico in Trieste,[4] the Ecole des Beaux-Arts in Paris,[5] and one sold at Sotheby's in 1974 and annotated *Collection Folinoux*.[6] The last of these is of particular interest, as it was etched by Georg Friedrich Schmidt in 1751; it was probably lent to Schmidt for this purpose by Francesco Algarotti.[7] Closely related to this group, and probably also of the same date, ca. 1730–34, are two paintings on the same theme: one in the Cailleux collection, and one formerly in the Besnard collection.[8] All of these works must be associated with the Veronese festival known as *Venerdì Gnoccolare*, which fell on the last Friday in carnival and was largely concerned with the cooking and consumption of vast quantities of *gnocchi*. Descriptions of the festival also show that groups of boys from the quarter of San Zeno wore the same costume (which is otherwise not at all characteristic of Punchinello), consisting of white clothes and hats together with the mask, as that worn by Giambattista's figures.[9]

No. 96

No. 96, Verso

The Punchinelli of Giambattista's second group are generally single figures; they may be dated ca. 1740–42. Good examples of this group belong to the Courtauld Institute of Art, London,[10] Mr. and Mrs. Eugene V. Thaw, New York,[11] and Janos Scholz, New York.[12]

A third group, to which the present example belongs, dates from the period 1754–62. Other fine examples are in the Shickman collection, New York,[13] and in that of Mrs. Hilda Harris, London.[14] There seems to be a further reference to *Venerdì Gnoccolare* in the conical pot at the extreme right of the Lehman drawing.

Thus it seems that the Punchinello theme occupied Giambattista at intervals over a period that may have lasted as long as thirty years. It is not out of the question that it was contact with Verona that stimulated this interest, beginning in about 1730 when Giambattista was working with Scipione Maffei on the illustrations of the *Verona illustra*. The later examples, including No. 96, may belong to the summer of 1760, when he was working in Verona on the ceiling of the Palazzo Canossa.

G. K.

NOTES:

1. Knox 1984.
2. Joachim and McCullagh 1979, p. 79, no. 117, pl. 125.
3. Udine 1965, p. 81, no. 47.
4. Vigni 1972, pp. 101–2, nos. 220, 221.
5. Delacre and Lavallée 1927, pl. 11.
6. Sale, Sotheby's, London, June 27, 1974, lot 64; Knox 1984, pp. 444, 446 n. 20, fig. 20.
7. Santifaller 1976a, pp. 204–9, fig. 2.
8. Morassi 1962, p. 40, figs. 420, 421. The first of these is now at Leeds Castle near Maidstone, Kent.
9. See Torri 1847, especially document VII, pp. 42–48, an account of the festival written in 1759 by Gianalberto Tumermani. See also Bloomington (Ind.) 1979, pp. 27, 154 no. S41.
10. London 1963, p. 117, no. 305.
11. Cambridge (Mass.) 1970, no. 86; New York 1975, pp. 54–55, no. 48.
12. Birmingham (Ala.) 1978, p. 90, no. 58.
13. Cambridge (Mass.) 1970, no. 84.
14. Morassi 1955, p. 147, pl. 41d.

PROVENANCE: Paul Wallraf, London. Acquired by Robert Lehman in 1962.

EXHIBITED: Venice 1959a, no. 71; Cologne 1959, no. 71; Washington 1974, no. 81; Birmingham (Ala.) 1978, no. 64; New York 1981, no. 75; Rochester 1981, no. 30; Detroit 1983, no. 24; Pittsburgh 1985, no. 22.

LITERATURE: Fröhlich-Bum 1957, p. 56, fig. 2; Bloomington (Ind.) 1979, p. 29, fig. 4; Szabo 1983, no. 70; Knox 1984, p. 444; fig. 21.

97. Caricature of a Fat Man, Seen from Behind

1975.1.459

Pen and black ink, gray wash. 165 × 120 mm. (the four corners cut). Numbered in brown ink on the backing paper, top right: *20*. Annotated in brown ink on the verso of the backing paper: *fr.6 = 6a* (top); *Tiepoletto veneziano 1760* (bottom).

The finest Tiepolo caricatures[1] are a series of one hundred six which came from an album formerly owned by Arthur Kay of Edinburgh.[2] In addition to these, there are well over a hundred others, recorded as coming from various sources, the largest group being a set of thirty-two once in the collection of the Conti Valmarana in Vicenza.[3] It is probable that the fifteen caricatures in the Lehman Collection all come from this source, though No. 103 may be an exception. They are distinguished by their old mounts with, in many cases, a number in ink at top right (the highest being *38* on No. 98), the annotation *fr.6 = 6a* on the verso at the top, and the annotation *Tiepoletto veneziano* (which is normally faded, as though some attempt had been made to erase it) and the date *1760*, also in ink, on the verso at the bottom. It is not clear whether

No. 97

this date should be read as the date of the drawing or that of the mounting. Like many of the drawings from the Kay album, some from this series were used as models by Domenico Tiepolo at a later date.

No. 97 is used by Domenico for a figure in two drawings of scenes from contemporary life: *Nine Gentlemen*, in the Biblioteca Reale in Turin,[4] and *The Country Walk*, formerly in the collection of Dr. O. Wertheimer, Paris.[5]

G. K.

NOTES:
1. For a general discussion of Tiepolo's caricatures, see Kozloff 1960–61.
2. Sold at Christie's on April 9, 1943. For the earlier history of the Kay album, so far as it is known, see Cambridge (Mass.) 1970, no. 87.
3. Venice 1959a, pp. 56, 59.
4. Bertini 1958, no. 680; Mariuz 1971, drawing no. 29.
5. Byam Shaw 1962, pl. 73.

PROVENANCE: Conti Valmarana, Vicenza; Paul Wallraf, London. Acquired by Robert Lehman in 1962.

EXHIBITED: Venice 1959a, no. 87; Cologne 1959, no. 87; Huntington (N.Y.) 1980, no. 26; New York 1981, no. 97; Detroit 1983, no. 35.

No. 98

98. Caricature of a Person in a Voluminous Gown, Seen from Behind

1975.1.450
Pen and black ink, gray wash. 174 × 102 mm. (the four corners cut). Numbered in brown ink on the backing paper, top right: *38*. Annotated in brown ink on the verso of the backing paper: *fr.6 = 6a* (top); *Tiepoletto veneziano 1760* (bottom).

See No. 97.

G. K.

PROVENANCE: Conti Valmarana, Vicenza; Paul Wallraf, London. Acquired by Robert Lehman in 1962.

EXHIBITED: Venice 1959a, no. 82; Cologne 1959, no. 82; New York 1981, no. 106.

99. Caricature of a Man in a Voluminous Cloak, Carrying a Walking Stick, Seen from Behind

1975.1.451

Pen and dark brown ink, brown wash. 185 × 122 mm. (the four corners cut). Numbered in brown ink on the backing paper, top right: *19.* Annotated in brown ink on the verso of the backing paper: *fr.6 = 6a* (top); *Tiepoletto veneziano 1760* (bottom).

See No. 97.

G. K.

PROVENANCE: Conti Valmarana, Vicenza; Paul Wallraf, London. Acquired by Robert Lehman in 1962.

EXHIBITED: Venice 1959a, no. 84; Cologne 1959, no. 84; New York 1981, no. 99.

100. Caricature of a Man in a Mask and a Cloak, Holding a Muff and a Tricorne, Standing in Profile to the Left

1975.1.452

Pen and brown ink, brown wash. 175 × 115 mm. (the four corners cut). Remains of a number in brown ink, cut off, on the backing paper, top right. Annotated in brown ink on the verso of the backing paper: *fr.6 = 6a* (top); *Tiepoletto veneziano 1760* (bottom).

See No. 97.

G. K.

PROVENANCE: Conti Valmarana, Vicenza; Paul Wallraf, London. Acquired by Robert Lehman in 1962.

EXHIBITED: Venice 1959a, no. 85; Cologne 1959, no. 85; Huntington (N.Y.) 1980, no. 28; New York 1981, no. 98; Pittsburgh 1985, no. 29.

101. Caricature of a Man with His Arms Folded, Standing in Profile to the Left

1975.1.453

Pen and brown ink, brown wash, over pencil. 176 × 80 mm. (the four corners cut).

See No. 97. There are no annotations on the mount in this instance. A very similar figure, probably based upon this drawing, appears in two of Domenico Tiepolo's *Scenes of Contemporary Life: The Lion's Cage* (Fig. 23) in the National Gallery of Canada, Ottawa,[1] and *A Family Party in a Villa Garden* in a French private collection.[2]

G. K.

Fig. 23. Domenico Tiepolo. *The Lion's Cage.* Ottawa, National Gallery of Canada

NOTES:
1. Ottawa 1974, no. 20.
2. Byam Shaw 1962, pl. 70.

PROVENANCE: Conti Valmarana, Vicenza; Paul Wallraf, London. Acquired by Robert Lehman in 1962.

EXHIBITED: Venice 1959a, no. 74; Cologne 1959, no. 74; New York 1981, no. 100; Pittsburgh 1985, no. 30.

No. 99

No. 101

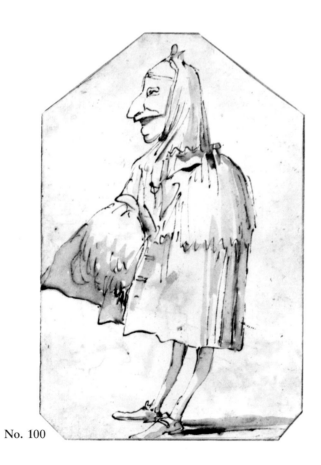

No. 100

102. Caricature of a Man in a Mask and a Tricorne, Standing in Profile to the Left

1975.1.454

Pen and brown ink, brown wash. 185 × 102 mm. (the four corners cut). Remains of a number in brown ink, cut off, on the backing paper, top right. Annotated in brown ink on the verso of the backing paper: *fr.6 = 6a* (top); *Tiepoletto veneziano 1760* (bottom).

See No. 97. G. K.

PROVENANCE: Conti Valmarana, Vicenza; Paul Wallraf, London. Acquired by Robert Lehman in 1962.

EXHIBITED: Venice 1959a, no. 77; Cologne 1959, no. 77; Washington 1974, no. 83; Huntington (N.Y.) 1980, no. 29; New York 1981, no. 108; Rochester 1981, no. 35; Detroit 1983, no. 33; Pittsburgh 1985, no. 32.

LITERATURE: Szabo 1983, no. 74.

103. Caricature of a Seated Man with a Book and a Cane

1975.1.455

Pen and brown ink, brown wash, over black chalk. 165 × 137 mm. (the four corners cut). Mounted on a fragment of the page of an album.

See No. 97. There are no annotations on the mount in this instance.

Morassi notes a similarity to a caricature of a seated man in the Morelli collection in Milan.[1] In this instance the subject may be identified as a schoolmaster.

G. K.

NOTE:
1. Venice 1959a, p. 55, no. 73.

PROVENANCE: Paul Wallraf, London. Acquired by Robert Lehman in 1962.

EXHIBITED: Venice 1959a, no. 73; Cologne 1959, no. 73; Washington 1974, no. 82; New York 1981, no. 101.

104. Caricature of a Man Holding a Tricorne, Seen from Behind

1975.1.456

Pen and black ink, gray wash. 197 × 122 mm. (the four corners cut). Numbered in brown ink on the backing paper, top right: 5. Annotated in brown ink on the verso of the backing paper: *fr.6 = 6a* (top); *Tiepoletto veneziano 1760* (bottom).

See No. 97. No. 104 is used by Domenico Tiepolo in one of his drawings of scenes from contemporary life, *The Peep Show*, in a French private collection.[1]

G. K.

NOTE:
1. Byam Shaw 1962, pl. 76.

PROVENANCE: Conti Valmarana, Vicenza; Paul Wallraf, London. Acquired by Robert Lehman in 1962.

EXHIBITED: Venice 1959a, no. 76; Cologne 1959, no. 76; Huntington (N.Y.) 1980, no. 30; New York 1981, no. 104; Rochester 1981, no. 34; Pittsburgh 1985, no. 31.

105. Caricature of a Man Seen from Behind

1975.1.457

Pen and black ink, gray wash. 190 × 113 mm. (the four corners cut). Numbered in brown ink on the backing paper, top right: *32*. Annotated in brown ink on the verso of the backing paper: *fr.6 = 6a* (top); *Tiepoletto veneziano 1760* (bottom).

See No. 97. G. K.

PROVENANCE: Conti Valmarana, Vicenza; Paul Wallraf, London. Acquired by Robert Lehman in 1962.

EXHIBITED: Venice 1959a, no. 78; Cologne 1959, no. 78; Huntington (N.Y.) 1980, no. 29; New York 1981, no. 109.

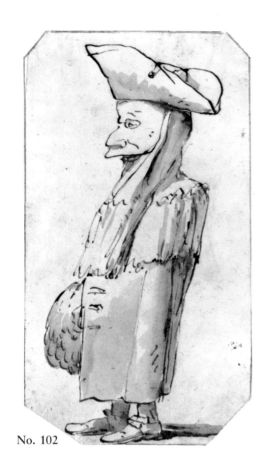

No. 102

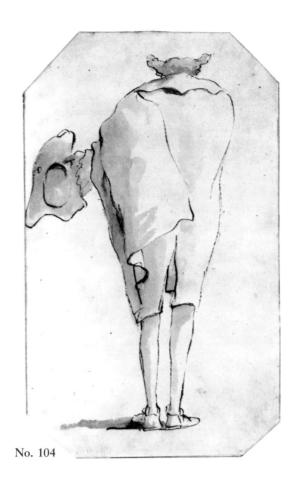

No. 104

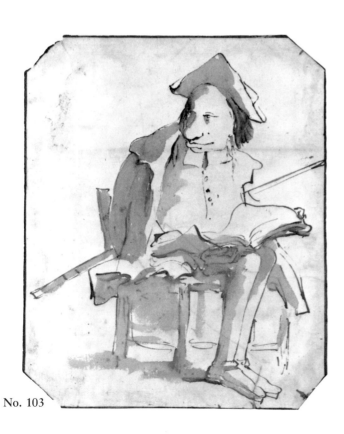

No. 103

No. 105

106. Caricature of a Man Wearing a Wig and a Tricorne, Seen from Behind

1975.1.458

Pen and black ink, gray wash. 185 × 115 mm. (the four corners cut). Annotated in brown ink on the verso of the backing paper: *fr.6 = 6a* (top); *Tiepoletto veneziano 1760* (bottom).

See No. 97.

G. K.

PROVENANCE: Conti Valmarana, Vicenza; Paul Wallraf, London. Acquired by Robert Lehman in 1962.

EXHIBITED: Venice 1959a, no. 79; Cologne 1959, no. 79; New York 1981, no. 103.

107. Caricature of a Fat Person Wearing a Long Cloak and a Tricorne, Seen from Behind

1975.1.449

Pen and black ink, gray wash. 175 × 123 mm. (the four corners cut).

See No. 97. In this instance there are no annotations on the mount.

G. K.

PROVENANCE: Conti Valmarana, Vicenza; Paul Wallraf, London. Acquired by Robert Lehman in 1962.

EXHIBITED: Venice 1959a, no. 86; Cologne 1959, no. 86; Birmingham (Ala.) 1978, no. 80; Huntington (N.Y.) 1980, no. 27; New York 1981, no. 105; Rochester 1981, no. 36; Detroit 1983, no. 34.

LITERATURE: Kozloff 1960–61, p. 33, fig. 12.

108. Caricature of a Man Wearing a Wig and a Tricorne, Seen from Behind

1975.1.460

Pen and dark brown ink, brown wash. 186 × 105 mm. (the four corners cut). Numbered in brown ink on the backing paper, top right: *1*. Annotated in brown ink on the verso of the backing paper: *fr.6 = 6a* (top); *Tiepoletto veneziano 1760* (bottom).

See No. 97.

G. K.

PROVENANCE: Conti Valmarana, Vicenza; Paul Wallraf, London. Acquired by Robert Lehman in 1962.

EXHIBITED: Venice 1959a, no. 81; Cologne 1959, no. 81; New York 1981, no. 107.

109. Caricature of a Man Carrying a Stick, Standing in Profile to the Left

1975.1.461

Pen and black ink, gray wash. 147 × 74 mm. (the four corners cut). Annotated in brown ink on the verso of the backing paper: *Tiepoletto veneziano 1760*.

See No. 97.

G. K.

PROVENANCE: Conti Valmarana, Vicenza; Paul Wallraf, London. Acquired by Robert Lehman in 1962.

EXHIBITED: Venice 1959a, no. 80; Cologne 1959, no. 80; New York 1981, no. 102.

No. 106

No. 108

No. 107

No. 109

133

No. 110

No. 111

110. Caricature of a Man Holding a Tricorne, Walking to the Left

1975.1.462

Pen and pale brown ink, gray wash. 173 × 111 mm. (the four corners cut). Numbered in brown ink on the backing paper, top right: 27. Annotated in brown ink on the verso of the backing paper: *fr.6 = 6a* (top); *Tiepoletto veneziano* [partly erased] *1760* (bottom).

See No. 97. Morassi suggests a date of ca. 1740–45 for this drawing.[1]

G. K.

NOTE:
1. Venice 1959a, p. 56, no. 75.

PROVENANCE: Conti Valmarana, Vicenza; Paul Wallraf, London. Acquired by Robert Lehman in 1962.

EXHIBITED: Venice 1959a, no. 75; Cologne 1959, no. 75; Birmingham (Ala.) 1978, no. 48; New York 1981, no. 110.

111. Caricature of a Man in a Long Cloak, Standing in Profile to the Left

1975.1.463

Pen and black ink, gray wash. 248 × 181 mm. (the four corners cut). Numbered in brown ink on the backing paper, top right: 30. Annotated in brown ink on the verso of the backing paper: *fr.6 = 6a* (top); *Tiepoletto veneziano* [partly erased] *1760* (bottom).

See No. 97.

G. K.

PROVENANCE: Conti Valmarana, Vicenza; Paul Wallraf, London. Acquired by Robert Lehman in 1962.

EXHIBITED: Venice 1959a, no. 83; Cologne 1959, no. 83; New York 1981, no. 111.

Domenico Tiepolo

(Venice 1727–Venice 1804)

Giovanni Domenico Tiepolo (Giandomenico, or simply Domenico, as he is usually called) was the elder of Giambattista Tiepolo's two artist sons, and so long as his father was alive—that is, until 1770, when Giambattista died in Spain and Domenico returned to Venice—he remained a devoted member of the family studio. It was an establishment of the sort that seems particularly characteristic of Venice from the fifteenth century onward. But whereas among the Vivarini (Antonio, Bartolommeo, and Alvise), and the three Bellini also, honors may have been even, a different pattern was set in the sixteenth-century studios of Jacopo Tintoretto, with his son and daughter, and of Jacopo Bassano, with his four sons. The master now in each case overshadowed his family, who were content to work devotedly as his assistants; and that was the situation in which Domenico Tiepolo and his brother Lorenzo grew up.

Of Domenico's early talent there can be no doubt. His earliest signed or documented paintings—*The Stations of the Cross* for San Polo in Venice (1747–48), the overdoors in the Kaisersaal at Würzburg (1751), one or two large altarpieces (for San Francesco di Paola, Venice, 1748, and Merlengo, 1750), and the charming genre scenes in the Villa Valmarana, painted when he was still only thirty years old—are enough to show that he was not far behind his father as an executant, however dependent he may have been on him for inspiration and style; only lately, paintings have been recognized as Domenico's that had long passed for the work of Giambattista. Nor is it easy to decide how much of the great works commissioned to Giambattista, at Würzburg, at the Valmarana, in Venice, at Strà, and in Madrid, was in fact carried out by his son in the course of their close collaboration.

The same doubt exists regarding many of the drawings of Domenico's earlier years, up to the death of his father in 1770—especially those chalk drawings, so many of which are now at Stuttgart, that correspond closely to details of the frescoes at Würzburg and other paintings produced at about that time: George Knox believes them to be working drawings for the frescoes by Giambattista himself, while others (including myself) believe them to be for the most part copies from the paintings made for record purposes, in some cases with a view to etching, by Domenico and his brother Lorenzo. But that particular problem need not concern us here, as no chalk drawings are included in this section of the Lehman catalogue.

It is evident that Robert Lehman had a special *penchant* for Domenico Tiepolo's drawings, and this group of sixty-four (not including two formerly attributed to Domenico which I believe to be by his brother Lorenzo) is one of the most varied to come from any one private collection. Together with the drawings that were already in the Metropolitan Museum, it probably makes that institution richer in the representation of Domenico than any other, public or private, at the present time. All the drawings described here are in pen and wash, or occasionally pen or brush only; they are all entirely characteristic, and most of them are signed.[1]

I am confident that most of these drawings are productions of Domenico's later years, made after his return from Spain. For a while, in the conservative atmosphere of Venice in the seventies and eighties, Domenico was the leading painter in the Grand Manner. He was required, as his father had been, to paint splendid allegories and mythologies for the palaces, as well as religious subjects for the churches, of the city and the surrounding country; there were frescoes for Casale sul Sile in 1781, for San Lio in Venice in 1783, for the Palazzo Contarini dal Zaffo in 1784, and a great ceiling for the doges' palace in Genoa in the same year. But the Grand Manner, even in Venice, began slowly to go out of fashion; and that Domenico was able to find time, chiefly about 1791–93, to continue on a considerable scale the decoration of his own family villa at Zianigo, north of Padua, which he had to some extent begun before the Tiepolos left for Spain in 1762, is probably sufficient evidence of the decline in demand for large-scale painting in the old style. Although the Camera dei Satiri at Zianigo had been begun in 1759, it was finished only in 1771 (both dates occur in inscriptions), whereas the Camerino dei Centauri is of 1791. I believe that all the drawings *in series*—that is, of approximately the same size and in the same style, and often numbered—both of satyr and centaur subjects are to be dated after 1770. There can be no doubt, furthermore, that two of Domenico's best series, the Scenes of Contemporary Life and the Punchinellos, belong to the last fifteen years of his life. This was the period when he seems to have applied himself almost exclusively to drawing, perhaps chiefly to amuse himself; he became, as the Marquis de Chennevières very aptly remarked in 1898, "*un bavard du dessin, le plus séduisant et le plus intarissable des bavards, si l'on peut dire.*"[2] Many of the Contemporary Life scenes bear the date 1791; no other date occurs, though from the high-waisted dresses of the ladies and the occasional beaver

hats and narrow trousers of the young gentlemen I suspect that some are later than that. As for the Punchinellos, delightful as they are, a few of them reveal a tremulous uncertainty in the penwork—compared, for instance, with the sureness of line in the scenes of high and low daily life of 1791—which suggests to me that this long series of 104 drawings was only completed in Domenico's very last years.

It might be thought, too, that the frequent repetition in these late drawings of certain human and animal figures from earlier works denotes a failing of the artist's imagination in old age. This practice is particularly evident in Domenico's drawings of animals, which are so well represented in the Robert Lehman Collection. It will be noticed, in the catalogue entries, that almost every animal drawing has some derivation from another source. It is difficult, in drawing attention to this, not to be tediously pedantic and, apart from that, to avoid giving the impression of an artist of very little originality. But in fact Domenico's practice of repeatedly using a stock figure from his portfolio—one of his own, or of his father's, or one borrowed from a print by some earlier artist—seems to have been characteristic of him from the first, and to have later become part of his established method: it might almost be considered a sort of ingenious game, in which he would sometimes half hide one of his favorite donkeys behind another, or cut off the hind legs of the ubiquitous large hunting-dog while leaving just enough of the animal to make it recognizable to an observant eye.[3] As for the plagiarism of earlier sources, that was quite common practice among all but the very greatest artists, and not only in the eighteenth century. Domenico was extremely adroit in taking an animal from Johann Elias Ridinger or Johann Heinrich Roos and adapting it to his own composition: his interpretation of a rather dry etching is masterly, and few people would suspect, in looking at the donkey in No. 147 or the sheep and goats in No. 154, that this had been the procedure.

J. B. S.

NOTES:
1. On Domenico's signature, see Byam Shaw 1962, pp. 63–64.
2. Chennevières 1898, p. 149.
3. See the entry for No. 152.

LITERATURE: Byam Shaw 1962; Mariuz 1971.

112. The Betrothal of the Virgin

1975.1.514

Pen and brown ink, brown wash, over black chalk. 483 × 386 mm. Signed in brown ink, on a paper attached to the column at the right: *Dom° Tiepolo f.*

This drawing and No. 113 are good examples from the long series of biblical subjects of very large dimensions, pictorially composed, which Domenico drew almost certainly after his return from Spain in 1770.[1] One hundred thirty-eight of them are bound in a folio volume in the Louvre, presented in 1889 and known as the Recueil Fayet, and there are two others with a different provenance in the same museum. Eighty-two more were sold from the collection of Roger Cormier of Tours in 1921, and the Lehman drawings are from that source. Robert Lehman formerly owned one other, the *Arrival of the Virgin in Bethlehem*.[2]

I think it likely—to judge by the numbers in the Recueil Fayet and in the former Cormier collection, with others traceable elsewhere[3]—that Domenico may have produced as many as 250 or more of these biblical (or at least religious) subjects in the same style and format. Many of them run in sequences: the Recueil Fayet has all fourteen Stations of the Cross, numbered below in Roman numerals, and no less than ten variants of the Flight into Egypt

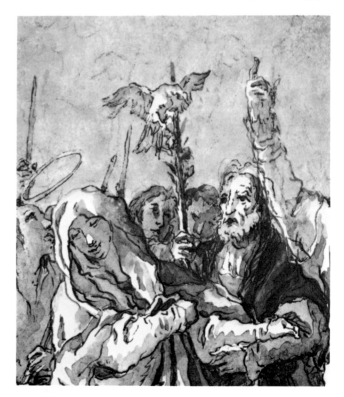

No. 112, Detail

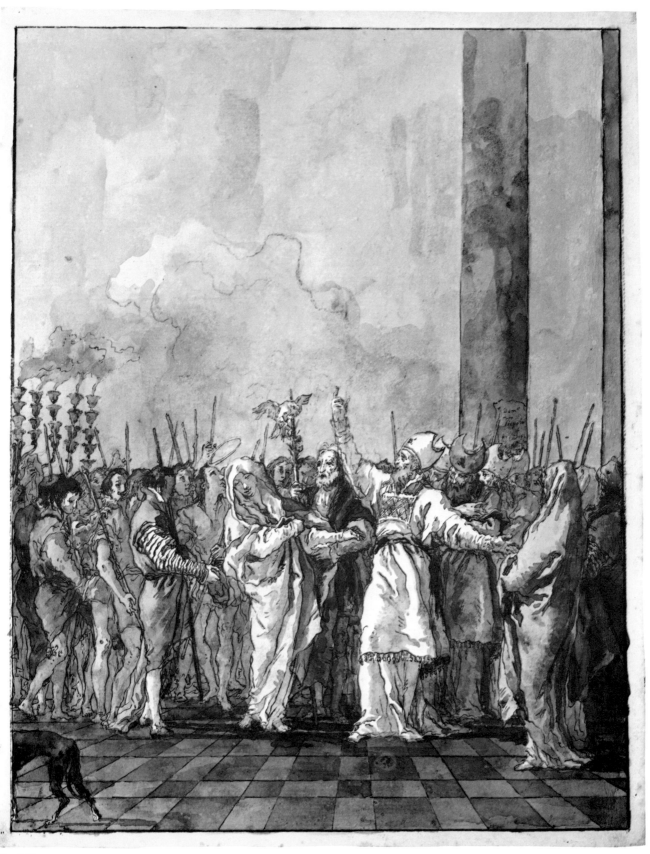

No. 112

—which is also the subject of No. 113 in the present catalogue and of three drawings in the Pierpont Morgan Library.[4]

The story of the betrothal of Mary and Joseph, and of the flowering of Joseph's rod to distinguish him from her other suitors, is common in the iconography of art though it is not found in the canonical gospels. Some of the subjects illustrated in Domenico's series of drawings are obscure, and may derive from fragmentary apocryphal gospels,[5] which seem to have been familiar to painters in the eighteenth century.

J. B. S.

NOTES:
1. I have described the series at some length in Byam Shaw 1962, pp. 36–37, reproducing six examples, pls. 38–43.
2. New York 1971, p. 102, no. 254.
3. Twelve in the Heinemann collection, New York (New York 1981, pp. 58–62, nos. 100–111), are from the Cormier sale, but those in the Morgan Library and in the Musée des Beaux-Arts et de l'Archéologie in Besançon, for instance, are from earlier sources. I do not know the sources of those in the Sterling and Francine Clark Art Institute in Williamstown.
4. Two of the Morgan Library drawings are catalogued in New York 1971, p. 103, nos. 255, 266.
5. See James 1953.

PROVENANCE: Luzarche, Tours; Roger Cormier, Tours; Cormier sale, Galerie Georges Petit, Paris, April 30, 1921, no. 44; Adrien Fauchier-Magnan, Paris and Cannes-La Bocca; Fauchier-Magnan sale, Sotheby's, London, December 4, 1935, lot 61; G. Bensimon, New York. Acquired by Robert Lehman in 1961.

EXHIBITED: Amsterdam 1936, no. 216; New York 1971, no. 253; Birmingham (Ala.) 1978, no. 131; New York 1981, no. 128.

LITERATURE: Guerlin 1921, p. 94; Santifaller 1976b, p. 78, fig. 17.

113. The Rest on the Flight into Egypt (with a Truncated Pyramid on the Right)

1975.1.474
Pen and brown ink, brown wash, over rough black chalk. 470 × 379 mm. Signed in brown ink, bottom left: *Dom⁰ Tiepolo f.*

PLATE 11.

In his many representations, within the Large Biblical Series to which this drawing belongs (see No. 112), of various incidents from the Flight into Egypt, Domenico occasionally used figures from his own beautiful series of etch-

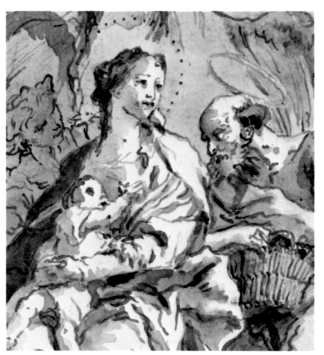

No. 113, Detail

ings, *Idee pittoresche sopra la Fugga in Egitto*, which he had produced at a much earlier date, between 1750 and 1753, and dedicated to the Prince-Bishop of Würzburg. Thus, in the present example, the figure of the Virgin corresponds closely with its counterpart in no. 4 of the set of etchings (that is, the first after the three dedication and title pages) and is clearly copied from it, though the Child's figure is altered.[1]

J. B. S.

NOTE:
1. An equally clear instance of copying occurs in an unpublished drawing of the subject, from the same Large Biblical Series, belonging to Miss Lovice Ullein-Reviczky in Zürich. There the angel leading the donkey is copied from no. 5 of the etched series.

PROVENANCE: Luzarche, Tours; Roger Cormier, Tours; Cormier sale, Galerie Georges Petit, Paris, April 31, 1921, no. 54; Duc de Trevise, Paris; Tomas Harris, London.

EXHIBITED: New York 1971, p. 103, no. 257; Birmingham (Ala.) 1978, no. 129; New York 1981, no. 127; Detroit 1983, no. 39; Pittsburgh 1985, no. 39.

LITERATURE: Szabo 1983, no. 76.

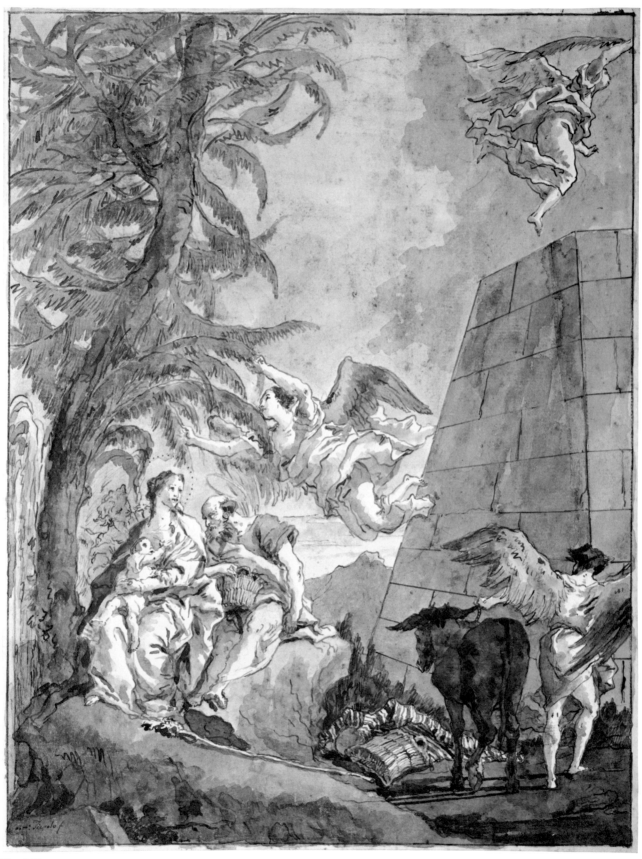

No. 113

114. The Baptism of Christ (with Two Ducks in the Water at Lower Right)

1975.1.475

Pen and brown ink, brown and gray wash. 245 × 194 mm. (small piece missing at upper left corner). Signed in brown ink, on the rock in center foreground: *Dom° Tiepolo f.* Annotated in brown ink on the verso: *A*[scratched out]. *f. I. CM. No. 2914.*

For the series to which this and the following five drawings belong, see my publication of 1962.[1] Since that book was written, thirteen more of the same series appeared at Christie's in an album, the property of Earl Beauchamp, which had once been in the collection of Horace Walpole at Strawberry Hill;[2] all of them have old numbers, including *86, 89,* and *98* at the upper left. Thirteen others are in the Stuttgart print room;[3] there, as here, the old numbers seem to have been cut off above; but all are annotated on the verso, in the same fashion as No. 114, with a code that denotes provenance from the collection of Giovanni Domenico Bossi (1765–1853) of Munich. That collection passed to Bossi's son-in-law Karl Beyerlen (1825–1881), after whose death it was sold at auction by H. G. Gutekunst of Stuttgart on March 27, 1882. It was by far the largest surviving collection of Tiepolo drawings, and the source of almost all those now in the Stuttgart print room.[4]

Other examples from this series are referred to in my book,[5] and others still in the Stuttgart catalogue of 1970.[6] Most of them are rather roughly drawn with a broad (reed?) pen, though it is noticeable that one of the Lehman group, No. 117, is done with a finer pen than the rest. Many have been trimmed in the height, thereby losing their old numbers.

Domenico shows remarkable skill, here as in all his religious series, in concocting different compositions from the same material without exactly repeating himself. The main ingredients, however, are always the same: Christ standing in the shallow water, the Baptist on the bank above him, generally with his lamb and banner, an angel or two holding Christ's robe, other candidates awaiting baptism, crowding spectators, usually including a turbaned Oriental, and the Holy Dove descending from the sky.

The Baptism series, like the Saint Anthony series (see No. 121), almost certainly dates from after 1770 and probably from before 1790.[7] There is a related painting, in oblong format, in the Museo Stibbert in Florence.[8]

J. B. S.

NOTES:

1. Byam Shaw 1962, pp. 33–34.
2. Sale, Christie's, London, June 15, 1965, lots 6–18. See also No. 121 below.
3. Stuttgart 1970, pp. 57–58, nos. 44–56.
4. For a history of the Bossi-Beyerlen collection, see George Knox's valuable introduction to the catalogue of the Tiepolo Bicentenary Exhibition at Stuttgart: Stuttgart 1970, pp. 7–8; see also Knox 1980b, pp. 200–207.
5. Byam Shaw 1962, loc. cit.
6. Stuttgart 1970, p. 47, under no. 44.
7. The date 1770, which Knox seems to accept as that of the whole series, did not occur among the inscriptions inside the cover of the Walpole-Beauchamp album. It does occur in the corner of the Gatteri album of Tiepolo drawings in the Museo Correr, Venice, which is certainly inscribed in the same hand (perhaps that of Giambattista's brother-in-law Francesco Guardi). There it cannot be more than an approximate guess—or, possibly, it is only the date at which the writer acquired the Correr album.
8. Mariuz 1971, p. 119, pl. 305.

PROVENANCE: Giovanni Domenico Bossi, Munich; Karl Christian Friedrich Beyerlen, Stuttgart; Beyerlen sale, H. G. Gutekunst, Stuttgart, March 27, 1892; A. D. Pilkington, London; P. & D. Colnaghi & Co., London. Acquired by Robert Lehman in 1961.

EXHIBITED: London 1953b, no. 28; New York 1981, no. 124; Rochester 1981, no. 47; Pittsburgh 1985, no. 37.

LITERATURE: Byam Shaw 1962, p. 34, n. 1.

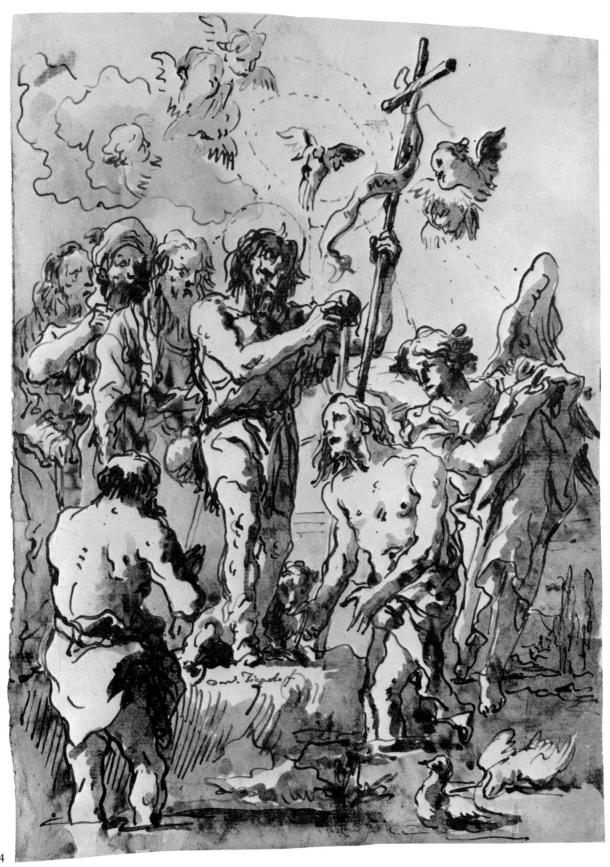

No. 114

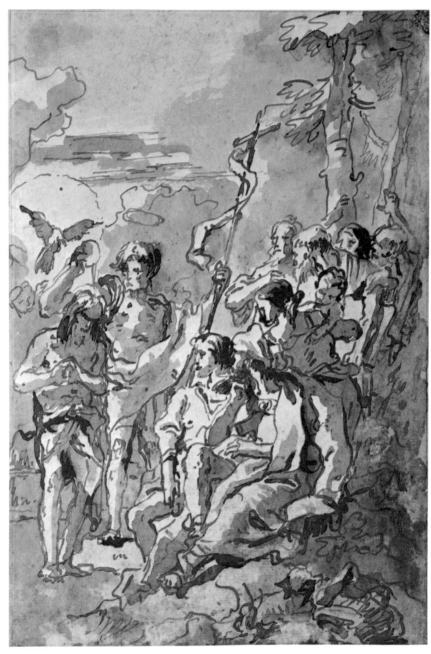

No. 115

115. The Baptism of Christ (with a Woman Holding a Child Among the Spectators at the Right)

1975.1.503

Pen and brown ink, brown wash. 263 × 170 mm. (almost certainly trimmed below, and perhaps above). Damp-stained below.

See No. 114. The fact that the drawing has been trimmed may account for the absence of signature and old number.

The detail of the figures is confused; it is difficult to distinguish the head and leg of the man seated beside the boy in the foreground. J. B. S.

PROVENANCE: The Hellenic and Roman Society, London; P. & D. Colnaghi & Co., London; T. Grange, London; Charles E. Slatkin Galleries, New York. Acquired by Robert Lehman in 1960.

EXHIBITED: New York 1981, no. 120.

LITERATURE: Byam Shaw 1962, p. 34, n. 1.

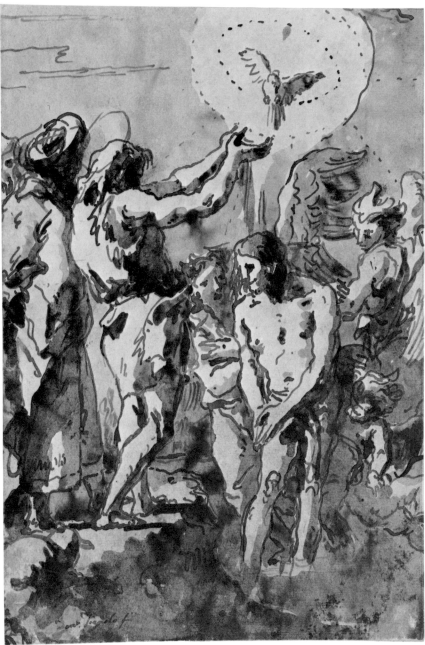

No. 116

116. The Baptism of Christ (with Saint John, Without his Cross, in Profile to the Right)

1975.1.477

Pen and brown ink, gray wash. 219 × 146 mm. Signed in ink, bottom left: *Dom° Tiepolo f.* Damp-stained below.

See No. 114. To judge from its dimensions compared to those of other drawings in the series (for example, No. 117), this sheet has almost certainly been trimmed on three sides—though probably not below, where the signature appears.

J. B. S.

PROVENANCE: The Hellenic and Roman Society, London; P & D. Colnaghi & Co., London; T. Grange, London.

EXHIBITED: New York 1981, no. 123.

LITERATURE: Byam Shaw 1962, p. 34, n. 1.

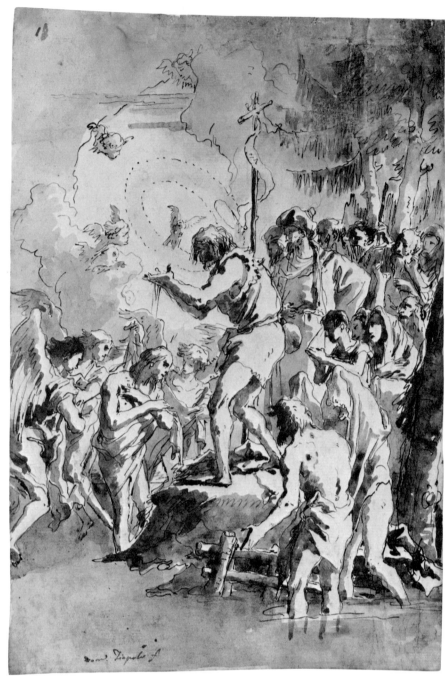

No. 117

117. The Baptism of Christ (with Three Angels Attending Him)

1975.1.478

Pen and brown-gray ink, brown-gray wash. 283 × 194 mm.
Signed in brown ink, bottom left: *Dom° Tiepolo f.*

See No. 114. This is the best of the Lehman drawings of
the Baptism series. It has more figures than the others, is
more carefully drawn with a finer pen, and is in good con-
dition.

J. B. S.

PROVENANCE: Sale, Hôtel Drouot, Paris, June 13, 1956, no. 21
(illustrated in the catalogue, pl. 5).

EXHIBITED: New York 1981, no. 121; Pittsburgh 1985, no. 36.

LITERATURE: Byam Shaw 1962, p. 34, n. 1.

144

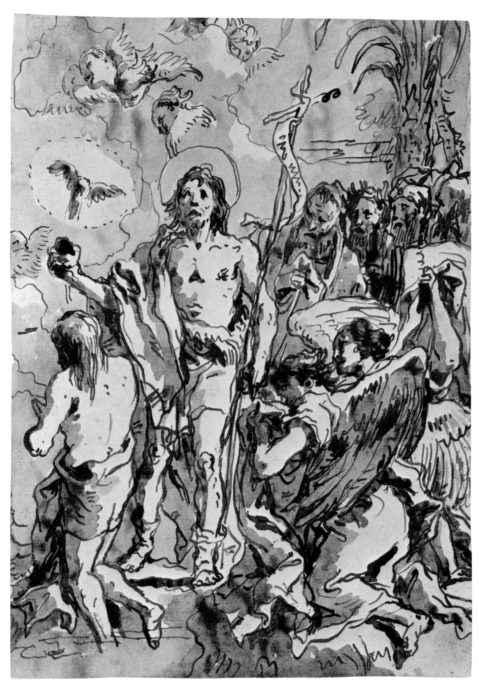

118. The Baptism of Christ (with Christ Half-Kneeling at Left, His Back Turned, and the Baptist Full-Face at Center, Looking Up)

1975.1.479
Pen and brown ink, brown-gray wash. 254 × 181 mm.

See No. 114. The signature may have been cut off below.

J. B. S.

PROVENANCE: Not established.

EXHIBITED: New York 1981, no. 122.

LITERATURE: Byam Shaw 1962, p. 34, n. 1.

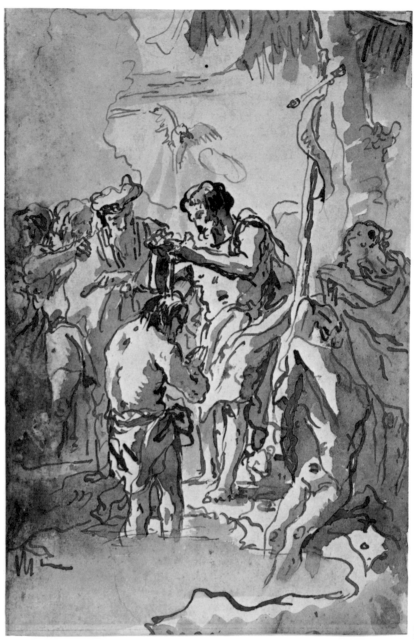

No. 119

119. The Baptism of Christ (with Christ Standing at Left Center, His Back Turned, and a Youth Stripping in the Right Foreground)

1975.1.476

Pen and brown ink, light brown wash. 257 × 171 mm. (probably trimmed at bottom).

See No. 114. The signature may have been cut off below.

The rather inappropriate figure of Christ is almost a repetition of the figure of an elderly man awaiting baptism in the left foreground of No. 114. Such repetitions are rare in Domenico's variations on a single theme.

J. B. S.

PROVENANCE: The Hellenic and Roman Society, London; P. & D. Colnaghi & Co., London; T. Grange, London; Charles E. Slatkin Galleries, New York. Acquired by Robert Lehman in 1960.

EXHIBITED: New York 1981, no. 125; Detroit 1983, no. 37.

LITERATURE: Byam Shaw 1962, p. 34, n. 1; Szabo 1983, no. 75.

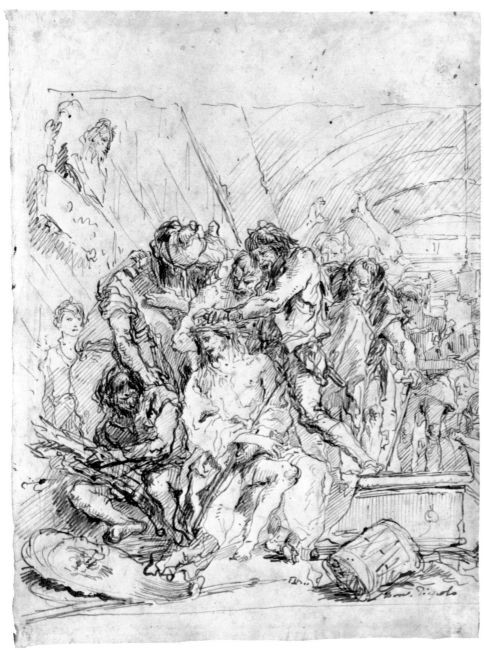

120. Christ Crowned with Thorns

1975.1.481

Pen and brown ink. 268 × 219 mm. Signed in brown ink, bottom right: *Dom. Tiepolo*.

This drawing belongs to a series of scenes from the Passion of Christ, all freely drawn in pen and ink without wash, which I have described in my book on Domenico's drawings.[1] Several of the series are in Stuttgart.[2] Four variant versions of the subject Christ Crowned with Thorns are known to me, the other three being one at Stuttgart,[3] one formerly in the collection of Tomas Harris in London,[4] and one that was with the dealer Gustav Nebehay in Vienna in 1927.[5] The Lehman drawing is the most finished and, in my opinion, the best of these four; the Stuttgart exhibition catalogue of 1970 mentions others at Leningrad and Dresden.[6] I do not believe that the drawings of this series are quite as early as Domenico's paintings of the Passion in San Polo, Venice (1747–48); but they are certainly considerably earlier than the Passion series finished by him in 1772, after his return to Venice, for the Madrid convent of San Felipe Neri. They are unusual in technique, being shaded with the pen, not washed with the brush, and yet pictorially composed. In the pres-

ent case, the desired dimensions are indicated by the rough borderline above and below. Perhaps a set of etchings was intended.

There is a resemblance here to the figure of Christ in Titian's late painting *Christ Crowned with Thorns* in the Alte Pinakothek, Munich.[7] Whether or not that Titian is the one sold to the Elector of Bavaria by Domenico Tintoretto,[8] it certainly appears in an inventory of Schloss Schleissheim of 1748, and Domenico Tiepolo is unlikely to have seen the original. The connection, however, seems certain, for in a drawing of the same subject belonging to the Large Biblical Series (for which see No. 112)[9] the figures of Christ and of the executioner on the right correspond rather closely *in the reverse direction* with those in the Munich Titian, rather than with those in the much earlier version of the subject by Titian, which is now in the Louvre. This might suggest that Domenico used an engraving after the painting, but no such engraving seems to be recorded.

J. B. S.

NOTES:

1. Byam Shaw 1962, pp. 35, 76 under pl. 19.
2. Stuttgart 1970, pp. 41–42, nos. 22–28.
3. Stuttgart 1970, p. 41, no. 24; Udine 1971, vol. 2, p. 43, no. 60.
4. Byam Shaw 1962, p. 76, pl. 19.
5. Nebehay n.d. (not paginated; drawings not numbered).
6. Stuttgart 1970, p. 41, under no. 24.
7. Wethey 1969–75, vol. 1, p. 83, no. 27, pls. 133, 135.
8. See Wethey 1969–75, loc. cit., but also Kultzen 1975, p. 126.
9. Domenico's large drawing is reproduced in the catalogue of the Cormier sale, Galerie Georges Petit, Paris, April 30, 1921, no. 14.

PROVENANCE: T. Grange, London.

EXHIBITED: New York 1981, no. 126; Detroit 1983, no. 38; Pittsburgh 1985, no. 38.

LITERATURE: Byam Shaw 1962, pp. 35, 76 under pl. 19.

121. Saint Anthony of Padua with the Christ Child, in an Interior

1975.1.480

Pen and brown ink, brown wash. 244 × 177 mm. Signed in ink, bottom center: *Dom° Tiepolo f.* Numbered in brown ink, top left, in a nearly contemporary hand: *74.*

No. 121 belongs to one of the most numerous of Domenico's series of variations on a single theme. Many of the drawings have, like this one, an old number at the top left corner. In my book published in 1962 I recorded numbers as high as *102* (which occurs on one of seven examples in

the Stuttgart print room);[1] since then, an album of over one hundred sixty drawings by Domenico, including no less than twenty of the Saint Anthony series, was sold at Christie's.[2] This album, the property of Earl Beauchamp, had once been in the collection of Horace Walpole at Strawberry Hill, and all of the drawings in it were numbered in the same way,[3] one of them (lot 20 in the sale) being inscribed *104.* George Knox, in his catalogue of the Tiepolo bicentenary exhibition held in Stuttgart in 1970, records a still higher number, *125,* on a drawing in the collection of the Landgrave of Hesse.[4] Nine of the Saint Anthony series are reproduced by Knox in that catalogue, and many others are mentioned. In 1978 Wolfgang Schulz, in a general essay on the subject,[5] reproduced fifteen, including the Lehman sheet, with a list of all those known to him, arranged according to the old numbers.

In most of the drawings the saint is represented in the clouds, with attendant angels or *putti* (who sometimes carry large books); but in some he is seated or standing in a chapel, or (as here) in a humble monk's cell with a cross in the background. It is generally agreed that the whole series must have been drawn after Domenico's return from Spain in 1770.[6] The inspiration for the subject may have been the oval painting now in the Prado, one of several works produced by the Tiepolos for the Royal Chapel at Aranjuez not long before Giambattista's death.[7] Whether that painting is all by Giambattista (as Morassi believed), or wholly or in part by Domenico (as Sir Michael Levey maintains), I believe that the corresponding drawing in red and white chalks, which was formerly in the Stuttgart print room,[8] is not Giambattista's preliminary study, but a record of the painting by Domenico—a record that he took back to Venice, and from which the Saint Anthony series of pen and wash drawings naturally developed at a later date. One of the twenty in the Walpole-Beauchamp album[9] might then be considered as an intermediate stage between the record-drawing of the Aranjuez painting and this series as a whole.[10]

J. B. S.

NOTES:

1. Byam Shaw 1962, p. 34.
2. Sale, Christie's, London, June 15, 1965, lots 19–38, all illustrated in the catalogue. See also No. 114.
3. The fact that Horace Walpole died in 1797, seven years before Domenico Tiepolo, might be taken as evidence that the old numbering on these drawings, which is the same as that which occurs on various other series by the artist, must have been done either by Domenico himself, toward the end of his life, or perhaps by one of his family. We do not know when Walpole acquired his album (see the foreword to the Christie's catalogue of 1965); it is out of the question that he should have acquired it when he was in Italy in 1739–41.

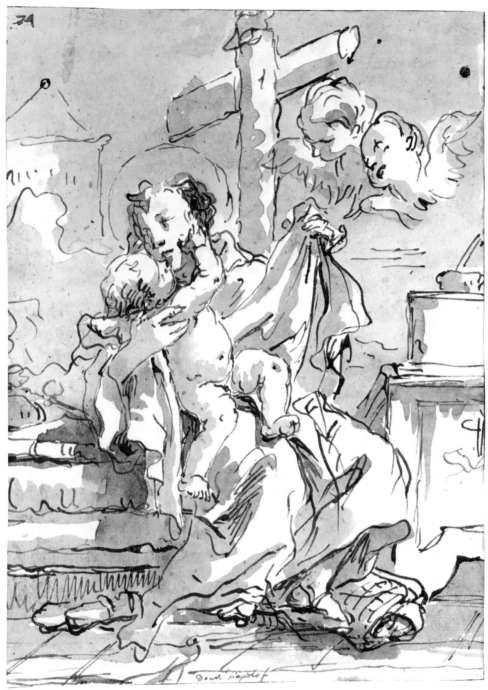

No. 121

It has not been traced in any of the Walpole sales. It may of course have been given to him not long before his death; it is just possible, I suppose, that it was among the books left to him in 1780 by his devoted friend Mme. du Deffand (the title page was inscribed in French).

4. Stuttgart 1970, p. 63, under no. 57.
5. Schulz 1978.
6. See n. 3 for the *terminus ante quem*.
7. Morassi 1962, p. 23, fig. 179 (then in the Rodríguez Bauzá collection, Madrid).
8. Stuttgart 1970, p. 142, no. 166.

9. Lot 19 in the Christie's catalogue of 1965.
10. See also Schulz 1978, pp. 72–73, and, for a different opinion, Knox in Stuttgart 1970, p. 142.

PROVENANCE: P. & D. Colnaghi & Co., London. Acquired by Robert Lehman in 1960.

EXHIBITED: London 1960, no. 14; New York 1981, no. 129; Pittsburgh 1985, no. 40.

LITERATURE: Schulz 1978, p. 72, no. 74, fig. 6; Byam Shaw 1979, p. 240, under no. 2.

122. A Saint Preaching, and the Head of an Oriental

1975.1.502

Pen and brown ink, brown wash, over rough black chalk.
190 × 260 mm.

The main group may represent Saint Anthony preaching to the fishes, with a crowd of spectators behind him, as in a drawing in Stuttgart.[1] According to the legend, when Saint Anthony was preaching on the shore at Rimini and the bystanders were tired of hearing him, the fishes gathered and he preached to them instead. The rough style of the drawing is like that of *Saint Gerolamo Miani Saying Mass* in the Musée Bonnat, Bayonne,[2] which is probably a sketch for the monochrome fresco painted by Domenico in the family chapel at Zianigo, near Padua, in 1759; and that must be about the date of the Lehman drawing. An even rougher sketch by Domenico, probably of the same subject but composed in the reverse direction, was sold at Christie's in 1978.[3]

Heads very like that of the Oriental on the right appear in drawings by Giambattista Tiepolo at Trieste.[4] On the verso of another sheet at Trieste[5] is a similar head certainly by Domenico; the recto is a *Holy Family* by Giambattista,[6] no doubt of the later 1750s. That dating for the present drawing seems to be supported by yet another Trieste example,[7] in which the same sort of Oriental head again appears (sketched, in this case, entirely with the point of the brush) on a larger scale and independently of other sketches on the same sheet, exactly as in the Lehman drawing: on the recto of that sheet,[8] also by Domenico, is a sketch for a grisaille medallion painted by him in the Villa Valmarana, near Vicenza, in 1757.[9]

J. B. S.

NOTES:
1. Byam Shaw 1962, p. 75, pl. 16; Stuttgart 1970, no. 21.
2. Byam Shaw 1962, pp. 75–76, pl. 17.
3. Sale, Christie's, London, December 12, 1978, lot 93 (illustrated in the catalogue).
4. Vigni 1942, p. 53, nos. 134–37.
5. Ibid., p. 67, no. 210 bis.
6. Ibid., p. 67, no. 210.
7. Ibid., p. 75, no. 252 bis.
8. Ibid., p. 75, no. 252.
9. See Vigni 1943, pp. 14–16.

PROVENANCE: Conte E. R. Lamponi-Leopardi, Florence (Lugt 1760); unidentified collector (mark bottom right); Paul Wallraf, London. Acquired by Robert Lehman in 1962.

EXHIBITED: Venice 1959a, no. 93; Cologne 1959, no. 93; New York 1981, no. 114; Rochester 1981, no. 41.

123. Angels in the Sky

1975.1.484

Pen and gray and brown ink, gray and brown wash.
165 × 230 mm. Damaged along the lower edge, and water-stained.

One or two drawings of similar subjects were among those sold in London by the Hellenic and Roman Society in 1958, and many were included in the contents of the album belonging to Earl Beauchamp that was broken up for sale at Christie's in 1965.[1] In most of these the principal figure is seen from the back with his great wings outspread, as here. Such figures appear in the ceiling paintings, whether of sacred or allegorical or mythological subjects, of the latter part of Domenico Tiepolo's career. Here one of the angels is carrying a wreath (which may be a martyr's crown), and the angel seen from behind is very like the angel "troubling the water" in a canvas now in the Louvre, *Christ at the Pool of Bethesda*.[2] Otherwise, the closest correspondence with the present drawing that I can find is in the figure of Fame, carrying two trumpets, in the ceiling fresco *The Glory of Spain* in the Queen's Antechamber in the Royal Palace at Madrid.[3] In any case the type was probably established before the departure of the Tiepolos for Spain in 1762 by the similar figure in Giambattista's *Apotheosis of the Pisani Family*, the great ceiling-piece in the Pisani villa at Strà, completed in that year.[4]

J. B. S.

NOTES:
1. See Nos. 114, 121.
2. Mariuz 1971, p. 132, pl. 167.
3. Mariuz 1971, p. 123, pl. 184.
4. Morassi 1955, p. 149, pl. 78.

PROVENANCE: Hellenic and Roman Society, London (?); P. & D. Colnaghi & Co., London (?). Charles E. Slatkin Galleries, New York. Acquired by Robert Lehman in 1960.

EXHIBITED: New York 1981, no. 145.

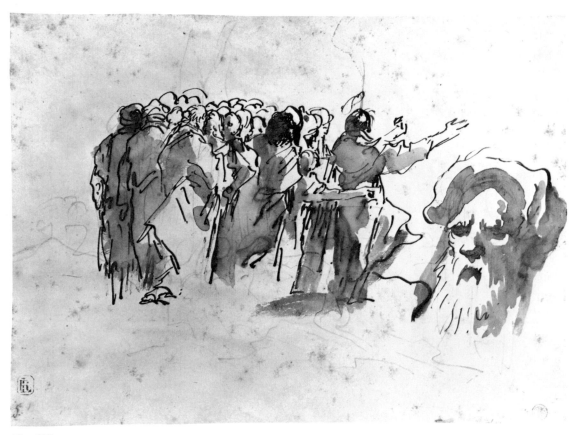

No. 122

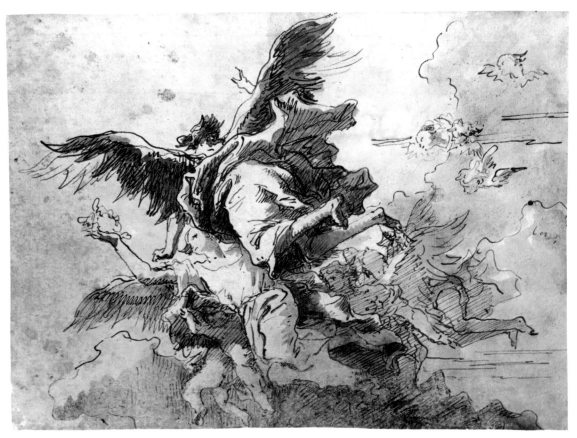

No. 123

124. A Flock of Winged Cherubs in the Sky, One Holding a Martyr's Palm

1975.1.486

Pen and brown ink, brown and gray wash. 170 × 250 mm. (area of ca. 20 × 120 mm. made up, center bottom; narrow strip, ca. 60 mm. long, added to right edge at bottom).

See the entry for No. 125 for the distinction between this drawing and Nos. 125, 126, and 127. The martyr's palm suggests that No. 124 was intended for a religious subject. There is also a slight difference in technique: here the cherub at the upper right corner and part of the sky are shaded with the pen in close parallel strokes, recalling Domenico's technique in etching.

J. B. S.

PROVENANCE: Hellenic and Roman Society, London; P. & D. Colnaghi & Co., London; Paul Wallraf, London. Acquired by Robert Lehman in 1962.

EXHIBITED: Venice 1959a, no. 109; Cologne 1959, no. 109; New York 1981, no. 139; Rochester 1981, no. 46.

125. Cupid Blindfold, Carried through the Sky by Seven Winged Putti

1975.1.483

Pen and brown ink, brown wash. 172 × 243 mm. Remains of the signature, in brown ink, cut off, bottom right.

In describing, in 1962, the many drawings by Domenico of Cupids and cherubs in the clouds,[1] I did not properly distinguish those that represent Cupid blindfold, with attendant *putti* and doves, as he appears here and in two other Lehman drawings, Nos. 126 and 127, from those such as No. 124, where there is no Cupid and where one of the cherubs is carrying a martyr's palm. Within the second category it is sometimes hard to decide whether the flying cherubs are intended for the vision of a martyred saint or some other religious subject, or whether they are simply little creatures of the air cast for some secular or mythological allegory. But the clusters of winged *putti* attending or carrying Cupid are easily recognized; the drawings in which they occur are almost as numerous as those of the other group, and often identical in style. Cupid often carries a bow and one arrow drawn from his quiver; he or one of his attendants may carry a garland; and there are nearly always two doves, released from harness to Venus's chariot, of which a wheel or a harnessing-pole

often appears, as it does in No. 126. The source of inspiration for the series may have been the ceiling-painting now in the Fondation Ephrussi de Rothschild at Saint-Jean-Cap-Ferrat, which I believe to be by Domenico himself.[2]

Four excellent examples with the blindfold Cupid, very like ours, were in the album formerly owned by Horace Walpole that was sold by Earl Beauchamp at Christie's in 1965;[3] among the many other drawings of flying *putti* in that sale some can be identified as representing Cupid with his attendants, even though the god is not blindfold, by the presence of his mother's chariot and doves.[4] Three more with Cupid blindfold, again identical with the Lehman drawings in style, are in the Royal Museum, Canterbury.[5]

It is difficult to see what Domenico's purpose was in making so many drawings of such subjects—drawings that often bear contemporary numbers, like those of his other series (in this series the numbers go as high as *137*, on lot 108 from the Walpole-Beauchamp album). His ability to vary the composition and the individual figures, without ever (so far as I can discover) exactly repeating himself, is astonishing. Perhaps he was simply displaying his virtuosity, like a pianist improvising on his instrument. I cannot find that any of the drawings were directly used for paintings with Cupids or cherubs, such as the oval *Triumph of Faith* in the Louvre or the ceiling fresco in Palazzo Contarini dal Zaffo, Venice, which is of 1784.[6] Nor can I with confidence suggest any but an approximate date—that is, after Domenico's return from Spain in 1770, when he turned more and more to drawing for its own sake. Morassi, however, dates the series within narrower limits, to 1780–90.[7]

J. B. S.

NOTES:
1. Byam Shaw 1962, pp. 38–39.
2. See Morassi 1962, p. 44, fig. 342 (as by Giambattista Tiepolo), and Byam Shaw 1979, p. 241, fig. 1.
3. Sale, Christie's, London, June 15, 1965, lots 118–21.
4. Lots 112, 113.
5. Byam Shaw 1979, p. 240, pls. 5–7; exhibited Canterbury 1985, nos. 37–39.
6. Mariuz 1971, pp. 132, 145, pls. 325, 329, 333, 334.
7. Venice 1959a, under no. 110.

PROVENANCE: Galerie Cailleux, Paris. Acquired by Robert Lehman in 1960.

EXHIBITED: New York 1981, no. 147; Rochester 1981, no. 44.

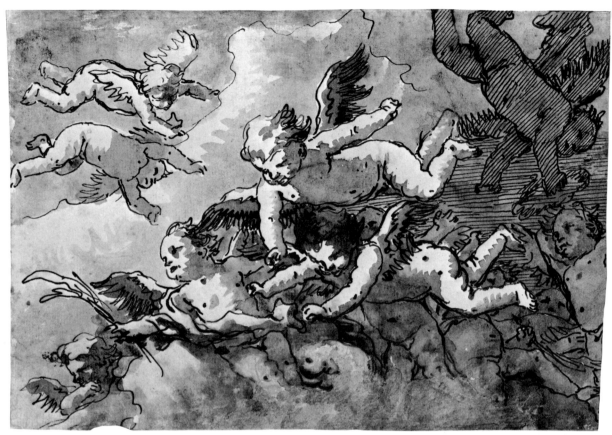

No. 124

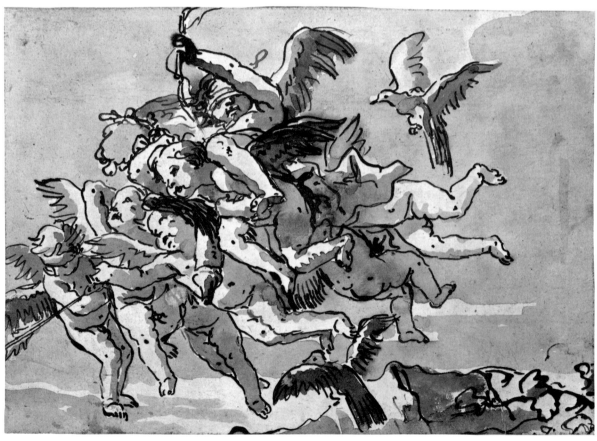

No. 125

153

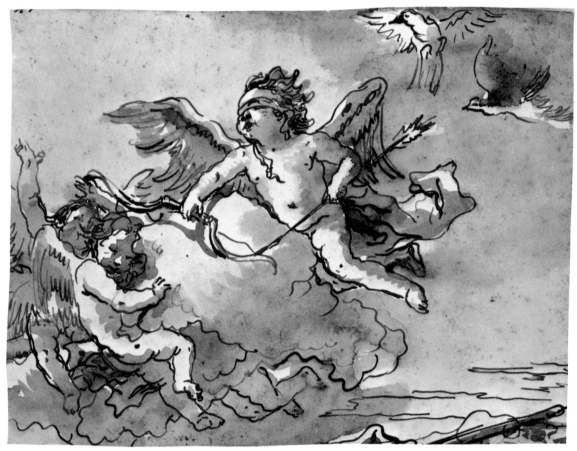

No. 126

126. Cupid Blindfold, on a Cloud Supported by Two Attendant Putti

1975.1.485
Pen and two shades of brown ink, brownish gray wash.
185 × 245 mm. Remains of an old three-figure number in
brown ink, cut off, top left.

See the entry for No. 125. The harnessing-pole of Venus's
chariot appears here at the lower right corner.

J. B. S.

PROVENANCE: Paul Wallraf, London. Acquired by Robert
Lehman in 1962.

EXHIBITED: Venice 1959a, no. 110; Cologne 1959, no. 110;
New York 1981, no. 149; Pittsburgh 1985, no. 50.

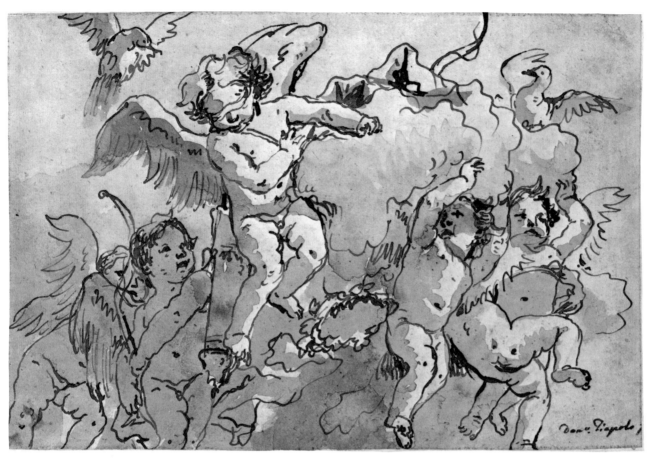

No. 127

127. Cupid Blindfold in the Clouds, with Five Attendant Putti

1975.1.509
Pen and brown ink, grayish brown wash. 163 × 240 mm.
Signed in gray ink, bottom right: *Dom°. Tiepolo f.*

See No. 125. The head of Cupid is almost identical with its counterpart in one of the three drawings of this series in the Royal Museum, Canterbury.[1]

J. B. S.

NOTE:
1. Byam Shaw 1979, p. 240, pl. 6; Canterbury 1985, no. 38.

PROVENANCE: Galerie Cailleux, Paris. Acquired by Robert Lehman in 1960.

EXHIBITED: New York 1981, no. 146; Rochester 1981, no. 45.

128. Sketch for a Ceiling with an Allegory of Fortitude and Wisdom

1975.1.482
Pen and brown ink, brown wash, over black chalk. 255 × 189
mm. (top right corner made up). Oval margin line indicated
below. Numbered in brown ink on added top right corner:
270 (the number has been retraced in gray ink).

The drawing, though not signed, is typical of Domenico's
rougher style. The composition owes something to various
ceiling paintings and sketches by his father: the sketch and
the finished fresco (transferred to canvas) with the Apotheosis
of Orazio Porto, from Palazzo Porto at Vicenza, both
now in the Art Museum of Seattle,[1] and the ceiling canvas
with an allegory of Fortitude and Wisdom now in the
Museo Civico at Udine.[2] The central figures in the Udine
painting resemble rather closely, in the reverse direction,
those representing the same Virtues in the upper part of
our drawing.

A variant version of the same composition, also by
Domenico but still more roughly drawn, and without the
angel blowing a trumpet in the sky above, is in the Biblio-
teca Ambrosiana, Milan.[3] The date of both drawings may
be 1780–85.

J. B. S.

NOTES:
1. Morassi 1962, p. 48, figs. 330, 331.
2. Ibid., p. 52, fig. 344. Almost identical figures of the two
 Virtues appear in a large canvas by Giambattista in Ca' Rez-
 zonico, Venice (ibid., p. 55, fig. 345), and in the oil sketch for
 that work in the Museo Poldi Pezzoli, Milan (ibid., p. 25,
 fig. 343).
3. Ruggeri 1976, pp. 62–63, no. 107.

PROVENANCE: T. Grange, London; Charles E. Slatkin Galleries,
New York. Acquired by Robert Lehman in 1960.

EXHIBITED: New York 1981, no. 153; Pittsburgh 1985, no. 53.

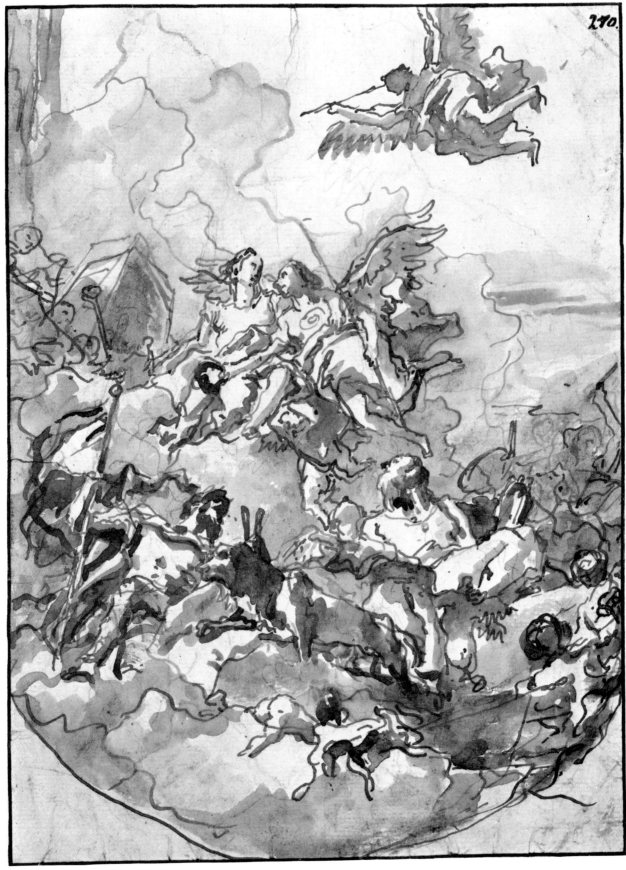

No. 128

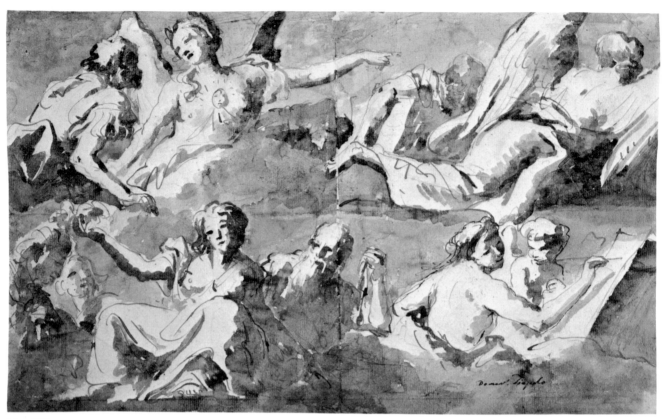

No. 129

129. Frieze of Allegorical Figures in Two Rows

1975.1.500

Pen and light brown ink, brush and gray wash over black chalk, partly strengthened with a fine pen and dark brown ink. 220 × 365 mm. Paper folded vertically at center before drawing was executed. Signed in dark brown ink, lower right: *Dom° Tiepolo.*

The figures on the left, in both the upper and lower rows, seem to represent Time Revealing Truth. On the right, is a winged genius, above, and an allegory of Painting, below. Morassi[1] refers to a continuation of the present drawing on a sheet, unknown to me, belonging to a collector in Zürich.

The drawing is unusual in Domenico's oeuvre; it is hard to date, but probably from after 1770.

J. B. S.

NOTE:

1. Venice 1959a, p. 70, no. 108.

PROVENANCE: Alfred Scharf, London; Paul Wallraf, London. Acquired by Robert Lehman in 1962.

EXHIBITED: Venice 1959a, no. 108; Cologne 1959, no. 108; New York 1981, no. 150; Detroit 1983, no. 50.

130. Rinaldo Enchanted by Armida

1975.1.494

Pen and gray ink, gray wash. 238 × 165 mm. Annotated in pencil on verso of backing paper: *Attributed to Vandyck.*

The subject of this pretty drawing has been supposed to be Mars and Venus, but I have no doubt that it is in fact an illustration of the same story, from Tasso's *Gerusalemme Liberata*, represented in another Lehman drawing, No. 131. Here the sorceress Armida, guided in her magic chariot to where the young Christian warrior Rinaldo lies asleep, casts a spell over him. They fall in love, and are only parted (as we see in No. 131) when the two knights Ubaldo and Guelfo find them and persuade Rinaldo to return to duty with the Crusaders. Unlike the other drawing (q.v.), this one seems to be an original composition of Domenico's, which perhaps accounts for the looser, sketchier style. It is however clearly inspired in a general way by the same subject in one of Giambattista's four canvases illustrating Tasso's story, now in the Art Institute of Chicago (this painting was, in fact, etched by Domenico).[1] The upper part of the figure of Rinaldo there is very like that of the young warrior here; and there too is

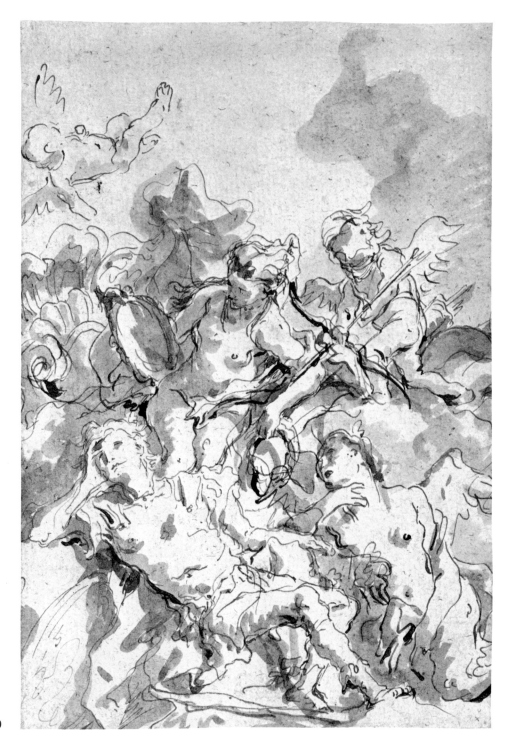

No. 130

Armida seated in her chariot, and Cupid, and the nymph who attended Armida.[2] The same scene is also represented by Giambattista in a fresco, of different composition, in the Villa Valmarana near Vicenza.[3]

J. B. S.

NOTES:
1. De Vesme 1906, pp. 422–23, no. 94.
2. For the painting see Morassi 1962, p. 8, fig. 273; for the etching, Udine 1970, no. 142.
3. Morassi 1962, p. 65, fig. 269.

PROVENANCE: T. Grange, London; Charles E. Slatkin Galleries, New York. Acquired by Robert Lehman in 1960.

EXHIBITED: New York 1981, no. 148; Detroit 1983, no. 49; Pittsburgh 1985, no. 51.

131. Rinaldo Persuaded by Ubaldo and Guelfo to Abandon Armida

1975.1.511
Pen and brown ink, brown wash, over black chalk.
220 × 180 mm.

The figure group is copied from Giambattista Tiepolo's signed canvas (Fig. 24), one of two illustrating Canto XVI of Tasso's *Gerusalemme Liberata* in the Staatsgalerie im Schloss, Würzburg (formerly in the Alte Pinakothek, Munich).[1] The two paintings, which were also etched by Lorenzo Tiepolo,[2] come from the Würzburg Residenz and were no doubt painted there between 1751 and 1753. They would therefore be some years earlier than the frescoes of 1757 in the Villa Valmarana near Vicenza, in which the same subject is given a quite different composition. But I doubt whether Domenico's drawing is as early as that, and since Lorenzo was only seventeen years old when the family left Würzburg I think it unlikely that he made the two etchings of his father's paintings before they returned to Venice. He must, rather, have used record-drawings, probably made by his brother or himself, as his models; and one of these, rather than the painting, would have served as the model for the present drawing by Domenico.

Domenico himself painted the same subject, differently composed, in a fresco in the family villa at Zianigo, now in Ca' Rezzonico, Venice.[3]

It is possible that the drawing has been cut on the right, where in Giambattista's Würzburg painting the figure of Armida appears: it may be observed that a piece of the sorceress's skirt shows at the right edge of the sheet. On the other hand, the drawing extends the scene a little farther to the left, thus centralizing the group of Rinaldo and his companions. In any case, Domenico has altered the position of the trees in the background and introduced a quiver full of arrows (Cupid's arrows?) at the lower right.

There were five drawings by Domenico of this same incident in the story in the Beauchamp album sold at Christie's in 1965.[4] For an earlier scene from the same story, see No. 130.

J. B. S.

NOTES:
1. Morassi 1962, p. 30 (as in the Alte Pinakothek, Munich).
2. De Vesme 1906, pp. 442–43, nos. 4, 6; Udine 1970, no. 223. The prints are in reverse.
3. Mariuz 1971, p. 140, pl. 246, datable after 1770.
4. Sale, Christie's, London, June 15, 1965, lots 125–129.

PROVENANCE: Galerie Cailleux, Paris. Acquired by Robert Lehman in 1960.

EXHIBITED: New York 1981, no. 115.

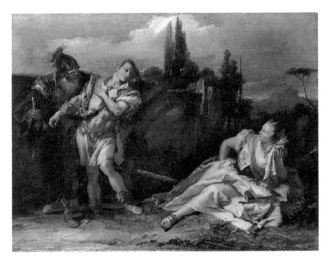

Fig. 24. Giovanni Battista Tiepolo. *Rinaldo Abandoning Armida*. Würzburg, Staatsgalerie im Schloss

No. 131

132. Actaeon, Changed into a Stag, Attacked by One of His Own Hounds

1975.1.488

Pen and brown ink, brown wash. 142 × 260 mm. Signed in brown ink, center right: *Dom°. Tiepolo f.* Stain below Actaeon's feet shows through from verso. Remains of an old number (*9?*), in brown ink, cut off, at top left.

This very rough sketch must be preliminary to the more careful version (twice signed, with a parapet introduced below) in the Fondazione Giorgio Cini, Venice.[1] The Cini drawing is probably of the same date (certainly after 1770) as the many animal subjects by Domenico that are connected with the decoration of the Tiepolo villa at Zianigo. It was later adapted by him in one of the best of his large Scenes from Contemporary Life (Fig. 25):[2] in that drawing two elegant young ladies, dressed in *Directoire* fashion and attended by two footmen holding their dogs, are examining a marble statue of this same Actaeon, now placed on a substantial plinth in a villa garden.

J. B. S.

NOTES:

1. From the collection of Giuseppe Fiocco. Venice 1955, p. 31, no. 87; Venice 1963, p. 71, no. 101.
2. Byam Shaw 1962, p. 49, pl. 69. The drawing, formerly in the collection of Adrien Fauchier-Magnan, was sold at

Fig. 25. Domenico Tiepolo. *The Actaeon Statue.* Formerly Paris and Cannes-La Bocca, Fauchier-Magnan collection

No. 132

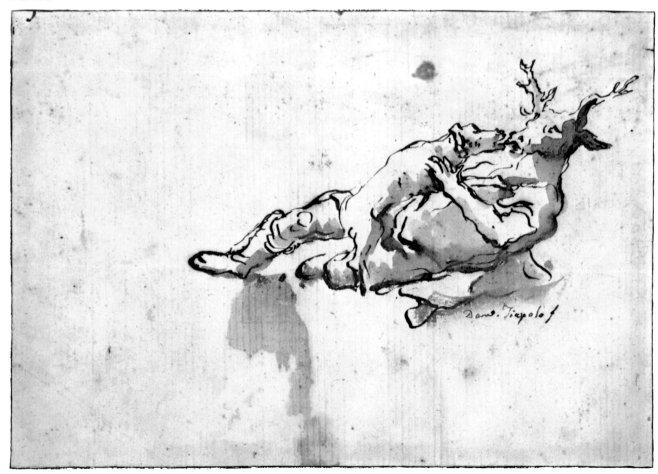

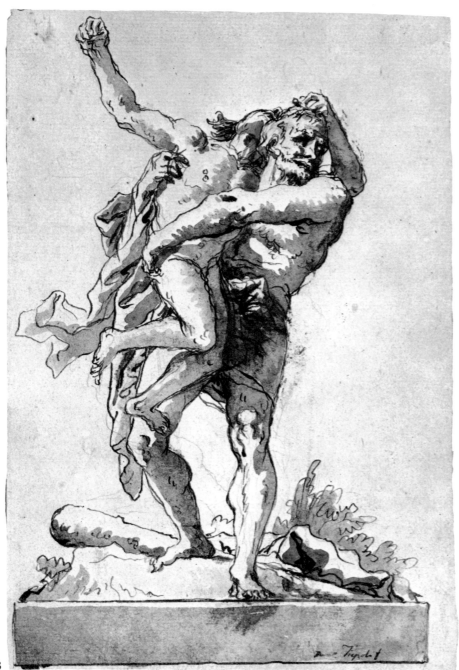

No. 133

Sotheby's, London, on July 6, 1967 (lot 54), and was after-wards with Colnaghi. Fauchier-Magnan owned twenty-two drawings of this series, all of them previously in the Beurdeley collection and many of them dated 1791.

PROVENANCE: T. Grange, London; Charles E. Slatkin Galleries, New York. Acquired by Robert Lehman in 1960.

EXHIBITED: New York 1981, no. 144.

LITERATURE: Byam Shaw 1962, p. 88, under no. 69.

133. Hercules and Antaeus (with a Base Below)

1975.1.491

Pen and brown ink, gray wash, over black chalk. 216 × 152 mm.
Signed in brown ink, bottom right: *Domº Tiepolo f.*

Thirty-eight drawings of this subject by Domenico, bound in a small album once in the Bordes collection, were bought by Colnaghi in 1936 from Paul Prouté in Paris, and were afterwards distributed to various collec-

tors, public and private. Ten of them are now in the Fondazione Giorgio Cini, Venice;[1] two passed with the Grenville Winthrop bequest to the Fogg Art Museum in 1943; in that year H. M. Calmann in London had eighteen from the same source; and five went to Durlacher Brothers in New York. Other drawings of the same series were known, however, before the Bordes album was broken up; Sack records one in the Berlin print room with the old number *94* at upper left,[2] and others were sold in Paris in 1919 and in Amsterdam in 1929.[3]

Some of the drawings, like this one, include a base resembling that of a statue or small bronze; others, like No. 134, have a continuous ledge or dado such as occurs in many of Domenico's small animal drawings. A further connection between the Hercules and the Animal series is suggested by No. 148, in which a bullock is drawn in profile over the faint beginnings of a *Hercules and Antaeus* in black chalk.

Giambattista Tiepolo had painted the subject, about 1725, in one of the narrow upright canvases flanking his vast *Achilles Discovered Among the Daughters of Lycomedes* in the collection of Conte da Schio at Castelgomberto near Vicenza.[4] Domenico's series of drawings must be at least half a century later than that. He himself painted some of the deeds, and the death, of Hercules in mock relief in the frescoes formerly in Palazzo Valmarana-Franco at Vicenza; one of these scenes is dated 1773. But the subject of Hercules and Antaeus was not included there.[5]

The source of inspiration for the present series of drawings may have been the small model by Antico (Pier Jacopo Alari-Bonacolsi, ca. 1460–1528) of which there are casts in the Victoria and Albert Museum, London, and the Kunsthistorisches Museum, Vienna; or even the antique marble presented by Pope Pius IV to Duke Cosimo I of Florence in 1560 and now in the courtyard of the Palazzo Pitti.[6] There is no difficulty in supposing that Domenico Tiepolo drew his inspiration—presumably through a drawing—from a statue that he had not seen; a clear instance of this is his drawing of Neptune[7] after Bernini's famous group now in the Victoria and Albert Museum, which, when the drawing was done, was probably already in England.

J. B. S.

NOTES:

1. Venice 1963, pp. 71–75, nos. 103–12.
2. Sack 1910, p. 319, no. 24.
3. See Paris 1952, under no. 60.
4. Morassi 1955, fig. 11.
5. Mariuz 1971, p. 147, pls. 247–58.
6. See London 1981, p. 136, under no. 55.
7. In the Walpole-Beauchamp album (see Nos. 114, 121), sold at Christie's, London, June 15, 1965, lot 142.

PROVENANCE: (probably) H. Bordes, Paris; Paul Prouté, Paris; P. & D. Colnaghi & Co., London.

EXHIBITED: New York 1981, no. 142; Rochester 1981, no. 43; Detroit 1983, no. 48.

LITERATURE: Byam Shaw 1962, pp. 38, 42.

134. Hercules and Antaeus (with a Ledge Below)

1975.1.492

Pen and brown ink, gray wash, over black chalk. 200 × 140 mm. Signed in brown ink, bottom right: *Domᵒ Tiepolo f.*

For the provenance (which in this case is certain), and for other comments on this series, see No. 133.

J. B. S.

PROVENANCE: H. Bordes, Paris; Paul Prouté, Paris; P. & D. Colnaghi & Co., London; Paul Wallraf, London. Acquired by Robert Lehman in 1962.

EXHIBITED: Venice 1959a, no. 95; Cologne 1959, no. 95; New York 1981, no. 142.

LITERATURE: Byam Shaw 1962, p. 38.

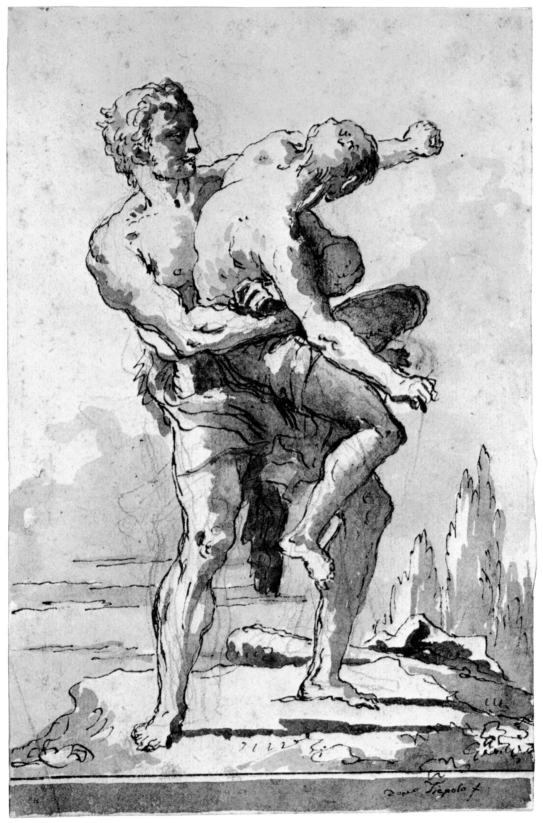

No. 134

135. Venus (?)

1975.1.487

Pen and brown ink, gray wash, over black chalk. 242 × 128 mm. (trimmed irregularly at the top).

No. 135 is one of a series representing pagan deities and heroes standing on pedestals, sometimes with attendant animals or attributes, in the manner of the sculptures that adorn the balustrades or gardens of villas in the Veneto, such as the Villa Cordellina near Vicenza or the Villa Pisani at Strà. Some of these drawings have old numbers at the upper left corner, the highest known to me being *98*, on one of several from the Fiocco collection in the Fondazione Giorgio Cini, Venice.[1] That drawing and another in the same collection[2] are unusual in showing several such figures on a single sheet: some of them seem to represent the same personages from different angles, which may suggest either that they were drawn from existing sculpture or that Domenico was considering different aspects of figures to be designed by himself and carried out by a sculptor. Some of the single figures in this series are freely copied from a similar series by Giambattista Tiepolo. In some cases, including the present one, Domenico also made near-replicas of his own drawings: a variant of No. 135, in which the nakedness of the figure is modified, not with drapery but with a branch of foliage (she might have been intended for Eve), was formerly also in Robert Lehman's collection.[3]

J. B. S.

NOTES:
1. Venice 1963, pp. 68–69, no. 95.
2. Ibid., p. 69, no. 96.
3. For other examples, and notes on this series generally, see Byam Shaw 1962, pp. 39–40, and Venice 1981, pp. 77–78, nos. 88, 89.

PROVENANCE: Luigi Grassi, Florence (Lugt 1171b); Grassi sale, Sotheby's, London, May 13, 1924, lot 129.

EXHIBITED: Chicago 1938, no. 99; New York 1981, no. 140; Detroit 1983, no. 47; Pittsburgh 1985, no. 49.

136. Leda

1975.1.493

Pen and brown ink, gray wash, over black chalk. 254 × 138 mm. Signed in brown ink, bottom center: *Dom°. Tiepolo f.*

A statue closely corresponding to this figure appears, with another of the same sort, standing on the stone parapet in one of the Punchinello series, *Punchinellos in the Garden of a Villa*, in the collection of John Nicholas Brown, Providence, Rhode Island.[1] The other statue in that drawing also derives from a single figure by Domenico, formerly in the Albertina, Vienna.

Robert Lehman presented two other female deities of the same series to the Metropolitan Museum in 1941;[2] both came, like Nos. 135 and 136, from Luigi Grassi, and one of them was probably also intended to represent Leda (with a very small swan).

J. B. S.

NOTES:
1. Chicago 1938, p. 48, no. 109; Byam Shaw 1962, p. 94, pl. 94; Bloomington (Ind.) 1979, p. 68, no. 16.
2. New York, Metropolitan Museum of Art, acc. nos. 41.187.1, 41.187.5.

PROVENANCE: Luigi Grassi, Florence (Lugt 1171b); Grassi sale, Sotheby's, London, May 13, 1924, lot 127.

EXHIBITED: Chicago 1938, no. 98; New York 1981, no. 141.

LITERATURE: Byam Shaw 1962, p. 94, under no. 94.

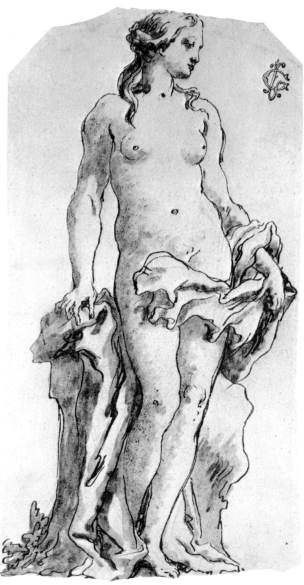

No. 135

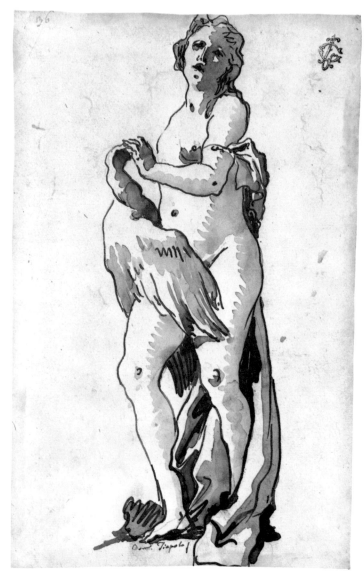

No. 136

137. Meleager, Turning to the Right

1975.1.490

Pen and brown ink, gray wash, over black chalk. 276 × 172 mm. Signed in brown ink, bottom right: *Domᵒ Tiepolo f.* Numbered in brown ink, upper left: *30.*

That the subject is Meleager, and not Endymion as it has hitherto been called, is made clear by a comparison with a similar figure in a drawing of the same series in the Lugt Collection (Fondation Custodia) at the Institut Néerlandais, Paris, which is inscribed *Meleagro* on the verso in the artist's hand.[1] A drawing by Giambattista in the same collection, from which Domenico's is derived, is also inscribed *MELEAGRO* by the artist.[2] The hound does not appear in either of the Lugt drawings, but it is perfectly appropriate to the young huntsman Meleager.

This drawing and No. 138, which seem to form a pair, are among the most elegant of the statue-like figures of this series, which immediately suggest garden sculpture. George Knox has shown that some of Giambattista's beautiful groups among the drawings in the Victoria and Albert Museum, London, are very closely related to existing sculpture at the Villa Cordellina, Montecchio Maggiore, near Vicenza.[3]

J. B. S.

NOTES:
1. Venice 1981, p. 78, no. 89; Byam Shaw 1983, vol. 1, pp. 296–97, no. 285.
2. Venice 1981, p. 77, no. 88; Byam Shaw 1983, vol. 1, pp. 294–95, no. 283.
3. Knox 1960, pp. 16–17, 55–56, nos. 74–80.

PROVENANCE: Antonio Morassi, Venice; Paul Wallraf, London. Acquired by Robert Lehman in 1962.

EXHIBITED: Venice 1959a, no. 97; Cologne 1959, no. 97; New York 1981, no. 152; Pittsburgh 1985, no. 52.

LITERATURE: Venice 1981, p. 78, under no. 89; Byam Shaw 1983, vol. 1, p. 297, under no. 285.

138. Meleager, Turning to the Left

1975.1.489

Pen and brown ink, gray wash, over black chalk. 276 × 172 mm. Signed in brown ink, bottom left: *Domᵒ. Tiepolo f.* Numbered in brown ink, top left: *36.*

See No. 137.

J. B. S.

PROVENANCE: Antonio Morassi, Venice; Paul Wallraf, London. Acquired by Robert Lehman in 1962.

EXHIBITED: Venice 1959a, no. 98; Cologne 1959, no. 98; New York 1981, no. 151.

LITERATURE: Venice 1981, p. 78, under no. 89; Byam Shaw 1983, vol. 1, p. 297, under no. 285.

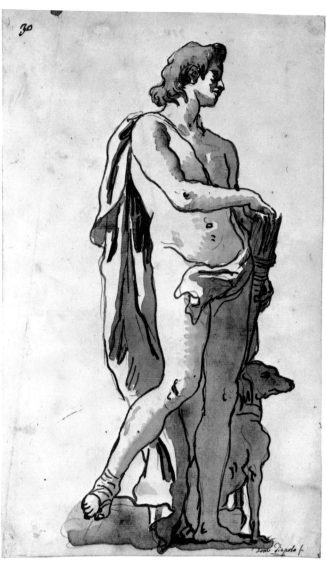

No. 137

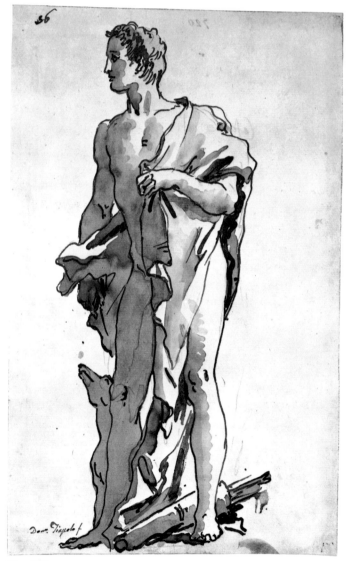

No. 138

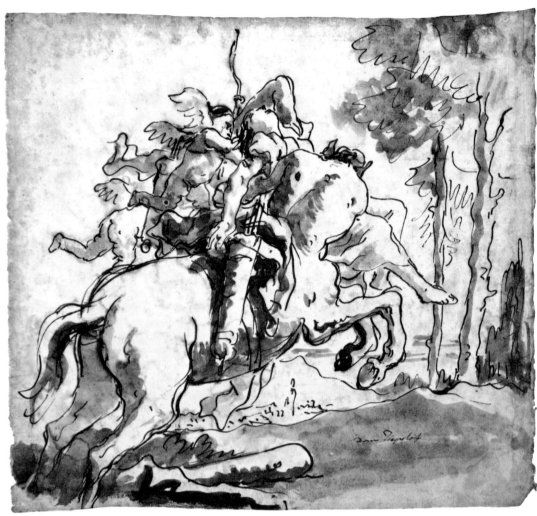

No. 139

139. Centaur Carrying Off a Nymph

1975.1.495
Pen and brown ink, light brown and gray-brown wash.
273 × 299 mm. Signed in brown ink, lower right: *Dom°
Tiepolo f.* Water-stained, mainly along the edges.

Jean Cailleux's valuable essay entitled "Centaurs, Fauns,
Female Fauns, and Satyrs among the Drawings of
Domenico Tiepolo" analyzes and classifies this numerous
series with great care; it distinguishes from the rest a small
group of drawings, including the present sheet, which are
of rather larger, nearly square dimensions and executed in
a rougher, sketchier style than the great majority.[1] Nearly
all the other drawings of similar subjects, including the
four others in the Lehman Collection, are oblong in for-
mat, more elaborately finished, and have figures rather
smaller in scale.

I am not sure that Cailleux is right in entitling the draw-
ings of this particular subject—to which No. 142 also be-
longs—*The Rape of Deianira* or *Nessus and Deianira*. He
catalogues a large number of them,[2] and the subject also
occurs in a small roundel fresco by Domenico from the
Tiepolo villa at Zianigo, now in Ca' Rezzonico, Venice;[3]
but in many of these, other figures appear—women,
boys, winged *putti*, satyrs male and female—that have
nothing to do with the Nessus and Deianira story as relat-
ed in Ovid (*Metamorphoses* 9.101–33) and elsewhere.

J. B. S.

NOTES:
1. Cailleux 1974, p. v. The present drawing is Cailleux's
 no. 23; nos. 14, 15, 19, and 30 (figs. 1, 2, 18, and 20) are
 other characteristic examples.
2. Cailleux 1974, pp. xi–xvi, nos. 11–36.
3. Cailleux, p. xii, fig. 21.

PROVENANCE: Italico Brass, Venice. Acquired by Robert
Lehman in 1960.

EXHIBITED: New York 1981, no. 154; Rochester 1981, no. 58;
Detroit 1983, no. 55.

LITERATURE: Cailleux 1974, p. xiii, no. 23, fig. 24.

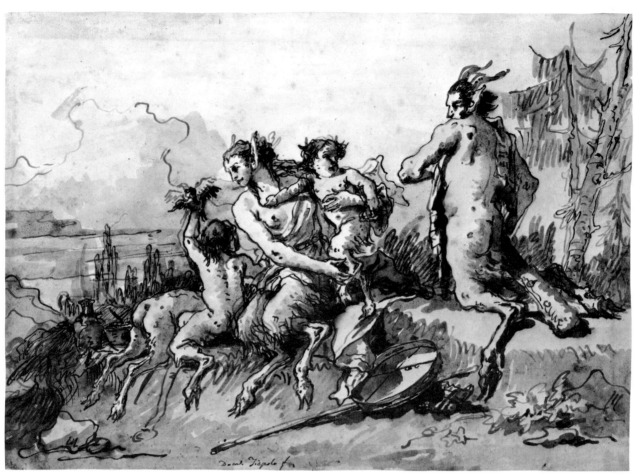

No. 140

140. Satyr Family in a Wild Landscape

1975.1.496
Pen and dark brown ink, over pen and lighter ink, with gray wash. 190×265 mm. Signed in dark brown ink, bottom center: *Dom°. Tiepolo f.*

This and No. 141 are among the most delightful of Domenico's satyr subjects, whether in the numerous series of drawings or in the monochrome frescoes from the Camera dei Satiri in the Tiepolo villa at Zianigo, now reconstituted in Ca' Rezzonico, Venice. The ceiling of the Camera dei Satiri, with classical scenes, is clearly dated 1759; but Mariuz has drawn attention to a later date, 1771, on the *Bacchanal of Satyrs* on a wall of the same room;[1] it seems certain therefore that these frescoes were finished only after Domenico's return from Spain. The Camerino dei Centauri, now also removed from Zianigo to Ca' Rezzonico, is dated twenty years later, 1791. But whereas the smaller group of drawings of centaur subjects in square format, loosely drawn, with figures on a larger scale, to which No. 139 belongs, may have been

done with the paintings in mind, I believe that the main series of drawings, including both centaurs and satyrs, was probably produced independently between the dates of the two rooms, 1771 and 1791. These drawings are not sketches but works of art in their own right, homogeneous in style, more pictorially composed and finished than the drawings of the smaller group, oblong in format, and all of nearly the same dimensions. The series must have been very numerous; many of the sheets are numbered, No. 143 apparently having the number *197* and one of nine examples in the British Museum having the number *102*. Four examples (Nos. 140–143; No. 139 belongs to a different group) are in the Robert Lehman Collection; eleven, all from the Biron collection, are in the Drawings Department of the Metropolitan Museum; six are in the Art Museum, Princeton University; and five are in the Uffizi.[2]

The drawings of this series are perhaps the most charming and original of all Domenico's drawings—original because less dependent on the inventions of other

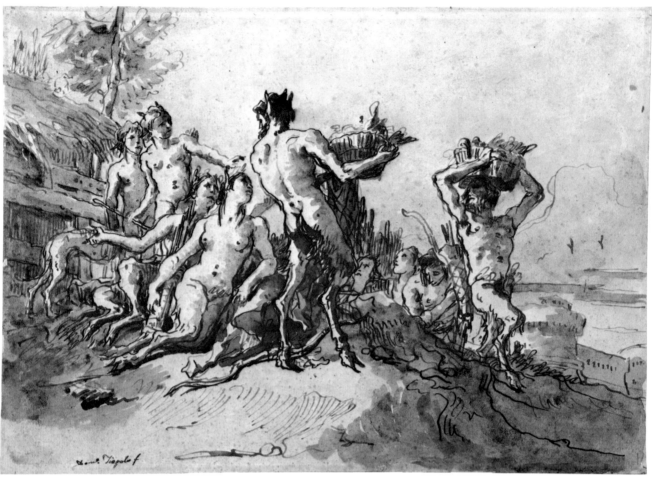

No. 141

artists than some of his other series (the Animals, for instance), and catching exactly the charm and gaiety of the pagan mythology:

Rough Satyrs danced, and Fauns with cloven heel
From the glad sound would not be absent long.

J. B. S.

NOTES:
1. Mariuz 1971, p. 141, pl. 242.
2. See Byam Shaw 1962, pp. 41–42, 79–80, pls. 38–41.

PROVENANCE: Galerie Cailleux, Paris; T. Grange, London; Charles E. Slatkin Galleries, New York. Acquired by Robert Lehman in 1960.

EXHIBITED: Paris 1952, no. 58; New York 1981, no. 157; Detroit 1983, no. 56.

LITERATURE: Byam Shaw 1962, p. 41; Cailleux 1974, pp. iv, xxv, no. 87, fig. 76.

141. Satyrs Carrying Baskets of Provision for Their Families

1975.1.497
Pen and brown and gray-brown ink, gray-brown wash.
194 × 276 mm. Signed in brown ink, bottom left: *Dom°.*
Tiepolo f.
PLATE 12.

This and No. 140 make a perfect pair, having been together since 1952 at least, when both were exhibited by Cailleux in Paris. Other particularly good pairs are in the collection of Conte Vitetti, Rome, and (formerly) in that of Carlo Broglio, Paris.[1]

The fortress in the right background here is a reminiscence of the citadel of Brescia, as represented in Domenico's fresco *Saints Faustino and Giovita Intervening in the Defense of Brescia* in the church dedicated to those two saints in that city.[2] The same citadel appears in No. 143.

J. B. S.

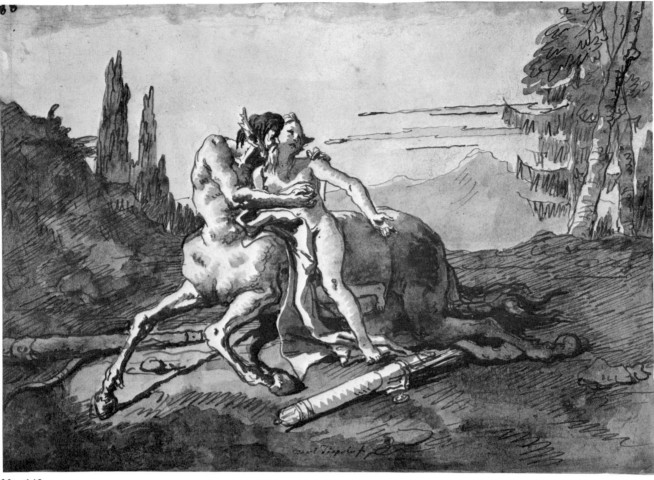

No. 142

NOTES:
1. For the latter, see Mariuz 1971, figs. 15, 16.
2. Mariuz 1971, p. 115, pl. 75.

PROVENANCE: Galerie Cailleux, Paris; T. Grange, London.

EXHIBITED: Paris 1952, no. 59; New York 1971, no. 245;
Birmingham (Ala.) 1978, no. 130; New York 1981, no. 158;
Rochester 1981, no. 59; Pittsburgh 1985, no. 48.

LITERATURE: Cailleux 1974, pp. iv, xxvi, no. 93, fig. 80.

142. Centaur Embracing a Nymph in a Wild Landscape

1975.1.498
Pen and brown and dark brown ink, gray-brown wash.
188 × 272 mm. Signed in dark brown ink, bottom center:
Domº Tiepolo f. Numbered in dark brown ink, top left:
88(?).

This drawing belongs to the same series as Nos. 140
(q.v.), 141, and 143. It is classified by Cailleux among the
so-called *Nessus and Deianira* drawings;[1] but on this in-
terpretation see the entry for No. 139.

J. B. S.

NOTE:
1. Cailleux 1974, pp. iii, xi, no. 11.

PROVENANCE: Thos. Agnew and Sons, London. Acquired by
Robert Lehman in 1960.

EXHIBITED: New York 1981, no. 155; Pittsburgh 1985, no. 47.

LITERATURE: Cailleux 1974, pp. iii, xi, no. 11, fig. 15.

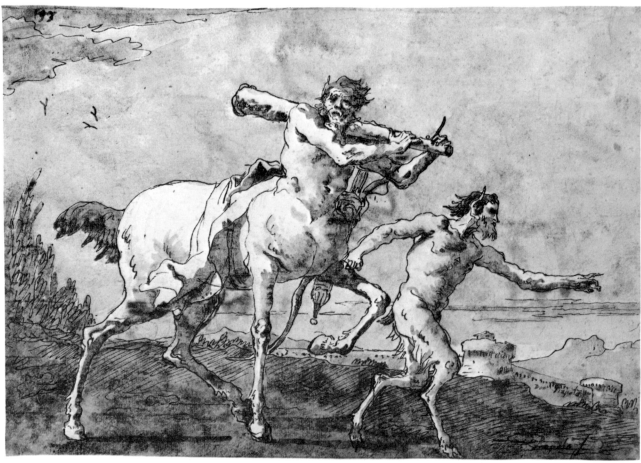

No. 143

143. Satyr Leading a Centaur, Who Carries a Club, Bow, and Quiver, Outside the Walls of a City

1975.1.499

Pen and brown ink, brown-gray wash, over traces of black chalk. 190 × 280 mm. Signed in light brown ink on the wall of the citadel, lower right: *Dom⁰ Tiepolo f.*; annotated (or signed again) in dark brown ink on the ground, bottom right: *Tiepolo f.* Numbered in dark brown ink in an old hand, top left: *197* (?).

The drawing belongs to the same series as the three preceding ones. The fortress in the background is a reminiscence of Brescia, as in No. 141.

J. B. S.

PROVENANCE: Galerie Cailleux, Paris.

EXHIBITED: New York 1981, no. 156; Detroit 1983, no. 57.

LITERATURE: Cailleux 1974, pp. iv, xxiii–xxiv, no. 72, fig. 66.

144. A Horse Attended by an Oriental Groom on a Country Road

1975.1.515

Pen and brown ink, brown wash, over black chalk. 290 × 420 mm. Signed in brown ink on a rock, lower left: *Dom⁰ Tiepolo f.*

There are many drawings of similar subjects by Domenico in various collections: the horse is usually led, attended, or ridden by a groom or warrior in Arab dress. Only occasionally is the groom a European.[1] In a drawing in the Uffizi (Fig. 26),[2] both horse and groom are nearly identical with those on the present sheet; only the landscape and the groom's legs are different. In yet another drawing by Domenico, in a private collection in Paris,[3] in which two elderly Orientals are inspecting a horse held by a Moor, the horse is again the same, except that the off foreleg is not raised as it is here.

The horse is of an Arab type, heavy in neck and shoulder, but with a small head and absurdly long, stiff forelegs —a sort of caricature of the breed of racehorse introduced into England in the first half of the eighteenth century

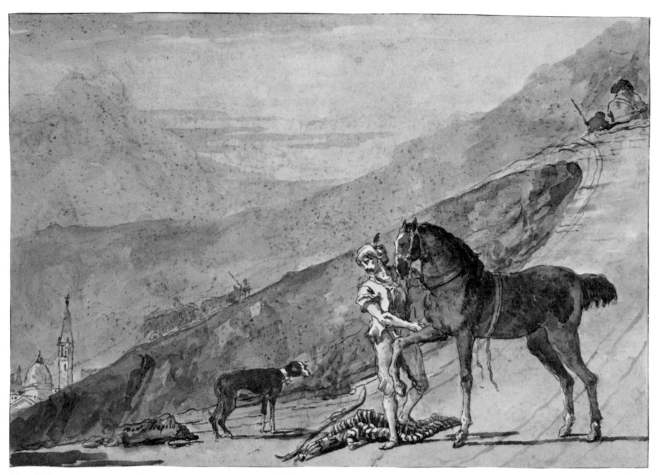

No. 144

with the Darley and Godolphin Arabians (as the horses were called, after their owners). They were much portrayed by John Wootton and other horse painters; many engravings of them were published in Domenico Tiepolo's time, and no doubt found their way to Italy; and I suspect that these subjects of his were at least inspired by English prints, if not occasionally copied from them, though I have not discovered an exact source.[4] In such prints the horses are sometimes held, as here, by grooms in Arab dress. It is noticeable that in those of Domenico's drawings in which the groom is European, the horse is of a heavier, more traditional European cavalry type—the type favored in the paintings of Giambattista Tiepolo.[5]

The same large dog appears in many of Domenico's later drawings, where he is shown whole or in part and occasionally in reverse. I have found him exactly repeated in at least six of the Contemporary Life scenes, seven of the Punchinellos, and two of the Large Biblical Series.[6] The original model, I suppose, was the dog in the left foreground of the *Europa* fresco by Giambattista on the stair-

Fig. 26. Domenico Tiepolo. *Horse and Groom*. Florence, Gabinetto Disegni e Stampe degli Uffizi

case of the Residenz at Würzburg.[7] The wild mountainous landscape in the present drawing is perhaps, as Morassi suggests, a reminiscence of Spain.[8] Certainly such drawings are to be dated after Domenico's return from Spain to Venice in 1770. J. B. S.

175

No. 145

NOTES:

1. As in a drawing from the Fiocco collection in the Fondazione Giorgio Cini (Venice 1963, no. 91), and another belonging to the Hon. Lady Wrightson, Neasham Hall, Co. Durham (Byam Shaw 1962, p. 80, pl. 43).

2. Florence, Gabinetto Disegni e Stampe degli Uffizi, no. 7805s.

3. Paris 1952, no. 62.

4. Inspiration may also have come from Domenico's favorite source, the prints of Johann Elias Ridinger (see No. 149). Ridinger produced a series of thirty-two plates of the different breeds of horses, generally with grooms in national dress, engraved by his son Martin Elias Ridinger (Thienemann 1856, pp. 115–19, nos. 562–93). See also his *Entwurff einiger Thiere* (1738–46), pt. 6, especially nos. 1–5.

5. See especially Lady Wrightson's drawing, referred to in n. 1.

6. See, for example, New York 1973, pp. 58–59, nos. 101, 102.

7. Morassi 1955, pl. 62.

8. Venice 1959a, p. 73, no. 112.

PROVENANCE: Paul Wallraf, London. Acquired by Robert Lehman in 1962.

EXHIBITED: Venice 1959a, no. 112; Cologne 1959, no. 112; Huntington (N.Y.) 1980, no. 34; New York 1981, no. 117; Detroit 1983, no. 45; Pittsburgh 1985, no. 117.

145. A Leopard, Moving to the Left (on a Base)

1975.1.517

Pen and brown ink, brown wash, over traces of black chalk. 112 × 164 mm. Signed in brown ink above the base, lower right: *Dom°. Tiepolo f.*

Domenico might perhaps have seen a leopard in a traveling circus, but in fact both here and in No. 166 (q.v.) his leopards are borrowed, like so many of his animals, from other masters. This one is from an etching by Stefano della Bella, no. 9 of the series *Diversi Animali*;[1] but the drawing is in the reverse direction, and therefore presumably made either from a reversed copy of the print or by means of a tracing. For other drawings derived from the same series see Nos. 146, 155, and 156.

The base or pedestal, which occurs here and in so many other animal drawings by Domenico in the Lehman Collection and elsewhere, suggests the support of a statue or, even more, of a small bronze; but no such bronzes are known to me.

J. B. S.

No. 146

NOTE:
1. De Vesme 1906, p. 190, no. 698.

PROVENANCE: T. Grange, London; Charles E. Slatkin Galleries, New York.

EXHIBITED: New York 1981, no. 176; Rochester 1981, no. 57.

146. A Boar, Galloping to the Left, and a Sleeping Sow (on a Base)

1975.1.518

Pen and brown ink, brown wash, over traces of black chalk. 121 × 170 mm. Signed in brown ink on the base, lower right: *Dom°. Tiepolo.*

The running boar corresponds closely, but in the reverse direction, with an etching by Stefano della Bella, no. 19 of the series *Diversi Animali*.[1] Domenico often made use of these etchings (see Nos. 145, 155, 156); in this and other cases he must have used either a reversed copy of the print or a tracing.

A boar of heavier build, also galloping to the left, on a similar base or pedestal, is in the Fondazione Giorgio Cini, Venice.[2] The sleeping sow reappears more than once in Domenico's work: for instance, in a good drawing in the Musée Bonnat, Bayonne, of two peasant women and a boy with a herd of pigs on a country road.[3]

J. B. S.

NOTES:
1. De Vesme 1906, p. 191, no. 708.
2. From the collection of Giuseppe Fiocco. Venice 1963, p. 70, no. 99.
3. Bean 1960, no. 162.

PROVENANCE: T. Grange, London; Charles E. Slatkin Galleries, New York. Acquired by Robert Lehman in 1960.

EXHIBITED: New York 1981, no. 175.

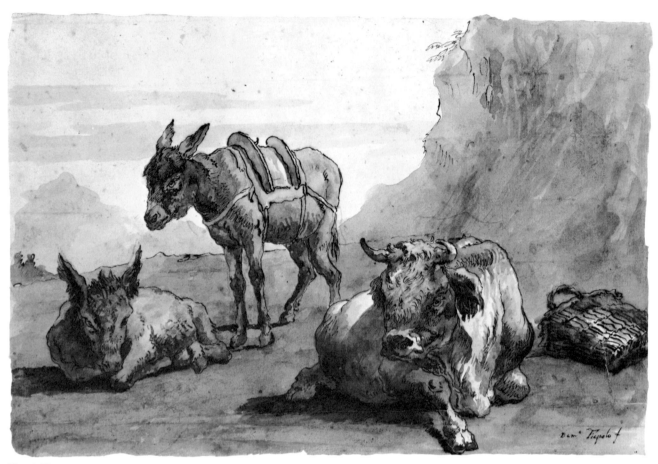

No. 147

147. A Bull Lying Down, and Two Donkeys, in a Landscape

1975.1.519

Pen and brown ink, brown wash, over black chalk. 187 × 282 mm. Signed in brown ink, bottom right: *Dom° Tiepolo f.*

The donkey foal is copied from one of the etchings[1] in the *Beesteboeckje* of Johann Heinrich Roos (1631–1685), a German artist who settled in Amsterdam in 1647 and later spent about four years in Rome; he was the father of Philipp Peter Roos, known as Rosa da Tivoli, the well-known animal painter. The *Beesteboeckje* is a source for Domenico's animals that has not previously been noticed; see also No. 154.

I suspect (but cannot be sure) that all three animals appeared on the left of one of the more damaged overdoor frescoes that are still *in situ* on the upper floor of the Tiepolo family villa at Zianigo, near Mirano on the Venetian mainland.[2] For other animals in those overdoors, see Nos. 148–151.

J. B. S.

NOTES:

1. Bartsch 1854–76, vol. 1, p. 147, no. 29.
2. Villa Tiepolo-Duodo, now the property of Antonio Nalon. For the frescoes, see Byam Shaw 1959.

PROVENANCE: Earl of Breadalbane, Kilchurn Castle, Dalmally, Argyll; Paul Wallraf, London. Acquired by Robert Lehman in 1962.

EXHIBITED: Venice 1959a, no. 105; Cologne 1959, no. 105; Huntington (N.Y.) 1980, no. 39; New York 1981, no. 171.

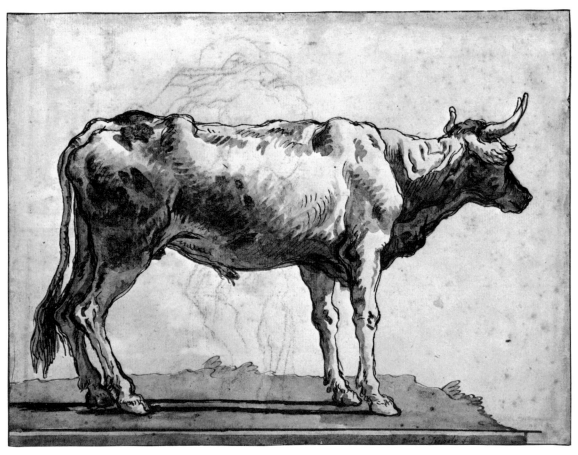

No. 148

148. A Bullock Standing to the Right (on a Base)

1975.1.520

Pen and brown ink, brown wash, over black chalk. 185 × 246 mm. Signed in brown ink on the base, bottom right: *Dom⁰ Tiepolo f.*

The bullock is drawn over a faint sketch of a man, in black chalk, apparently the beginning of a *Hercules and Antaeus* (see Nos. 133, 134).

The animal is an adaptation of the red chalk drawing formerly in the Springell collection at Keswick, which Knox believes to be Domenico's study for one of the grisaille frescoes of pagan sacrifice painted by him at the Villa Pisani at Strà, 1760–61.[1] The same bullock can again be distinguished, with other cattle, on the right of a sadly faded overdoor painting in the Villa Tiepolo at Zianigo—the fresco at the southeast corner of the upper room, which probably contained the bull and the donkeys in No. 147.

J. B. S.

NOTE:

1. Knox 1980b, vol. 1, p. 219, no. M87, vol. 2, pl. 252; exhibited Canterbury 1985, no. 31.

PROVENANCE: Gustav Nebehay, Vienna; Paul Wallraf, London. Acquired by Robert Lehman in 1962.

EXHIBITED: Venice 1959a, no. 107; Cologne 1959, no. 107; New York 1981, no. 168.

LITERATURE: Byam Shaw 1959, p. 392; Byam Shaw 1962, p. 38.

149. A Stag Lying Down (on a Base); The Head of a Crocodile

1975.1.521.

Pen and brown ink, brown wash, over traces of black chalk. 285 × 200 mm. Signed in brown ink on the base, center right: *Dom°. Tiepolo f.*

Both animals appear for the first time in the Tiepolo oeuvre as early as 1752–53, in the *America* fresco on the staircase of the Residenz at Würzburg, where Giambattista, with his sons Domenico and Lorenzo as assistants, was at work from early 1751. The stag is lying immediately below the figure of America herself, and the crocodile —slightly modified, but unmistakably the same—is the giant creature on which America is riding.[1]

The stag, I suspect, is derived from one of the vast number of animals etched by the Augsburg artist Johann Elias Ridinger (1698–1767), with whom the Tiepolos may well have made friends at Augsburg on their way to Würzburg in the winter of 1750. Perhaps Ridinger gave them some of his prints, for Domenico certainly made use of them elsewhere (see Nos. 150, 151, 166); in this case, however, I have not found an exact source other than the Würzburg fresco.[2]

The stag then appears again in various much later works of Domenico: in an amusing drawing (Fig. 27), once in Henry Reitlinger's collection, of two old men watching deer in a rocky landscape; in one of the better preserved of the overdoor frescoes that still remain in the Villa Tiepolo at Zianigo (the same that contains the group of deer represented in No. 151); and in the painted frieze around the ceiling-fresco in Palazzo Contarini Dal Zaffo, Venice, of 1784.[3]

In spite of the fact that these creatures are found on the Würzburg staircase, I am convinced that this drawing and the others in similar style (often with the base or ledge below) in the Lehman Collection and elsewhere are all to be dated, like the animal frescoes at Zianigo, after Domenico's return from Spain in 1770. He may have made record-drawings in chalk of the animals at Würzburg.

J. B. S.

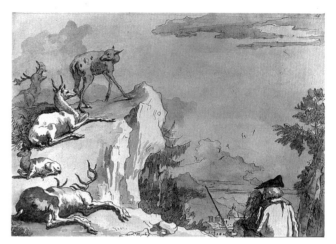

Fig. 27. Domenico Tiepolo. *Two Old Men Watching Deer.* Formerly Henry Reitlinger collection, London

NOTES:

1. Morassi 1955, pl. 58.
2. Domenico did, however, copy another crocodile from a Ridinger print (one of the *Paradies* series: Thienemann 1856, p. 169, no. 808) in an excellent drawing in the Witt collection at the Courtauld Institute, London. When I first published the drawing (Byam Shaw 1938, pl. 59) I was unaware of the Ridinger connection, which was pointed out to me afterwards by Dr. H. Brauer of Berlin.
3. The Reitlinger drawing was sold at Sotheby's, London, December 11, 1953, lot 104; for the Zianigo overdoor fresco see Byam Shaw 1959, p. 392, fig. 38, and Mariuz 1971, p. 153, pl. 347; and for the frieze in Palazzo Contarini Dal Zaffo, Mariuz 1971, pp. 145–46, pl. 336.

PROVENANCE: Earl of Breadalbane, Kilchurn Castle, Dalmally, Argyll; Paul Wallraf, London. Acquired by Robert Lehman in 1962.

EXHIBITED: Venice 1959a, no. 104; Cologne 1959, no. 104; New York 1981, no. 169; Pittsburgh 1985, no. 55.

LITERATURE: Byam Shaw 1959, p. 392, fig. 38.

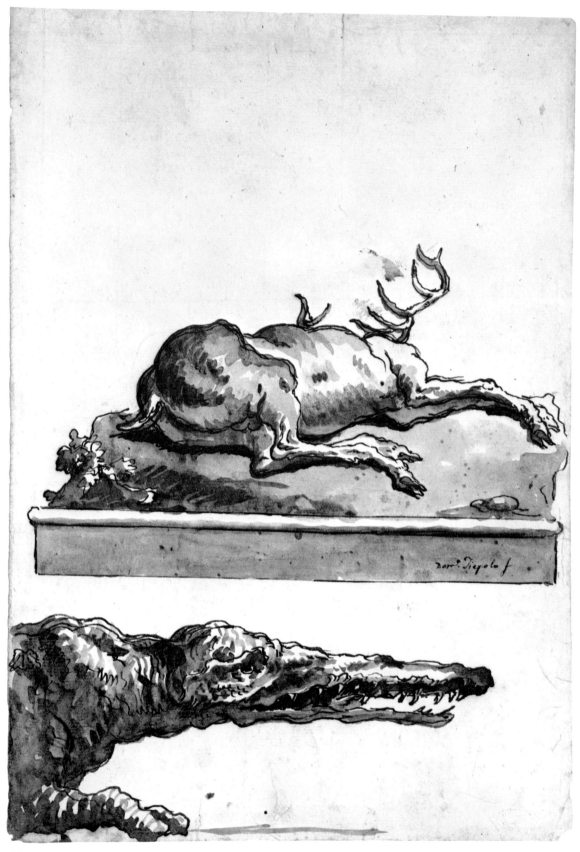

No. 149

150. Two Stags, One Standing and One Lying, on a Grassy Knoll (with a Base)

1975.1.522

Pen and brown ink, brown wash, over traces of black chalk. 285 × 200 mm. Signed in brown ink above the base, lower right: *Dom°. Tiepolo f.*

The stag licking its back is exactly copied from a print by Johann Elias Ridinger of Augsburg (Fig. 28).[1]

Both of the animals in the present drawing appear in an overdoor fresco in the Villa Tiepolo at Zianigo, which also includes the lying stag in No. 149.[2] They are found again in a larger, more elaborate drawing by Domenico, sold in New York in 1981, in which a herd of deer is watched by a man from behind a fence on the right (Fig. 29);[3] and the stag on the left recurs in another fine drawing of deer in a landscape in the Accademia Carrara, Bergamo.[4]

J. B. S.

NOTES:

1. Thienemann 1856, p. 61, no. 239. For Ridinger see No. 149; see also Byam Shaw 1959, pp. 392–95.
2. Byam Shaw 1959, pp. 392–95, fig. 35.
3. Sale, Christie's, New York, January 7, 1981, no. 86.
4. Exhibited by the Lions Club International, Bergamo, 1963 (illustrated on a postcard).

PROVENANCE: Earl of Breadalbane, Kilchurn Castle, Dalmally, Argyll; Paul Wallraf, London. Acquired by Robert Lehman in 1962.

EXHIBITED: Venice 1959a, no. 103; Cologne 1959, no. 103; New York 1981, no. 172; Rochester 1981, no. 56; Detroit 1983, no. 51.

LITERATURE: Byam Shaw 1959, pp. 392, 395, fig. 36; Byam Shaw 1962, pp. 42–43.

Fig. 28. Johann Elias Ridinger. *Stags at Midday*, engraving

Fig. 29. Domenico Tiepolo. *A Man Looking Through a Fence at a Herd of Deer.* Sold at Christie's, New York, January 7, 1981

No. 150

No. 151

151. A Stag and Four Hinds on a Grassy Knoll (with Base)

1975.1.523
Pen and brown ink, brown wash, over traces of black chalk. 285 × 200 mm. Signed in brown ink above the base, lower right: *Dom°. Tiepolo f.*

At least one of the animals is derived from Ridinger.[1] The whole group then appears on a similar grassy knoll on the left of Domenico's overdoor fresco at Zianigo, mentioned in the entry for No. 150, and in the large drawing, also mentioned in that entry (Fig. 29), which was sold in New York in 1981. Furthermore, three of the hinds, differently placed, can be identified in the drawing of deer in a landscape in the Accademia Carrara, Bergamo, in which one of the animals from No. 150 reappears.[2]

These two Lehman drawings, Nos. 150 and 151, from the same old Scottish collection, make a pair of exactly the same dimensions, similarly conceived; and both seem to have been used freely, as I have indicated, in subsequent drawings and paintings by Domenico—all, I believe, of the later part of his career, after 1770.

J. B. S.

NOTES:
1. Thienemann 1856, p. 60, no. 237.
2. See No. 150, n. 4.

PROVENANCE: Earl of Breadalbane, Kilchurn Castle, Dalmally, Argyll; Paul Wallraf, London. Acquired by Robert Lehman in 1962.

EXHIBITED: Venice 1959a, no. 102; Cologne 1959, no. 102; New York 1981, no. 170; Pittsburgh 1985, no. 56.

LITERATURE: Byam Shaw 1959, p. 392, fig. 39.

152. A Donkey Lying on the Grass, with an Italian Greyhound (on a Base)

1975.1.524
Pen and gray ink, various shades of gray wash. 167 × 197 mm. Signed in dark gray ink on the base, lower right: *Dom⁰. Tiepolo f.*

Domenico has exactly copied the donkey, and the saddle and strap lying on the ground beside him, from the resting pack-ass in his own early etching, no. 19 of the series *Idee pittoresche sopra la Fugga in Egitto*; the print is dated 1752, the middle year of the Tiepolos' stay in Würzburg.[1] The animal, as there depicted, evidently pleased

Domenico, for he reappears frequently in later work: for instance, in one of the drawings of the Rest on the Flight in the Large Biblical Series;[2] in the damaged fresco over the staircase door in the Zianigo villa; and once more, half hidden behind another donkey, in one of the Punchinello series, *Punchinello Selling Donkeys*, formerly in the collection of Paul Suzor in Paris and now in a private collection in the United States.[3] The saddle and strap appear in both the fresco and the Punchinello drawing.

Since the Punchinello drawings are certainly among Domenico's latest works, this recurrence of the donkey is a striking example of his persisting with a single model from the beginning to the end of his long career.

J. B. S.

NOTES:
1. Udine 1970, no. 84.
2. Cormier sale, Galerie Georges Petit, Paris, April 30, 1921, no. 42 (illustrated in the catalogue).
3. Bloomington (Ind.) 1979, no. S35.

PROVENANCE: Sale, Karl & Faber, Munich, November 14–15, 1957, no. 197; T. Grange, London; Charles E. Slatkin Galleries, New York. Acquired by Robert Lehman in 1960.

EXHIBITED: New York 1981, no. 173.

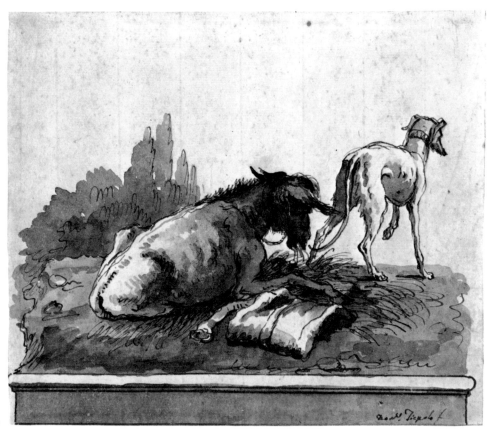

No. 152

153. A Flock of Sheep Drinking at a Pool, with a Bullock and a Dog

1975.1.525

Pen and black and gray ink, gray wash. 268 × 198 mm.
Signed in gray ink on the bank, lower right: *Dom° Tiepolo f.*
Signed again in pale brown ink on the ledge, bottom right: *Dom° Tiepolo f.*

The whole drawing is copied—with the addition of a few rushes and the ledge below—from the left half of an engraving by Pietro Monaco (Fig. 30) after a painting by Giovanni Benedetto Castiglione, published in Volume II of the *Raccolta di centododici stampe* (Venice, 1763).[1] According to the inscription on the print, the painting was then in the collection of the noble family of Nani, at San Geremia, Venice, and represented the Miracle of the Bitter Water Turned to Sweet (Exod. 15:23–25).

The same flock of sheep, with the sheepdog and rather more of the bullock, appears in a large, pictorially composed drawing by Domenico formerly in the Paris collection of Mrs. D. Kilvert; there the animals are confronting a horseman and his greyhound, and the drawing is appropriately entitled, in an old handwriting, *La chasse interrompue.*[2] They appear again on the extreme left of a fresco that is still *in situ* over the staircase door in the Villa Tiepolo at Zianigo (where the donkey from No. 152 also appears), and in one of the Large Biblical Series, *Christ and the Woman of Samaria,* no. 91 of the Recueil Fayet in the Louvre.

J. B. S.

NOTES:

1. Since Domenico was in Spain when the print was published, this connection is almost certain proof, if any were needed, that the Lehman drawing (and all the other works referred to here in which the same animals recur) must be dated after 1770, the year of his return to Venice. He used parts of another print from the same Castiglione-Monaco series for two drawings with sheep advancing toward the spectator, which were exhibited at the Heim Gallery (London 1967, p. 15, nos. 70, 71).
2. Paris 1952, p. 55, no. 61, pl. 32.

PROVENANCE: Hermitage, Leningrad; Mrs. F. L. Evans, London; P. & D. Colnaghi & Co., London; Paul Wallraf, London. Acquired by Robert Lehman in 1962.

EXHIBITED: London 1957, no. 28; Venice 1959a, no. 106; Cologne 1959, no. 106; New York 1981, no. 167; Detroit 1983, no. 52.

Fig. 30. Pietro Monaco. *Sheep at a Pool,* engraving

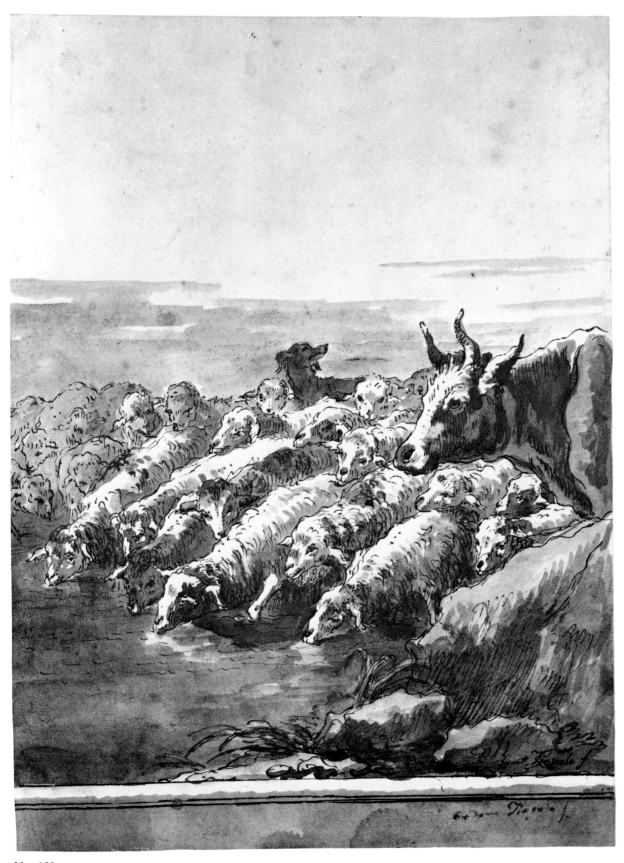

No. 153

154. Goats and Sheep in a Landscape

1975.1.526

Pen and brown ink, brown wash, over black chalk. 193 × 292 mm. Signed in brown ink on a stone, lower left: *Dom° Tiepolo f.* Annotated in light brown ink, bottom center: *tiepolo fecit.* Numbered in brown ink, top center: *43.*

PLATE 13.

The animals are very well drawn and perfectly natural; nevertheless, here again Domenico has derived most of them from an earlier source—not, in this case, from Stefano della Bella or Ridinger, but, as in No. 147 (q.v.), from etchings in the *Beesteboeckje* of Johann Heinrich Roos. The she-goat facing right in the center and the sheep lying against her are copied from one of that series (Fig. 31),[1] and the ram on the right and the goat with its head turned away in left center from another (Fig. 32).[2]

J. B. S.

NOTES:
1. Bartsch 1854–76, vol. 1, p. 143, no. 21.
2. Ibid., p. 144, no. 24.

PROVENANCE: Italico Brass, Venice. Acquired by Robert Lehman in 1960.

EXHIBITED: New York 1981, no. 118.

Fig. 31. Johann Heinrich Roos. *Goat and Sheep, with Muleteers,* etching

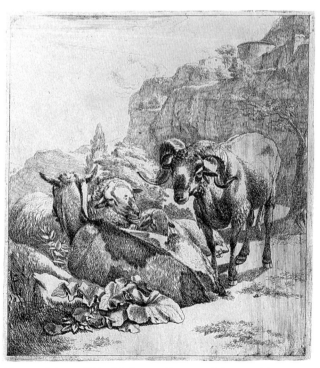

Fig. 32. Johann Heinrich Roos. *Sheep and Goat, with a House on a Promontory,* etching

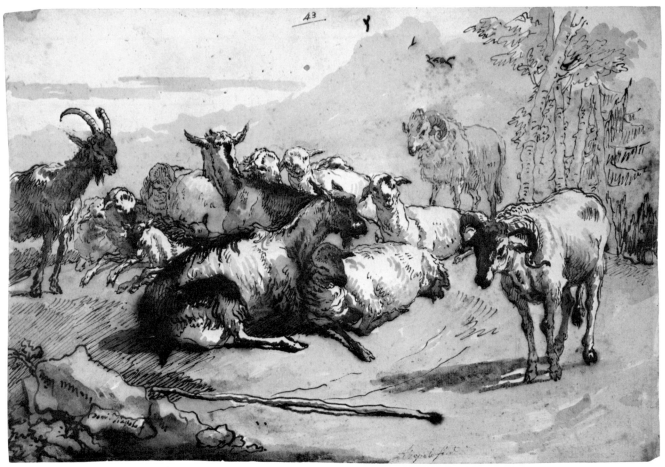

No. 154

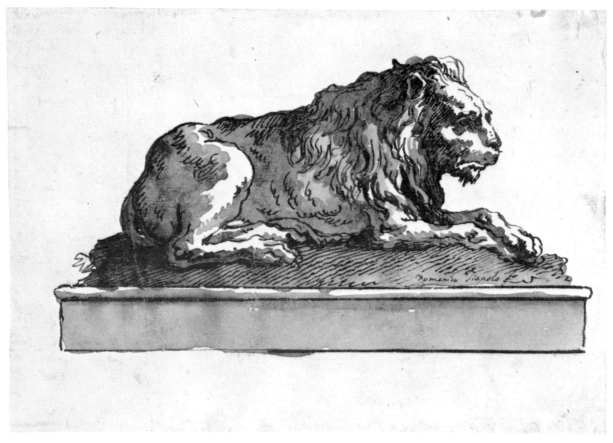

No. 155

155. A Lion, Lying Toward the Right (on a Base)

1975.1.527

Pen and brown ink, brown wash, over traces of black chalk. 120 × 173 mm. Signed in brown ink above the base, lower right: *Domenico Tiepolo f.*

Like the leopard and the boar in Nos. 145 and 146, this lion corresponds, in the reverse direction, to one in a print by Stefano della Bella;[1] he is probably drawn from a reversed copy of Stefano's etching. He does not seem to have been directly used in Domenico's overdoor fresco with a pride of lions, which is still *in situ* in the northwest corner of the upper room at Zianigo.[2]

J. B. S.

NOTES:
1. No. 5 of the series *Diversi Animali*; De Vesme 1906, p. 190, no. 694.
2. Byam Shaw 1959, p. 392, fig. 34; Mariuz 1971, p. 153, pl. 346.

PROVENANCE: P. & D. Colnaghi & Co., London; Paul Wallraf, London. Acquired by Robert Lehman in 1962.

EXHIBITED: London 1956, no. 65; Venice 1959a, no. 100; Cologne 1959, no. 100; New York 1981, no. 174.

LITERATURE: Byam Shaw 1962, p. 43.

156. Eight Monkeys, a Dead Goose, and a Cormorant

1975.1.528

Pen and brown ink, brown wash, over black chalk. 182 × 283 mm. Signed in brown ink, bottom right: *Dom°. Tiepolo f.* Annotated in brown ink on verso of backing paper, center left: *Kaye Dowland 1868. / By Jean Dominique Tiepolo / Ecole Venetienne / 81 / u.*; in the same hand, lower left: *N°: / 429.* Some foxing.

For the various sources (Stefano della Bella, Ridinger, Giambattista Tiepolo) from which these animals derive, and for the many repetitions in Domenico's own drawings, see my book of 1962.[1] Three of the monkeys correspond in reverse with Stefano's etching no. 3 (Fig. 33)[2] of

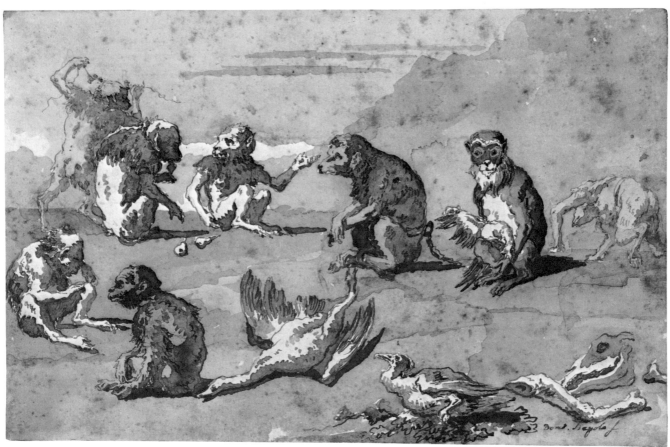

No. 156

the series *Diversi Animali*, of which Domenico may have owned a set of reversed copies. It appears from the catalogue of the *Vente Tiepolo* held in Paris in 1845 that many prints by Stefano were in Domenico's collection at his death.[3]

J. B. S.

NOTES:
1. Byam Shaw 1962, p. 82, pl. 48.
2. De Vesme 1906, p. 190, no. 692.
3. For the catalogue, see Byam Shaw 1962, pp. 18–19, n. 8.

PROVENANCE: Kaye Dowland; F. Hill, Southwell, Nottinghamshire; sale, Sotheby's, London, June 27, 1928, lot 7; Detlev Freiherr von Hadeln; H. M. Calmann, London; Paul Wallraf, London. Acquired by Robert Lehman in 1962.

EXHIBITED: Cologne 1959, no. 126; Huntington (N.Y.) 1980, no. 40; New York 1981, no. 177; Detroit 1983, no. 54; Pittsburgh 1985, no. 57.

LITERATURE: Byam Shaw 1962, p. 82, pl. 48.

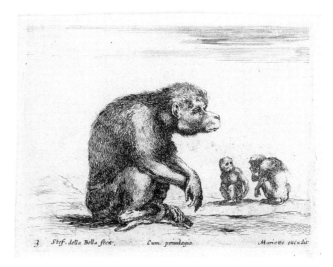

Fig. 33. Stefano della Bella. *Three Monkeys*, etching

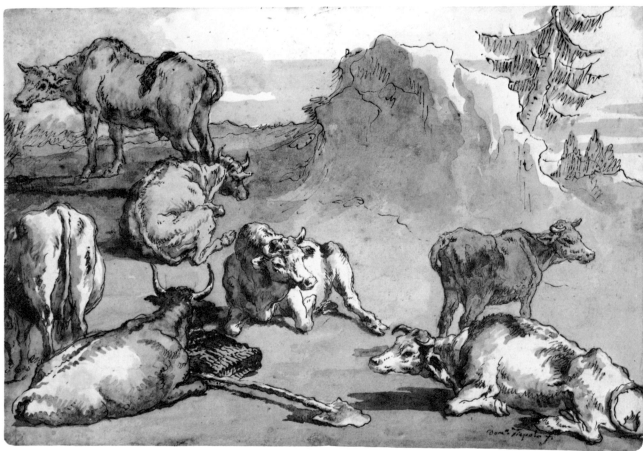

No. 157

157. Cattle in a Landscape

1975.1.529
Pen and brown ink, brown wash, over black chalk. 187 × 280
mm. Signed in brown ink, bottom right: *Dom°. Tiepolo f.*

The two animals at the upper left, and the one whose
hindquarters only appear at the far left, recur in one of the
Punchinello drawings, now in the Cleveland Museum of
Art.[1] The landscape is also adapted for the same drawing.

J. B. S.

NOTE:
1. Bloomington (Ind.) 1979, pp. 149–50, no. S31.

PROVENANCE: Carlo Broglio, Paris.

EXHIBITED: New York 1981, no. 119; Detroit 1983, no. 53.

LITERATURE: Mariuz 1971, fig. 17; Bloomington (Ind.) 1979,
p. 150, under no. S31.

158. A Sea Horse and a Dolphin

1975.1.530
Pen and brown ink, brown wash, over traces of black chalk.
65 × 153 mm. Signed in gray ink, bottom right: *Do.° Tiepolo f.*

Morassi suggests that these may be ideas for a fountain.[1]
The dolphin (so called) is borrowed from an etching
by Stefano della Bella, *Two Tritons Struggling with Sea-
Monsters* (Fig. 34).[2] Domenico has copied the creature
rather closely, eliminating the Triton.

J. B. S.

NOTES:
1. Venice 1959a, p. 67, no. 101.
2. De Vesme 1906, p. 260, no. 999.

PROVENANCE: Paul Wallraf, London. Acquired by Robert
Lehman in 1962.

EXHIBITED: Venice 1959a, no. 101; Cologne 1959, no. 101;
New York 1981, no. 178.

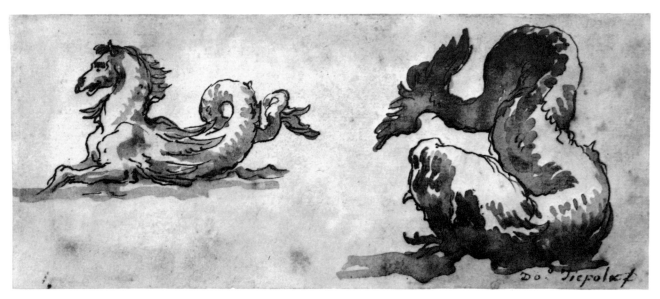

No. 158

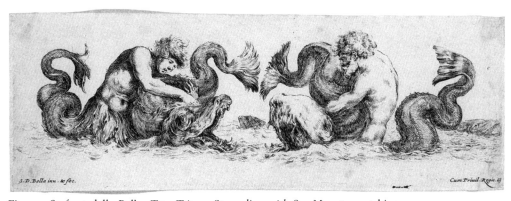

Fig. 34. Stefano della Bella. *Two Tritons Struggling with Sea Monsters*, etching

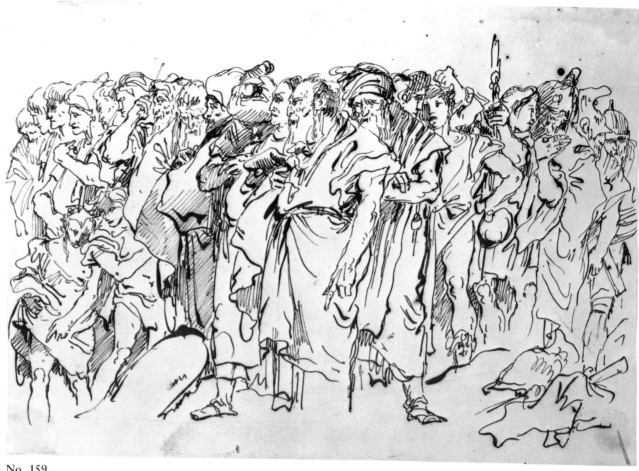

No. 159

159. A Crowd of Ancient Warriors, Orientals, and Two Boys, Gathering for a Sacrifice

1975.1.505
Pen and brown ink. 195 × 280 mm.

This and No. 160 are characteristic examples of a considerable group of drawings by Domenico representing closely packed crowds of figures in antique Roman or Oriental dress, often composed in a sort of wedge-shaped formation (as here), gathering at pagan altars as though for sacrifice. Their purpose is not entirely clear; but it seems certain that the subject is inspired by Giambattista Tiepolo's series of etchings called *Capricci* and *Scherzi di Fantasia*. The question of the priority of date of these two series, which has been much disputed, is not of much importance here if we accept George Knox's present view that both series were produced about 1743.[1] It is evident that once the prints were published they remained in some respects a source of inspiration to Domenico throughout

the early years of his career—beginning about 1747, when at the age of twenty he was already painting the *Stations of the Cross* in San Polo, Venice.[2] Drawings in the style of the present sheet are surely not to be dated much later than that.

Besides the other Lehman drawing, No. 160, two drawings in the Fitzwilliam Museum, Cambridge, are very close indeed to this one in subject, composition, and types.[3] In both of them as in No. 159, the old man with the long beard, wrapped in a cloak, is the most prominent figure. Three other similar groups (but in upright format) are in the Royal Museum, Canterbury;[4] two more were in the Orloff collection, sold in Paris in 1920;[5] and another is in Trieste.[6]

<div align="right">J. B. S.</div>

NOTES:
1. See Byam Shaw 1976a (review of Knox 1975), pp. 181–82.
2. See, for example, the crowds of spectators in the backgrounds of Stations III, IX, and XI (Mariuz 1971, pls. 3, 9, 12).

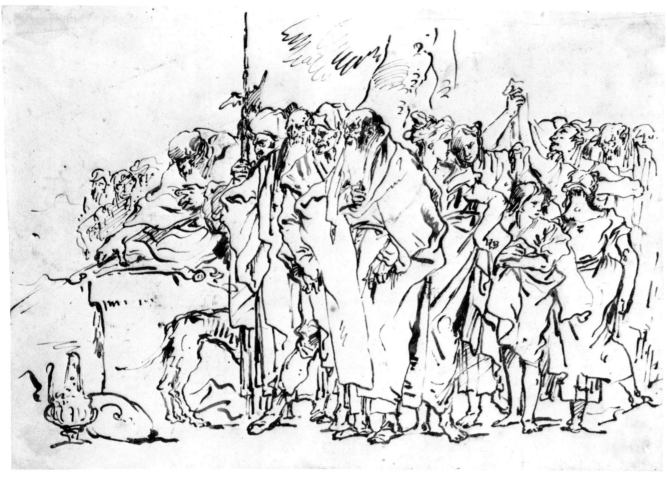

No. 160

3. For one of these, from the Ricketts and Shannon bequest of 1937, see Cambridge 1979, p. 78, no. 197; the other (inv. no. 2613) was acquired in 1979.
4. Byam Shaw 1979, p. 242, pls. 10–12; exhibited Canterbury 1985, nos. 25, 32, 33 (reproduced in the catalogue).
5. Orloff sale, Galerie Georges Petit, Paris, April 29–30, 1920, nos. 146, 147.
6. Vigni 1942, pp. 60–61, no. 173.

PROVENANCE: Sir Gilbert Lewis; Sir Henry Duff-Gordon, Bart., Harpton Court, Kingston, Herefordshire; Duff-Gordon sale, Sotheby's, London, February 19, 1936, lot 72; P. & D. Colnaghi & Co., London; Paul Wallraf, London. Acquired by Robert Lehman in 1962.

EXHIBITED: Venice 1959a, no. 91; Cologne 1959, no. 91; Birmingham (Ala.) 1978, no. 100; New York 1981, no. 160.

LITERATURE: Byam Shaw 1962, pp. 80–81, pl. 44.

160. A Crowd of Persons in Antique Roman or Oriental Dress, Gathering at a Pagan Altar

1975.1.507
Pen and brown ink. 195 × 285 mm.

See the entry for No. 159, which is very similar in composition and figure types.

J. B. S.

PROVENANCE: Paul Wallraf, London. Acquired by Robert Lehman in 1962.

EXHIBITED: Venice 1959a, no. 90; Cologne 1959, no. 90; New York 1981, no. 116; Pittsburgh 1985, no. 34.

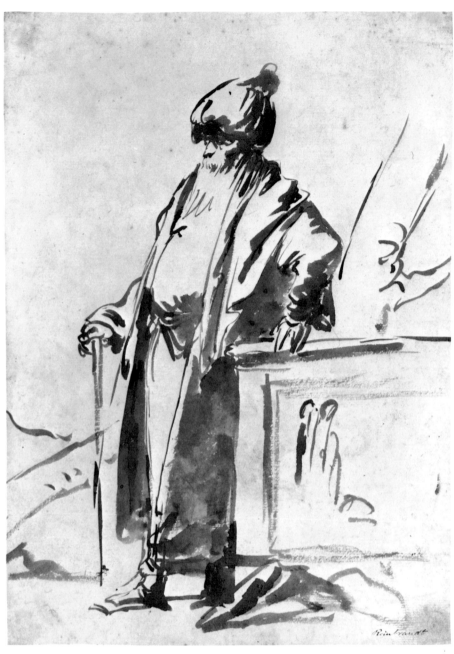

No. 161

161. An Old Man in Oriental Dress, Standing by a Pagan Altar

1975.1.506
Point of the brush and brown ink. 250 × 180 mm.
Annotated in dark brown ink, in a late eighteenth- or early nineteenth-century hand, bottom right: *Rimbrandt*.

Figure studies like this, often drawn with the brush only, are characteristic of Domenico in the middle years of the century, when he was imitating his father most nearly. Morassi drew attention to a half-length Oriental in this technique in the Orloff sale of 1920;[1] several similar figures, one signed by Domenico, were in the Duff-Gordon sale of 1936.[2] One of the best of the Duff-Gordon group, sold as lot 77, exactly like the Lehman drawing in subject, style, and technique, now belongs to Mrs. Rudolf Heinemann.[3]

Such drawings may be to some extent inspired by figures in Rembrandt's etchings, as Morassi, referring to the absurd annotation on the present example, suggests; but I doubt whether any of them are copies from that master. They have in the past been attributed to Giambattista Tiepolo, but there can be no doubt that the Lehman drawing and many others are by his son. A study of an Oriental

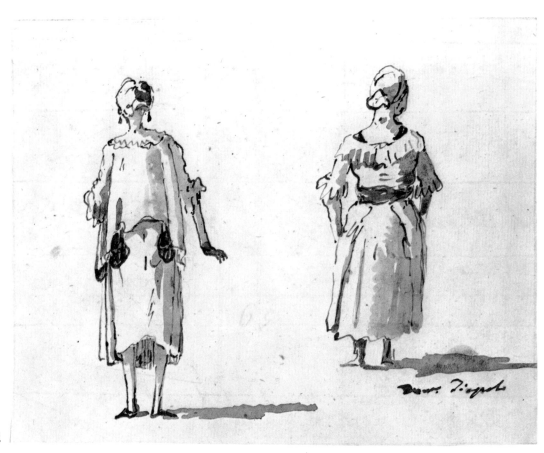

No. 162

facing to the right, again exactly in the style of No. 161, which was in the collection of the late Sir Bruce Ingram, is signed *Dom° Tiepolo*, the first name being quite clear though some attempt has been made to erase it; another signed drawing, certainly comparable despite its pen-and-ink technique, is in the Royal Museum, Canterbury.[4]

J. B. S.

NOTES:

1. Venice 1959a, pp. 94–95, no. 94; Orloff sale, Galerie Georges Petit, Paris, April 29–30, 1920, no. 77.
2. Duff-Gordon sale, Sotheby's, London, February 19, 1936, lots 75, 76, 77, 82, 89.
3. Oppé 1930, p. 31, pl. 11 (as Giambattista Tiepolo); New York 1973, p. 53, no. 85.
4. Byam Shaw 1979, pp. 240–42, pl. 8; exhibited Canterbury 1985, no. 28 (reproduced in the catalogue).

PROVENANCE: Paul Wallraf, London. Acquired by Robert Lehman in 1962.

EXHIBITED: Venice 1959a, no. 94; Cologne 1959, no. 94; Birmingham (Ala.) 1978, no. 128; Huntington (N.Y.) 1980, no. 32; New York 1981, no. 161; Rochester 1981, no. 42; Detroit 1983, no. 46; Pittsburgh 1985, no. 54.

162. Caricature of Two Women Seen from Behind

1975.1.508

Pen and gray ink, brown and gray wash. 156 × 196 mm. Signed in brown ink, lower right: *Dom° Tiepolo*.

No. 162 is an example of Domenico's late "ragged" style. Both he and his father, in their caricatures, delighted in drawing figures seen from the back. The lanky lady on the left reappears, holding up an umbrella, in no. 74 of the Punchinello series, a drawing in the Cleveland Museum of Art, generally called *The Summer Shower.*[1]

J. B. S.

NOTE:

1. Bloomington (Ind.) 1979, p. 82, no. 23.

PROVENANCE: Paul Wallraf, London. Acquired by Robert Lehman in 1962.

EXHIBITED: Venice 1959a, no. 113; Cologne 1959, no. 113; Huntington (N.Y.) 1980, no. 33; New York 1981, no. 162; Rochester 1981, no. 54; Detroit 1983, no. 40.

LITERATURE: Bloomington (Ind.) 1979, p. 82, under no. 23.

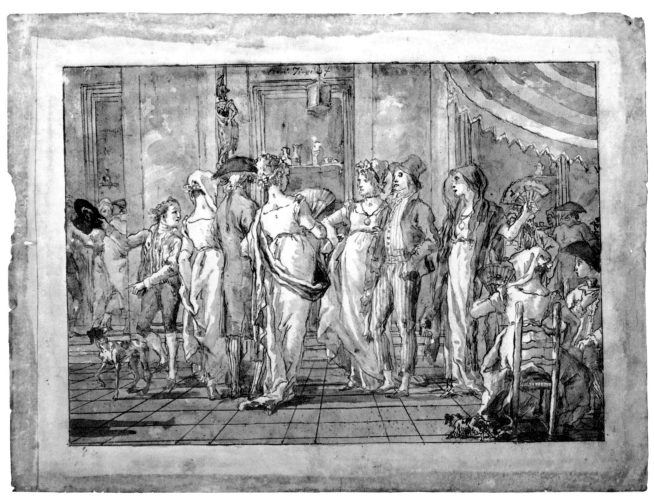

No. 163

163. "In Piazza"

1975.1.510

Pen and brown ink, brown wash, over black chalk. 365 × 501 mm. (whole sheet); 290 × 420 mm. (without margin). Signed in brown ink, top center: *Dom⁰ Tiepolo f.*

This is one of the most delightful of Domenico's Scenes of Contemporary Life, many of which are dated 1791; in it an elderly naval officer, with two young ladies on his arms, meets a young gentleman, also escorting two ladies, under the colonnade of the Procuratie Nuove. The drawing makes a pair with a *Café on the Quayside* belonging to Mrs. F. A. Shaw in London.[1]

Morassi[2] contrasts the fashions favored by the two gentlemen: the younger is dressed in the style of the very end of the eighteenth century, with striped trousers and top hat tilted back. The young ladies' *coiffure* and high-waisted dresses are characteristic of the same period.

A close but feeble copy of this drawing, with heavy-handed wash and with the false signature *Tiepolo F* above, was in a private collection in the United States in 1970. According to the owner it was acquired from the family of a former owner of Domenico's original.

J. B. S.

NOTES:
1. Byam Shaw 1962, p. 88, pl. 71.
2. Venice 1959a, pp. 74–75, no. 114.

PROVENANCE: Guggenheim sale, Palazzo Balbi, Venice, September 30, 1913, no. 1156; Conte Dino Barozzi, Venice; Paul Wallraf, London. Acquired by Robert Lehman in 1962.

EXHIBITED: Venice 1959a, no. 114; Cologne 1959, no. 114; Washington 1974, no. 112; Birmingham (Ala.) 1978, no. 26; Huntington (N.Y.) 1980, no. 37; New York 1981, no. 163; Rochester 1981, no. 60; Detroit 1983, no. 41; Pittsburgh 1985, no. 45.

LITERATURE: Morazzoni 1931, pl. 86; Byam Shaw 1933, p. 57, pl. 65; Morassi 1941, p. 281; Juynboll 1956, p. 79; Byam Shaw 1962, p. 88, under no. 71.

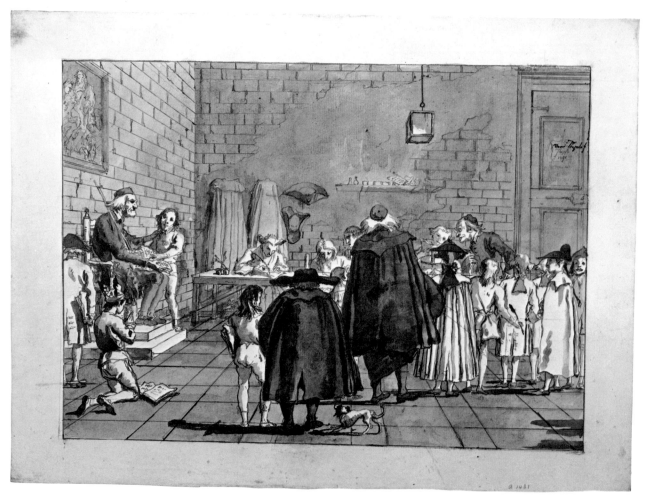

No. 164

164. The School

1975.1.512

Pen and brown ink, gray wash, over black chalk. 371 × 503 mm. (whole sheet); 299 × 453 mm. (without margin). Signed and dated faintly in brown ink on a paper attached to the wall, upper right: *Tiepolo 1791*; signed again more clearly in dark brown ink, just above the first signature: *Domº Tiepolo f.* Watermark: see New York 1971, no. 20.

PLATE 14.

It is curious that the date 1791, which appears here, is the only date to be found (so far as I know) on any of Domenico's drawings; yet it occurs on a considerable number of his Scenes of Contemporary Life, both high and low. In that year he was still at his best as a draftsman, and these pictorial commentaries, which catch something of the spirit of the age and are at times mildly satirical, are a source of considerable interest to the historian and sociologist as well as of pleasure to the amateur of art. They are not studies for paintings, though the same compositions occur occasionally in Domenico's small cabinet pieces; they were intended rather for the collector's portfolio,

and I remember with particular pleasure how many of them reposed, thirty years ago, in the portfolios of that most discerning collector, Adrien Fauchier-Magnan, at Cannes-La Bocca on the French Riviera.

Parts of this drawing were adapted by Domenico in one of the Punchinello series, *Punchinello as a Schoolmaster*, formerly in the collection of the Duc de Talleyrand.[1]

J. B. S.

NOTE:

1. Bloomington (Ind.) 1979, p. 44, no. 4; the drawing bears the old number 25.

PROVENANCE: P. & D. Colnaghi & Co., London; Henry Oppenheimer, London; Granville Tyser, London; sale, Sotheby's, London, November 18, 1959, lot 14; P. & D. Colnaghi & Co., London. Acquired by Robert Lehman in 1960.

EXHIBITED: London 1953a, no. 190; London 1960, no. 15; New York 1971, no. 262; Huntington (N.Y.) 1980, no. 35; New York 1981, no. 164; Rochester 1981, no. 53; Detroit 1983, no. 42; Pittsburgh 1985, no. 46.

LITERATURE: Parker 1931, p. 49, pl. 42; Byam Shaw 1962, p. 63, n. 6.

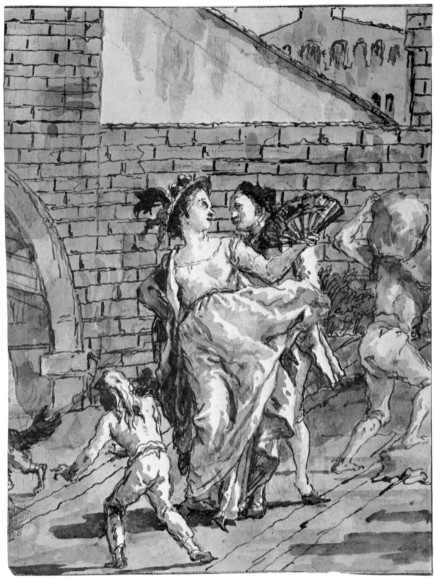

No. 165

165. A Flirtation

1975.1.513
Pen and brown ink, brown wash, over black chalk. 286 × 222 mm.

The absence of the usual signature and the unusual vertical format, besides the apparent curtailment of the scene, especially on the left, make it virtually certain that the sheet has been cut and that a considerable part is missing.

In spite of its probable mutilation, to which George Szabo draws attention,[1] this is a charming scene, more elegant than the rather similar episode with the Punchinello and his lady painted by Domenico about 1797 on the wall of one of the small rooms on the ground floor of the Villa Tiepolo at Zianigo and now transferred to the Ca' Rezzonico in Venice.[2] The date may be about the same.

J. B. S.

NOTES:
1. Huntington (N.Y.) 1980, p. 12, no. 36.
2. Mariuz 1971, p. 142, pls. 370, 374.

PROVENANCE: Julius Herz von Hertenried; Oskar von Bondy, Vienna; Leopold Blumka, Vienna and New York; Wildenstein and Co., New York. Acquired by Robert Lehman in 1961.

EXHIBITED: New York 1959, no. 104; Huntington (N.Y.) 1980, no. 36; New York 1981, no. 165; Rochester 1981, no. 55; Detroit 1983, no. 44.

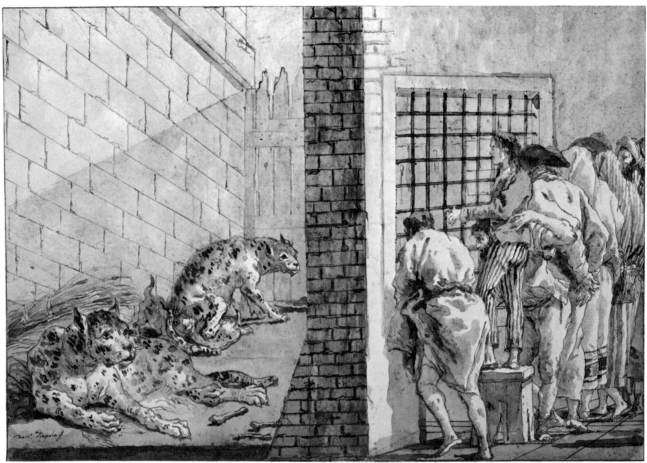

No. 166

166. The Leopards' Cage at the Menagerie

1975.1.516
Pen and brown ink, brown wash, over black chalk. 288 × 415 mm. Signed in brown ink, bottom left: *Domº Tiepolo f.*

The perspective, not to say the architecture, of the rather ramshackle yard that serves as the leopards' cage is difficult to understand, and the drawing gives the impression of having been put together, not very successfully, from two halves.

Both animals are exactly copied by Domenico from a print by the Augsburg artist Johann Elias Ridinger (Fig. 35), one of the series called *Betrachtung der wilden Thiere*, of which Domenico also made use elsewhere.[1] The leopard corresponds in reverse, while the leopardess is shown in the same direction as in the print. The same leopard reappears in one of the Punchinello series, now in the National Gallery of Canada,[2] and again, alone, in a drawing sold at Sotheby's in 1978.[3] The leopardess suckling her cubs recurs, rather strangely, with three lions

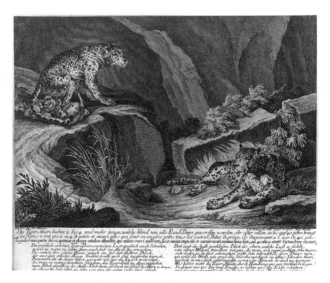

Fig. 35. Johann Elias Ridinger. *Two Leopards*, engraving

and the Holy Family's pack-ass in a drawing of the Rest on the Flight belonging to Domenico's Large Biblical Series.[4]

A rather more successfully composed drawing of *The Lions' Cage*, formerly in the Beurdeley and Fauchier-Magnan collections, was sold in Paris in 1967.[5] That drawing, like the present one, was adapted in one of the Punchinello series.[6]

<div align="right">J. B. S.</div>

NOTES:

1. Thienemann 1856, p. 59, no. 233. In the text under the print the animals are called tigers. For Ridinger, see No. 149.
2. Bloomington (Ind.) 1979, p. 96, no. 30; according to the old number on the drawing, it was no. 38 in the series.
3. Sale, Sotheby's, London, May 21, 1978, lot 24.

4. Cormier sale, Galerie Georges Petit, Paris, April 30, 1921, no. 45 (illustrated in the catalogue).
5. Sale, Palais Galliéra, Paris, June 12, 1967, no. 162 (illustrated in the catalogue).
6. Bloomington (Ind.) 1979, pp. 159–60, no. S55.

PROVENANCE: Jacques Seligmann, Paris; Otto Wertheimer, Paris; T. Grange, London; M. Knoedler and Co., New York. Acquired by Robert Lehman in 1960.

EXHIBITED: London 1958, no. 8; Huntington (N.Y.) 1980, no. 38; New York 1981, no. 166; Rochester 1981, no. 52; Detroit 1983, no. 43.

LITERATURE: *Weltkunst* 1958, p. 10; Byam Shaw 1962, p. 48, n. 7.

Punchinello

The 104 drawings by Domenico Tiepolo illustrating a story of Punchinello[1] have by now become so famous that it is hardly necessary to add to the literature on the subject. I have given something of the earlier history of that well-known character from the Commedia dell'Arte, and details of the whole series of drawings, in my book of 1962,[2] and it would be tedious to repeat it all here; but I may be allowed to summarize.

The drawings—which develop the themes painted by Domenico in delightful frescoes, *en grisaille*, in the family villa at Zianigo—first appeared from an unrecorded source in a sale at Sotheby's, London, on July 6, 1920; they were catalogued as 102 in number, but were in fact 103, the title page (presumably) not being counted.[3] They were sold in one lot and bought by Colnaghi, who sold them later, still in one lot, to Richard Owen. Owen first exhibited them at the Musée des Arts Décoratifs in Paris, and then sold them piecemeal.[4] They are now scattered in various collections, public and private, all over the world: twelve are in the collection of Sir Brinsley Ford in London, nine in the Robert Lehman Collection, and eight in the Cleveland Museum of Art; apart from these, I know of no collection that has more than two.[5]

I attempted in 1962[6] to suggest a possible sequence for the series, following (to some extent at least) the old numbering that occurs on most of the drawings in the wide margin at top left. Unfortunately, the old numbers are not always recorded, and are often hidden by mounts and frames; those that are recorded do not always correspond with the numbers written years ago on the backs of the only two complete sets of photographs known to me; nor is the numbering of those two sets, which belong to Sir Brinsley Ford and to Henry Sayle Francis, mutually consistent.[7] In short, the sequence seems to have been confused after the sale of 1920—and perhaps long before that. Nevertheless, I still think there is something to be said for an arrangement such as I suggested: a history beginning with the birth of Punchinello's father, the marriage of his parents, and his birth and childhood, then proceeding through his various occupations and adventures at home and in distant lands to his illness, his death, and the appearance of his ghost. The old numbers, so far as they are known to me, do not entirely suit this pattern; but generally speaking the birth, marriage, and childhood scenes do carry the earlier numbers, and the illness, death, and funeral scenes carry late ones.[8] If, therefore, I

follow my own suggested order in the present catalogue, it must be understood that this is only conjectural, and something of a *faute de mieux* solution.[9]

I think it is possible that in the case of the Punchinellos the old numbering may have been done after Domenico's death by one of his family or executors; this must certainly be the last of his many series of drawings, finished perhaps within a year or so of his death in 1804, though perhaps begun earlier. There are no dates on the Punchinellos, but the drawings are surely later than the grisaille frescoes in the Camera dei Pagliacci at Zianigo (now reconstructed in Ca' Rezzonico, Venice), which are probably of about 1793. In some of the drawings, admittedly, the penwork and the wash are neater, nearer to the style of the Scenes from Contemporary Life, many of which are dated 1791; but in many of them, which I take to be the later ones, the penwork is more straggling and the wash more untidy. Furthermore, the artist's visual memory and imagination seem to be failing; in no other series of drawings does he depend so much, whether for an individual figure or for a composition, on earlier drawings of his father's and his own; more particularly, he borrows repeatedly from his own Contemporary Life series.[10] Nevertheless, in spite of these criticisms, I believe that the Punchinello drawings will remain the most popular, and may always be considered the most amusing and characteristic, of all the works of Domenico Tiepolo.

J. B. S.

NOTES:

1. Pulcinella, Polichinelle, or Punch. I use an anglicized hybrid form of the name, because it is near to that used by Domenico himself in the inscription *Grazia a Punch/nela* on a paper held by an officer in the drawing *Punchinello Released from Prison* in the Cleveland Museum of Art (Bloomington [Ind.] 1979, p. 108, no. 36). George Knox, in an article on the Punchinello drawings (Knox 1983b; see also No. 96), has developed—plausibly, in my opinion—a theory that some of them were inspired by the annual carnival celebration at Verona called the *Baccanale del Gnocco*, the feast of that peculiarly Veronese form of pasta. See, for example, a drawing in the Heinemann collection, New York (Bloomington [Ind.] 1979, p. 154, no. S41), where a Punchinello riding a donkey brandishes *gnocchi* on the end of a fork. Marcia E. Vetrocq, in the catalogue just referred to (p. 27), had already hinted at the possibility of such a connection.

2. Byam Shaw 1962, pp. 52–59.

3. According to the title page, now in the Nelson-Atkins Museum of Art, Kansas City (Byam Shaw 1962, p. 91, pl. 81), the series consisted of "*carte no. 104*"; one was therefore missing when the rest were sold at Sotheby's, and there is no doubt in my mind that the missing drawing was *Punchinellos with an Elephant* (Bloomington [Ind.] 1979, p. 94, no. 29), which came to the Pierpont Morgan Library with the Fairfax Murray collection in 1910 and must therefore have been detached from the set before that date. *Punchinello's Skeleton Crawling from His Grave to a Pagan Altar* (Bloomington [Ind.] 1979, p. 58, no. 11), a drawing now in the collection of Mrs. Jacob Kaplan, New York, bears the old number *104* in the margin (not *102* as stated in New York 1971, p. 111, no. 284), confirming the total figure given on the title page.

4. It is perhaps interesting to record some prices: Colnaghi, having bought the lot for £610 in 1920, sold them in the same year to Owen for £800. On July 3, 1980, two single examples from the series, offered by Sotheby's at auction (lots 63 and 64), fetched respectively £27,000 and £23,000. I have never seen a catalogue of the 1921 exhibition at the Musée des Arts Décoratifs, Paris; probably none was printed.

5. Those that belonged to the brothers Léon and Paul Suzor in Paris, who between them owned thirteen (two are reproduced in Byam Shaw 1962, p. 94, pls. 95, 96), were mostly sold and scattered in 1965 and 1966.

6. Byam Shaw 1962, pp. 54–56.

7. See the concordance in Bloomington (Ind.) 1979, p. 36.

8. Thus old numbers 2, 7, 9, and 11 occur on the drawings reproduced in Byam Shaw 1962, pls. 82–85, No. 168 in the present catalogue has old number 8, and No. 167 has 15; according to my conjectural reconstruction, these drawings all represent early incidents in the story. The old number 99 is on *Punchinello's Last Illness* (Bloomington [Ind.] 1979, p. 56, no. 10; the wrong number is given in Byam Shaw 1962, p. 94, pl. 96); the *Funeral* has *102*; the *Burial* (No. 175 in the present catalogue) has *103*; and *Punchinello's Skeleton Crawling from His Grave* (see above, n. 3) has *104*.

9. Of the excellent catalogue (Bloomington [Ind.] 1979), by Adelheid Gealt and Marcia E. Vetrocq, of the exhibition *Domenico Tiepolo's Punchinello Drawings*, held at Indiana and Stanford Universities and at the Frick Collection in New York, I have only this complaint: that the entries are arranged in no logical order. It is, however, the only source for illustrations of the whole series, and the commentary is entertaining and instructive.

10. For examples, see Byam Shaw 1962, p. 57, n. 1.

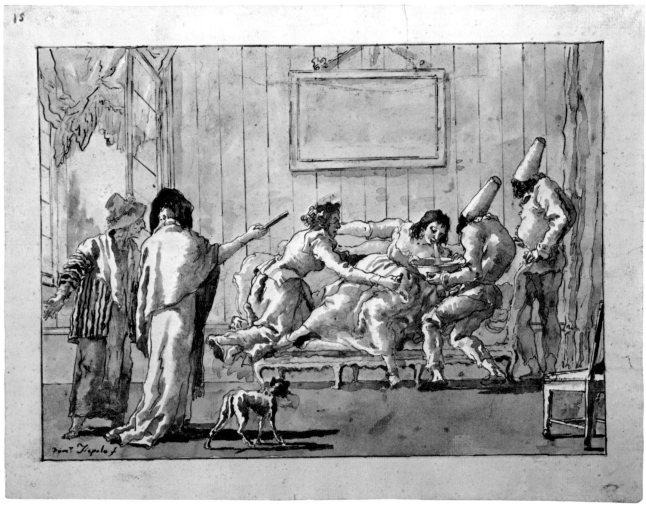

No. 167

167. Punchinello's Mother (?) Sick in Pregnancy

1975.1.470

Pen and brown ink, brown wash, over black chalk. 353 × 470 mm. (whole sheet); 295 × 414 mm. (without margin). Signed in brown ink, bottom left: *Domᵒ Tiepolo f*. Old number, in brown ink, in upper left margin: *15*. Watermark: single crescent (see New York 1971, watermark no. 13).

The subject is surely the pregnancy either of Punchinello's mother or of his wife; the lady might be the same as the mother in bed with her baby in No. 168. The scene with the lady fainting (no doubt for the same reason) in a drawing sold at Sotheby's in 1980[1] and bearing the preceding old number, *14*, is followed naturally enough by the *contretemps* illustrated here. J. B. S.

NOTE:

1. Sale, Sotheby's, London, July 3, 1980, lot 63.

PROVENANCE: Sale, Sotheby's, London, July 6, 1920, part of lot 41; P. & D. Colnaghi & Co., London; Richard Owen, Paris; Savile Gallery, London.

EXHIBITED: Paris 1921; London 1929, no. 5; Chicago 1938, no. 104; New York 1939, no. 10; New York 1971, no. 270; New York 1980, no. S16; New York 1981, no. 132; Detroit 1983, no. 59.

LITERATURE: Borenius 1929, p. 149; Morassi 1941, p. 279; Byam Shaw 1962, p. 56, n. 3.

168. The Infant Punchinello in Bed with His Parents

1975.1.465

Pen and brown ink, two shades of brown wash, over black chalk. 351 × 467 mm. (whole sheet); 293 × 411 mm. (without margin). Old number, in brown ink, in upper left margin: *8*. Watermark: coat of arms (see New York 1971, watermark no. 10). Some foxing.

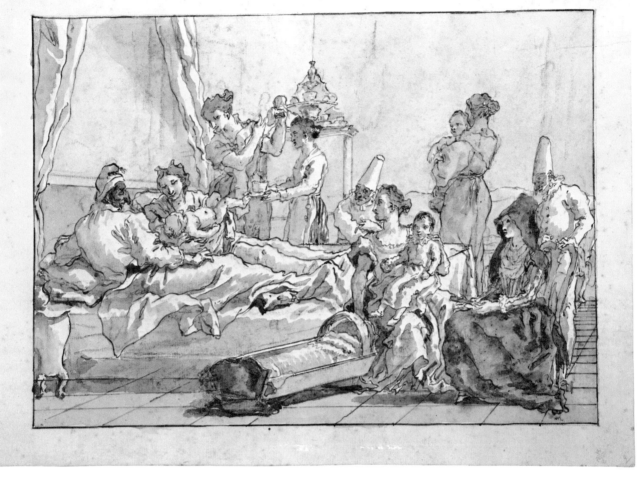

No. 168

This charming scene evidently belongs to the childhood of Punchinello (observe the developing nose of the child in his mother's arms), as the early number in the margin suggests; it is plausibly given this title by Gealt and Vetrocq.[1]

The lady with the fan, seated here on the right, exactly corresponds—but in the reverse direction—with the duenna watching her charge in the hands of the dressmaker in an amusing drawing by Domenico in the Pierpont Morgan Library.[2] That work is dated 1791 (the only date, so far as I know, that occurs on any of his drawings); the contours are firmer than they are here, and the present drawing is certainly later. Domenico must here have used a tracing; as often, he has used a ruler for the furniture of the room.

The cradle is the same as one in no. 4 of Domenico's early series of etchings, *Idee Pittoresche sopra la Fugga in Egitto* (1750–53).[3]

J. B. S.

NOTES:

1. Bloomington (Ind.) 1979, p. 138, no. S2. On the other hand, I am inclined to believe that the drawing with the old number *1* (ibid., p. 138, no. S1), which belongs to Sir Brinsley Ford and shows a little Punchinello hatched by a turkey from an enormous egg, represents the birth of the father of our hero.
2. New York 1971, p. 104, no. 260.
3. Marcia E. Vetrocq (Bloomington [Ind.] 1979, p. 138, no. S2) has pointed out that the composition of the drawing recalls that of the etching.

PROVENANCE: Sale, Sotheby's, London, July 6, 1920, part of lot 41; P. & D. Colnaghi & Co., London; Richard Owen, Paris; Lady Elliot, London; sale, Sotheby's, London, March 6, 1957, lot 34 (to Kauffmann); Marianne Feilchenfeldt, Zürich.

EXHIBITED: Paris 1921; New York 1971, no. 271; Birmingham (Ala.) 1978, no. 119; New York 1980, no. S2; Huntington (N.Y.) 1980, no. 41; New York 1981, no. 130; Rochester 1981, no. 48; Detroit 1983, no. 58.

LITERATURE: Byam Shaw 1962, pp. 55–56; Szabo 1983, no. 77.

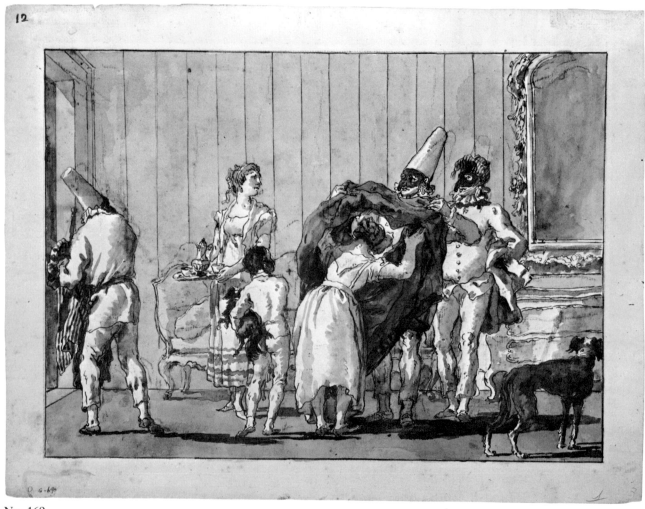

No. 169

169. Punchinello as Dressmaker

1975.1.466

Pen and brown ink, brown wash, over black chalk. 354 × 470 mm. (whole sheet); 292 × 412 mm. (without margin). Old number, in brown ink, in upper left margin: *12*. Watermark: three crescents diminishing in size.

PLATE 15.

According to the classification of the Punchinello subjects suggested in my book,[1] this drawing belongs to Chapter II of the narrative, "The Trades and Occupations of Punchinello." I have given reasons for supposing that the original order was not exactly that of the old numbering in the upper left margin; certainly the number *12* here does not suit my proposed sequence.

 The furniture and *décor* of the room here is much the same as in a drawing in the Pierpont Morgan Library entitled *At the Dressmaker's*, which does not belong to the Punchinello series and is dated 1791.[2] The wavering con-

tours in No. 169, and the fact that the girl carrying the coffee tray wears a high-waisted "Regency"-style dress (as in Goya), indicate that this drawing is certainly of later date.

<div align="right">J. B. S.</div>

NOTES:
1. Byam Shaw 1962, p. 56.
2. New York 1971, p. 104, no. 260.

PROVENANCE: Sale, Sotheby's, London, July 6, 1920, part of lot 41; P. & D. Colnaghi & Co., London; Richard Owen, Paris; Mrs. D. Kilvert, Paris; Rosenberg & Stiebel, New York. Acquired by Robert Lehman in 1961.

EXHIBITED: Paris 1921; New York 1971, no. 278; Birmingham (Ala.) 1978, no. 121; New York 1980, no. S17; Huntington (N.Y.) 1980, no. 43; New York 1981, no. 133; Rochester 1981, no. 49; Detroit 1983, no. 60.

LITERATURE: Byam Shaw 1962, p. 56; Szabo 1975, fig. 179; Szabo 1983, no. 78.

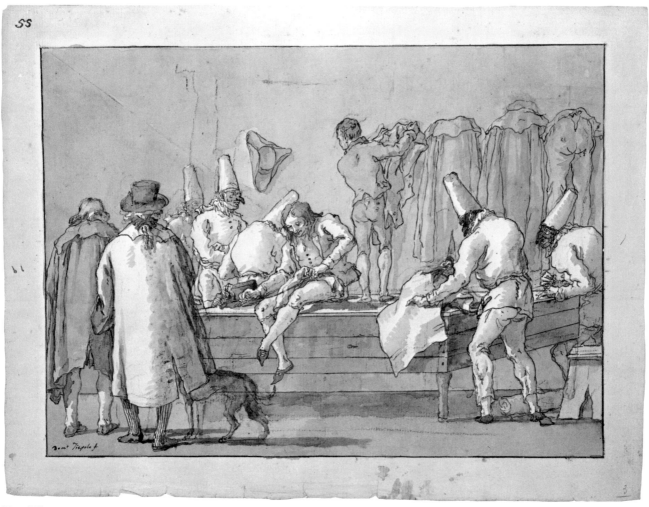

No. 170

170. Punchinello as Tailor's Assistant

1975.1.472

Pen and brown ink, light brown wash, over black chalk.
353 × 470 mm. (whole sheet); 293 × 411 (without margin).
Signed in brown ink, bottom left: *Dom° Tiepolo f.* Old number,
in brown ink, in upper left margin: *55*. Watermark: three cres-
cents, diminishing in size (see New York 1971, watermark
no. 18).

This drawing belongs, according to my conjectural ar-
rangement of the series, to Chapter II of the narrative,
"The Trades and Occupations of Punchinello."

J. B. S.

PROVENANCE: Sale, Sotheby's, London, July 6, 1920, part of lot
41; P. & D. Colnaghi & Co., London; Richard Owen, Paris;
Mrs. D. Kilvert, Paris; Rosenberg & Stiebel, New York. Ac-
quired by Robert Lehman in 1961.

EXHIBITED: Paris 1921; New York 1971, no. 277; New York
1980, no. S50; New York 1981, no. 136; Rochester 1981, no. 51;
Pittsburgh 1985, no. 41.

LITERATURE: Byam Shaw 1962, p. 92, pl. 88; Szabo 1983,
no. 80.

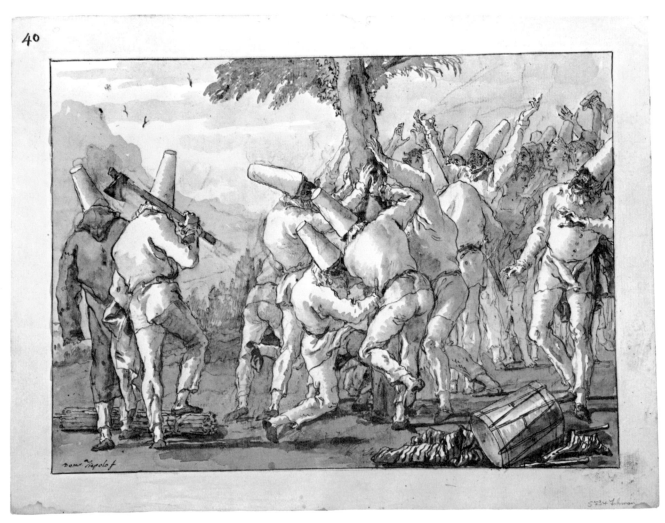

No. 171

171. Punchinellos Felling (or Planting) a Tree

1975.1.468

Pen and brown ink, brown wash, over rough black chalk. 353 × 473 mm. (whole sheet); 294 × 414 mm. (without margin). Signed in brown ink, bottom left: *Dom° Tiepolo f*. Old number, in brown ink, in upper left margin: *40*. Watermark: three crescents, diminishing in size.

PLATE 16.

It can be clearly seen in this drawing, as in many others of the Punchinello series, that the original indications in black chalk are not at all closely followed in the penwork. It looks as though the artist's first intention was to have flags flying at the upper right corner; and this, together with the drum at the lower right, lends support to the ingenious suggestion of Gealt and Vetrocq[1] that the drawing was intended to make fun of the ceremony of planting a "tree of Liberty," which took place in various cities of the Veneto to celebrate the "liberation" of Venice by the French revolutionary forces in 1797. In 1962 I made a similar suggestion about another of the Punchinello se-

ries, *Punchinellos in a Tavern*, now in a private collection in New York, where the writing on the wall might be interpreted as evidence of a "Resistance" after the French invasion.[2] It may be significant that that drawing has the old number *41* and thus immediately follows the present one, which is numbered *40*.

In quality, this is one of the best of the series.

J. B. S.

NOTES:
1. Bloomington (Ind.) 1979, p. 148, no. S28.
2. Byam Shaw 1962, p. 58; Bloomington (Ind.) 1979, p. 90, no. 27.

PROVENANCE: Sale, Sotheby's, London, July 6, 1920, part of lot 41; P. & D. Colnaghi & Co., London; Richard Owen, Paris; sale, Paris, Palais Galliéra, December 6, 1966, no. 10.

EXHIBITED: Paris 1921; New York 1971, no. 274; New York 1980, no. S28; New York 1981, no. 135; Pittsburgh 1985, no. 42.

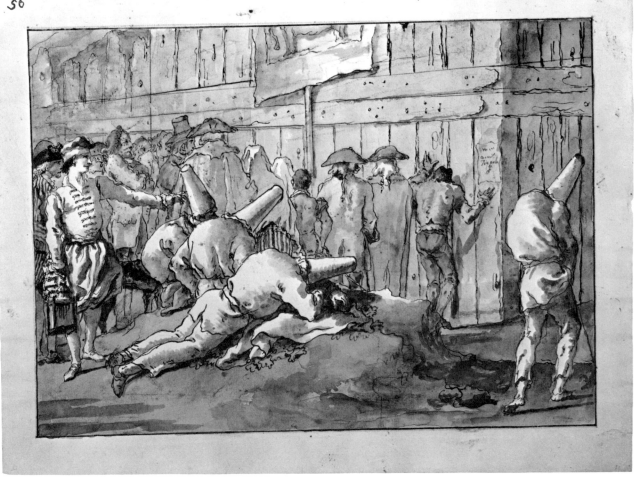

No. 172

172. Punchinellos Outside a Circus

1975.1.469

Pen and brown ink, brown wash, over black chalk. 349 × 464 mm. (whole sheet); 291 × 412 mm. (without margin). Signed in brown ink on a paper attached to the fence, center right: *Dom⁰ Tiepolo f.* Old number, in brown ink, in upper left margin: *50.* Watermark: single crescent (see New York 1971, watermark no. 13). Water-stained at upper left corner.

Other circus subjects are those bearing the old numbers *38,*[1] *39,*[2] and *46,*[3] and also the Pierpont Morgan Library drawing *Punchinellos with an Elephant,*[4] which has no margin and consequently no old number, and which was separated from the rest of the series at an early date (before 1910).[5]

The boy with the lantern at the left seems inappropriate to the occasion, and in fact he is exactly copied from an amusing Venetian scene, dated 1791, which once belonged to Adrien Fauchier-Magnan at Cannes-La Bocca.[6] He also reappears elsewhere in Domenico's work.

J. B. S.

NOTES:
1. Bloomington (Ind.) 1979, p. 96, no. 30.
2. Ibid., pp. 159–60, no. S55.
3. Ibid., p. 98, no. 31.
4. New York 1971, p. 109, no. 276; Bloomington (Ind.) 1979, p. 94, no. 29. See my introduction to the Punchinello series, p. 203, n. 3.
5. Also the drawing listed as S56 in the Bloomington catalogue of 1979, which was probably no. *45* (present whereabouts unknown).
6. Sale, Sotheby's, London, July 6, 1967, lot 43.

PROVENANCE: Sale, Sotheby's, London, July 6, 1920, part of lot 41; P. & D. Colnaghi & Co., London; Richard Owen, Paris; Paul Suzor, Paris; sale, Hôtel Drouot, Paris, March 19, 1965, no. 72.

EXHIBITED: Paris 1921; Paris 1950, no. 147; New York 1971, no. 275; New York 1980, no. S54; New York 1981, no. 137; Rochester 1981, no. 50; Detroit 1983, no. 61.

LITERATURE: Byam Shaw 1962, p. 56; Szabo 1983, no. 79.

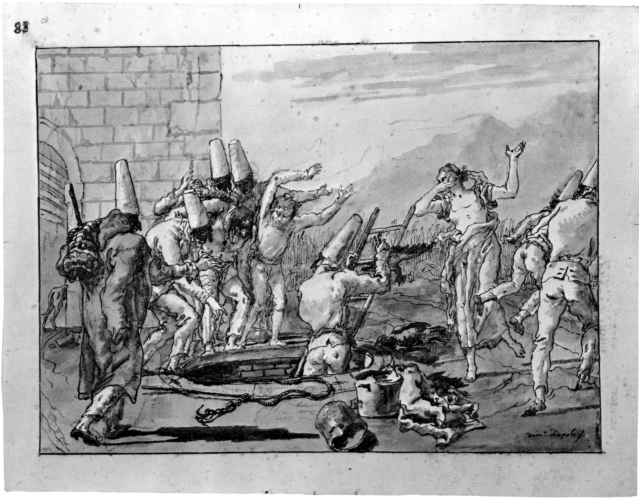

No. 173

173. Punchinello Retrieving Dead Fowls from a Well

1975.1.471

Pen and brown ink, brown wash, over black chalk. 350×465 mm. (whole sheet); 290×413 mm. (without margin). Signed in brown ink, bottom right: *Dom° Tiepolo f.* Old number, in brown ink, in upper left margin: *83* (the second figure has been altered). Watermark: three crescents, diminishing in size.

The culprit who threw the fowls in the well might be the Punchinello who is being punished in No. 174. That drawing bears the next old number but one, *85* (also with the second figure altered).

J. B. S.

PROVENANCE: Sale, Sotheby's, London, July 6, 1920, part of lot 41; P. & D. Colnaghi & Co., London; Richard Owen, Paris; Savile Gallery, London.

EXHIBITED: Paris 1921; London 1929, no. 4; Chicago 1938, no. 112; New York 1939, no. 11; Cincinnati 1959, no. 233; New York 1971, no. 280; New York 1980, no. S8; New York 1981, no. 131.

LITERATURE: Borenius 1929, p. 149, illustrated p. 194; Morassi 1941, p. 280, illustrated p. 277.

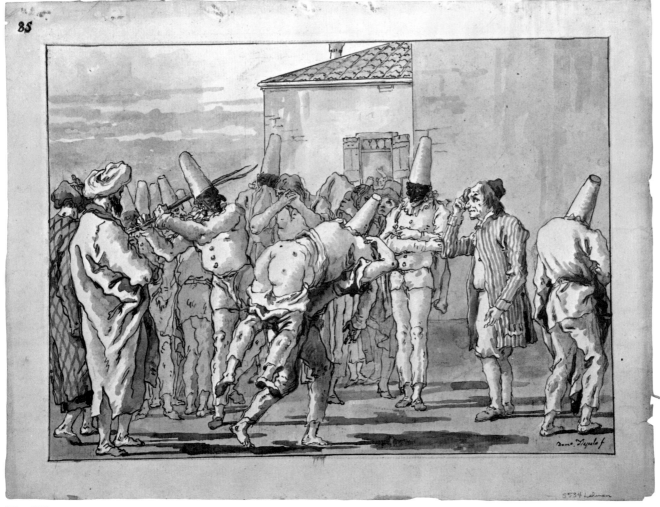

No. 174

174. The Flogging of a Punchinello

1975.1.467

Pen and brown ink, brown wash, over black chalk. 355 × 472 mm. (whole sheet); 295 × 412 mm. (without margin). Signed in brown ink, bottom right: *Dom⁰ Tiepolo f.* Old number, in brown ink, in upper left margin: *85* (the second figure has been altered). Watermark: crowned eagle above the letters *GFA* (see New York 1971, watermark no. 23).

The two figures on the extreme left are taken over from another drawing by Domenico, *Four Orientals Buying a Horse*, sold in Paris in 1963.[1] Furthermore, as Gealt and Vetrocq point out,[2] the spectator on the right with his glass to his eye (who appears to be quizzing the executioner rather than the victim—perhaps because the former is holding his birch in a grip quite impossible for his purpose) is copied from a caricature by Giambattista in the Museo Civico, Milan, and reappears, rather differently dressed, in the large *Mondo Novo* fresco from the Villa Tiepolo at Zianigo, now in the Ca' Rezzonico, Venice.[3]

That fresco is dated 1791; I suspect that the present drawing is somewhat later.

In Fielding's novel of 1749 the flogging of Tom Jones by his tutor Mr. Thwackum was to be carried out by the same method, the victim "mounted on the back of a footman."[4]

J. B. S.

NOTES:
1. Sale, Palais Galliéra, Paris, July 13, 1963, no. 1.
2. Bloomington (Ind.) 1979, p. 160, no. S57.
3. Mariuz 1971, pp. 140–41, pl. 366.
4. Henry Fielding, *The History of Tom Jones*, book 3, chapter 7.

PROVENANCE: Sale, Sotheby's, London, July 6, 1920, part of lot 41; P. & D. Colnaghi & Co., London; Richard Owen, Paris; Sale, Palais Galliéra, Paris, December 6, 1966, no. 11.

EXHIBITED: Paris 1921; New York 1971, no. 281; New York 1980, no. S57; New York 1981, no. 138; Pittsburgh 1985, no. 43.

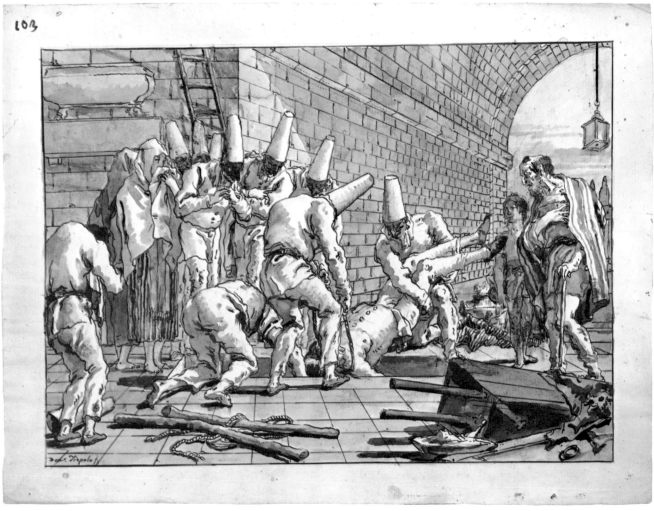

No. 175

175. The Burial of Punchinello

1975.1.473

Pen and brown ink, brown and yellow wash, over black chalk. 353 × 473 mm. (whole sheet); 295 × 413 mm. (without margin). Signed in brown ink, bottom left: *Dom° Tiepolo f.* Old number, in brown ink, in upper left margin: *103*. Watermark: three crescents, diminishing in size (see New York 1971, watermark no. 18).

This drawing, no. 103 of the series, represents the end of our hero but not quite the end of the story:

Last scene of all,
That ends this strange, eventful history

is a drawing in the collection of Mrs. Jacob Kaplan in New York, bearing the next (and final) number, *104*, in the upper left margin. In it the skeleton of Punchinello, when his friends attempt to rebury it in the open country,

comes to life and crawls up to the pedestal of a pagan altar or tomb, to the consternation of the burial party.[1]

J. B. S.

NOTE:

1. New York 1971, p. 111, no. 284 (Bean and Stampfle are mistaken in giving the serial number as *102*); Bloomington (Ind.) 1979, p. 58, no. 11.

PROVENANCE: Sale, Sotheby's, London, July 6, 1920, part of lot 41; P. & D. Colnaghi & Co., London; Richard Owen, Paris; Léon Suzor, Paris; sale, Hôtel Drouot, Paris, March 19, 1965, no. 70.

EXHIBITED: Paris 1921; Paris 1950, no. 152; New York 1971, no. 283; New York 1980, no. S25; New York 1981, no. 134; Pittsburgh 1985, no. 44.

Lorenzo Baldiserra Tiepolo

Venice 1736–Madrid 1776

Lorenzo, the younger of the two artist sons of Giovanni Battista Tiepolo, was a devoted assistant to his father from 1751, when he was only fourteen or fifteen, in Würzburg, to 1770, when his father died in Madrid. He is little known as an independent artist; only a few signed drawings, together with nine etchings (after Giambattista's paintings) and some portraits and half-length genre scenes in pastel are attributed with any certainty to him. Lorenzo died young, still in Madrid, where he is known to have made pastel portraits of several members of the Spanish royal family.

<div align="right">J. B. S.</div>

176. Figures in Antique Dress Grouped About a Pagan Tomb

1975.1.504
Pen and brown ink, over rough black chalk. 203 × 305 mm.

About a dozen figures, including one nude shown with his back turned, are listening to an aged priest or philosopher, who is pointing to the tomb. In the foreground is a globe, half-buried in the ground, with human skulls and severed heads piled against it. There is an obelisk at the far right.

The strange macabre subject is like those of many of Giambattista Tiepolo's etched series *Scherzi di Fantasia*, which clearly impressed the draftsman here. Much of the detail, too, shows that influence: the half-buried globe appears in several of the prints, particularly *Scherzo* no. 14,[1] as well as in the related drawing by Giambattista in the Victoria and Albert Museum, London.[2] The boy carrying a book, at the far left, is almost a reverse copy of the boy attending the philosopher in the same etching; for the severed head in the foreground, see *Scherzo* no. 4;[3] and for the obelisk, and the horse in the background to the left, see *Scherzo* no. 3.[4]

No. 176

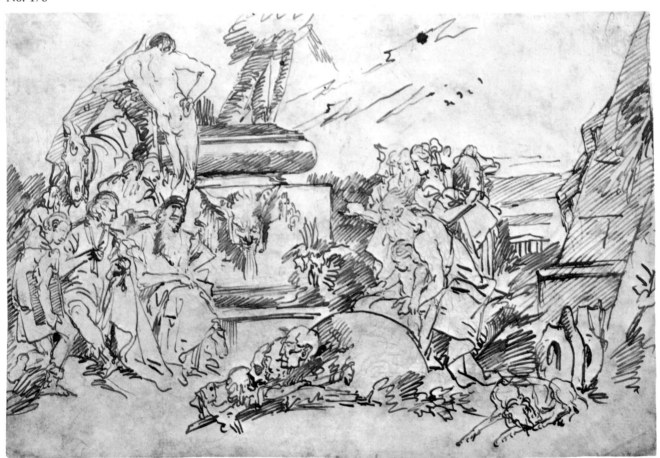

Yet the draftsman is certainly not Giambattista Tiepolo; and I am convinced that it is not by Domenico, to whom it has been attributed in the past—although Domenico drew scenes of this kind, imitating the *Scherzi* etchings in some of the crowded compositions to which I have referred in the entry for No. 159, and sometimes introducing skulls and severed heads and other paraphernalia of necromancy.[5] I believe that the present drawing can be shown to be by Domenico's younger brother, Lorenzo, through comparison with a drawing in Würzburg (Fig. 36).[6] That drawing represents a woman and her child in conversation with a satyr and a faun, in a fantastic landscape that includes a broken pine tree, an obelisk, two headless statues on pedestals, a wine jar, a tambourine, and panpipes; and it is clearly signed *Lorenzo Tiepolo del. Venet.* The Würzburg drawing is in pen and wash; the Lehman drawing is in pen only, with scribbled shading. Apart from that, the style is identical: the profile of the woman with the child is exactly that of the woman who seems to be holding up a mirror in the middle background toward the right of the Lehman

sheet; the roughly sketched figures farther back are the same in both drawings; and the clouds in the sky are indicated by the same streaky zigzag lines.

Two other drawings known to me, of similarly fantastic subjects, show all the same peculiarities and are, in my opinion, unquestionably by the same hand as No. 176 and the signed drawing in Würzburg. One, drawn on both sides of the paper and like the Würzburg drawing in upright format, was with Colnaghi's in London in 1980–81; it showed the same woman in profile, the same zigzag lines of cloud in the sky, the same horse in the background and the identical sleeping dog in the right foreground as in No. 176, and the obelisk and broken pine tree as in the Würzburg drawing. The other, which I know only from a photograph, seems to be more strongly washed in brown, but otherwise it is all much the same again, with the headless statue and broken pine tree as in the Würzburg fantasy, the boy with the book (reversed), the half-buried globe, and the satyr mask on the sarcophagus as in No. 176, and the zigzag lines of cloud as in both. This drawing belonged in 1981 to M. Prouté in Paris, and it has strong connections not only with those I have already discussed but also with No. 177 in the present catalogue.

J. B. S.

NOTES:
1. Udine 1970, no. 16.
2. Knox 1960, p. 63, no. 119.
3. Udine 1970, no. 6.
4. Udine 1970, no. 5.
5. See, for instance, one of the drawings in the Fitzwilliam Museum, Cambridge, mentioned under No. 159, n. 3.
6. Martin von Wagner Museum der Universität Würzburg, inv. no. 1029.

PROVENANCE: T. Grange, London; Charles E. Slatkin Galleries, New York. Acquired by Robert Lehman in 1960.

EXHIBITED: New York 1981, no. 159 (as Domenico Tiepolo).

Fig. 36. Lorenzo Tiepolo. *Capriccio with a Woman, a Satyr, and a Child*. Würzburg, Martin von Wagner Museum der Universität Würzburg

No. 177

177. Philosophers Instructing Pupils by an Antique Sarcophagus

1975.1.501
Pen and brown ink, brown wash, over black chalk. 205 × 303 mm.

The drawing has been attributed both to Giambattista and to Domenico Tiepolo, and indeed in its close relationship to the *Scherzi* etchings it is nearer to Giambattista; but it is much too weak in execution for him—note, for instance, the clumsy drawing of the hands. I believe it to be by the same draftsman as No. 176, although the broadly applied brown wash in the present sheet makes a different impression at first. Here again are many features borrowed from the *Scherzi:* the half-buried globe, the ragged trees, the obelisk, the jars, the skull (in this case that of a horse, as in *Scherzo* no. 6), and the dogs. All of these features also occur in No. 176, or in the signed drawing by Lorenzo Tiepolo at Würzburg, or in the two other drawings, referred to in the previous entry, which I also attribute to Lorenzo. It will be noticed that the scribbled

pen shading is exactly like that in No. 176.

Lorenzo Tiepolo was only forty years old when he died in Madrid in 1776. It is not surprising that he was so strongly influenced by his father's etchings, which appeared probably in the middle forties when he was still a boy but already learning his profession. He became a skillful etcher himself, though he completed only nine plates after his father's paintings.

J. B. S.

PROVENANCE: Sir Gilbert Lewis; Sir Henry Duff-Gordon, Bart., Harpton Court, Kingston, Herefordshire; Duff-Gordon sale, Sotheby's, London, February 19, 1936, lot 73; Richard Owen, Paris; Tomas Harris, London; Paul Wallraf, London. Acquired by Robert Lehman in 1962.

EXHIBITED: Venice 1959a, no. 92 (as Domenico Tiepolo); Cologne 1959, no. 92 (as Domenico Tiepolo); New York 1981, no. 113 (as Domenico Tiepolo); Detroit 1983, no. 36 (as Domenico Tiepolo).

LITERATURE: Oppé 1930, pp. 30–31 (as Giambattista Tiepolo).

Francesco Tironi

Venice ca. 1745–Venice 1797

Tironi, who received a priest's burial in 1797 in San Pietro di Castello, was said at that time to be aged about fifty-two years. Following the publication by Hermann Voss of two paintings in Berlin with the monogram *F.T.*, a number of paintings have been attributed to Tironi but nothing certain about his activity as a painter has been established. Our firm knowledge of him rests upon the series of twenty-four engravings of islands in the Lagoon made after his drawings by Antonio Sandi (1733–1817). These were published by Furlanetto at some date after 1779, since they do not appear in his list of that year. Many of these drawings by Tironi survive. Others, including two in the Pierpont Morgan Library, commemorate the visit of Pope Pius VI to Venice in 1782.

<div style="text-align: right">G. K.</div>

LITERATURE: Voss 1927–28; Pignatti 1974; Gorizia 1983, pp. 345–47, nos. 441–43.

178. View of Mazzorbo

1975.1.541

Pen and brown ink, gray wash. 280 × 414 mm. Some foxing.

Verso: A red line roughly following the silhouette of the buildings on the recto. Annotated in pencil, top center: *Città di Mazzorbo luogo de Delizie de Veneziani.*

No. 178 is a study for one of Antonio Sandi's engravings of islands in the Lagoon; about thirty such drawings by Tironi are known. Pignatti mentions six in the Albertina,[1] one in the Whitworth Art Gallery, Manchester,[2] two in the National Gallery of Art, Washington,[3] and six in the Victoria and Albert Museum.[4] Two other drawings mentioned by Pignatti, in the Pierpont Morgan Library, represent *feste dogali.*[5]

Other examples may be noted. A view of the Isola del Rosario was exhibited in London in 1911 and sold at Sotheby's in 1922.[6] Views of Burano, San Giorgio in

No. 178

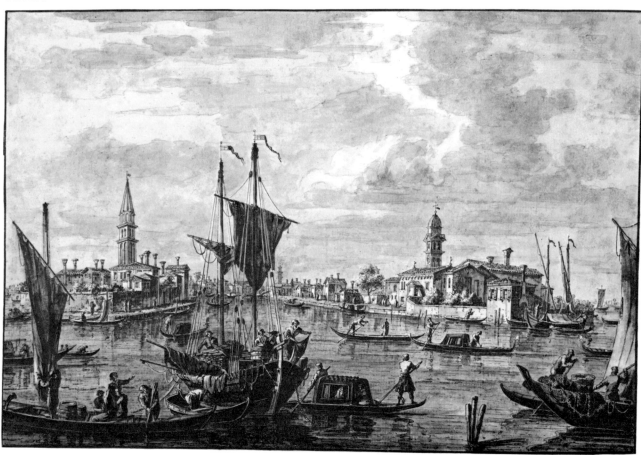

Fig. 37. Antonio Sandi. *View of Mazzorbo*, engraving

No. 178, Detail

Alga, and San Secondo were sold at Christie's in 1964.[7] One of San Michele in Isola was sold at Sotheby's in 1974,[8] and another, of the Isola di Sant'Elena, was exhibited at Colnaghi's in 1978.[9]

No. 178 is of considerable topographical interest, for the buildings shown in the drawing have all been destroyed. To the right is the church and Benedictine monastery of San Matteo di Mazzorbo.[10] Sandi's engraving (Fig. 37), which measures 270 × 400 mm., follows the drawing exactly.

G. K.

NOTES:

1. Pignatti 1974, nos. 36–41. See also Stix and Fröhlich-Bum 1926, nos. 361–64, 367, 368.
2. Pignatti 1974, no. 43. See also Stock 1980, no. 113.
3. Pignatti 1974, nos. 46, 47.
4. Ibid., nos. 52–57.
5. Ibid., nos. 48, 49. See also New York 1971, p. 115, no. 298.
6. London 1911, no. 59; sale, Sotheby's, London, February 15, 1922, lot 3.
7. Sale, Christie's, London, March 24, 1964, lots 118–120.
8. Sale, Sotheby's, London, March 21, 1974, lot 44.
9. London 1978, no. 72.
10. For further details see Zorzi 1977, pp. 430–31.

PROVENANCE: R. S. Holford (Lugt 2243); Paul Wallraf, London. Acquired by Robert Lehman in 1962.

EXHIBITED: Venice 1959a, no. 115; Cologne 1959, no. 115; New York 1981, no. 179; Rochester 1981, no. 61; Detroit 1983, no. 62.

LITERATURE: Pignatti 1974, no. 27, drawing no. 42.

179. View of the Island of San Giacomo in Paludo

1975.1.294
Pen and brown ink, gray wash. 275 × 415 mm.

See No. 178. No. 179 is also a study by Francesco Tironi for one of Antonio Sandi's twenty-four engravings of Venetian islands.[1] The engraving (Fig. 38), which measures 270 × 396 mm., follows the drawing exactly with the addition of eight birds in the sky.

The island of San Giorgio in Paludo, which lies between Murano and Burano, is bare and deserted today.[2] Tironi's drawing is the best extant record of its appearance in the eighteenth century.

No. 179 was an early acquisition of Robert Lehman's; it was formerly attributed to Canaletto.

G. K.

NOTES:
1. Pignatti 1974, no. 25.
2. Zorzi 1977, p. 404. For a description of the island's present state, see Venice 1978b, pp. 135–52.

Fig. 38. Antonio Sandi. *View of the Island of San Giacomo in Paludo*, engraving

PROVENANCE: Josef Carl. von Klinkosch, Vienna (Lugt 577); Klinkosch sale, Wawra, Vienna, April 16, 1889, no. 274; K. E. Hasse, Göttingen (Lugt 860); E. Ehlers, Göttingen; Ehlers sale, Boerner, Leipzig, May 9–10, 1930, no. 93.

EXHIBITED: Poughkeepsie 1943 (as Canaletto); Huntington (N.Y.) 1980, no. 1 (as Canaletto); New York 1981, no. 11 (as Canaletto).

No. 179

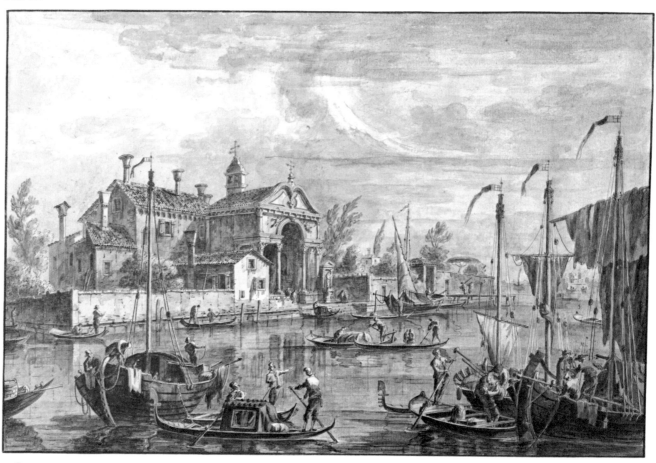

Giuseppe Zais

Forno di Canale (Belluno) 1709–Treviso 1784

After the departure of Francesco Zuccarelli for London in 1752, Zais was the leading painter of landscapes and battle pieces in Venice. His somewhat uneventful life is marked by his appearance in the lists of the Fraglia dei Pittori in 1748 and by his election to the Venetian Academy in 1774 after Zuccarelli's retirement to Florence.

G. K.

180. The Annunciation

1975.1.548

Pen and brown ink, gray wash, over black chalk. 350 × 220 mm. Signed in brown ink, bottom left: *Zais in: et Del:*.

Figure drawings by Zais are comparatively rare; he is better known for his classical landscapes, which are somewhat in the manner of Zuccarelli. There is, however, a very similar and similarly signed drawing in the Philadelphia Museum of Art, *The Virgin and Child Appearing to Saint Anthony of Padua* (Fig. 39).[1]

G. K.

NOTE:
1. Washington 1974, p. 47, no. 96.

PROVENANCE: Charles E. Slatkin Galleries, New York.

EXHIBITED: Wellesley 1960, no. 72; New York 1981, no. 180; Rochester 1981, no. 62; Detroit 1983, no. 63.

Fig. 39. Giuseppe Zais. *The Virgin and Child Appearing to Saint Anthony of Padua.* Philadelphia, Philadelphia Museum of Art

No. 180

Anton Maria Zanetti the Elder

Venice 1680–Venice 1767

Zanetti was an antiquarian, an etcher, and a maker of chiaroscuro woodcuts. In 1733 he published an invaluable guide to Venice, but his most magnificent publications are *Le antiche statue greche e romane*, which appeared in two parts in 1740 and 1743, and the *Diversarum iconum*, a volume of chiaroscuro woodcuts after Parmigianino, which apparently was first issued with a title page in 1743. As a draftsman, Zanetti seems to have confined himself to making large numbers of caricatures. Some of these are contained in an album at Windsor Castle assembled by Consul Smith, and there is a very large group in an album at the Fondazione Giorgio Cini in Venice.

G. K.

LITERATURE: Venice 1969b.

181. Man with a Long Pigtail and a Stick, Standing in Profile to the Left

1975.1.549
Pen and brown ink. 300 × 182 mm.

The attribution to Anton Maria Zanetti the elder is due to Antonio Morassi.[1] I do not consider it altogether satisfactory; the style of the drawing is not fully consistent with Zanetti's style as a caricaturist, which is established by the 48 drawings in Consul Smith's album of caricatures at Windsor[2] and by the album of 350 caricatures at the Fondazione Giorgio Cini.[3]

G. K.

NOTES:
1. Venice 1959a, p. 76, no. 117.
2. See Blunt and Croft-Murray 1957, pp. 146–49 and pls. 17–23.
3. See Venice 1969b.

PROVENANCE: Paul Wallraf, London. Acquired by Robert Lehman in 1962.

EXHIBITED: Venice 1959a, no. 117; Cologne 1959, no. 117; New York 1981, no. 181; Rochester 1981, no. 63.

No. 181

Francesco Zuccarelli

Pitigliano (Tuscany) 1702–Florence 1788

Zuccarelli is recorded in Florence in 1729, but he seems to have become established in Venice, under the patronage of the future British consul Joseph Smith, by 1732. Richard Wilson painted his portrait, in exchange for a picture, in Venice in 1751 and described him as "a famous painter of this place." Zuccarelli went to England in 1752 and remained there ten years; in February 1762 he held a sale of his pictures in London "by reason of his returning to Italy." He stayed in Italy for three years, becoming a member of the Venetian Academy in 1763. From 1765 until 1771 he was again in London, where he became a founding member of the Royal Academy of Arts in 1768. In 1772 he was made president of the Venetian Academy, and in 1773 he retired to Florence, where he remained for the rest of his life.

Apart from an album of some twenty figure studies formerly in the Tassi collection and now in the Piazzini dei Conti Albani collection, Bergamo,[1] Zuccarelli's drawings are generally classical landscapes enlivened by contemporary figures. A sale of "Mr. Zuccarelli's drawings at Langford's, the 3rd April 1769" suggests a *terminus ante quem* for those with an English provenance.

<div align="right">G. K.</div>

NOTE:

1. Bassi-Rathgeb 1948; Pignatti 1966, p. 194, no. 87.

LITERATURE: Levey 1959; Venice 1969a, pp. 274–75.

182. Classical Landscape: A Town and a Mountain by the Coast

1975.1.550
Pen and brown ink, gray wash, with white heightening (partly oxidized). 306×462 mm.

Zuccarelli's landscape drawings are not numerous, but they are remarkably consistent in style. An important series, some items in which have a relatively early provenance, is in the National Gallery of Scotland, Edinburgh.[1] However, most of the drawings now known seem to have

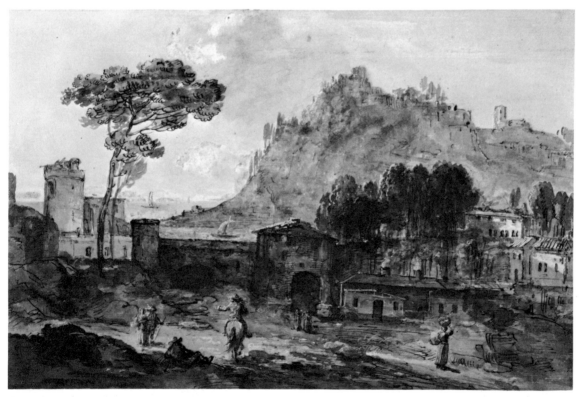

No. 182

emerged from obscurity in recent years, and no information about their earlier provenance has come to light. Three examples were exhibited at Colnaghi's in 1978.[2]

Drawings very similar to No. 182 have been variously dated by scholars. Pignatti proposes a late date for one in the Detroit Institute of Arts;[3] one in the Fogg Art Museum, on the other hand, is said to be early.[4]

Another similar drawing is in the Stiftung Ratjen, Vaduz.[5]

G. K.

NOTES:
1. Andrews 1968, pp. 129–30, figs. 858–65.
2. London 1978, nos. 85, 86, 87.
3. Washington 1974, p. 47, no. 97. The drawing was purchased from E. Parsons & Sons, London, in 1934.
4. Wellesley 1960, no. 73.
5. Munich 1977, pp. 226–27, no. 104.

PROVENANCE: Villiers David, London; Paul Wallraf, London. Acquired by Robert Lehman in 1962.

EXHIBITED: Cologne 1959, no. 127; New York 1981, no. 182; Detroit 1983, no. 64; Pittsburgh 1985, no. 58.

Attributed to the School of Zuccarelli
183. Landscape with Ruined Architecture

1975.1.551
Charcoal or black chalk. 231 × 334 mm. Inscribed in graphite: *Cavalier* [?] *Dalgozzi* [?] *disegno* (partly erased).

The drawing is made to look very like a stippled engraving; it even has a fictive plate mark. The inscription, which is not easily legible, suggests the possibility of an attribution to Marco Gozzi (San Giovanni Bianco 1759–Bergamo 1839), a painter of classical landscapes.[1]

G. K.

NOTE:
1. See Accademia Carrara 1912, p. 32, pl. 12.

PROVENANCE: Not established.

No. 183

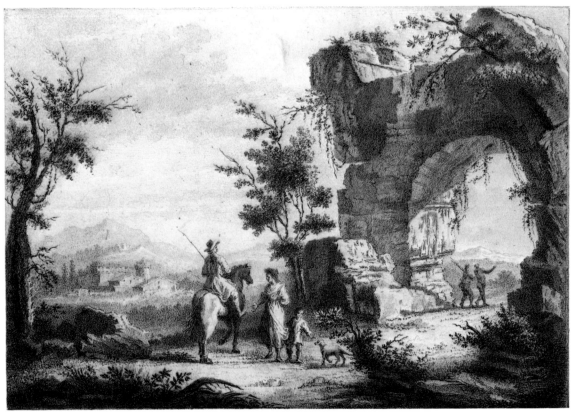

Antonio Zucchi

Venice 1726–Rome 1795

The decorative painter Antonio Zucchi was the son of the engraver Francesco Zucchi and was trained under Francesco Fontebasso and Jacopo Amigoni. His name appears in the lists of the Fraglia dei Pittori in 1754, and he is recorded as painting some angels in the church of San Teonisto in Treviso in 1759. Alessandro Longhi's *Compendio delle vite dei pittori veneziani* tells us that in 1762 Zucchi was traveling in Italy with an English dilettante, presumably Robert Adam. In 1766 he went to England with Adam and worked as an architectural decorator at Syon House. He became a founding member of the Royal Academy of Arts in 1770, and in 1776 he married Angelica Kauffmann. In 1783 he settled in Rome, where he spent his last years. There is a series of fourteen signed and dated drawings from Zucchi's last period in the Hermitage, Leningrad,[1] and a similar example, signed and dated 1783, in the National Gallery of Canada, Ottawa.[2]

G. K.

NOTES:
1. Dobroklonsky 1961, nos. 1747–60.
2. Popham and Fenwick 1965, p. 78, no. 115.

184. An English Family Group

1975.1.554
Pen and brown ink, brown wash. 255 × 360 mm.

The traditional attribution of this drawing and of No. 185 to Zucchi is repeated by Antonio Morassi in the Wallraf catalogue.[1] A portrait drawing in black and red chalk in the Museo Correr is ascribed to the artist,[2] and there are drawings from his hand in the British Museum and Sir John Soane's Museum, but it is not yet clear whether there are other paintings or drawings that might help to establish Zucchi's role as a painter of group portraits.

An attribution of the present drawing and of No. 185 to Angelica Kauffmann might also be considered: compare her portrait group of the family of Ferdinand IV of Naples, painted in 1782–83.[3]

A variant based upon No. 184 was with a London dealer in 1973.[4]

G. K.

No. 184

NOTES:
1. Venice 1959a, p. 77, nos. 118, 119.
2. Venice 1964, no. 119.
3. Naples 1979, vol. 1, p. 438, no. 257.
4. See the advertisement in *Apollo*, November 1973, p. 171.

PROVENANCE: Paul Wallraf, London. Acquired by Robert Lehman in 1962.

EXHIBITED: Venice 1959a, no. 119; Cologne 1959, no. 119; Huntington (N.Y.) 1980, no. 45; New York 1981, no. 183; Detroit 1983, no. 65; Pittsburgh 1985, no. 59.

185. Four Connoisseurs Seated at a Table

1975.1.555
Pen and brown ink, brown wash, with white heightening.
190 × 260 mm.

See No. 184.

G. K.

PROVENANCE: Brinsley Ford; Paul Wallraf, London. Acquired by Robert Lehman in 1962.

EXHIBITED: Venice 1959a, no. 118; Cologne 1959, no. 118; Huntington (N.Y.) 1980, no. 44; New York 1981, no. 184; Pittsburgh 1985, no. 60.

No. 185

Unidentified Artist, Venice (?)

186. Presumed Portrait of Jacopo Alvarotto

1975.1.336
Black chalk, brown wash. 270 × 198 mm. (the bottom
corners cut). Foxing throughout, particularly heavy to the
right of the face. Annotated in pen and brown ink, upper
right: *JACOBUS DE ALVAROTIS / 1453- Obijt.*

According to the annotation the sitter, dressed in fur and
wearing a *cappuccio* (the turbanlike Florentine head-
gear), is Jacopo Alvarotto il Vecchio (1385–1453). Born
and active in Padua, he was a highly respected doctor of
law and was called as judge to Florence, Siena, and other
cities in Italy. He was the author of various legal tracts,
among them the *Oratio pro communitate Paduae ad
Federicum III. imperatorem* (1452) and the *Lectura in
usus feudorum* (1476 and numerous later editions). He
was buried in Padua in the church of Sant'Antonio.[1]

The drawing gives the impression of being a copy,
probably of the eighteenth century and possibly Venetian,
after an earlier work.[2] The annotation may be contempo-
rary, but seems to be by a different hand from that of the
drawing itself. Whether the sitter is indeed Jacopo Alva-
rotto, and what the model for the drawing may have
been, could not be established.

<div align="right">E. H.-B.</div>

NOTES:
1. The information on Jacopo Alvarotto (Giacomo Alveroto,
 Jacobus Alverotus Patavinus) is based on Vedova 1831–36,
 vol. 1, pp. 49–50.
2. This drawing was originally intended to be catalogued
 among the Italian drawings of the fifteenth and sixteenth
 centuries. Anna Forlani Tempesti suggested the present clas-
 sification. The entry was written by Egbert Haverkamp-
 Begemann with information provided by Ronda Kasl.

PROVENANCE: Nathaniel Hone, London (Lugt 2793). Accord-
ing to a note (in French) on the reverse of the backing paper, the
drawing was sold with an attribution to Benozzo Gozzoli at an
auction which has not been identified, as no. 29 and illustrated
in the catalogue on pl. 8. The text of this catalogue, as recorded
on the backing paper, states that the drawing had previously
belonged to Lord Wolseley.

No. 186

COLORPLATES

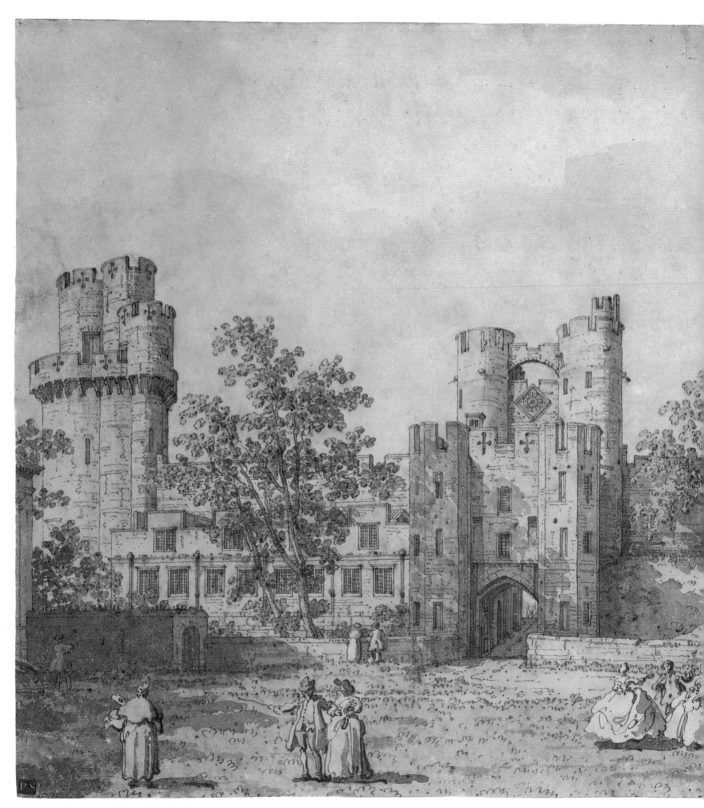

PLATE 1. Canaletto. *Warwick Castle: The East Front* (No. 19)

PLATE 2. Canaletto. *Piazza San Marco from the Southwest Corner, with the Procuratie Nuove on the Right* (No. 21)

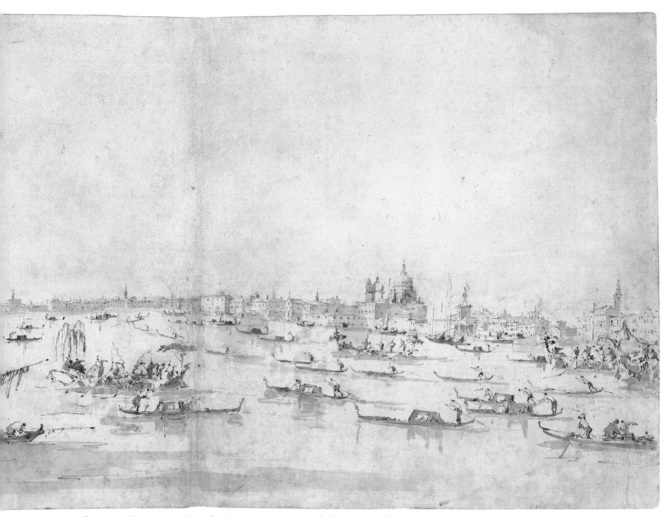

PLATE 3. Francesco Guardi. *Panoramic View of the Bacino di San Marco, Looking up the Giudecca Canal* (No. 29)

PLATE 4. Francesco Guardi. *An Architectural Capriccio, with Classical Ruins* (No. 33)

PLATE 5. Giovanni Battista Piranesi. *View through the Herculaneum Gate, Pompeii* (No. 68)

PLATE 6. Giovanni Battista Tiepolo. *Bacchus and Ariadne* (No. 76)

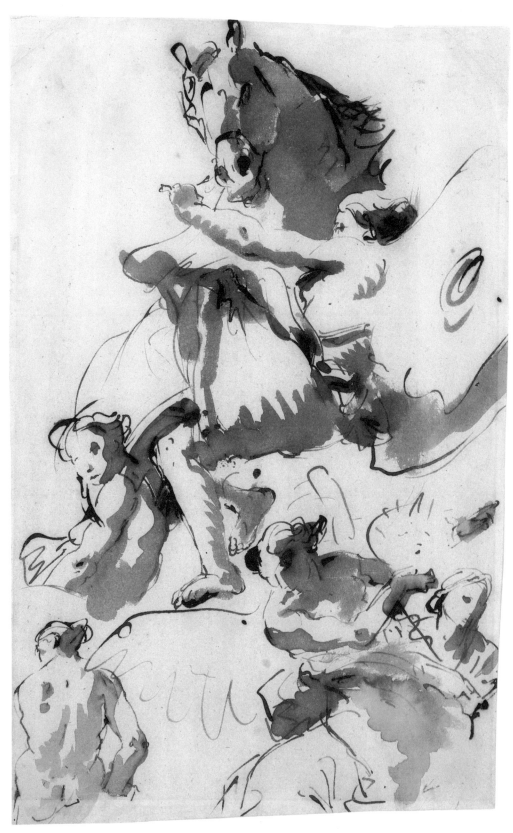

PLATE 7. Giovanni Battista Tiepolo. *One of the Hours Holding the Bridle of a Horse of the Sun, and Other Figures* (No. 82)

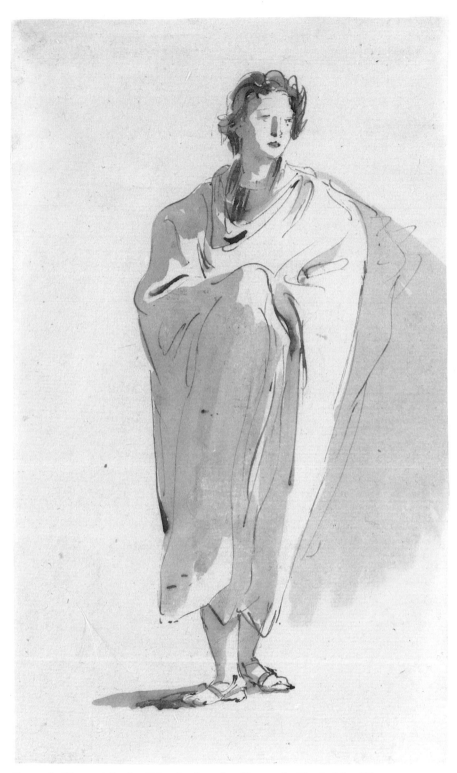

PLATE 8. Giovanni Battista Tiepolo. *Standing Figure of a Youth* (No. 88)

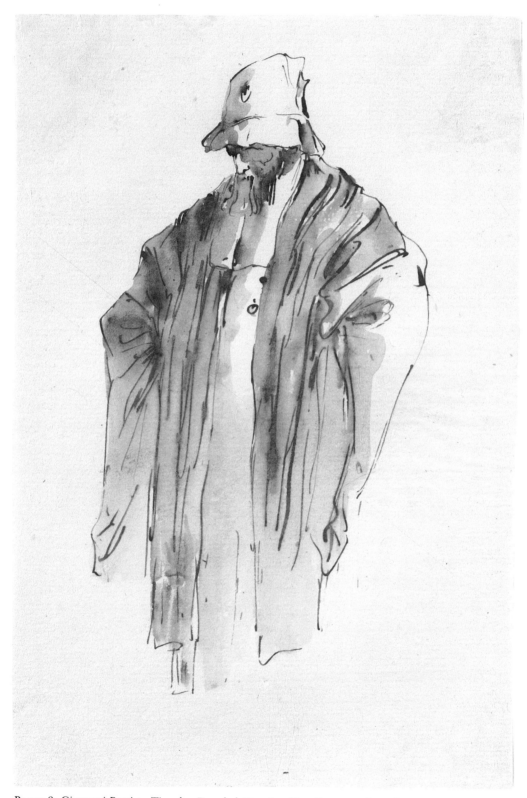

PLATE 9. Giovanni Battista Tiepolo. *Bearded Man Looking Down to the Left* (No. 89)

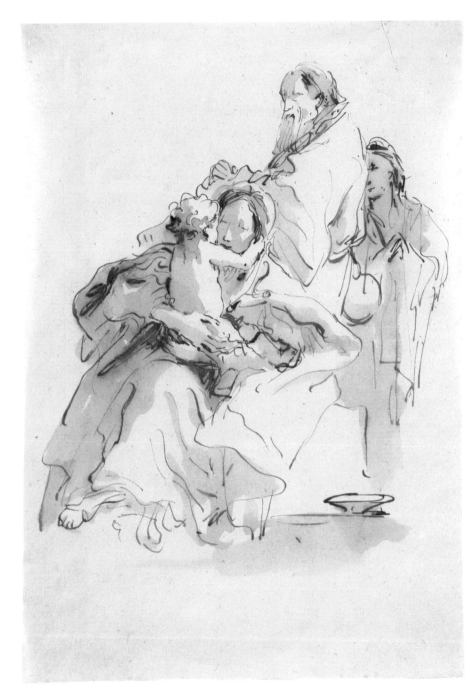

PLATE 10. Giovanni Battista Tiepolo. *The Holy Family with Saint John* (No. 93)

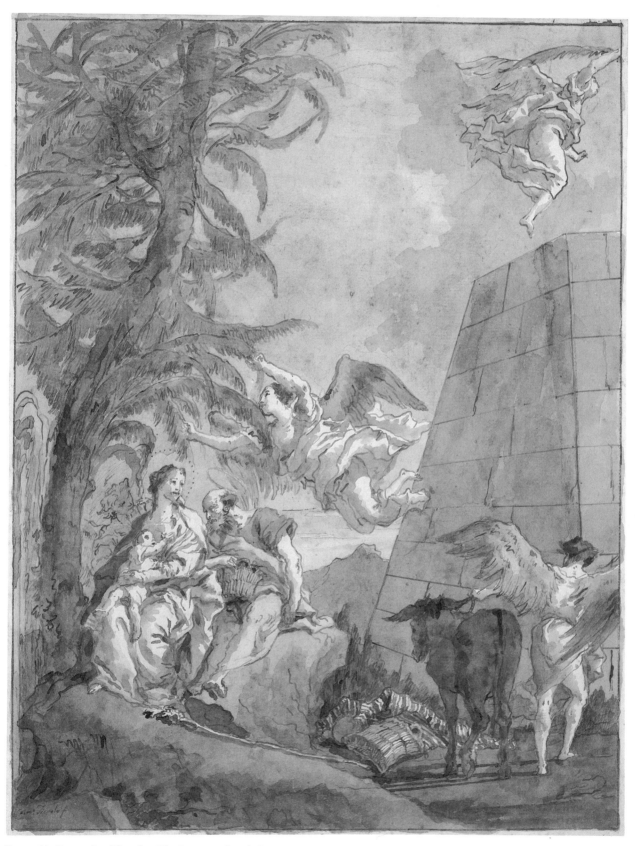

PLATE 11. Domenico Tiepolo. *The Rest on the Flight into Egypt, with a Truncated Pyramid on the Right* (No. 113)

PLATE 12. Domenico Tiepolo. *Satyrs Carrying Baskets of Provision for Their Families* (No. 141)

PLATE 13. Domenico Tiepolo. *Goats and Sheep in a Landscape* (No. 154)

PLATE 14. Domenico Tiepolo. *The School* (No. 164)

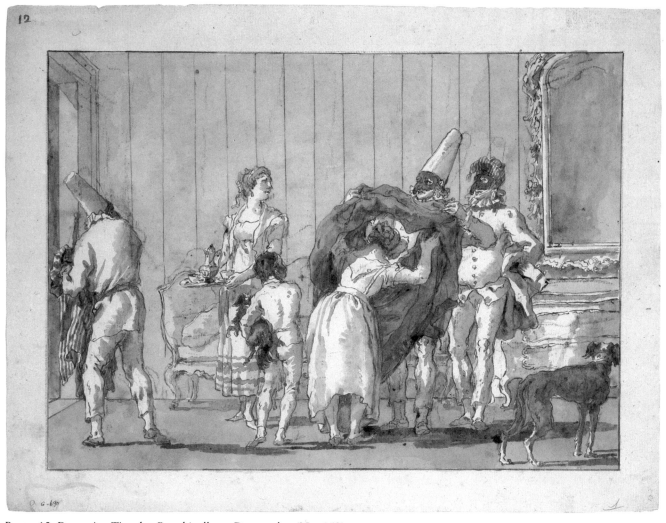

PLATE 15. Domenico Tiepolo. *Punchinello as Dressmaker* (No. 169)

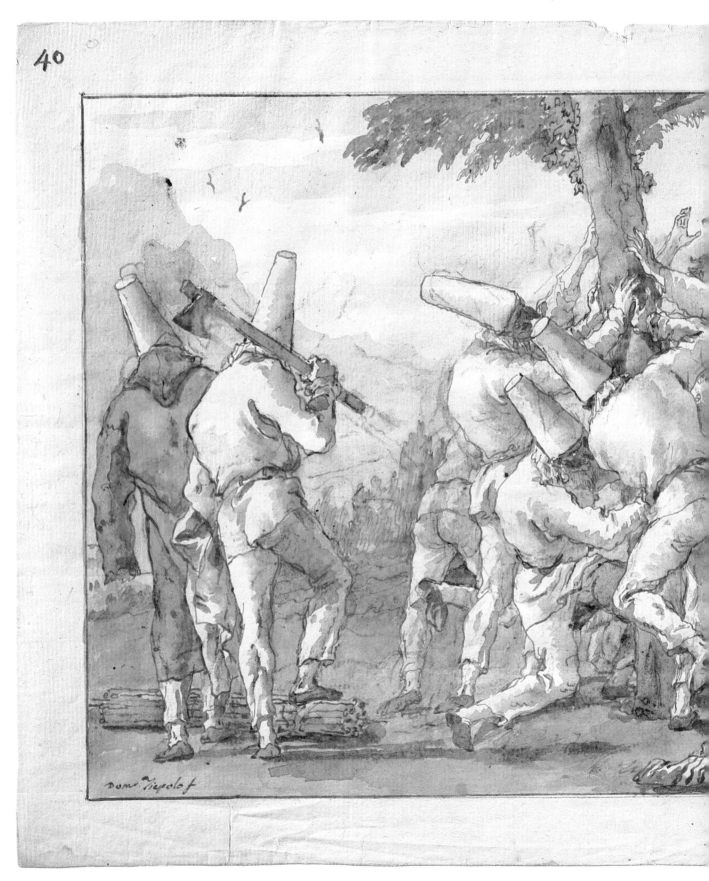

Dom. Tiepolo f

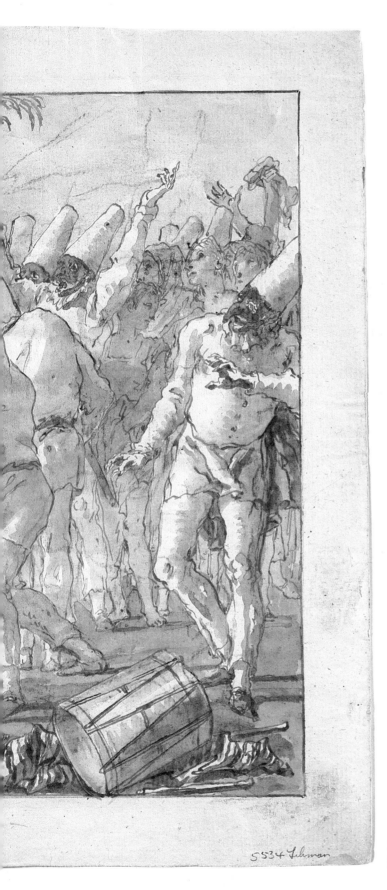

5534 Lehman

PLATE 16. Domenico Tiepolo. *Punchinellos Felling (or Planting) a Tree* (No. 171)

245

Bibliography

Accademia Carrara 1912	*Elenco dei quadri dell'Accademia Carrara in Bergamo.* Bergamo, 1912.
Ames 1963	Winslow Ames. *Italian Drawings from the 15th to the 19th Century.* New York, 1963.
Andrews 1968	Keith Andrews. *National Gallery of Scotland: Catalogue of Italian Drawings.* 2 vols. Cambridge, 1968.
Arisi 1961	Ferdinando Arisi. *Gian Paolo Panini.* Piacenza, 1961.
Bartsch 1854–76	Adam von Bartsch. *Le peintre graveur.* 21 vols. Leipzig, 1854–76.
Bassi-Rathgeb 1948	Roberto Bassi-Rathgeb. *Un album inedito di Francesco Zuccarelli.* Bergamo, 1948.
Bean 1960	Jacob Bean. *Bayonne, Musée Bonnat: Les dessins italiens de la collection Bonnat.* Inventaire général des dessins des musées de province, vol. 4. Paris, 1960.
Bean 1971	Jacob Bean. "Venise: Quelques dessins exceptionnels." *Connaissance des arts,* no. 228 (Feb. 1971), pp. 78–83.
Benesch 1947	Otto Benesch. *Venetian Drawings of the Eighteenth Century in America.* New York, 1947.
Bertini 1958	Aldo Bertini. *I disegni italiani della Biblioteca Reale di Torino.* Rome, 1958.
Binion 1980	Alice Binion. "Three Drawings by Canaletto." *Master Drawings,* 18 (1980), pp. 373–75.
Blunt and Croft-Murray 1957	Anthony Blunt and Edward Croft-Murray. *Venetian Drawings of the XVII and XVIII Centuries in the Collection of Her Majesty the Queen at Windsor Castle.* The Italian Drawings at Windsor Castle, [vol. 14]. London, 1957.
Borenius 1929	Tancred Borenius. "[Illustrierte Berichte:] London." *Pantheon,* 3 (Jan.–June 1929), pp. 148–52.
Bromberg 1974	Ruth Bromberg. *Canaletto's Etchings: A Catalogue and Study Illustrating and Describing the Known States, Including Those Hitherto Unrecorded.* London and New York, 1974.
Byam Shaw 1928	J. J. B. S. [James Byam Shaw]. "Giovanni Battista Tiepolo: Design for a Ceiling Decoration, with Neptune, the Young Bacchus, and Two Other Deities." *The Vasari Society for the Reproduction of Drawings by Old and Modern Masters,* ser. 2, pt. 9 (1928), p. 7, no. 6.
Byam Shaw 1933	James Byam Shaw. "Some Venetian Draughtsmen of the Eighteenth Century." *Old Master Drawings,* 7 (1933), pp. 47–63.
Byam Shaw 1938	James Byam Shaw. "Giovanni Domenico Tiepolo." *Old Master Drawings,* 12 (1937–38), pp. 56–57.
Byam Shaw 1950	James Byam Shaw. "Un altro disegno del Guardi per il 'Teatro Manin.'" *Arte veneta,* 4 (1950), pp. 154–55.
Byam Shaw 1951	James Byam Shaw. *The Drawings of Francesco Guardi.* London, 1951.
Byam Shaw 1959	James Byam Shaw. "The Remaining Frescoes in the Villa Tiepolo at Zianigo." *Burlington Magazine,* 101 (1959), pp. 391–95.
Byam Shaw 1962	James Byam Shaw. *The Drawings of Domenico Tiepolo.* London, 1962.
Byam Shaw 1970	James Byam Shaw. "The Biron Collection of Venetian Eighteenth-Century Drawings at the Metropolitan Museum." *Metropolitan Museum Journal,* 3 (1970), pp. 235–58.
Byam Shaw 1976a	James Byam Shaw. "The Second Edition of the Victoria and Albert's Catalogue of Tiepolo Drawings." Review of Knox 1975. *Master Drawings,* 14 (1976), pp. 180–84.

Byam Shaw 1976b	James Byam Shaw. "Guardi Drawings (Antonio Morassi)." Review of Morassi 1975. *Burlington Magazine*, 118 (1976), pp. 856–59.
Byam Shaw 1977	James Byam Shaw. "Some Guardi Drawings Rediscovered." *Master Drawings*, 15 (1977) pp. 3–15
Byam Shaw 1979	James Byam Shaw. "Some Unpublished Drawings by Giandomenico Tiepolo." *Master Drawings*, 17 (1979), pp. 239–44.
Byam Shaw 1981	James Byam Shaw. "Current and Coming Exhibitions. London, The Queen's Gallery: Canaletto." *Burlington Magazine*, 123 (1981), pp. 178–82.
Byam Shaw 1983	James Byam Shaw. *The Italian Drawings of the Frits Lugt Collection.* 3 vols. Paris, 1983.
Cailleux 1974	Jean Cailleux. "Centaurs, Fauns, Female Fauns, and Satyrs Among the Drawings of Domenico Tiepolo." *Burlington Magazine*, 116 (1974), Advertisement Supplement, pp. i–xxviii.
Chaet 1970	Bernard Chaet. *The Art of Drawing.* New York, 1970.
Chennevières 1898	Henry de Chennevières. *Les Tiepolo.* Paris, [1898].
Claye 1974	Elaine Claye. "A Group of Portrait Drawings by Jacopo Amigoni." *Master Drawings*, 12 (1974), pp. 41–48.
Connoisseur 1954	"International Sale-Room." *The Connoisseur*, 133 (March-June, 1954), pp. 264–65.
Constable 1962	William George Constable. *Canaletto: Giovanni Antonio Canal, 1697–1768.* 2 vols. Oxford, 1962.
Constable and Links 1976	William George Constable. *Canaletto: Giovanni Antonio Canal, 1697–1768.* 2nd ed., rev. J. G. Links. 2 vols. Oxford, 1976.
Corboz 1985	André Corboz. *Canaletto: Una Venezia immaginaria.* 2 vols. Milan, 1985.
Crespi 1769	Luigi Crespi. *Vite de' pittori bolognesi non descritte nella "Felsina Pittrice."* Rome, 1769.
Croft-Murray 1937	Edward Croft-Murray. "A Sketchbook of Giovanni Paolo Pannini in the British Museum." *Old Master Drawings*, 11 (1936–37), pp. 61–65.
Czére 1977	Andrée Czére. "Esquisse de Niccolò Bambini dans la collection de Budapest." *Bulletin du Musée Hongrois des Beaux-Arts*, 48–49 (1977), pp. 157–64.
Daniels 1976a	Jeffery Daniels. *Sebastiano Ricci.* Hove, 1976.
Daniels 1976b	Jeffery Daniels. *L'opera completa di Sebastiano Ricci.* Milan, 1976.
Delacre and Lavallée 1927	M. Delacre and P. Lavallée. *Dessins de maîtres anciens.* Paris, 1927.
Denison and Mules 1981	Cara D. Denison and Helen B. Mules. *European Drawings 1375–1825: Catalog.* New York, 1981.
De Vesme 1906	Alessandro Baudi de Vesme. *Le peintre-graveur italien: Ouvrage faisant suite au Peintre-graveur de Bartsch.* Milan, 1906.
Dobroklonsky 1961	Mikhail Vasil'evich Dobroklonsky. *Leningrad, Hermitage: Drawings of the Italian School, 17th–18th Centuries* [in Russian]. Leningrad, 1961.
Fairfax Murray 1905–12	C. Fairfax Murray. *J. Pierpont Morgan Collection of Drawings by the Old Masters Formed by C. Fairfax Murray.* 4 vols. London, 1905–12.
Ferrari and Scavizzi 1966	Oreste Ferrari and Giuseppe Scavizzi. *Luca Giordano.* 3 vols. Naples, 1966.
Finberg 1920–21	Hilda Finberg. "Canaletto in England." *The Walpole Society*, 9 (1920-21), pp. 21–76.
Fiocco 1923	Giuseppe Fiocco. *Francesco Guardi.* Florence, 1923.
Fiocco 1929	Giuseppe Fiocco. "La pittura veneziana alla Mostra del Settecento." *Rivista mensile della città di venezia*, 8 (1929), pp. 495–581.

Fiocco 1933 — Giuseppe Fiocco. "Francesco Guardi pittore di teatro." *Dedalo*, 13 (1933), pp. 360–67.

Fogolari 1931 — Gino Fogolari. "Il bozzetto del Tiepolo per il trasporto della Santa Casa di Loreto." *Bollettino d'arte*, 25 (1931–32), pp. 18–32.

Freeden and Lamb 1956 — Max Hermann von Freeden and Carl Lamb. *Das Meisterwerk des Giovanni Battista Tiepolo: Die Fresken der Würzburger Residenz*. Munich, 1956.

Fröhlich-Bum 1957 — Lili Fröhlich-Bum. "Old Master Drawings—XI. Four Unpublished Drawings by G. B. Tiepolo." *Apollo*, 66 (1957), pp. 56–57.

Gaeta Bertelà and Ferrara 1974 — Giovanna Gaeta Bertelà and Stefano Ferrara. *Incisori bolognesi ed emiliani del sec. XVIII*. Catalogo generale della raccolta di stampe antiche della Pinacoteca Nazionale di Bologna, Gabinetto delle Stampe, sec. 3, [vol. 3]. Bologna, 1974.

Garas 1978 — Klára Garas. "Appunti per Jacopo Amigoni e Jacopo Guarana." *Arte veneta*, 32 (1978), pp. 383–89.

Gaunt 1927 — William Gaunt. "Tiepolo." *Drawing and Design*, n.s. 3 (1927), pp. 65–69.

Gibbons 1977 — Felton Gibbons. *Catalogue of Italian Drawings in the Art Museum, Princeton University*. 2 vols. Princeton, 1977.

Gradenigo 1942 — Pietro Gradenigo. *Notizie d'arte tratte dai notatori e dagli annali del n. h. Pietro Gradenigo*, ed. Lina Livan. Venice, 1942.

Guerlin 1921 — Henri Guerlin. *Giovanni Domenico Tiepolo. Au temps du Christ: Jésus, la Vierge, les Apôtres*. Tours, [1921].

Hadeln 1928 — Detlev von Hadeln. *The Drawings of G. B. Tiepolo*. 2 vols. New York and Paris, [1928]. Reprinted New York, 1970.

Hadeln 1929 — Detlev von Hadeln. *The Drawings of Antonio Canal, Called Canaletto*. London, 1929.

Haskell 1956 — Francis Haskell. "Stefano Conti, Patron of Canaletto and Others." *Burlington Magazine*, 98 (1956), pp. 296–300.

Haverkamp-Begemann and Logan 1970 — Egbert Haverkamp-Begemann and Anne-Marie S. Logan. *European Drawings and Watercolors in the Yale University Art Gallery, 1500–1900*. 2 vols. New Haven and London, 1970.

Hennessey 1983 — Leslie T. Hennessey. "Jacopo Amigoni (c. 1685–1752): An Artistic Biography with a Catalogue of His Venetian Paintings." Ph.D. diss., University of Kansas, 1983.

Hind 1914 — Arthur M. Hind. "Giovanni Battista Piranesi: Some Further Notes and a List of His Works (Continued)." *Burlington Magazine*, 24 (1914), pp. 187–203.

Holler 1984 — Wolfgang Holler. "Jacopo Amigoni—Studien zu seinem Frühwerk: Die Jahre in Deutschland." Diss., University of Munich, 1984.

James 1953 — Montague Rhodes James, trans. *The Apocryphal New Testament, Being the Apocryphal Gospels, Acts, Epistles, and Apocalypses, with Other Narratives and Fragments*. Corrected ed. Oxford, 1953.

Joachim and McCullagh 1979 — Harold Joachim and Suzanne Folds McCullagh. *Italian Drawings in the Art Institute of Chicago*. Chicago and London, 1979.

Juynboll 1956 — W. R. Juynboll. "Een caricatuur van Giovanni Domenico Tiepolo." *Bulletin Museum Boymans*, 7 (1956), pp. 67–81.

Knox 1960 — George Knox. *Catalogue of the Tiepolo Drawings in the Victoria and Albert Museum*. London, 1960.

Knox 1961 — George Knox. "The Orloff Album of Tiepolo Drawings." *Burlington Magazine*, 103 (1961), pp. 269–75.

Knox 1965 — George Knox. "A Group of Tiepolo Drawings Owned and Engraved by Pietro Monaco." *Master Drawings*, 3 (1965), pp. 389–97.

Knox 1970a	George Knox. *Domenico Tiepolo: Raccolta di teste*. Milan, 1970.
Knox 1970b	George Knox. "Tiepolo Drawings from the Saint-Saphorin Collection." In *Atti del Congresso internazionale di studi sul Tiepolo*, [Udine], 1970, ed. E. Quargnal, pp. 58–63. Milan, n.d.
Knox 1973	George Knox. *Un quaderno di vedute di Giambattista e Domenico Tiepolo*. [Milan, 1973].
Knox 1975	George Knox. *Catalogue of the Tiepolo Drawings in the Victoria and Albert Museum*. 2nd ed. London, 1975.
Knox 1976	George Knox. "Francesco Guardi as an Apprentice in the Studio of Giambattista Tiepolo." In *Studies in Eighteenth-Century Culture*, vol. 5, ed. Ronald C. Rosbottom, pp. 29–39. Madison, Wis, 1976.
Knox 1978a	George Knox. "Giambattista Tiepolo's Processional Mace for the Scuola dei Carmini." *Master Drawings*, 16 (1978), pp. 48–50.
Knox 1978b	George Knox. "Tiepolo Drawings at Birmingham." *Master Drawings*, 16 (1978), pp. 61–62.
Knox 1980a	George Knox. "Anthony and Cleopatra in Russia: A Problem in the Editing of Tiepolo Drawings." In *Editing Illustrated Books: Papers Given at the Fifteenth Annual Conference on Editorial Problems*, University of Toronto, November 2–3, 1979, ed. William Bissett, pp. 35–55. New York, 1980.
Knox 1980b	George Knox. *Giambattista and Domenico Tiepolo: A Study and Catalogue Raisonné of the Chalk Drawings*. 2 vols. Oxford, 1980.
Knox 1980c	George Knox. "The Sala dei Banchetti of the Ducal Palace: The Original Decorations and Francesco Guardi's 'Veduta Ideata.'" *Arte veneta*, 34 (1980), pp. 201–5.
Knox 1983a	George Knox. "'The Tombs of Famous Englishmen' as Described in the Letters of Owen McSwiny to the Duke of Richmond." *Arte veneta*, 37 (1983), pp. 228–35.
Knox 1983b	George Knox. "Domenico Tiepolo's Punchinello Drawings: Satire or Labour of Love." In *Satire in the Eighteenth Century*, ed. John Browning, pp. 124–46. [McMaster Studies in the Eighteenth Century, vol. 10]. New York, 1983.
Knox 1984	George Knox. "The Punchinello Drawings of Giambattista Tiepolo." In *Interpretazioni veneziane*, ed. David Rosand, pp. 439–46. Venice, 1984.
Kozakiewicz 1972	Stefan Kozakiewicz. *Bernardo Bellotto*. 2 vols. London and Greenwich, Conn., 1972.
Kozloff 1960–61	Max Kozloff. "The Caricatures of Giambattista Tiepolo." *Marsyas*, 10 (1960–61), pp. 13–33.
Kultzen 1975	[Rolf Kultzen]. *Alte Pinakothek München: Katalog*, vol. 5, *Italienische Malerei*. Munich, 1975.
Kultzen 1976	Rolf Kultzen. "Ein Spätwerk von Francesco Guardi in der Alten Pinakothek." *Pantheon*, 34 (1976), pp. 217–20, 240.
Lavrova 1970	O. Lavrova. "Le tele di Giambattista Tiepolo nel Museo Statale delle Belle Arti A. S. Pushkin (Mosca)." In *Atti del Congresso internazionale di studi sul Tiepolo*, [Udine], 1970, ed. E. Quargnal, pp. 124–30. Milan, n.d.
Levey 1959	Michael Levey. "Francesco Zuccarelli in England." *Italian Studies*, 14 (1959), pp. 1–20.
Levey 1971	Michael Levey. *National Gallery Catalogues: The Seventeenth and Eighteenth Century Italian Schools*. London, 1971.
Links 1977	J. G. Links. *Canaletto and His Patrons*. New York, 1977.
Links 1982	J. G. Links. *Canaletto*. Ithaca, N.Y., 1982.
Loret 1935	Mattia Loret. "Pier Leone Ghezzi." *Capitolium*, 11 (1935), pp. 291–307.

Macandrew 1980 — Hugh Macandrew. *Ashmolean Museum Oxford: Catalogue of the Collection of Drawings*, vol. 3, *Italian Schools: Supplement*. Oxford, 1980.

Marconi 1970 — Sandra Moschini Marconi. *Gallerie dell'Accademia di Venezia: Opere d'arte dei secoli XVII, XVIII, XIX*. Rome, 1970.

Mariuz 1971 — Adriano Mariuz. *Giandomenico Tiepolo*. Venice, 1971.

Matteucci 1957 — Anna Maria Matteucci. "Opere Veneziane della collezione Lehmann [sic] esposte a Parigi." *Arte veneta*, 11 (1957), pp. 253–55.

Mauroner 1945 — Fabio Mauroner. *Luca Carlevarijs*. Padua, 1945.

Merriman 1980 — Mira Pajes Merriman. *Giuseppe Maria Crespi*. Milan, 1980.

Morassi 1941 — Antonio Morassi. "Domenico Tiepolo." *Emporium*, 93 (1941), pp. 265–82.

Morassi 1955 — Antonio Morassi. *G. B. Tiepolo: His Life and Work*. London, 1955.

Morassi 1962 — Antonio Morassi. *A Complete Catalogue of the Paintings of G. B. Tiepolo, Including Pictures by His Pupils and Followers Wrongly Attributed to Him*. London, 1962.

Morassi 1973 — Antonio Morassi. *Guardi: Antonio e Francesco Guardi*. 2 vols. Venice, [1973].

Morassi 1975 — Antonio Morassi. *Guardi: Tutti i disegni di Antonio, Francesco e Giacomo Guardi*. Venice, 1975.

Morazzoni 1931 — Giuseppe Morazzoni. *La moda a Venezia nel secolo XVIII*. Milan, 1931.

Moskowitz 1962 — Ira Moskowitz. *Great Drawings of All Time*. New York, 1962.

Nebehay 1928 — Gustav Nebehay (firm). *Die Zeichnung. Aus dem Besitz der Kunsthandlung Gustav Nebehay*, vol. 1, *Italienische Handzeichnungen des XVIII. Jahrhunderts*. Vienna, [1928].

Novelli 1834 — Pietro Novelli. *Memorie di vita di Pietro Antonio Novelli scritte da lui medesimo*. Padua, 1834.

Oppé 1930 — A. P. Oppé. "A Fresh Group of Tiepolo Drawings." *Old Master Drawings*, 5 (1930–31), pp. 29–32.

Pallucchini 1943 — Rodolfo Pallucchini. *I disegni del Guardi al Museo Correr di Venezia*. Venice, 1943.

Pallucchini 1960 — Rodolfo Pallucchini. *La pittura veneziana del Settecento*. Venice and Rome, 1960.

Pallucchini 1968 — Anna Pallucchini. *L'opera completa di Giambattista Tiepolo*. Milan, 1968.

Pallucchini 1981 — Rodolfo Pallucchini. *La pittura veneziana del Seicento*. 2 vols. Venice, 1981.

Parker 1931 — K. T. Parker. "Giovanni Domenico Tiepolo (1726–1804)." *Old Master Drawings*, 6 (1931–32), pp. 49–50.

Parker 1948 — K. T. Parker. *The Drawings of Antonio Canaletto in the Collection of His Majesty the King at Windsor Castle*. The Italian Drawings at Windsor Castle, [vol. 7]. Oxford and London, 1948.

Parker 1956 — K. T. Parker. *Catalogue of the Collection of Drawings in the Ashmolean Museum*, vol. 2, *Italian Schools*. Oxford, 1956.

Parker 1960 — K. T. Parker. *Ashmolean Museum: Report of the Visitors, 1960*. Oxford, [1960].

Pignatti 1963 — Terisio Pignatti. "Canaletto and Guardi at the Cini Foundation." *Master Drawings*, 1 (1963), pp. 49–53.

Pignatti 1966 — Terisio Pignatti. *I disegni veneziani del Settecento*. Treviso, [1966].

Pignatti 1967 — Terisio Pignatti. *Disegni dei Guardi*. Florence, 1967.

Pignatti 1969 — Terisio Pignatti. *Pietro Longhi: Paintings and Drawings*. London, 1969.

Pignatti 1974 — Terisio Pignatti. *24 isole della Laguna disegnate da Francesco Tironi e incise da Antonio Sandi*. Venice, 1974.

Pignatti 1981 Terisio Pignatti, ed. *Disegni antichi del Museo Correr di Venezia*, vol. 2, *Dall'Oglio–Fontebasso*. Venice, 1981.

Popham and Fenwick 1965 A. E. Popham and K. M. Fenwick. *European Drawings (and Two Asian Drawings) in the Collection of the National Gallery of Canada*. Toronto, 1965.

Posse 1931 Hans Posse. "Die Briefe des Grafen Francesco Algarotti an den sächsischen Hof und seine Bilderkäufe für die Dresdner Gemäldegalerie 1743–1747," *Jahrbuch der preussischen Kunstsammlungen*, 52 (1931), Beiheft.

Ripa 1603 Cesare Ripa. *Iconologia*. Rome, 1603.

Rizzi 1967 Aldo Rizzi. *Luca Carlevarijs*. Venice, 1967.

Rizzi 1970 Aldo Rizzi. *I disegni antichi dei Musei Civici di Udine*. Udine, 1970.

Rizzi 1971 Aldo Rizzi. *The Etchings of the Tiepolos*. London, 1971.

Rizzi 1976 Aldo Rizzi. *Disegni del Bison*. Udine, 1976.

Rosenberg 1935 Jacob Rosenberg. "Two Piranesi Drawings." *Old Master Drawings*, 10 (1935–36), pp. 9–10.

Ruggeri 1976 Ugo Ruggeri. *Disegni veneti del Settecento nella Biblioteca Ambrosiana*. Venice, 1976.

Sack 1910 Eduard Sack. *Giambattista und Domenico Tiepolo: Ihr Leben und ihre Werke*. Hamburg, 1910.

Santifaller 1976a Maria Santifaller. "In margine alle ricerche Tiepolesche. Un ritrattista germanico di Francesco Algarotti: Georg Friedrich Schmidt." *Arte veneta*, 30 (1976), pp. 204–9.

Santifaller 1976b Maria Santifaller. "Giandomenico Tiepolos 'Hl. Joseph mit dem Jesuskind' in der Staatsgalerie Stuttgart und seine Stellung in der Ikonographie des Barock." *Jahrbuch der Staatlichen Kunstsammlungen in Baden-Württemberg*, 13 (1976), pp. 65–86.

Scholz 1967 Janos Scholz. "Italian Drawings in the Art Museum at Princeton University." *Burlington Magazine*, 109 (1967), 290–99.

Schulz 1978 Wolfgang Schulz. "Tiepolo-Probleme: Ein Antonius-Album von Giandomenico Tiepolo." *Wallraf-Richartz-Jahrbuch*, 40 (1978), pp. 63–73.

Seilern 1959 [Antoine von Seilern]. *Italian Paintings and Drawings at 56 Princes Gate London SW 7*. 2 vols. London, 1959.

Stix and Fröhlich-Bum 1926 Alfred Stix and Lili Fröhlich-Bum. *Beschreibender Katalog der Handzeichnungen in der Graphischen Sammlung Albertina*, vol. 1, *Die Zeichnungen der venezianischen Schule*. Vienna, 1926.

Szabo 1975 George Szabo. *The Robert Lehman Collection: A Guide*. New York, 1975.

Szabo 1983 George Szabo. *Masterpieces of Italian Drawing in the Robert Lehman Collection, The Metropolitan Museum of Art*. New York, 1983.

Taylor 1976 Mary Cazort Taylor. "The Pen and Wash Drawings of the Brothers Gandolfi." *Master Drawings*, 14 (1976), pp. 159–65.

Térey 1916 Gabriel von Térey. *Die Gemäldegalerie des Museums für Bildende Künste in Budapest*. Berlin, 1916.

Thienemann 1856 Georg August Wilhelm Thienemann. *Leben und Wirken des unvergleichlichen Thiermalers und Kupferstechers Johann Elias Ridinger, mit dem ausführlichen Verzeichniss seiner Kupferstiche, Schwartzkunstblätter und . . . Handzeichnungen*. Leipzig, 1856.

Thomas 1952–55 Hylton A. Thomas. "Piranesi and Pompeii." *Kunstmuseets Årsskrift*, 39–42 (1952–55), pp. 13–28.

Thomas 1954 Hylton Thomas. *The Drawings of Giovanni Battista Piranesi*. New York, 1954.

Torri 1847 Alessandro Torri. *Cenni storici su l'origine e celebrazione dell'annua festività ricorrente in Verona il venerdì ultimo di carnovale denominato gnoccolare*. 2nd ed. Verona, 1847.

Vedova 1831–86 Giuseppe Vedova. *Biografia degli scrittori padovani.* 3 vols. Padua, 1831–36.

Venturi 1901–40 Adolfo Venturi. *Storia dell'arte italiana.* 11 vols. Milan, 1901–40.

Vigni 1942 Giorgio Vigni. *Disegni del Tiepolo.* Padua, 1942.

Vigni 1943 Giorgio Vigni. "Note su Giambattista e Giandomenico Tiepolo." *Emporium,* 98 (1943), pp. 14–24.

Vigni 1972 Giorgio Vigni. *Disegni del Tiepolo.* 2nd ed. Trieste, 1972.

Voss 1927–28 Hermann Voss. "Francesco Tironi: Ein vergessener venezianischer Vedutenmaler." *Zeitschrift für bildende Kunst,* n.s. 61, (1927–28), pp. 266–70.

Walpole 1762–80 Horace Walpole. *Anecdotes of Painting in England; With Some Account of the Principal Artists. . . .* 4 vols. Strawberry Hill, 1762–80.

Weltkunst 1958 "Londoner Ausstellungen." *Die Weltkunst,* vol. 28, no. 14 (July 15, 1958), p. 10.

Wethey 1969–75 Harold E. Wethey. *The Paintings of Titian.* 3 vols. London, 1969–75.

Williams 1939 Hermann W. Williams. "Drawings and Related Paintings by Francesco Guardi." *Art Quarterly,* 2 (1939), pp. 265–75.

Wunder 1962 Richard Wunder. *Extravagant Drawings of the 18th Century.* New York, 1962.

Zorzi 1972 Alvise Zorzi. *Venezia scomparsa.* Venice, 1972.

Zugni-Tauro 1971 Anna Paola Zugni-Tauro. *Gaspare Diziani.* Venice, 1971.

Exhibitions

Amsterdam 1936 | Rijksmuseum. *Oude kunst uit het bezit van den internationalen handel*, 1936.

Bassano 1964 | Palazzo Sturm. *Marco Ricci*, 1964. Catalogue by Giuseppe Maria Pilo.

Bassano 1970 | Museo Civico. *Giambattista Tiepolo, 1696–1770: Acqueforti, disegni e lettere nel secondo centenario della morte*, 1970. Catalogue by Bruno Passamani.

Birmingham (Ala.) 1978 | Birmingham Museum of Art; Museum of Fine Arts, Springfield, Mass. *The Tiepolos: Painters to Princes and Prelates*, 1978. Catalogue by Edward Weeks.

Bloomington (Ind.) 1979 | Indiana University Art Museum, Bloomington, Indiana; Stanford University Museum of Art, Stanford, Calif.; The Frick Collection, New York. *Domenico Tiepolo's Punchinello Drawings*, 1979–80. Catalogue by Adelheid M. Gealt and Marcia E. Vetrocq.

Bologna 1979 | Palazzi del Podestà e di Re Enzo. *L'arte del Settecento emiliano. La pittura: L'Accademia Clementina*, 1979. Catalogue by Andrea Emiliani et al.

Buffalo 1935 | Albright Art Gallery. *Master Drawings Selected from the Museums and Private Collections of America*, 1935. Catalogue by Agnes Mongan.

Cambridge 1979 | Fitzwilliam Museum. *All for Art: The Ricketts and Shannon Collection*, 1979. Catalogue ed. by Joseph Darracott.

Cambridge (Mass.) 1940 | Fogg Art Museum. *Masters Drawings Lent by Philip Hofer, Class of 1921*, 1940.

Cambridge (Mass.) 1944 | Fogg Art Museum. *Loan Exhibition*, 1944.

Cambridge (Mass.) 1970 | Fogg Art Museum. *Tiepolo: A Bicentenary Exhibition, 1770–1970*, 1970. Catalogue by George Knox.

Canterbury 1985 | Royal Museum. *Guardi, Tiepolo and Canaletto from the Royal Museum, Canterbury and Elsewhere, and a Selection of Venetian 18th Century Decorative Arts*, 1985.

Chicago 1938 | The Art Institute of Chicago. *Loan Exhibition of Paintings, Drawings and Prints by the Two Tiepolos: Giambattista and Giandomenico*, 1938.

Cincinnati 1959 | Cincinnati Art Museum. *The Lehman Collection, New York*, 1959.

Cologne 1959 | Wallraf-Richartz-Museum. *Venezianische Handzeichnungen des achtzehnten Jahrhunderts aus der Sammlung Paul Wallraf*, 1959. Catalogue by Antonio Morassi.

Detroit 1983 | The Detroit Institute of Arts; Oklahoma Museum of Art, Oklahoma City; Denver Art Museum; The Museum of Fine Arts, Houston. *Eighteenth Century Italian Drawings from the Robert Lehman Collection of The Metropolitan Museum of Art*, 1983–84. Catalogue by George Szabo, with an introduction by Agnes Mongan.

Florence 1953 | Palazzo Strozzi. *Tiepolo: 150 disegni dei Musei di Trieste*, 1953. Catalogue by Carlo Ragghianti.

Florence 1973 | Gabinetto Disegni e Stampe degli Uffizi. *Mostra di disegni bolognesi, dal XVI al XVIII secolo*, 1973. Catalogue by Catherine Johnston.

Gorizia 1973 | Musei Provinciali di Palazzo Attems. *I maestri della pittura veneta del '700*, 1973–74. Catalogue by Aldo Rizzi.

Gorizia 1983 | Musei Provinciali di Palazzo Attems; Museo Correr, Venice. *Da Carlevarijs ai Tiepolo: Incisori veneti e friulani del Settecento*, 1983. Catalogue ed. by Dario Succi.

Huntington (N.Y.) 1980 | Heckscher Museum. *From the Pens of the Masters: Eighteenth Century Venetian Drawings from the Robert Lehman Collection of The Metropolitan Museum of Art*, 1980. Catalogue by George Szabo.

London 1911	Burlington Fine Arts Club. *Exhibition of Venetian Painting of the Eighteenth Century*, 1911.
London 1917	Burlington Fine Arts Club. *A Collection of Drawings by Deceased Masters, with Some Decorative Furniture and Other Objects of Art*, 1917.
London 1927	Magnasco Society, Warren Gallery. *Loan Exhibition of 17th and 18th Century Drawings*, 1927.
London 1928	Savile Gallery. *Catalogue of an Exhibition of Drawings by Giovanni Battista Tiepolo (1696–1770)*, 1928.
London 1929	Savile Gallery. *Drawings by Old Masters*, 1929. Catalogue by Tancred Borenius.
London 1930	Savile Gallery. *Drawings by Old Masters*, 1930. Catalogue by Tancred Borenius.
London 1936	P. & D. Colnaghi & Co. *Exhibition of Old Master Drawings*, 1936.
London 1953a	Royal Academy of Arts. *Drawings by Old Masters*, 1953.
London 1953b	P. & D. Colnaghi & Co. *Exhibition of Old Master Drawings*, 1953.
London 1954	Royal Academy of Arts. *European Masters of the Eighteenth Century*, 1954–55.
London 1956	P. & D. Colnaghi & Co. *Exhibition of Old Master Drawings*, 1956.
London 1957	P. & D. Colnaghi & Co. *Exhibition of Old Master Drawings*, 1957.
London 1958	M. Knoedler & Co. *Exhibition of Old Master, Impressionist and Contemporary Drawings*, 1958.
London 1960	P. & D. Colnaghi & Co. *Exhibition of Old Master Drawings*, 1960.
London 1963	Royal Academy of Arts. *Goya and His Times*, 1963–64.
London 1967	Heim Gallery. *Baroque Sketches, Drawings & Sculptures*, 1967.
London 1972	Heim Gallery. *Venetian Drawings of the Eighteenth Century: An Exhibition in Aid of the Venice in Peril Fund*, 1972. Catalogue by Alessandro Bettagno.
London 1975	Heim Gallery. *Paintings by Luca Giordano*, 1975.
London 1978	P. & D. Colnaghi & Co. *Pictures from the Grand Tour*, 1978.
London 1979	Sotheby's. *One Hundred and Fifty-Two Caricature Drawings by Pier Leone Ghezzi (Rome 1674–1755), The Property of the Rt. Hon. Lord Braybrooke*, 1979. Catalogue by Antonella Pampalone.
London 1981	Victoria and Albert Museum. *Splendours of the Gonzaga*, 1981–82. Catalogue ed. by David Chambers and Jane Martineau.
Munich 1977	Staatliche Graphische Sammlung, Munich; Staatliche Museen Preussischer Kulturbesitz, West Berlin; Kunsthalle, Hamburg; Kunstmuseum, Düsseldorf; Staatsgalerie, Graphische Sammlung, Stuttgart. *Stiftung Ratjen, Italienische Zeichnungen des 16.–18. Jahrhunderts: Eine Ausstellung zum Andenken an Herbert List*, 1977–78. Catalogue by Eckhard Schaar et al.
Naples 1979	Museo e Gallerie Nazionali di Capodimonte. *Civiltà del '700 a Napoli, 1734–1799*, 1979.
New Haven 1960	Yale University Art Gallery. *Paintings, Drawings and Sculpture Collected by Yale Alumni*, 1960.
New London 1936	Lyman Allyn Museum. *Drawings*, 1936.
New York 1939	Jacques Seligmann & Co. *The Stage: A Loan Exhibition for the Benefit of the Public Education Association*, 1939.
New York 1941	Durlacher Brothers. *Fifth Annual Exhibition of Drawings*, 1941.
New York 1949	Wildenstein & Co. *Drawings through Four Centuries*, [1949].
New York 1953	Pierpont Morgan Library. *Landscape Drawings & Water-Colors, Bruegel to Cézanne*, 1953. Catalogue by Felice Stampfle.

New York 1959	Wildenstein & Co. *Timeless Master Drawings*, [1959].
New York 1971	Metropolitan Museum of Art. *Drawings from New York Collections, III: The Eighteenth Century in Italy*, 1971. Catalogue by Jacob Bean and Felice Stampfle.
New York 1973	Pierpont Morgan Library. *Drawings from the Collection of Lore and Rudolf Heinemann*, 1973. Catalogue by Felice Stampfle and Cara D. Denison, with an introduction by James Byam Shaw.
New York 1975	Pierpont Morgan Library. *Drawings from the Collection of Mr. and Mrs. Eugene V. Thaw*, 1975. Catalogue by Felice Stampfle and Cara D. Denison.
New York 1979	Metropolitan Museum of Art. *European Landscape Drawings of Five Centuries from the Robert Lehman Collection*, 1979.
New York 1980	See Bloomington (Ind.) 1979. Nine drawings in the Robert Lehman Collection were added to the exhibition when it came to the Frick Collection, New York, in 1980.
New York 1981	Metropolitan Museum of Art. *Eighteenth Century Italian Drawings from the Robert Lehman Collection*, 1981. Catalogue by George Szabo.
New York 1985	Metropolitan Museum of Art. *Portrayals of the Basilica of San Marco*. Adjunct exhibition to *The Treasury of San Marco, Venice*, 1985.
Northampton (Mass.) 1950	Smith College Art Museum. *Antonio Canaletto 1697–1768*, 1950.
Ottawa 1974	National Gallery of Canada. *The Bronfman Gift of Drawings*, 1974. Catalogue by Mary Cazort Taylor.
Ottawa 1976	National Gallery of Canada. *European Drawings from Canadian Collections, 1500–1900*, 1976. Catalogue by Mary Cazort Taylor.
Paris 1921	Musée des Arts Décoratifs. *Dessins de G. D. Tiepolo*, 1921.
Paris 1950	Musée Carnavalet. *Chefs-d'oeuvre des collections parisiennes*, 1950.
Paris 1952	Galerie Cailleux. *Tiepolo et Guardi, provenant de collections françaises*, 1952. Catalogue by Jean Cailleux.
Paris 1957	Musée de l'Orangerie. *Exposition de la collection Lehman de New York*, 1957. Catalogue by Charles Sterling, Olga Raggio, Michel Laclotte, and Sylvie Béguin.
Paris 1971	Galerie Heim. *Le dessin vénétien du XVIII siècle*, 1971–72. Catalogue by Alessandro Bettagno.
Paris 1978	Grand Palais. *Dessins antiques*, 1978. Catalogue by Pietro Scarpa et al.
Philadelphia 1950	Philadelphia Museum of Art. *Masterpieces of Drawing: Diamond Jubilee Exhibition*, 1950–51.
Pittsburgh 1985	Frick Art Museum. *Eighteenth Century Venetian Drawings from The Robert Lehman Collection of The Metropolitan Museum of Art*, New York, 1985. Catalogue by George Szabo.
Portland (Oreg.) 1956	Portland Art Museum; Seattle Art Museum; California Palace of the Legion of Honor, San Francisco; Los Angeles County Museum; Minneapolis Institute of Arts; City Art Museum of St. Louis; William Rockhill Nelson Gallery of Art, Kansas City (Mo.); Detroit Institute of Arts; Museum of Fine Arts, Boston. *Paintings from the Collection of Walter P. Chrysler, Jr.*, 1956–57. Catalogue by Bertina Suida Manning.
Poughkeepsie 1943	Vassar College Art Museum. *Old Master Drawings Lent by Robert Lehman*, 1943.
Princeton 1966	The Art Museum, Princeton University. *Italian Drawings in the Art Museum, Princeton University: 106 Selected Examples*, [1966]. Catalogue by Jacob Bean.
Rochester 1981	University of Rochester, Memorial Art Gallery; Cornell University, Herbert F. Johnson Museum of Art, Ithaca, N.Y.; Vassar College Art Gallery, Poughkeepsie, N.Y.; Skidmore College Art Gallery, Saratoga Springs, N.Y. *XVIII Century Venetian Drawings from the Robert Lehman Collection, The Metropolitan Museum of Art*, 1981–82. Catalogue by George Szabo.

Springfield (Mass.) 1937 — Springfield Museum of Fine Arts. *Francesco Guardi, 1712–1793*, 1937.

Stuttgart 1970 — Graphische Sammlung, Staatsgalerie, Stuttgart. *Tiepolo: Zeichnungen von Giambattista, Domenico und Lorenzo Tiepolo aus der Graphischen Sammlung der Staatsgalerie Stuttgart, aus württembergischem Privatbesitz und dem Martin von Wagner Museum der Universität Würzburg, 1970.* Catalogue by George Knox and Christel Thiem.

Udine 1962 — Loggia del Lionello. *Cento disegni del Bison, 1962–63.* Catalogue by Aldo Rizzi.

Udine 1963 — Loggia del Lionello; Galleria Nazionale delle Stampe, Rome. *Disegni, incisioni e bozzetti del Carlevarijs, 1963–64.* Catalogue by Aldo Rizzi.

Udine 1964 — Church of San Francesco. *Mostra del Bombelli e del Carneo, 1964.* Catalogue by Aldo Rizzi.

Udine 1965 — Loggia del Lionello. *Disegni del Tiepolo, 1965.* Catalogue by Aldo Rizzi.

Udine 1970 — Loggia del Lionello. *Le acqueforti dei Tiepolo, 1970.* Catalogue by Aldo Rizzi.

Udine 1971 — Villa Manin di Passariano. *Mostra del Tiepolo, 1971.* Catalogue by Aldo Rizzi.

Venice 1929 — Palazzo delle Biennali. *Il Settecento italiano, 1929.*

Venice 1941 — Ridotto. *Mostra degli incisori veneti del Settecento, 1941.* Catalogue by Rodolfo Pallucchini.

Venice 1955 — Fondazione Giorgio Cini. *Cento antichi disegni veneziani, 1955.* Catalogue by Giuseppe Fiocco.

Venice 1956 — Fondazione Giorgio Cini. *Disegni del Museo Civico di Bassano, da Carpaccio a Canova, 1956.* Catalogue by Licisco Magagnato.

Venice 1957 — Fondazione Giorgio Cini. *Disegni veneti nella collezione Janos Scholz, 1957.* Catalogue by Michelangelo Muraro.

Venice 1958a — Fondazione Giorgio Cini. *Disegni veneti di Oxford, 1958.* Catalogue by K. T. Parker.

Venice 1958b — Fondazione Giorgio Cini. *Disegni veneti in Polonia, 1958.* Catalogue by Maria Mrozinska.

Venice 1959a — Fondazione Giorgio Cini. *Disegni veneti del Settecento nella collezione Paul Wallraf, 1959.* Catalogue by Antonio Morassi.

Venice 1959b — Fondazione Giorgio Cini. *Disegni e dipinti di Giovanni Antonio Pellegrini, 1675–1741, 1959.* Catalogue by Alessandro Bettagno.

Venice 1959c — Ca' Pesaro. *La pittura del Seicento a Venezia, 1959.* Catalogue by Pietro Zampetti, Giovanni Mariacher, and Giuseppe Maria Pilo.

Venice 1962 — Fondazione Giorgio Cini. *Canaletto e Guardi, 1962.* Catalogue by K. T. Parker and James Byam Shaw.

Venice 1963 — Fondazione Giorgio Cini. *Disegni veneti del Settecento della Fondazione Giorgio Cini e delle collezioni venete, 1963.* Catalogue by Alessandro Bettagno.

Venice 1964 — Fondazione Giorgio Cini. *Disegni veneti del Settecento nel Museo Correr di Venezia, 1964.* Catalogue by Terisio Pignatti.

Venice 1966 — Fondazione Giorgio Cini. *Disegni di una collezione veneziana del Settecento, 1966.* Catalogue by Alessandro Bettagno.

Venice 1969a — Palazzo Ducale. *Dal Ricci al Tiepolo: I pittori di figura del Settecento a Venezia, 1969.* Catalogue by Pietro Zampetti.

Venice 1969b — Fondazione Giorgio Cini. *Caricature di Anton Maria Zanetti, 1969.* Catalogue by Alessandro Bettagno.

Venice 1977 — Museo Correr. *L'altra Venezia di Giacomo Guardi, 1977.* Catalogue by Attilia Dorigato.

Venice 1978a — Fondazione Giorgio Cini. *Disegni di Giambattista Piranesi, 1978.* Catalogue by Alessandro Bettagno.

Venice 1978b Scuola Grande di San Teodoro. *Isole abbandonate della laguna*, 1978.

Venice 1980 Fondazione Giorgio Cini. *Disegni veneti di collezioni inglesi*, 1980. Catalogue by Julien Stock.

Venice 1981 Fondazione Giorgio Cini. *Disegni veneti della collezione Lugt*, 1981. Catalogue by James Byam Shaw.

Venice 1982 Fondazione Giorgio Cini. *Canaletto: Disegni–dipinti–incisioni*, 1982. Catalogue ed. by Alessandro Bettagno.

Washington 1974 National Gallery of Art; Kimbell Art Museum, Fort Worth; The St. Louis Art Museum. *Venetian Drawings from American Collections*, 1974–75. Catalogue by Terisio Pignatti.

Waterville (Me.) 1956 Colby College. *An Exhibition of Drawings*, 1956.

Wellesley (Mass.) 1960 Wellesley College, Jewett Arts Center; Charles E. Slatkin Galleries, New York. *Eighteenth Century Italian Drawings*, 1960. Catalogue by Janet Cox Rearick.

Index of Artists

Adam, Robert, p. 223

Alari-Bonacolsi, Pier Jacopo, called Antico, p. 164, under No. 133

Amigoni, Jacopo, pp. 2–3, No. 1; p. 74; p. 76, under No. 61; p. 223

Antico, *see* Alari-Bonacolsi, Pier Jacopo

Bambini, Nicolò, pp. 4–5, No. 2

Bella, Stefano della, pp. 176–77, under Nos. 145–46; pp. 190–93, under Nos. 155–56, 158

Bellotto, Bernardo, pp. 6–17, Nos. 3–15; pp. 24–25, under Nos. 20–21

Bellucci, Antonio, p. 2

Berardi, Fabio, p. 16, under No. 15

Bison, Giuseppe Bernardino, p. 18, No. 16

Bombelli, Sebastiano, p. 70, under No. 57

Brustolon, Giambattista, p. 26; p. 44

Buffagnotti, Carlo Antonio, p. 19, No. 17

Canaletto (Antonio Canal), p. 6; pp. 10–17, under Nos. 8–15; pp. 20–29, Nos. 18–23; p. 38; p. 44, under No. 31; p. 218, under No. 179; Plate 1, pp. 228–29; Plate 2, p. 230

Canaletto, *see also* Bellotto, Bernardo

Carlevaris, Luca, p. 70, under No. 57

Carriera, Rosalba, p. 84; p. 90

Castiglione, Giovanni Benedetto, p. 186, under No. 153

Cedini, Costantino, p. 18

Cervelli, Federico, p. 90

Crespi, Giuseppe Maria, pp. 30–31, No. 24

Diziani, Gaspare, p. 32; p. 72

Diziani, Giuseppe, pp. 32–33, No. 25

Fontebasso, Francesco, p. 75, under No. 60; p. 223

Gandolfi, Gaetano, p. 34

Gandolfi, Mauro, pp. 34–35, No. 26

Ghezzi, Giuseppe, p. 36

Ghezzi, Pier Leone, pp. 36–37, Nos. 27–28

Gozzi, Marco, p. 222, under No. 183

Gozzoli, Benozzo, p. 225, under No. 186

Graziani, Ercole, p. 75, under No. 60

Guarana, Jacopo, p. 80, under No. 64

Guardi, Domenico, p. 38

Guardi, Francesco, pp. 38–61, Nos. 29–34; pp. 48–49, No. 34; p. 55, under No. 38; p. 60, under No. 46; p. 63, under Nos. 47–49; p. 64, under Nos. 51–52; pp. 67–68, under Nos. 54–55; p. 80, under No. 64; p. 98, under No. 74; Plate 3, p. 231; Plate 4, p. 232

Guardi, Giacomo, p. 38; p. 42, under No. 30; p. 46, under No. 32; pp. 48–69, Nos. 34–56

Guardi, Giovanni Antonio, p. 32, under No. 25; p. 38

Guardi, Nicolò, p. 38; p. 48

Kauffmann, Angelica, pp. 223–24

Lazzarini, Gregorio, p. 92

Leoni, Ottavio, p. 70, under No. 57

Longhi, Alessandro, p. 76, under No. 61; p. 223

Longhi, Pietro, p. 44, under No. 31; pp. 70–71, No. 57

Lorenzi, Francesco, p. 94, under No. 72

Maratta, Carlo, p. 4

Marieschi, Jacopo, pp. 72–73, No. 58

Mazzoni, Sebastiano, p. 4; p. 90

Molinari, Antonio, p. 84

Monaco, Pietro, p. 186, under No. 153

Moretti, Giovanni Battista, p. 22, under No. 18

Novelli, Pietro Antonio, p. 32; pp. 74–81, Nos. 59–65

Pagani, Paolo, p. 84

Panini, Giovanni Paolo, pp. 82–83, No. 66

Parmigianino, p. 78, under No. 63; p. 220

Parodi, Filippo, p. 80, under No. 64

Pellegrini, Giovanni Antonio, pp. 84–85, No. 67; p. 88; p. 90

Piranesi, Francesco, p. 86, under No. 68

Piranesi, Giovanni Battista, pp. 86–87, No. 68; Plate 5, p. 233

Pitteri, Marco, p. 44, under No. 31; p. 98, under No. 74

Raggi, Giovanni, p. 94, under No. 72

Rembrandt, p. 196, under No. 161

Ricci, Marco, p. 84; pp. 88–89, No. 69

Ricci, Sebastiano, p. 75, under No. 60; p. 88; pp. 90–91, No. 70

Ridinger, Johann Elias, p. 136; p. 176, under No. 144; p. 180, under No. 149; p. 182, under No. 150; p. 184, under No. 151; p. 190, under No. 155; p. 201, under No. 166

Roos, Johann Heinrich, p. 136; p. 178, under No. 147; p. 188, under No. 154

Roos, Philipp Peter (Rosa da Tivoli), p. 178, under No. 147

Sandi, Antonio, pp. 216–18, under Nos. 178–79

Spagnuolo (Lo), *see* Crespi, Giuseppe Maria

Tacca, Pietro, p. 79, under No. 64

Tiepolo, Domenico, p. 30; p. 48, under No. 34; p. 74; p. 94, under No. 72; p. 126, under No. 97; p. 128, under No. 101; p. 130, under No. 104; pp. 135–212, Nos. 112–175; pp. 214–15, under Nos. 176–77; Plate 11, p. 239; Plate 12, p. 240; Plate 13, p. 241; Plate 14, p. 242; Plate 15, p. 243; Plate 16, pp. 244–45

Tiepolo, Giovanni Battista, p. 30; p. 48; p. 76, under No. 61; p. 90; pp. 92–134, Nos. 71–111; pp. 135–36, under No. 112; p. 148, under No. 121; p. 150, under Nos. 122–23; p. 156, under No. 128; pp. 159–61, under Nos. 130–31; p. 164, under No. 133; p. 166, under No. 135; p. 168, under No. 137; p. 175, under No. 144; p. 190, under No. 156; p. 194, under No. 159; p. 196, under No. 161; p. 211, under No. 174; pp. 213–15, under Nos. 176–77; Plate 6, p. 234; Plate 7, p. 235; Plate 8, p. 236; Plate 9, p. 237; Plate 10, p. 238

Tiepolo, Lorenzo Baldiserra, p. 135; p. 160, under No. 131; pp. 213–15, Nos. 176–77

Tironi, Francesco, pp. 216–18, Nos. 178–79

Titian, p. 148, under No. 120

Unidentified Artist, p. 225, No. 186

Visentini, Antonio, pp. 6–10, under Nos. 3–8; pp. 48, 56, 59–60, 64, 67–68, under Nos. 34, 41, 44–45, 50–51, 53, 55

Zais, Giuseppe, p. 219, No. 180

Zanetti, Anton Maria the Elder, p. 18; p. 220, No. 181

Zuccarelli, Francesco, p. 219; pp. 221–22, Nos. 182–83

Zucchi, Antonio, pp. 223–24, Nos. 184–85

Zucchi, Francesco, p. 223

Index of Previous Owners

Abdy, Sir Robert, No. 92 (G. B. Tiepolo)

Agnew, Thomas, and Sons, No. 142 (D. Tiepolo)

Algarotti-Corniani, Conte, Nos. 83–91 (G. B. Tiepolo)

Ashburnham, Lady Catherine, No. 29 (F. Guardi)

Asscher, Martin, No. 88 (G. B. Tiepolo)

Barozzi, Conte Dino, No. 163 (D. Tiepolo)

Bateson, William, Nos. 76–77 (G. B. Tiepolo)

Bensimon, G., No. 112 (D. Tiepolo)

Beurdeley collection, No. 132 (D. Tiepolo)

Beyerlen, Karl Christian Friedrich, No. 92 (G. B. Tiepolo); No. 114 (D. Tiepolo)

Blumka, Leopold, No. 165 (D. Tiepolo)

Bondy, Oskar von, No. 165 (D. Tiepolo)

Bordes, H., Nos. 133–34 (D. Tiepolo)

Bossi, Giovanni Domenico, No. 92 (G. B. Tiepolo); No. 114 (D. Tiepolo)

Breadalbane, Earl of, Nos. 147, 149–51 (D. Tiepolo)

Broglio, Carlo, No. 157 (D. Tiepolo)

Cailleux, Galerie, Nos. 125, 127, 131, 140–41, 143 (D. Tiepolo)

Calmann, H. M., No. 156 (D. Tiepolo)

Canova, Antonio, Nos. 78–80, 93–94 (G. B. Tiepolo)

Canova, Monsignor, Nos. 78–80, 93–94 (G. B. Tiepolo)

Cavendish-Bentinck, Mrs. R., No. 28 (Ghezzi)

Cheney, Edward, Nos. 78–80, 83–91, 93–94 (G. B. Tiepolo)

Chevalier, Paul, No. 30 (F. Guardi)

Cicognana, Leopoldo, Nos. 78–80, 93–94 (G. B. Tiepolo)

Clarke, Mrs. Amy, Nos. 37–56 (G. Guardi)

Colnaghi, P. & D., & Co., No. 19 (Canaletto); No. 28 (Ghezzi); Nos. 37–56 (G. Guardi); No. 61 (Novelli); Nos. 78–80, 93–94 (G. B. Tiepolo); Nos. 114–16, 119, 121, 123–24, 132–34, 153–54, 159, 164, 167–75 (D. Tiepolo)

Colville, Colonel N., No. 68 (Piranesi)

Cooke, F., No. 33 (F. Guardi)

Cormier, Roger, Nos. 112–13 (D. Tiepolo)

David, Villiers, No. 21 (Canaletto); No. 182 (Zuccarelli)

Dowland, Kaye, No. 156 (D. Tiepolo)

Drey, F. A., No. 33 (F. Guardi)

Drouot, Hôtel Nos. 117, 172, 175 (D. Tiepolo)

Duff-Gordon, Sir Henry, No. 159 (D. Tiepolo); No. 177 (L. Tiepolo)

Dugdale, Lady Eva, No. 19 (Canaletto)

Elliot, Lady, No. 168 (D. Tiepolo)

Evans, Mrs. F. L., No. 153 (D. Tiepolo)

Fatio, Edmond, No. 66 (Panini)

Fauchier-Magnan, Adrien, No. 19 (Canaletto); No. 32 (F. Guardi); Nos. 112, 132 (D. Tiepolo)

Feilchenfeldt, Marianne, No. 168 (D. Tiepolo)

Ford, Brinsley, No. 185 (Zucchi)

Galliéra, Palais Nos. 171, 174 (D. Tiepolo)

Gentili di Giuseppe, Federico, No. 74 (G. B. Tiepolo)

Grange, T., Nos. 115–16, 119–20, 128, 130, 132, 140–41, 145–46, 152, 166 (D. Tiepolo); No. 176 (L. Tiepolo)

Grassi, Luigi, Nos. 135–36 (D. Tiepolo)

Greville, Hon. Charles, No. 19 (Canaletto)

Gutekunst, Mr. and Mrs. Otto, No. 21 (Canaletto)

Hadeln, Detlev, Freiherr von, No. 156 (D. Tiepolo)

Harris, Mrs. Hilda, No. 96 (G. B. Tiepolo)

Harris, Tomas, No. 113 (D. Tiepolo); No. 177 (L. Tiepolo)

Hasse, K. E., No. 179 (Tironi)

Hellenic and Roman Society, Nos. 115–16, 119, 123–24 (D. Tiepolo)

Hermitage, Leningrad, No. 153

Herz von Hertenried, Julius, No. 165 (D. Tiepolo)

Hill, F., No. 156 (D. Tiepolo)

Hofer, Philip, No. 19 (Canaletto); No. 76 (G. B. Tiepolo)

Holford, R. S., No. 178 (Tironi)

Holgen, H. J., No. 18 (Canaletto)

Hone, Nathaniel, No. 186 (Unidentified Artist)

Horne, Herbert P., No. 33 (F. Guardi)

Italico Brass, No. 22 (Canalettó); Nos. 139, 154 (D. Tiepolo)

Karl & Faber, No. 152 (D. Tiepolo)

Kerr, Admiral Lord Mark, No. 36 (G. Guardi)

Kilvert, Mrs. D., Nos. 169–70 (D. Tiepolo)

Klinkosch, Josef Carl von, No. 179 (Tironi)

Knoedler, M., and Co., No. 166 (D. Tiepolo)

Komor, Mathias, No. 1 (Amigoni)

Lamponi-Leopardi, Conte E. R., No. 122 (D. Tiepolo)

Lewis, Sir Gilbert, No. 159 (D. Tiepolo); No. 177 (L. Tiepolo)

Lock Galleries, No. 66 (Panini)

Luzarche collection, Nos. 112–13 (D. Tiepolo)

Mayor, William, No. 34 (G. Guardi)

Mestral de Saint-Saphorin, Armand-Louis de, No. 2 (Bambini); No. 81 (G. B. Tiepolo)

Mildmay, Humphrey, No. 69 (M. Ricci)

Mongan, Agnes, No. 70 (S. Ricci)

Morassi, Antonio, Nos. 137–38 (D. Tiepolo)

Nebehay, Gustav, No. 148 (D. Tiepolo)

Norris, Christopher, No. 31 (F. Guardi)

Oppenheimer, Henry, No. 164 (D. Tiepolo)

Owen, Richard, Nos. 78–80, 93–94 (G. B. Tiepolo); Nos. 167–75 (D. Tiepolo); No. 177 (L. Tiepolo)

Parsons, E., & Sons, Nos. 78–80, 83–91, 93–94 (G. B. Tiepolo)

Pascall, Mrs. Clive, No. 31 (F. Guardi)

Pesaro, Francesco, Nos. 78–80, 93–94 (G. B. Tiepolo)

Philippi, L. H., No. 68 (Piranesi)

Pilkington, A. D., No. 114 (D. Tiepolo)

Private collection, Berlin, No. 36 (F. Guardi)

Prouté, Paul, Nos. 133–34 (D. Tiepolo)

Provenance not established, No. 17 (Buffagnotti); No. 20 (Canaletto); No. 24 (Crespi); No. 27 (Ghezzi); No. 95 (G. B. Tiepolo); No. 118 (D. Tiepolo); No. 183 (Zuccarelli)

Ranfurly, Earl of, Nos. 78–80, 93–94 (G. B. Tiepolo)

Reichlen, J. L., No. 2 (Bambini)

Reitlinger, Henry S., No. 93 (G. B. Tiepolo)

Roche, Colonel Edward, Nos. 37–56 (G. Guardi)

Rosenberg & Stiebel, Nos. 169–70 (D. Tiepolo)

Salem, Mrs., No. 74 (G. B. Tiepolo)

Sandby, Paul, No. 19 (Canaletto)

Savile Gallery, No. 76 (G. B. Tiepolo); Nos. 167, 173 (D. Tiepolo)

Savoia-Aosta collection, No. 65 (Novelli)

Scharf, Alfred, No. 129 (D. Tiepolo)

Scholz, Janos, No. 2 (Bambini); No. 22 (Canaletto); No. 65 (Novelli)

Seiferheld, Helene C., No. 2 (Bambini); No. 26 (Gandolfi)

Seligmann, Jacques, No. 166 (D. Tiepolo)

Slatkin, Charles E., Galleries, No. 60 (Novelli); Nos. 115, 119, 123, 128, 130, 132, 140, 145–46, 152 (D. Tiepolo); No. 176 (L. Tiepolo); No. 180 (Zais)

Sotheby's (London), Nos. 156, 164, 167–75 (D. Tiepolo)

Spector, Stephen, No. 68 (Piranesi)

Suzor, Léon, No. 175 (D. Tiepolo)

Suzor, Paul, No. 172 (D. Tiepolo)

Trevise, Duc de, No. 113 (D. Tiepolo)

Tyser, Granville, No. 164 (D. Tiepolo)

Unidentified collector, No. 122 (D. Tiepolo)

Vallardi, Giuseppe, No. 61 (Novelli); No. 71 (G. B. Tiepolo)

Valmarana, Conti, Nos. 97–102, 104–11 (G. B. Tiepolo)

Venice, S. Maria della Salute, Somasco Convent Library, Nos. 78–80, 93–94 (G. B. Tiepolo)

Vries, R. W. P. de, No. 18 (Canaletto)

Wachtmeister, Countess, No. 88 (G. B. Tiepolo)

Wallraf, Paul, Nos. 3–15 (Bellotto); Nos. 18, 21–23 (Canaletto); No. 25 (Diziani); Nos. 31–33 (F. Guardi); No. 34 (F. & G. Guardi); Nos. 35–56 (G. Guardi); No. 57 (Longhi); No. 58 (Marieschi); Nos. 59, 61–65 (Novelli); No. 67 (Pellegrini); No. 69 (M. Ricci); Nos. 71–75, 77–88, 91–94, 96–111 (G. B. Tiepolo); Nos. 122, 124, 126, 129, 134, 137–38, 144, 147–51, 153–56, 158–63 (D. Tiepolo); No. 177 (L. Tiepolo); No. 178 (Tironi); No. 181 (Zanetti); No. 182 (Zuccarelli); Nos. 184–85 (Zucchi)

Wertheimer, Otto, No. 166 (D. Tiepolo)

Wildenstein & Co., No. 93 (G. B. Tiepolo); No. 165 (D. Tiepolo)

Wolseley, Lord, No. 186 (Unidentified Artist)

PHOTOGRAPH CREDITS